THE HUNGRY EYE

THE HUNGRY EYE

Eating, Drinking, and European Culture

from Rome to the Renaissance

Leonard Barkan

Princeton University Press

Princeton and Oxford

Dedication

As is indicated by my Acknowledgments, there are countless friends and colleagues surrounding me in my academic life, and it would be a pleasure, as it has been previously, to dedicate this volume to one or more of them. I have chosen to move in a different direction, however, one that seems especially appropriate for this book. The final stages of manuscript work on *The Hungry Eye* coincided with some of the deepest lockdown phases of the Covid-19 pandemic, and as I write this, the crisis is by no means over. My beloved spouse, Nick Barberio, and I made the decision to be particularly rigorous in our personal quarantine, scarcely exiting from our Princeton house for many months. We would never have been able to take this step were it not for the fact that many sources of food and drink, along with other domestic needs, were uninterruptedly active, discharging their production and transport efforts with efficiency and safety. We are—is it any surprise?—a pair of demanding customers when it comes to all the materials of dining, whether it's fresh eggs from New Jersey or olive oil from Umbria. To know, at our end, that such a market basket was available and, at the suppliers' end, that there was employment for such a wide population of butchers and greengrocers, farmers and livestock keepers, pickers and packers, shippers and deliverers: this represented sustenance in a dark time.

I dedicate this book to all those heroes who have been nourishing our bodies and souls for these lonely months.

L.B.
Princeton, October 2020
Week 30 of lockdown

Requests for permission to reproduce material from this work should be sent to permissions@press.princeton.edu
Published by Princeton University Press, 41 William Street, Princeton, New Jersey 08540
In the United Kingdom: Princeton University Press, 6 Oxford Street, Woodstock, Oxfordshire OX20 1TR

press.princeton.edu

Cover illustrations: (front) Clara Peeters, *Still Life with Cheeses, Artichoke, and Cherries*, c. 1625. Los Angeles County Museum of Art, California. © 2021 Museum Associates / LACMA / Art Resource, New York; and (back) xenia with fruit bowl, 1st century CE, from the House of Julia Felix, Pompeii. Museo Archeologico Nazionale, Naples. Scala / Art Resource, New York

Illustrations in front matter: p. ii, detail of fig. 3.8; p. vi, fig. 2.23 Chapter opener details: chapter 1, detail of fig. 1.8; chapter 2, detail of fig. 2.10; chapter 3, detail of fig. 3.16; chapter 4, detail of fig. 4.12; chapter 5, detail of fig. 5.13

Library of Congress Cataloging-in-Publication Data
Names: Barkan, Leonard, author.
Title: The hungry eye : eating, drinking, and European culture from Rome to the Renaissance / Leonard Barkan.
Description: Princeton : Princeton Univeristy Press, [2021] | Includes bibliographical references and index.
Identifiers: LCCN 2020044598 (print) | LCCN 2020044599 (ebook) | ISBN 9780691211466 (hardback) | ISBN 9780691222387 (ebook)
Subjects: LCSH: Aesthetics, European. | Dinners and dining—Europe—History. | Arts, European—Themes, motives.
Classification: LCC BH221.E853 B37 2021 (print) | LCC BH221.E853 (ebook) | DDC 364.1/20940902—dc23
LC record available at https://lccn.loc.gov/2020044598
LC ebook record available at https://lccn.loc.gov /2020044599
British Library Cataloging-in-Publication Data is available

This publication is made possible in part from the Barr Ferree Foundation Fund for Publications, Department of Art and Archaeology, Princeton University.

Designed by Jeff Wincapaw

This book has been composed in Adobe Caslon Pro

Printed on acid-free paper. ∞

Printed in Italy

10 9 8 7 6 5 4 3 2 1

Contents

Acknowledgments

I started as a scholar of the Renaissance and antiquity who loved to cook, to eat, and to taste wine; then, by various happy accidents, I began to receive requests that I actually *write about* cooking, eating, and tasting wine. After a couple of decades during which I kept scholarly and gastronomic undertakings sealed off from each other, it began to seem inevitable that I would hook them up, attempting somehow to maintain the rigor of a cultural historian with the attentiveness to pleasure of the gastronome. Whether I have succeeded, others can decide. That I have been permitted to *try* is courtesy of a great many wise, affectionate, and pleasure-loving friends.

When I think about beginnings for these efforts, two colleagues of Olympian stature immediately come to mind. Near the beginning of my time at New York University, when I scarcely knew anyone outside my own departments, Marion Nestle, the great scholar-activist in the fields of nutrition and public health, somehow caught wind of the fact that I was a foodie, and sight unseen she invited me to give a brief talk in a panel about food and culture. I didn't really know what was expected at such a forum, so I jotted down a few notes toward what I called a culinary autobiography. Marion sat in the front row sporting her inimitable smile and at the end, essentially, welcomed me to the world of food studies. Fifteen years later, the miraculous Shirley Tilghman, then president of Princeton University, invited me to give one of her President's Lectures. I wanted to do something worthy of her (no easy task!). My talk, entitled "Did Eating Have a Renaissance?" fell well short of that worthiness; nevertheless it was, and remains, the basis of this book. Thank you, Marion; thank you, Shirley.

The fact that I could be a writer about food and wine at all is owing to the generosity of some very remarkable people over many years. Even though I wrote a book about it, I still don't know how I was lucky enough to land in Rome at just the moment when a ragtag group of intellectuals, politicos, and gourmands was creating the vast enterprise of gastronomic journalism known as *Gambero Rosso*, nor am I certain how it is that they let me hang out with them. Since those days they have dispersed into many different enterprises, but they still constitute my pantheon of good company: Daniele Cernilli, Linda Davidson, Paolo Zaccaria, Marina Thompson, Sergio Ceccarelli, Sandro Sangiorgi, the late Stefano Bonilli. I raise many glasses to you all.

Over the years, from the inception of this project to the present and beyond (I hope), I have been privileged to be welcomed in two extraordinary academic and cultural institutions: the American Academy in Rome and the American Academy in Berlin. No coincidence that in both cases these are sites where much of the intellectual life is conducted with the kind of sociability that good food and good wine inspire, for which I salute the respective geniuses of cuisine during my time at those academies: Mona Talbott in Rome, Reinold Kegel in Berlin. We weren't *always* at the dining table in these beautiful and inspiring spaces, of course. During my time in Rome I was blessed with the learned and affectionate companionship of Carmela Franklin, Chris Celenza, Martin Brody, Corey Brennan, Ramie Targoff, Bill Franklin, Ann Vasaly,

Lisa Bielawa, Stephen Westfall, David Rosand, Ellen Rosand, and Nick Wilding. In Berlin, it's a pleasure to acknowledge Gary Smith, Rick Atkinson, Joel Harrington, Susan Howe, Nathan Englander, Andrew Norman, and David Abraham. The support of two trustees of the American Academy in Berlin, Gerhard Casper and Gahl Burt, has been a source of joy.

It has also been a pleasure and an honor to speak about these materials among some very engaged audiences, under the auspices of the Muhlenberg Center for American Studies at the Martin-Luther Universität Halle-Wittenberg, and as the inaugural James Loeb Lecturer at the Zentralinstitut für Kunstgeschichte in Munich. Wonderful hospitality with fittingly pleasurable dining on both occasions; much thanks to the Harvard Club of Munich, Dr. Hermann Mayer, Robert Skokstad, and Erik Redling. I also had the marvelous experience of being the Rudolf Arnheim Gastprofessur at the Institut für Kunst- und Bildgeschichte at the Humboldt University Berlin. Many ideas elaborated in these pages began in my lectures there on the subject of art and food. Warmest gratitude to the extraordinary Horst Bredekamp, a man whose soul is as expansive as his learning. And loving thanks to the indefatigable and charming Tarek Ibrahim, who served as my assistant at the Humboldt.

A penultimate and all-encompassing expression of gratitude to Princeton: the Firestone Library, the Princeton University Art Museum, the Marquand Art Library, the Barr-Ferree publications fund, my colleagues, and my students. And, of course, the Princeton University Press, with whom, once again, it has been a pleasure to collaborate, for which much thanks to Michelle Komie, Christie Henry, Peter Dougherty, and Amy K. Hughes. It is a privilege to live among these remarkable persons and benefit from these extraordinary institutions.

I've saved a unique expression of gratitude for last. If, dear reader, you are pleased to hold in your hand a volume filled with beautiful images—of fruits and vegetables, of princely dinners and Last Suppers—please join me in thanking Ashton Fancy, who undertook the astonishing task of procuring images and rights across the world when the world had pretty much shut down.

I have always found that the people I drink with, dine with, cook with are those who have inspired me as a scholar and a person. I cannot list you all, but I long for the time when we're undistanced and can cook and drink and dine in each others' company once more.

Introduction

SIR TOBY BELCH. Does not our life consist of the four elements?
SIR ANDREW. Faith, so they say; but I think it rather consists of eating and
 drinking.
SIR TOBY BELCH. Thou'rt a scholar; let us therefore eat and drink.
 Twelfth Night, Act 3, Scene 2[1]

In a little throwaway conversation between two relatively minor characters, Shake-speare puts into words what we might consider the most fundamental of the impulses that underlie the present volume: we love to eat and drink. To be sure, Sir Toby and Sir Andrew may not be the most creditable spokespersons; they are, not to put too fine a point on it, drunks. They career through *Twelfth Night* in a blaze of overindulgence that is lovable, but just up to a point. Only in this interchange do we catch a glimpse that their intemperance might be (as we sometimes say nowadays) *theorized*. It appears that Sir Andrew, a wealthy but unsophisticated country dweller who is sojourning among the urbane personages in Illyria, has amassed a certain degree of learning, per-haps in his more abstemious youth. Hence Sir Toby's appeal to his expertise concern-ing those fundamentals—earth, air, fire, and water—that in the old cosmology were said to be the constituents of the natural world. Sir Andrew has, however, replaced the old cosmology with a new one: eating and drinking. And Sir Toby, who must be delighted at this rewriting of the textbooks, gets on board quickly by pursuing the per-fectly logical consequence—namely, that in honor of this scientific reassessment, they ought to spend all their time eating and drinking. Nor is it a completely preposterous notion, since it's impossible to imagine life of any kind without something equivalent to eating and drinking.

Shakespeare, then, provides one perfectly simple premise upon which this book rests. There is nothing more important, more basic, more inevitable in human life (*all* life) than the consumption of food and drink. Granted, Shakespeare locates this truth in the mouths of some dubious characters. What Sir Andrew learned in school was right, and his new cosmology is not right: the world *is* made up of the four elements, and his brand of heretical New Science is merely an excuse for the kind of excess that gives eating and drinking a bad name. Indeed, any sort of heavy focus on those activities—for instance, writing a book in which all sorts of cultural enterprises are being *read for the food* (to cite the title of our first chapter)—is flirting with this sort of bad name.

Throw in another quotation, as remote in time and place from Shakespeare as is possible to imagine:

> To be cultured [in China] is, first, to know the rites and the classics; second, to have a certain flair for poetry and painting; third, to be an aesthete of food—to appreciate the precise flavor and texture. But although good professional cooks are respected, cooking, with its unavoidable violence of chopping and cutting, boiling and frying, and its intimate association with blood and death, tends to arouse unease.[2]

Those of us whose formations are wholly European and who love to talk about food need always to remember that, compared to many ages of civilization in China, such high points of cuisine as Renaissance Italy or nineteenth-century France amount to chump change—not only in what was served to gourmets but also in the table talk concerning such delectables. The present book remains wholly in that European realm. But though we may not hear of the East again in these pages, I allow myself to exploit the insight of the distinguished geographer Yi-Fu Tuan, who points out a paradox in the world that he has studied. High cultural attainment in China afforded equal reverence to sacred ritual, to the arts of the ancients, to poetry and painting, *and* to being, as he puts it, "an aesthete of food." Pause there for a moment, and we take note of a proposition familiar even to those of us who are not Asianists: in the long history of Chinese civilization, the art of cuisine has been afforded the same kinds of honor that were enjoyed by art, literature, music, sacred studies, and the rest of high cultural attainment. Then, however, there is a *but*: despite this veneration, there are aspects of cuisine—chopping, boiling, frying, not to mention blood and death—that (in Tuan's marvelous formulation) "arouse unease."

This is a book about that mix of veneration and unease, which Yi-Fu Tuan observed in China, but *mutatis mutandis*—that is, changing what needs to be changed so as to plot it onto European culture from the ancients to the early moderns. And quite a lot needs to be changed. The story to be told here is not so much about great sages, artists, or theologians who also proved to be exquisitely productive gourmets (though there may be some along the way) but rather about the fact that the operations of eating and drinking—call it Sir Toby's cosmology—inevitably found their way into the work of such culturally creative individuals: philosophers philosophized at dinner tables; religions revolved around epochal feasts; rulers enforced their sway by

means of banquets; painters depicted food and drink that may not have always been mere metaphors for something more important, and they may have also noticed that their own labor was not so very different from that of the kitchen; poets found that the language of consumption, nutrition, and taste was an inspiring mode of framing the very effects they aimed to produce via their own more mediated and incorporeal productions—just to name a few possibilities.

But—to revert once again to Professor Tuan's double-sided account—it's not just that Western European cultural heroes prove to be chefs and gourmets in disguise or via a particular close reading of their work (though that can be true), but that the other half of the formulation—the part about arousing unease—is fundamental to these operations as well. The makers of the works discussed in these pages find that eating and drinking are central and essential to their imaginative undertakings, but all this creative exuberance can never quite shed that sobering dose of unease that we detect in the somewhat dubious authority of *Twelfth Night*'s tipsy spokespersons, whether it's the chopping and frying or the anxieties about body and pleasure or the abjection that awaits at the end of the process.

It would be a shame to conclude on that particular sour note. *The Hungry Eye* is not a thoroughgoing history of gastronomy, though it covers some large swaths of the past and approaches them through historical methods. Nor is it likely to provide much advice on what to serve for dinner, despite its prejudice (as the reader will hear many times) in favor of food as food rather than food as a figure for something else, something (quite possibly) less tasty and nutritious, less pleasurable. Rather the book is a celebration of the complex forms of debt, with whatever portions of joy and unease, that Western high culture, particularly from antiquity to early modernity, owes to mealtime.

That phrase "Western high culture" merits a pause for reflection. This is a book about the lives and works, from antiquity to early modernity, of a very selected stratum of individuals. Those are the persons, for the most part, whose work in whatever medium survives in sufficient fullness to make a portrait of the past possible. We all know that this yields a highly selective past; we also know that historians have developed ways to see beyond the limits of the verbal, the visual, and all the other forms of literacy. The present volume accepts, even embraces, the archive of the widely known and readily knowable past, however, on the principle that it has been common, available, and shared through the millennia. At the same time, it focuses precisely on a fundamental activity that *all* persons of whatever stratum have had in common: the experience of taste and the gaining of nourishment. Between the time this book was written and its appearance in print, the entire globe has had the experience of deprivation, not just of taste and nourishment but, for hundreds of thousands, of life itself. There is no repairing this loss or pretending to palliate it with a book. All that can be said by way of contributing to the present historical moment is to affirm that eating and drinking—and particularly the *pleasures* thereof—deserve to be remembered and celebrated, to be awarded their rightful place, as this book strives to do, and thus to bring some shred of everyone's past into the present.

A few words, finally, about the structure of the book. The opening chapter will enlarge upon what might be called the paradigm of this volume: the operations of

high culture—philosophy, aesthetics, literature, art—finding themselves in need of references to eating and drinking in order to make their claims about more prestigious activities; somewhere, in virtually every lofty expression of the human spirit, someone is thinking about the next meal or actually consuming it. That chapter will also have quite a bit to say about the methodological principles of the whole book. After that, the chapters develop more specific focal points. In chapters 2 and 3, the subject matters are largely historical and chronological. The former, "Rome Eats," is concerned with classical antiquity, the latter, "Fooding the Bible," with the Judeo-Christian traditions, not only within their ancient origins but in their reception and recuperation as well. The final two chapters divide up the subject on a different, more conceptual basis. In both, the works under discussion are drawn predominantly from the early modern period, along with some of its classical forebears. But each of them follows a distinct path through a broad subject matter appropriate to the themes of eating and drinking. Chapter 4, "The Debate over Dinner," concerns itself with the celebration of dining from the time of Athenaeus to the Renaissance, but it chronicles as well the counterattack, on the grounds that eating and drinking might have been considered culturally unworthy, frivolous, prone to excess, and lacking in the kind of system, or *techne*, that loftier enterprises could boast; as we'll see, many respond in defense, via both theory and practice. The final chapter, "Mimesis, Metaphor, Embodiment," tackles the question of the material versus the metaphorical, which is to say, from food as the thing itself to abstract realms in which such forces as consumption, nourishment, taste, and commensality are either expunged or metaphoricalized almost beyond recognition; the chapter argues not only for the opposition between these approaches but also for their interdependence. These itineraries—more about this in chapter 1—are not always precisely linear; it is hoped that they invite readers to make their own paths of recognition and reflection through this contribution to a particular account of civilization as reflected through eating and drinking.

THE
HUNGRY
EYE

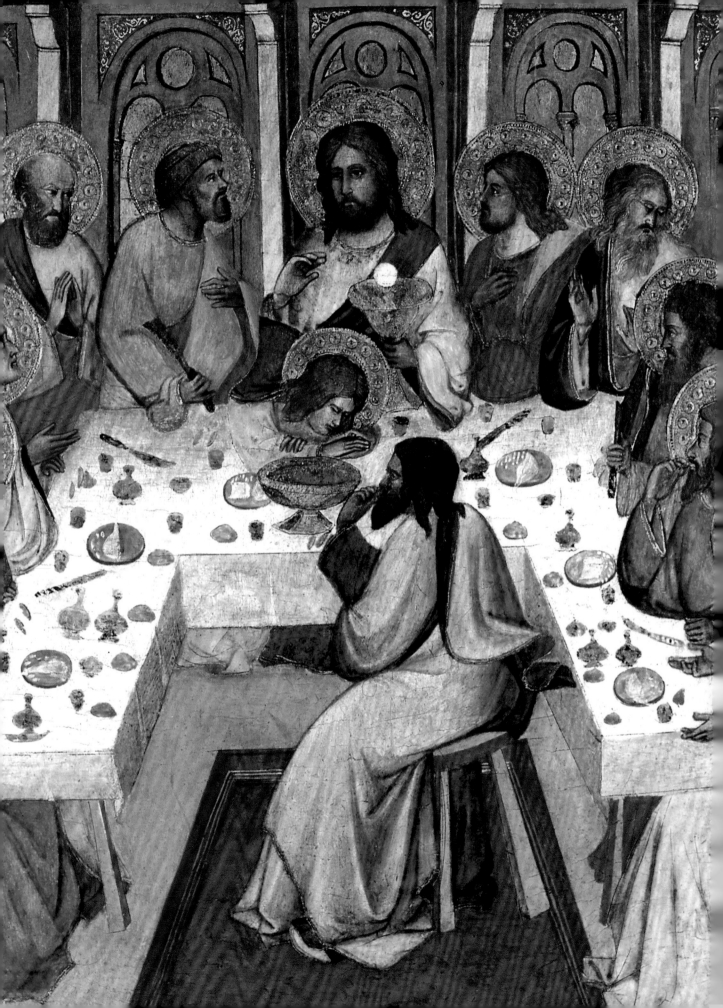

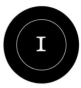

Reading for the Food

In principle, at least, the Greeks distinguished rigorously between two phases of a formal meal (fig. 1.1). First came the *deipnon*, with many and varied courses of food, and then the *symposion*, which was principally devoted to drink, as the word itself (συν- πίνω; "drink together") suggests. This latter phase could move onward into the wee hours with loose talk among the (inevitably) all-male diners or even to erotic activity involving the visits of slave girls, hetaerae, and the like.[1]

How, then, shall we comprehend the most famous symposium of all, scripted by Plato, in which Socrates and his learned colleagues quite soberly discuss the nature of love? One path to an understanding would have to travel through the opening pages of the dialogue, in which there are only the vaguest references to love—Socrates flatters Agathon's beauty while also offering some sarcastic insinuations about his intelligence—but a plethora of references to dinner, including who got invited or didn't get invited, the introduction of Socrates as a guest who brings another person along but arrives late himself, and a description of the officially sanctioned arrangement of the dinner couches.

Most particularly, though, there is a discussion about drink. The symposiasts seem to be pursuing a quite canonical structure for the meal. Having concluded the eating portion of the occasion, "They poured a libation to the god, sang a hymn, and—in short—followed the whole ritual. Then they turned their attention to drinking."[2] But this attention is devoted mostly to how they *won't* be drinking. Both Pausanias and Aristophanes, it turns out, already have hangovers from the night before, Agathon is also a bit the worse for wear, and the physician Eryximachus is prepared to offer a medical lecture about the evils of alcohol (which we are all spared). They also agree to dismiss the flute girl, whose sensuous entertainment is of a piece with heavy drinking.

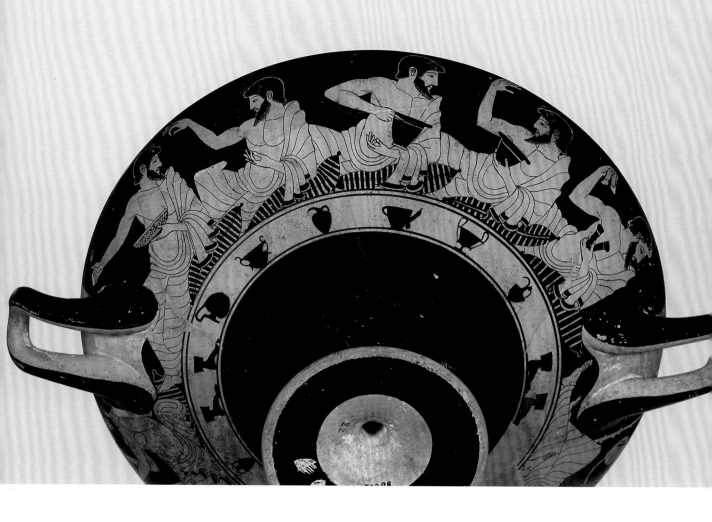

What sort of occasion is this, then? In the "Table Talk" section of his *Moralia*, Plutarch will triumphantly point out that the food consumed on sympotic occasions leaves nothing but "yesterday's smell,"[3] whereas the wise words of philosophy remain eternally fresh, and that, he says, is why the *Symposium* includes no account of the menu but only of the conversation. (An observation, it should be pointed out, offered in the midst of several chapters in the "Table Talk" filled with minute gastronomic observations.) Nevertheless, Plato has designed a narrative in which the most transcendent of philosophical matters is framed around a meal. The *deipnon* phase of the evening is duly, if briefly, chronicled, but the drinking phase that is supposed to follow, though coyly offered as a possibility, is cancelled in favor of rigorous teetotaling and some apparently contrary set of activities. Yet, if the alcoholic phase does not take place, why is the dialogue given the name of a drinking party?

1.1. Triptolemos Painter, Banquet scene (symposium) on red figure kylix (drinking cup), 5th century BCE. Antikensammlung, Staatliche Museen, Berlin

• • •

The great philosopher of a later age Immanuel Kant spent some years developing a set of lectures that would eventually become *Anthropology from a Pragmatic Point of View*.[4]

Neither exactly anthropological nor pragmatic in the modern senses, these lectures represent Kant's wish to branch out from the world of purely abstract philosophical reasoning, of metaphysics or epistemology, in favor of something closer to a description of human activity, especially cognition, as it actually takes place.

Throughout his work in both these areas, Kant was intensely concerned with aesthetics, and especially aesthetic judgments. In the *Critique of Judgment*, the ruminations are at base abstract and logical. He is laboring to define the philosophical status of judgments about beauty and what sort of truth they might contain, as distinct from judgments about, say, ethics. His *Anthropology*, on the other hand, aspires to describe and analyze actual human processes, and so he is less interested in the validity of aesthetic judgments than in the human faculties that produce them. Consequently, it is no longer abstract logic that governs his thinking but rather a description of human subjectivity, with its capacities for pleasure and displeasure.

The term that encapsulates aesthetic judgment and human subjectivity is, inevitably, *taste*; and Kant remains sufficiently a philosophical systematizer to be searching for universals in this apparently individualist realm. "The word *taste*," he writes, in a section of *Anthropology* entitled "On the feeling for the beautiful," "is also taken for a sensible faculty of judgment, by which I choose not merely for myself, but also according to a certain rule which is represented as valid for everyone."[5] He proceeds to do quite a bit of philosophical heavy lifting around the conflict between individual judgments and universal rules, citing, for instance, the distinct traditions of the Germans versus the English in regard to the way they begin their meals, the Germans preferring soup, the English solid foods.

But the whole matter of taste, once it has made a transit through mealtime, requires of Kant that a separate *Anmerkung*, or note, be appended to this section—a practice he does not follow elsewhere in the *Anthropology*. "How could it have happened," Kant begins his *Anmerkung*, "that modern languages in particular have designated the aesthetic faculty of judging with an expression (*gustus, sapor*) that merely refers to a certain sense organ (the inside of the mouth)?" (*Anthropology*, 139). It's worth paying special attention to that "merely" (*bloß*). In Kant's search to find a through line between aesthetics and universals, to offer a philosophical account of *taste*, the inside of the mouth looms threateningly. Why indeed should that particular bodily sensation, whether generated by German cabbage soup or English soused mackerel, have become archetype and eponym for so many aesthetic experiences of greater importance than anything produced by mere *amuse-bouches*?[6]

• • •

In 1435, Leon Battista Alberti produced his highly influential treatise *On Painting*, which he wrote first in Latin and then translated, with some changes, into Italian. In a quite brief stretch of pages, Alberti celebrates the glories of painting, covers technical issues in representation and perspective, and enunciates up-to-date rules for pictorial decorum. In particular, he canonizes a certain kind of narrative composition, which he calls a *historia*, endowing it with cultural significance very much along the lines that Horace bestowed on poetry in his *Ars poetica*.

Laying down the guidelines for this composition, Alberti arrives at questions having to do with what he calls *compositio*. He doesn't like a picture to be too empty or too crowded, and he goes on to say,

> In a "historia" I strongly approve of the practice I see observed by the tragic and comic poets, of telling their story with as few characters as possible. In my opinion there will be no "historia" so rich in variety of things that nine or ten men cannot worthily perform it.[7]

Alberti is drawing an analogy between the number of characters in a classical drama and the number of bodies in a painting. The parallel makes sense: he is, after all, talking about narrative; and the ancient dramas with which he may have been familiar (say, Terence and Seneca)[8] could well stand as paradigms for economy of storytelling, readily transferrable from the three dimensions of the theater to the two dimensions of panel paintings. We are, in other words, witnessing a logical shift from one aesthetic medium to another; in a familiar intermedial mode, Alberti wishes to garner some of the prestige accorded to classical text and transfer it to modern painting.[9]

But Alberti does not close with the theatrical analogy. Having established the limit of nine or ten persons in a painting on the authority of the ancient dramatists, he caps off this discussion by saying, "I think Varro's dictum is relevant here: he allowed no more than nine guests at dinner, to avoid disorder." The swerve from Sophocles to the supper table, surprising in itself, becomes even more striking when we look back at Alberti's source. He hasn't actually read Varro; he couldn't have, since that text is lost.[10] Instead, he has drawn this classical injunction from its citation in the *Attic Nights* of Aulus Gellius,[11] one of those pedantic and meandering compendia that acted as a sort of late antique Wikipedia ever available to furnish humanists with classical exempla.

In the context of the *Attic Nights*, Varro's opinion about dinner parties is not an analogy for something else, as it is in Alberti; it is simply advice about dinner parties. But within that text, the prescription regarding hospitality is itself justified by analogies: "The number of the guests," says Varro, or so Aulus Gellius tells us, "ought to begin with that of the Graces and end with that of the Muses" (13.11)—that is, between three and nine. In fact, Alberti may have known, and Varro certainly *did* know, that the number nine for a dinner was a consequence of the *triclinium*,[12] which, in one of its forms, consisted of three couches with three diners on each; hence, the association with the Muses was itself a kind of mythological back-formation. In any event, Alberti, the lawgiver for painting, has found the justification for one of his rules in a gastronomic context that itself sought authority from the classical subjects of Graces and Muses. Graces and Muses are, of course, time-honored pictorial subjects in their own right. But Alberti ignores painterly practice as an exemplum for painting and instead reaches around to the dinner table. He also has to sidestep the fact that paintings of actual dinners within his own culture, such as Last Suppers or weddings at Cana, could scarcely ever be squeezed into the numbers of Varro's guest list. On the other hand, dozens of panel paintings in the Albertian tradition,[13] often sacred altarpieces whose subjects have nothing whatever to do with mealtime, end up following his dinner-inflected prescription, though without looking much like dinner parties.

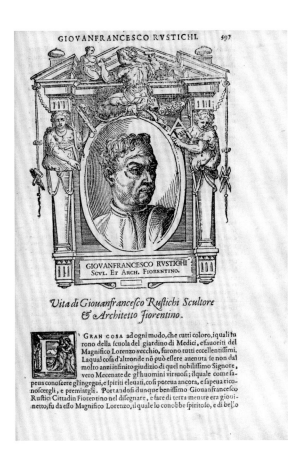

GIOVANFRANCESCO RVSTICHI.
SCVL. ET ARCH. FIORENTINO.

Vita di Giouanfrancesco Rustichi Scultore
& Architetto Fiorentino.

GRAN COSA ad ogni modo, che tutti coloro, iquali fu-
rono della scuola del giardino di Medici, e fauoriti del
Magnifico Lorenzo vecchio, furono tutti eccellentissimi.
Laqual cosa d'altronde nõ può essere auenuta se non dal
molto anzi infinito giudizio di quel nobilissimo Signore,
vero Mecenate de gl'huomini virtuosi; ilquale come sa-
peua conoscere gl'ingegni, e spiriti eleuati, così poteua ancora, e sapeua rico-
noscergli, e premiargli. Portandosi dunque benissimo Giouanfrancesco
Rustici Cittadin Fiorentino nel disegnare, e fare di terra mentre era gioui-
netto; fu da esso Magnifico Lorenzo, ilquale lo conobbe spiritoso, e di bell'o

1.2. Portrait of Giovanni Francesco Rustici in a decorated frame, in Giorgio Vasari, *Le vite de' piu eccellenti pittori, scultori, e architettori*, Florence, 1568

• • •

For the final, expanded edition (1568) of his *Lives of the Painters, Sculptors, and Architects*, Giorgio Vasari composed almost two hundred artists' lives.[14] Not all of them were Donatellos and Raphaels, of course, nor did Vasari possess encyclopedic information about every one of his subjects. When a biography needed to be fleshed out, he often had recourse either to anecdotal material (sometimes more formulaic than historically accurate) or to the recounting of personality traits that turned the biography into something like a humoral character sketch.

Giovanni Francesco Rustici (fig. 1.2) seems to have required both of these strategies. Vasari presents him as the archetypal eccentric: he has a pet porcupine; he fills a room with garter snakes; he dabbles in necromancy. He is also something of a well-intentioned schlemiel: though he was "a man of surpassing goodness, and very loving to the poor," his career is forever going awry.[15] More surprisingly, in telling Rustici's story, Vasari interrupts the customary sequence of career milestones—apprenticeship, commissions won or lost, works produced—with an account of Rustici's membership in a circle of artist-gourmets. On one evening in that company, for instance, Vasari tells us,

> the contribution of Rustici was a cauldron in the form of a pie, in which was Ulysses dipping his father in order to make him young again; which two figures were boiled capons that had the form of men, so well were

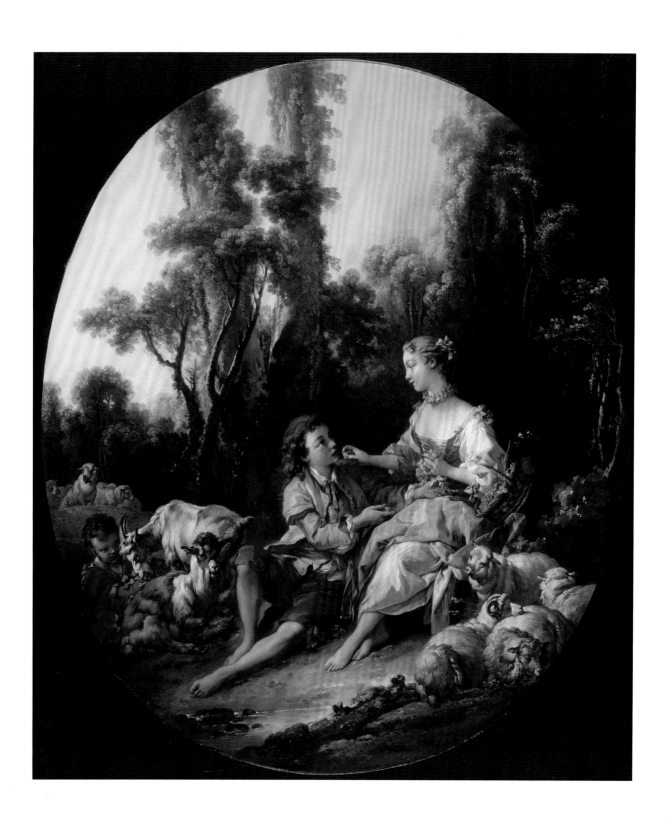

1.3. François Boucher,
*Pensent-ils au raisin? (Are They
Thinking about the Grapes?)*,
1747. Art Institute of Chicago

the limbs arranged, and all with various things good to eat. Andrea del
Sarto presented an octagonal temple, similar to that of S. Giovanni, but
raised upon columns. The pavement was a vast plate of jelly, with a pat-
tern of mosaic in various colors; the columns, which had the appearance
of porphyry, were sausages, long and thick; the socles and capitals were
of Parmesan cheese; the cornices of sugar, and the tribune was made of
sections of marchpane. In the centre was a choir-desk made of cold veal,
with a book of lasagne that had the letters and notes of the music made
of pepper-corns; and the singers at the desk were cooked thrushes stand-
ing with their beaks open, and with certain little shirts after the manner
of surplices, made of fine cauls of pigs, and behind them, for the basses,
were two fat young pigeons, with six ortolans that sang the soprano.
(2.524)

The above, it should be noted, is a small fraction of Vasari's full gastro-ekphrasis,
which runs to nearly half of the seventy-five-hundred-word biography of Rustici. It
may be that this interlude is a compensation for the second- or third-class status of
Rustici as an artist, or a confirmation of his eccentricity. But how do these bizarre
culinary escapades relate to the central concerns of Vasari's *Lives*—that is, artists
making art?

• • •

At the Paris Salon of 1747, François Boucher exhibited a painting whose subject
derived from a pastoral entertainment composed by his friend Charles-Simon Favart.[16]
In one of the episodes that Boucher illustrated, an amorous shepherd plays the flute for
his beloved; in the other, far more famous picture, she feeds him grapes (fig. 1.3). As
with many works of rococo, simplicity is achieved here via quite a lot of complication,
in this case a cross between realistic details of country life and full-dress classical-style
pastoral. Unshod and slightly grimy feet thus keep company with an elaborate multi-
color frock, and elegantly idealized human figures have as bookends some shaggy goats
on one side and pudgy sheep on the other.

We would not be talking about this picture—and most likely the world wouldn't
have been talking as much as it has—were it not for the fact that it comes with a
title: *Pensent-ils au raisin? (Are They Thinking about the Grapes?)*.[17] But the title is also
a problem. We cannot be certain that it was authorial, only that it appeared on a
very early engraving that had a wide distribution (fig. 1.4). Nor is it the kind of title
that is characteristic of Boucher's oeuvre, which abounds in straightforward designa-
tions, whether the subject is a genre scene (*The Milliner*) or an episode out of classical
mythology (*Diana Bathing*). Whether Boucher is responsible or not, this painting
comes down to us wedded to a notably provocative label. The very fact that it is in the
form of a question is provocative: the picture is no longer just an episode in pastoral
life, sealed off in some make-believe world, it is a game between the art object and
the viewer, who must assemble material evidence from the canvas in order to deduce
the internal state of the figures represented—the very thing that painting can never
reliably reveal.

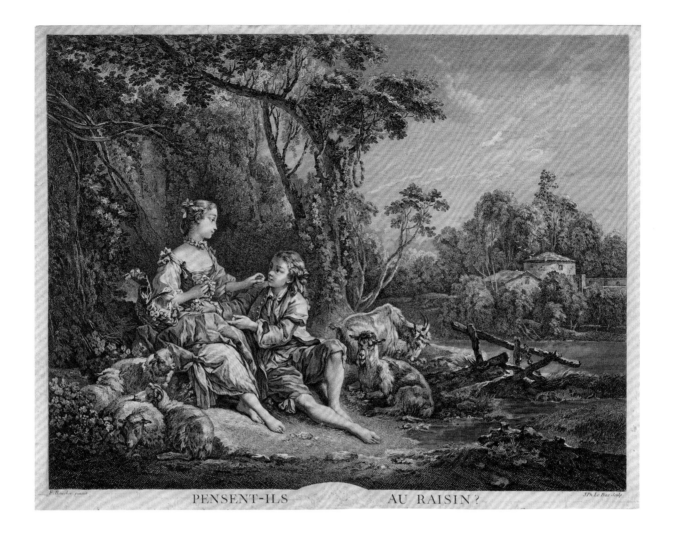

PENSENT-ILS AU RAISIN?

And there are further provocations. The titular question guides our viewing quite specifically; in pursuit of an answer, we focalize on the lady holding a bunch of grapes in her left hand and placing a single grape before the mouth of her lover with her right hand. The grapes lead us to some interesting places—his mouth, her breast— yet that visual itinerary turns out to provide a striking counterplot to the story we might have followed without benefit of such a title, that is, the passionate trajectory of vision between the two lovers, which in fact bypasses the grapes altogether. In the end, though, it doesn't really matter; whether we follow the eyes or the grapes, the message is the same. The cigar in this case is *not* just a cigar; in fact, it's scarcely a cigar at all. With this image in front of us, and the question, "Are they thinking about the grapes?" having been posed, we know the answer: Hell, no! Who would think of food at a time like this?

Clearly, I would.

Or perhaps not. Several years ago I published a book in which I argued that the fifteenth- and sixteenth-century discovery of ancient art objects buried in the soil of Rome was the key to a whole set of operations around history, culture, and artistic production.[18] A crucial incident in this story took place on January 14, 1506, when a

1.4. Jacques Philippe Le Bas after François Boucher, *Pensent-ils au raisin? (Are They Thinking about the Grapes?)*, 18th century. The Metropolitan Museum of Art, New York

Roman citizen, digging up the Esquiline Hill in order to plant a vineyard, happened to come upon the statue of the *Laocoön* (fig. 1.5).

The particulars of this event are known to us from an eyewitness account written sixty years later by Francesco da Sangallo, himself an architect and sculptor. In this now famous letter he detailed the emergence of the statue, the presence of Michelangelo as bystander, and the identification of the work based on Pliny's account of it in the *Natural History*. Other scholars had focused on this episode, but the payoff that I especially wished to extract appeared at the end of the document:

> Then they dug the hole wider so that they could pull the statue out. As soon as it was visible everyone started to draw, all the while discoursing on ancient things, chatting as well about the ones in Florence.[19]

It was this last pair of activities, which begins as soon as the statue is completely extracted, that fascinated me. "Sangallo and the other onlookers," I wrote, "respond in two ways: they draw, and they talk." And, in effect, I generated the succeeding 450 pages of my book out of that combination.

The only trouble is that I may have translated it wrong. Once the *Laocoön* is visible, says Sangallo, "ci tornammo a desinare." We turned (presumably from a direct contemplation of the statue) to *desinare*. It's a piece of sixteenth-century spelling, and I (along with other commentators—if I was wrong, I wasn't wrong *alone*)—understood it as *disegnare*, that is, "to draw." Hence, my nice little phrase, "they draw, and they talk." But there is another possible meaning of *desinare*. In Tuscan Italian, it could be the equivalent of *digiunare*—in other words, to break the fast, or eat a meal.[20] So we are left with two quite different pictures of what happened on the occasion of this momentous discovery. Which ending did Sangallo choose for this story? Either they dug up the *Laocoön* and proceeded to have an art class, or they dug up the *Laocoön* and proceeded to have lunch.[21] I chose art class; the truth is that after all that digging, they were probably hungry.

• • •

No great enigma in discovering the through line for this rapid circuit of cultural tidbits across two millennia. In at least one strand of what we might loosely call the classical tradition, it seems as though eating and drinking play the role of a photobomb—muscling their way into the picture when matters of grander import are supposed to be on view.

Socrates and his fellow truth seekers do everything they can to guarantee the seriousness of their enterprise, but it is folded into the structure of an evening meal, and that brings up the inevitable prospect of inebriation. Kant is stuck with the term *taste*, and he is far too sensitive a ponderer of linguistic undermeanings to be able to dismiss its origins on the tongue, though it troubles him. Alberti, for his part, freely chooses the dinner analogy, but it, too, is troubling: What effect does it have on his plan to bestow prestige on painting, and how well does the idea of a mealtime sort with the kind of earnest subject matter, whether classical or Christian, that his "historia" is designed to promote? And what happens when Vasari—again, of his own free will, since nobody *required* a three-thousand-word interpolation about nouvelle cuisine dinner parties inside the life of Rustici—places artistic composition via caul fat and marzipan in competition with such media as marble and bronze? Similarly, why should Boucher insert a red herring (food metaphors are either the bane or the joy of this subject matter) in his pastoral love story? If *they're* not thinking of the grapes, why should *I* be? And while we're on the subject of *me*, why did I, with a lifetime of interest in food and drink, and a pretty good knowledge of early modern Italian, completely overlook the most plausible meaning of *desinare*?

• • •

Consider those grapes, to begin with. The lovers, we can agree in answer to the titular question, are *not* thinking about them, but the viewers are forced to. Boucher's problem—I am cutting through a great many centuries and practices in the visual arts, not to mention life in general—is that he is not permitted to represent sex itself. We might look at any amorous pair of persons in a painting and allow our imaginations to wander off the canvas in more erotic directions than the conventions of representation themselves permit. In this case, the grapes—especially when they are represented in both image and word—are the vehicle that takes us there.

Vehicle indeed: this is a transfer very much along the lines of metaphor; and, as usual with metaphor, the figural element in the equation (what I. A. Richards taught us to call the "vehicle")[22] leaves a quite specific mark on the "real" subject or, in Richards's terms, the "tenor." Boucher's lovers are not dallying with a statue, a kitten, or a book (we'll leave that last to Paolo and Francesca in the upper part of Dante's hell). They're involved with something edible, and a quite specific edible. They're not dallying with broccoli, either.

We could take grapes in many directions—the pagan Dionysus or the Christian Eucharist, just for starters—but for Boucher's medium there is a foundational story about grapes. In the *Natural History*, Pliny tells us how the fourth-century BCE Greek

painter Zeuxis boasted that his painting of grapes was so real that birds flew down to peck at them.[23] Whereupon his contemporary Parrhasius handed him a newly executed work of his own. "Let me just open the curtain and see the picture," said Zeuxis, only to realize that the curtain he was about to draw aside was, in fact, the painting. Though Zeuxis had deceived birds, Parrhasius had deceived a human—and an artist, no less. A Boucher-like tease is going on here, in this case, grapes versus curtains. The representation of the grapes is, to be sure, marvelous, since the achievement of a verisimilitude capable of deceiving animals functions as an archetypal sign of artistic talent that bypasses all the human mediating faculties of cognition and language. Yet, however grandiose a compliment Pliny is here paying to Zeuxis, it is clearly outdone by the compliment to Parrhasius.

In fact, it's all about food. The birds reveal the limitations of their aesthetic sense—and thereby the limitations of Zeuxis's aesthetic ambitions—because they want to *eat* the grapes, rather than admire the artistic talent that produced them. (*They're* the ones who are merely "thinking of the grapes.") And, of course, they *can't* eat the grapes because they're painted. Zeuxis loses this contest to Parrhasius, who operates on a higher, human level of visual production and reception. And the point about the winning painting—which is simply of a curtain that pretends to be in front of a painting—is that what it offers is, precisely, nothing. The second-class artist represents food, and as long as he limits himself to the real—and, as we'll often see, food is the very embodiment of the real—he is sentenced to a subordinate status, as Plato so influentially argued in the *Republic*.[24] The first-class artist, on the other hand, represents nothing but the act of representing, which is understood as immeasurably higher than such a consumable object as a bunch of grapes. Boucher has, in fact, produced his own Parrhasius painting; he is drawing, as it were, a curtain across the scene that cannot be represented. Edible grapes, though somehow essential, are nevertheless a waste product, a mere signpost, on the way to either love or art.

Boucher's painting is all about grapes (at least in my view); Vasari's *Lives* are all about art. Food, however, rears its head aggressively in the life of Rustici, where Vasari enumerates something like fifty participants in these culinary games. Yet every one of these extravagant creations consists of work that is precisely the kind of project Renaissance artists were executing with their normal (that is, non-comestible) materials. Some are architecture: Andrea del Sarto's Florentine baptistery, as mentioned above, and, later in the passage, what appears to be a Vitruvian colossus with ground plan, columns, architraves, and so on. Other works produced at these dinners are figural, like narrative paintings: depictions of pagan hell, with appropriate tormenters and monstrous beasts, or pagan heaven, with the gods of Olympus in their accustomed iconography. Everything is made of food.

What happens when, instead of pigment and marble, a crowd of Florentine masters is working in tripe and ricotta? This parody of artistic creativity serves to remind us (and the participants) that *all* the materials used in the making of art are humble products of the earth and that the creation of masterpieces is equally miraculous whether the constituent parts are rocks from Carrara or cheese from Parma. (In Stephen Nichols's elegant formulation, "For reasons we must seek for back in antiquity, food has naturally evoked artistic process because it is so enmeshed in process itself.")[25]

In fact, the scene revives the drama of verisimilitude. By this moment in the history of art, and in Vasari's *Lives*, we may be quite weary of the Zeuxis miracle: grapes so real that birds peck at them, portraits so real they seem to breathe, statues so real they seem to speak. The new medium ups the difficulty factor and makes mimesis a miracle once again. Painting lifelike food is all very well, but creating grand representational works *from* food is another story.

Yet there is something less celebratory going on here as well. If food is parallel to pigment and marble, it is also by comparison radically abject. After all, as Vasari presents it, Rustici, Andrea del Sarto, and the rest not only construct these things out of lasagne, caul fat, and so on, they also destroy them. In fact, the eating in these scenes is always described in terms of demolition. The lower story of one building, the revelers decide, is badly constructed, so they break it apart and feast on the pastry and liver that were its construction materials; then they go after a huge column, devouring the Parmesan cheese base and the capital made of capon, veal, and tongue. When the raw—or should we say "cooked"?—materials shift to the edible, they also enact a mutability that is vastly more disturbing than the customary Renaissance romance of long-term artistic decay, generally focused on antiquity. With this transfer in medium, and the violence that accompanies it, I won't say these artists are defecating Florence *quite*, but they're certainly tearing it to pieces.

What is that far-fetched analogy to the dinner party doing for Alberti as he attempts to canonize a certain vision of modern narrative art? Why not stick with the chartering offered by ancient dramas, and why ignore the equally useful examples of Graces and Muses? The passage that ends up with the comparison to Varro's dinner parties begins, "Odi solitudinem in historia" ("I hate solitude in paintings"); and though he goes on to say that he hates excessive crowding as well, it's nevertheless clear that his recourse to a gastronomic analogy relates to a kind of pleasure principle that is only partly kept in check by all the formal limitations that he is imposing. Graces and Muses, with their canonically limited numbers and their orderly dances, are all very well. Dinner parties, however, even if you limit the numbers, may get out of hand, as is clear from Alberti's reference just a couple of pages earlier to the disastrous wedding party brawl between the Centaurs and the Lapiths.

But it is precisely the symbolic image of food that insists on pushing against all his strictures on decorum:

> Just as with food and music, novel and extraordinary things delight us for
> various reasons but especially because they are different from the old ones
> we are used to, so with everything the mind takes great pleasure in variety
> and abundance. So, in painting, variety of bodies and colours is pleasing.
> I would say a picture was richly varied if it contained a properly arranged
> mixture of old men, youths, boys, matrons, maidens, children, domestic
> animals, dogs, birds, horses, sheep, buildings and provinces. (2.40)

Food and music present themselves here as bringing something to the painter's party that those decorous ancient dramatists, with all their classical and literary prestige, didn't offer. And that hugely copious list of possible subject matters confirms the

need for a kind of pleasure principle. After all, you could never accommodate such a menagerie, from old men to provinces, on a canvas if you stuck to the number of the Graces or the number of the Muses. The taste of food and the experience of dining, refracted across the gap between antiquity and Renaissance, offer an insistent alternative to an orderliness that, however philosophically praiseworthy, risks taking the form of that hated solitude. "Odi solitudinem in historia" is not only about paintings after all; you can also read it as "I hate solitude in history."[26] Couldn't we say that the whole humanist project of rebirthing the past is an attempt to counteract loneliness by means of a transhistorical dinner party?

Consider an alternative route through the same Albertian material. As we've observed, it was not possible to restrict sacred scenes from the Christian story to the numbers of Varro's guest list, but there may yet have been some cross-contamination. The three-times-three form of the triclinium (as we will see in the next chapter) had a strong imaginative force, so much so in fact that Varro, this time in a work not lost to us or to the early moderns, uses it as an example of perfect decorum. Failure to observe the rules of Latin grammar, he says in the *Lingua Latina*, is the equivalent to any infraction against the perfectly uniform size or placement of the tables that constitute the triclinium.[27] That placement involved a central table and two flanking tables at something like forty-five-degree angles to it. The formula is, after all, that of linear perspective itself. And in the same period when—whether by Alberti's influence or by ideas (as they say) "in the air"—narrative paintings begin to reflect this structure, the Last Supper takes on a shape that often resembles the triclinium.[28]

A little background on this development, acknowledging the fact that we shall be returning to the Last Supper later, in chapter 5, where our subject will be the food: In the present case, where the issue is the triclinium, the problem is of the composition itself: how to represent some dozen or thirteen persons seated around a dinner table such that it appears "real" but also (as we say nowadays) viewer-friendly. Along these lines, it is instructive to compare the father and son painters Taddeo Gaddi in the 1330s and Agnolo Gaddi in the 1390s.[29] The elder Gaddi demonstrates two alternatives, both of which are characteristically pre-Albertian. In a small quatrefoil panel made originally for the sacristy cupboard at Santa Croce in Florence (and influenced by Giotto's version in the Arena Chapel in Padua) (fig. 1.6), the figures are indeed placed around a table in what we might loosely call a realistic fashion, but there is little sense of shape or space—the table itself is a kind of amorphous blob, and there is no concession to the vantage point of the viewer (i.e., no perspective). The same artist's far larger-scale fresco in Santa Croce (fig. 1.7) opens up the composition and displays the apostles in something like their individual forms, but they are necessarily arrayed as a kind of shopwindow of saints, all but one of whom are on one side of the table. That one is, of course, singled out, as he should be, but the composition pays no tribute to a "real" dinner table.

That arrangement will, of course, have a long history well into the future. But it is instructive to offer, by comparison, Agnolo Gaddi's version, now in the Lindenau Museum in Altenburg (fig. 1.8). Here we see a spatial form, an element of interior design that will become one of the standard structures for the representation of banquet seating. The painter has dealt with the problem of seating thirteen at a table for

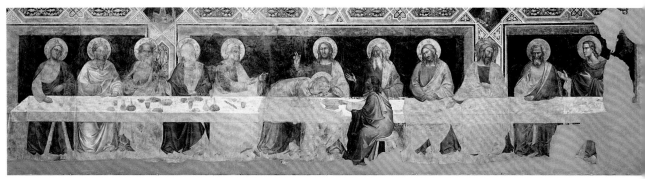

nine by squeezing two apostles in corners, placing one (presumably Judas) in isolation at the front, and truncating the sleeping Saint Peter such that he requires no seating space. The result is fundamentally the triclinium: three benches, with three individuals occupying each bench. (The triclinium, after all, was shaped in that three-part way not for the artifice of viewership but as a consequence of dining service.) By the early sixteenth century, as we see in the Luca Signorelli predella now in Cortona (fig. 1.9), the perspectival triclinium is becoming a classic, even if the numbers of diners may not be so evenly distributed. So, whether Alberti knew it or not, the matter of the dinner party may not have been so unworthy a point of comparison to the *historia* after all; it functions as a building block of linear perspective.

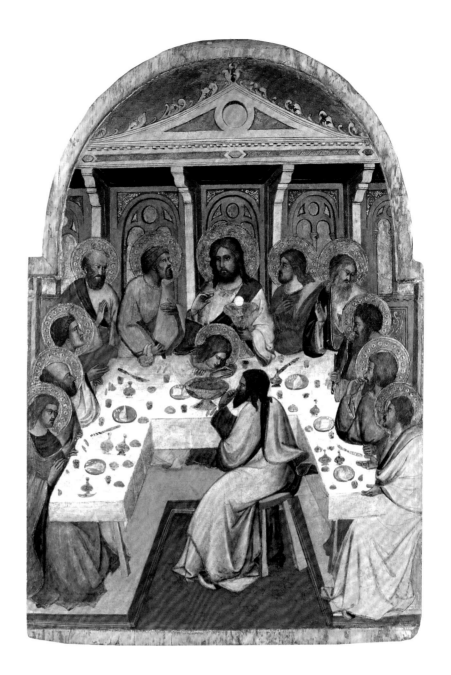

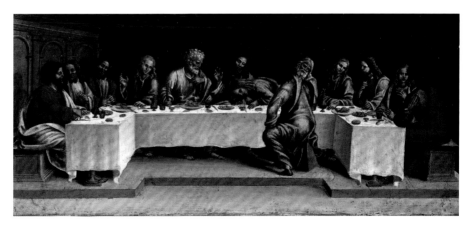

Kant, as it turns out, has his mind on dinner parties as well, though he comes to them via a different (and, I would say, even more circuitous) route. Given the terms of his argument, Kant is in fact up against what looks like an insoluble logical dilemma. When the subject of aesthetics transits from the philosophical world of the *Critique* to what he calls the "anthropological" world—that is, of actual human processes—the concept of "taste," with all its grandly abstract meanings, can no longer be separated from the inside of the mouth. Which would be well and good, were it not for the fact that Kant is still looking for universals.

For a nonphilosopher like me, there is some pleasure in watching Kant squirm his way through this problem. The dinner party is his first proposal for a solution:

> There is no situation in which sensibility and understanding unite in one
> enjoyment that can be continued as long and repeated with satisfaction
> as often as a good meal in good company. (*Anthropology*, 139)

But he immediately recognizes that the mouth is hardly essential to this account of taste; one does not, after all, choose dinner guests by means of one's taste buds, or even one's guests' taste buds. (I set aside, with some relief, the nowadays compulsory gesture of asking one's dinner guests ahead of time whether there is anything they don't eat.) The host, Kant goes on to say, has taste in choosing the guests—still nothing to do with his mouth—and the guests enjoy a variety of tastes (quite the opposite of the universals that Kant is looking for). Finally, he has recourse to a sort of proto-Darwinian linguistic argument. *Sapor* (or flavor) is related to *sapientia* (wisdom); the human species, it turns out, possesses a sense—taste—that instinctually identifies that which is wholesome and repels that which is noxious.

Nice try, and it may work for Königsberger Klopse, my own favorite dish from Kant's hometown, but good luck explaining the allure of oysters, vindaloo, and durian. In fact, Kant's struggles here illustrate just how difficult it is for food to be comfortably included in any kind of rules governing aesthetics (not the last time we'll hear about that). On this point, I believe we have to follow a far less philosophically sophisticated dictum than anything in Kant's oeuvre:

De gustibus non est disputandum.

It is a phrase of no great classical pedigree (it may not even be classical),[30] but in my view it quite clearly answers Kant's question why the "aesthetic faculty of judging" should get stuck with the inside of the mouth as its standard bearer. Our relation to food—specifically, our relation to food as regards *pleasure*—is radically individualistic. And the metaphor that transfers the experience of the mouth to the appreciation of Mozart and Masaccio and Milton, though it denies Kant's universalism by operating via one set of taste buds at a time, nevertheless has the virtue of binding individuals to their favorite art objects as though these works were actually being consumed within their bodies and producing nourishment—like food. The metaphor of consumption radicalizes the more mediated operations of the other senses.

Plato's problem is different from Kant's problem, as we'll see, but eating and drinking—in this case, especially drinking—get interposed here as well. In the account of Plato's work that comes down to us under the category of "philosophy," the *Symposium* consists of a series of speeches, for the most part of steadily increasing validity, that build toward a kind of *summa* on the subject of love, attaining step by step increasing levels of philosophical rigor and ecstatic sublimity. The crescendo culminates in the speech of Socrates, which attains its climax via the yet higher level of wisdom represented by his absent interlocutrix, Diotima.

But this account of the *Symposium* as panel discussion does not pay nearly enough attention to the insistent presence of the collective dining experience. As we have seen, the event calls itself a symposium, but the traditional sympotic activity is banned. Yet the ban fails. Plato has in fact framed the narrative in such a manner that the repressed insists on returning with a vengeance. To begin with, there is a case of the hiccups. The order of speakers has been determined to follow precisely the placement of the individuals on their couches, which in itself suggests that the rules of the banquet are imposing themselves on the rules of the disputation. But this order is violated when it comes to Aristophanes's turn because he has suddenly been afflicted by hiccups. It is obviously fitting that a comic playwright should have a comical affliction. In fact, not only are the hiccups a generally deflationary move—with the spiritual reconnected to the physical—they are specifically connected with drinking (for the Greeks as for us). So the philosophical symposium is, at least temporarily, derailed by a feature of the vinous symposium that it supposedly is *not*.[31] And only a doctor—whose name, Eryximachus, translates as "belch conqueror"—can perform the temporary job of filling in.

Aristophanes may have been secretly tippling in defiance of the rules and may get outed by his eructation. But someone else, currently offstage, has been engaging in sympotic activity that is far more drastic. Just when Socrates has reached the pinnacle afforded by the ladder of love that sheds all reference to individual desire in an ecstasy of contemplating heavenly beauty, the proceedings are interrupted by noises off:

> A large drunken party had arrived at the courtyard door and they were rattling it loudly, accompanied by the shrieks of some flute-girl they had brought along. (212C)

The intruder at the anti-feast is the drunken Alcibiades. Once he has crashed the sober precincts of the panel discussion, he then becomes the third man on what are rigorously supposed to be two-man couches, which interposes him in a kind of love triangle formed along with Socrates and Agathon.

Alcibiades has his own idea of rules—the rules of drinking, including the nomination of a master of ceremonies, who in the traditional system is supposed to determine the ratio of wine to water. But he undermines these rules by electing himself to the post (assuring that not much water will be mixed into the wine) and, while ordaining prodigious quantities of alcoholic consumption, also insists that there be conversation rather

than mere silent guzzling. The conversation is mostly Alcibiades himself. The abstemious philosophers offered one version of their subject, turning the assignment (which was to praise Love, or the god of love) into something increasingly abstract. The intoxicated interloper, on the other hand, recounts the *experience* of love, which turns out to be a portrait of Socrates; and it has the effect of completely undermining some of the fundamental premises of the whole previous discussion, concerning the orderly—one might even say scholastic—distinction between the lover and the beloved.

Inebriation turns out to be not an accident but a necessity in the economies of this narrative. Plato's problem—an issue that stretches far beyond this one dialogue—is that he cannot quite decide whether the truth should be revealed via dialectic or via inspiration. Shall a sequence of speeches, delivered by learned and sober gentlemen, each building on what has gone before, arrive at the truth about love? Even prior to Alcibiades's entrance, this process is evidently not sufficient in the context of the *Symposium*, since it requires the intervention *in absentia* of the priestess Diotima to reach its ecstatic peak. But that peak is not ecstatic enough, or at least not wholly sufficient. Without enough strong drink, the philosophers are impaired in their search to define love. Ἐν οἴνῳ ἀλήθεια, which we know better as *in vino veritas*.[32]

But the *veritas* for our purposes depends on the whole structure of the dialogue. Plato's *Symposium* is for me the master narrative about eating and drinking. These two activities, nutritionally and socially vital but subject to comparatively low esteem when compared, in this case, to the earnest practice of philosophy as sober disputation—get shunted to the margins. Food, after all, is dismissed even more unceremoniously than drink: as the evening's topic is being decided upon, the idea that someone might write a book about salt[33] receives offhand ridicule (in comparison with the subject of love), and the edible aspect of the *deipnon* is held in such low esteem that, astonishingly, Agathon tells the slaves to serve his guests whatever they damn well please (175A). It's the same kind of marginalization that we observe, *mutatis mutandis*, in Alberti's dinner party, Vasari's edible art, and Boucher's grapes. But these culinary gestures refuse to tolerate their banishment, and they exert pressure on the center. Alcibiades crashes the temperance meeting—and in the process brings us closer to the truth.

This, then, is a book about High Culture and Low Culture, about Centers and Peripheries, about the Return of the Repressed.[34] (All these frameworks are themselves discussable, of course; for me, they are heuristically useful rather than transcendently true.) I take it for granted that in the realm where I am operating, and uniformly across a couple of millennia, the business of eating and drinking finds itself valued, at least officially, at a lower position than many other cultural activities and that this comparative valuation is likelier to be taken as a given rather than submitted to investigative reasoning. From certain points of view, this assumption can certainly be challenged. Eating and drinking are obviously more essential to the human organism than unearthing ancient sculpture or philosophizing about love. And those who find themselves closer to that realm of necessity—not only starving masses but also everyday managers of households and perhaps even certain monarchs (like James I of England or Catherine de Médicis in France) who governed via banquet-style entertainments[35]—have every reason to declare that my assumption about the presumed inferior status of food and drink is flawed from the get-go.

To those I can only say that the discussion of these assumptions will inevitably involve questioning them.

Mostly, I don't question them, however, because I come to this subject matter from a lifetime of cross-disciplinary concern, historical and transhistorical, with European high culture. For me, that has meant above all literature and the visual arts. But if one spends one's lifetime dealing seriously with aesthetic objects, not merely as a consumer but also as a scholar, there is an inevitable trail attached to them of history, philosophy, politics, statecraft, and all the life-affirming or life-denying circumstances that adorn or litter the past. Food and drink appear in every one of these enterprises, and I am willing to declare, at least by way of an opening premise, that by and large wherever they appear, the position officially assigned to them is likely to be on the margins.

As with many other stories about centers and peripheries, the relative neglect suffered by marginalized persons and activities is not only a fact of history but also a fact of scholarship. I look back with some nostalgia at the time, thirty years ago, when I began to discuss these matters, and I could get a lot of mileage out of merely asserting—with a suitable panoply of historical examples—that food had been surprisingly important in the realm of high culture that scholars of literature, art, and music take as their province. In those days, in fact, when I traveled to other universities to give lectures on earnest topics like Shakespeare or the Revival of Antiquity, my hosts would go through the pre-circulated bio and get to the part that says, "He is also a regular contributor to publications in both the US and Italy on the subject of food and wine." Invariably, at that point, there was laughter in the room, as though I had included my obsession with HO-gauge model trains in my CV. (For the record, I have no such obsession.)

Things have changed. Obviously, margins have become—dare I say?—central in all fields of scholarship. In this particular area, the History of Everyday Life has encouraged us to realize that everyone, both majorities and minorities, lives a history that is much more shaped by the quotidian than by the epochal.[36] We have been encouraged to perceive how groups on the sidelines of history's grand narrative have their own distinctive stories, and we have worked to reframe universal history so as to include, or even foreground, these groups. And though in principle gastronomy might be gendered in either direction, or not gendered at all, it's clear that interest in it might grow at a time when scholars are paying more attention to what might be called women's work.[37] Indeed, the bookshelf on food history has become impressively robust in both quantity and quality. Which perhaps explains why, in the foregoing pages, I have not insisted upon traditional timelines.

One might even say that the free associative order of the exhibits I have offered above, cutting across media and time frames, may reflect in its background not so much responsible historiography as a certain kind of obsessive compulsive encyclopedism. And it's true that one of the intellectual pathways which led me toward and through this material was, precisely, eclectic and unsystematic. This is, in fact, the aspect of the material that is enshrined in this chapter's title (and which will be often repeated in the text that follows). Having noticed the nearly ubiquitous presence of eating and drinking in works that weren't ostensibly *about* eating and drinking, I

started *reading for the food*. An invitation along these lines to take part in a seminar on the Gospel of Matthew (about which I knew very little) produced anxiety that I would find nothing more culinary than "Man cannot live by bread alone"; in the end, I discussed some forty passages in which eating and drinking were literally or metaphorically significant.[38] Another invitation to speak, this time about Shakespeare, so long as I discussed *The Tempest* (about which I knew quite a lot), proved equally surprising in the breadth and depth of materials relating to food and drink, both in the text and in the background literatures concerning New World exploration.[39]

This kind of work—let's call it, anachronistically, the amassing of note cards—stops well short of a finished scholarly project. On the other hand, it is an honored scholarly practice to look for one's central subject matter *everywhere*. Slightly less universal is the practice of looking for it where one least expects to find it; in fact, concentrating the search in those places. Yet, if I begin with the premise that my subject matter is marginal, it becomes imperative that I look for it—where else?—but on the margins. When asked for a theoretical justification, I tend to bypass Curtius and Foucault while turning instead to Monty Python. Specifically, what they called "News for Parrots," as in:

> No parrots were involved in an accident on the M1 today, when a lorry carrying high octane fuel was in a head-on collision. . . . A spokesman for parrots said he was glad no parrots were involved.[40]

The truth is that I'm never quite certain that the spokesman for parrots scanned the M1 sufficiently. I like to ask—if we may put the matter in non-psittacine terms—what happens when we take a text, an image, a cultural production of some kind and try to turn it into "News for *X*," where *X* equals something that gives little evidence of being central to the text or even apparently present at all? The work is demanding, and doubtless on occasion it turns up things that aren't really there or aren't really important. But until it has been done thoroughly, can we be quite certain that somewhere, in the ten-mile-long traffic jam caused by the lorry accident, there weren't indeed a couple of discombobulated parrots? It may even turn out that parrots were the hidden cause of the whole mess.

So there is in this chapter's title an injunction to pay close attention across what is admittedly a vast miscellany of cultural objects that may have nothing more to do with each other than the happenstance of a stray parrot or a bunch of grapes. But if this practice is subject to concerns about the sufficiency of its historicism (that is, locating everything in its proper place on the calendar), I am, at least up to a point, content with running that risk. Hunger and thirst, dearth and excess, sobriety and inebriation, the exercise of commensality, and the relationship in human experience between flavor and pleasure: all of these are on view in these pages, and I take all of them to be fundamentally transhistorical. In that sense, I regard the title of this chapter and the title of the book as complementary: the "Hungry Eye" is the universal condition of all who exercise their creative imaginations; "Reading for the Food" is the fitting response, and—potentially, at least—its validity knows no particular historical or geographical limitations.

That being said, the instances of eating and drinking that form the core of this book cleave to a highly established notion of the European tradition, such as I have considered elsewhere. There are many itineraries through this territory, but for me they all lead back to art historian and cultural theorist Aby Warburg. I have found myself both inspired and comforted by two snapshots taken along the way. One is of Ernst Cassirer, sitting in the Kulturwissenschaftliche Bibliothek Warburg in the 1920s, where he gets exposed to a near infinity of close readings of cultural practice—global, interdisciplinary, and largely indifferent to positivist interrogation as to their true value—from which he attempts to build a systematic and rigorous philosophy.[41] The other is from Warburg himself, thinking in particular of his celebrated if unpublished, and nearly unpublishable, *Mnemosyne*, a set of wooden boards covered in what might appear to be whimsically chosen images (explanatory words were largely banished), each grouping designed to evoke the recognition of some affective strand in cultural experience.[42]

Whether one or the other of these enterprises constitutes a system may be debated, but together—and together with the work of many others operating in this tradition—they provide the grounding for a particular sort of analysis, in which myth and art, history and experience, find common grounds that themselves exist somewhere between the phenomenal and the metaphorical. Cassirer's term for these is "symbolic forms," and generations of scholars devoted to the analysis of imaginative artistic production have comfortably addressed poems, paintings, and works of religion and philosophy under this rubric.

That miscellany ("poems, paintings, . . .") is a shorthand for one of the most fundamental aspects of the tradition in which I am placing this project. The category of symbolic forms, whatever its philosophical viability, helped to break down the walls between disciplines. To do the kind of work that represents the Warburg tradition at its best, one has had to be, just for starters, a literary scholar and an art historian at the same time. And, in the process, to remake those disciplines by fixing upon the immense and often unobserved overlaps between the creative exercises of poets and painters whose work was the basis for scholarship. Speaking personally, I would never have come to the topic of eating and drinking in the history of the classical tradition if I hadn't spent decades accustoming myself to the transdisciplinary life of *ut pictura poesis*, which includes both the mutual fulfillment and the unresolvable frictions between those imaginative enterprises.[43]

But this wasn't just a matter of adding one more medium to my personal intermediality. If I found myself, long ago, asking questions about literature that needed to be answered via the visual arts, it was because I sensed that poets wanted to be painters. (Later, I learned to recognize the converse: the painters wanted to be poets.) Indeed, the "parrots" that I located, courtesy of Monty Python, in the hidden corners of the motorway when I read Shakespeare or gazed at Titian were signs of longing for an alternative system of artistic communication. What is at stake here—I'm thinking particularly of the poets now—is the problematic of the discursive versus the sensuous, the desire to break out of the highly mediated realm of language (words, after all, not actually *being* things but more or less arbitrary signs) into a realm that makes a more ineluctable claim on the emotions. After nearly a century of skeptical

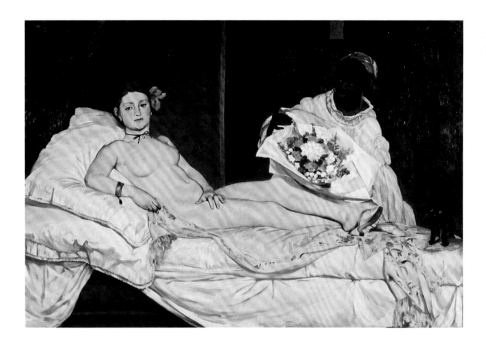

hermeneutics, we know full well that Edouard Manet's *Olympia* (fig. 1.10) isn't any more "real" than Charles Baudelaire's verbal portrait of the *passante*,[44] and we may even feel that we experience more intimate sensations from reading "Longue, mince, en grand deuil, douleur majestueuse" than from seeing a reclining nude female who is constructed out of pigment slathered on canvas. And yet the sensuous, however artificial or mechanical its means of production, asserts an irresistible claim. It's no accident that Cassirer's symbolic forms, though in principle logocentric, so quickly turn into symbolic *images*.

Here, however, my interdisciplinary reach goes a step further into the sensuous, the unmediated, the corporeal, and thereby into a realm where the relationship to language and mediation is more mysterious. Eating and drinking—by which I mean the substances consumed, the practices of dining, the material surroundings within which the meal takes place, and all the powers of retrospection and memorialization applied to an experience that, after all, is (apart from breathing) the most continuous activity in the life of the human organism—strike me as constituting the quintessential symbolic form, as intermedial, as densely interpretable, as reflective of history as any of the classic Warburgian subjects, and possibly more universal. To cite another of the great scholars in this tradition, Erwin Panofsky puts at the top of his iconology/iconography pyramid, it may be recalled, the reading of what he calls "intrinsic meaning or content," which he deems accessible via the viewer's "familiarity with the *essential tendencies of the human mind*" (italics original).[45] I believe that our subject may give us privileged access to that all-important register of interpretation, though I might expand from Panofsky's "human mind" into something like the human sensorium.

It is no coincidence that so many of the scholars in this tradition, far from being merely ahistorical or transhistorical, were invested in the Renaissance, and specifically in a vision of the early moderns as individuals who had both received and remade ancient culture. That receiving and remaking was for them, as it is for me,

prime evidence for what Cassirer called *Homo symbolicus*—Man the Symbol-Making Animal—which I would further gloss (with thanks to Paul Ricoeur)[46] as Man the Hermeneutical Animal, that is, the animal that travels the great circular route of both creating symbolic expressions and working to unpack them. With that sense of history, as well as trans-history, I want to conclude this exposition of our subject with a culinary representation that may stand as an embodiment of both my topic and my method.

· · ·

Though the medium of mosaic enjoyed enormous diffusion in late antiquity, Pliny the Elder, to whom we owe virtually everything we know about visual production in the Greek and Roman worlds, has rather little to say about it. An elitist of genres, Pliny tends to downgrade anything not produced in bronze, marble, or pigment, and it may be that mosaics suffered in his ranking because of their association with the interiors of private homes. But he does single out one such work:

> In this latter field [mosaics] the most famous exponent was Sosus, who at Pergamum laid the floor of what is known in Greek as "the Unswept Room" because, by means of small cubes tinted in various shades, he represented on the floor refuse from the dinner table and other sweepings, making them appear as if they had been left there.[47]

The citation of a single master by name is itself remarkable in this rather industrial segment of the *Natural History*, where materials and processes occupy much more space than artists. Whatever the medium, though, it's safe to say that Pliny's interest is always piqued by illusionism, as the Zeuxis-Parrhasius story about birds and grapes has already demonstrated; the fact that Sosus produced an especially surprising instance of trompe l'oeil doubtless helped propel this work beyond the limitations, as Pliny saw them, of its medium.

Sosus's mosaic has, of course, long since disappeared, as have most of Pliny's favorite art objects. The best extant version (figs. 1.11 and 1.12), produced three or four hundred years after Sosus's time, is a sizable work that adorned the dining room of a villa on Rome's Aventine Hill.[48] Now preserved in the Museo Gregoriano Profano at the Vatican, the mosaic consists of segments from three sides of a border, plus a small chunk of the central design. Most of the broad border space is occupied by a stunningly varied array of discarded foodstuffs: fish skeletons and fins, lobster claws, shells from many different kinds of ocean dwellers (including several especially picturesque furry urchins), chicken legs and feet, olive pits, bunches of grapes picked almost clean, bean pods, dates, nuts, lettuce leaves, and most strikingly (fig. 1.13), an almost empty walnut shell with a mouse gnawing away at the meager edible remains.

We can certainly do food history on this remarkable object. It's clear that some group of wealthy and cultivated persons—and one can never be quite certain with Roman copies after lost Greek originals which set of data from which century we have before us—in the Mediterranean basin had the kind of diet that we would now consider highly privileged; and doubtless they considered it so as well, since the very

OVERLEAF

1.11. Heraclitus of Rome, *Asàrotos òikos* (*Unswept Floor*), mosaic, detail, 2nd century CE. Museo Gregoriano Profano, Musei Vaticani, Vatican City

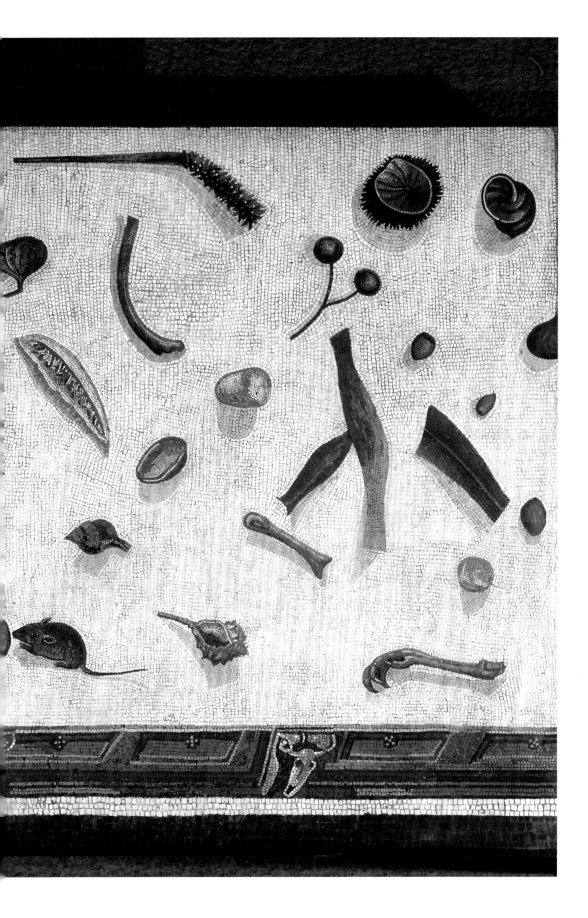

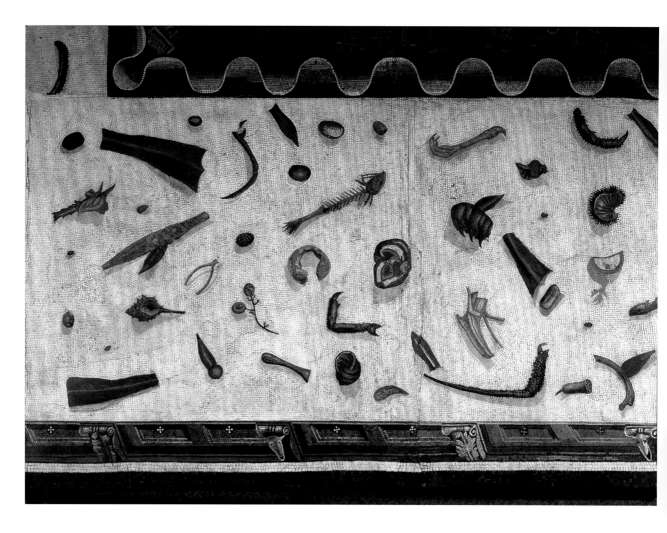

1.12. Heraclitus of Rome, *Asàrotos òikos* (*Unswept Floor*), mosaic, detail, 2nd century CE. Museo Gregoriano Profano, Musei Vaticani, Vatican City

1.13. Heraclitus of Rome, *Asàrotos òikos* (*Unswept Floor*), mosaic, detail of mouse, 2nd century CE. Museo Gregoriano Profano, Musei Vaticani, Vatican City

1.14. Heraclitus of Rome, *Asàrotos òikos* (*Unswept Floor*), mosaic, detail of chicken bone, 2nd century CE. Museo Gregoriano Profano, Musei Vaticani, Vatican City

presence of these foodstuffs in the mosaic is a sign of ostentation. It's also clear that they had considerable quantities of waste, which may have been normally left for the servants or consecrated as offerings to the gods.

But this object is not best considered as a document in that anthropological sense. The *Unswept Floor* is a monument to the possibilities of rendering edibles as art. Tessellated mosaic, which uses vast quantities of tiny stones, blocks, and glass, is itself made from materials that, were it not for the existence of this art form, would be the invisible dross of the earth. In that sense, all such works, even when far less ambitious than the *Unswept Floor*, are masterpieces of illusion that nevertheless retain (in ways that paint generally does not) the visible record of their lowly constituent origins. Mostly, though, when we look at a piece of mosaic like this, we don't see bits of landfill, we see their transformation into uncannily authentic representations. That process of transformation would in any event sanctify the result, making it no ordinary quotidian object but something radiating the aura of both labor and inspiration. The Vatican *Unswept Floor* furthers this project—of rendering the object aglow with magic well beyond what it would possess were it real instead of fabricated—via a whole set of representational artifices. The glowing white background, the perfect verisimilitude of every object, the placement of each in its own autonomous space, each with a scale independent of the scale of the objects around it, and—my favorite touch of all—the tiny shadow that each casts (fig. 1.14; not exactly easy in mosaic!): all these artistic choices are lavished upon the materials of dinner.

Or rather the *ex*-materials of dinner. Not only from trash to art but from trash to art that represents trash. The host—presumably a person of grandly playful wit—brings his hungry guests into a room where a banquet seems to have already taken place and the cleanup crew hasn't yet done its job. He seats them not only in perfect position for viewing the artwork but also such that their own mealtime debris, were they to throw it on the floor, as was customary, would be located in exactly the same space as the waste products of their predecessors. Of course, there are no such predecessors; indeed, no real diners with real detritus could ever have laid out such a jewel box of garbage. *Mise en abime* is the appetizer for tonight's dinner.

The particular dimensions of this game are characteristic of late antiquity. Pliny tells the story—retold by me so often that it has become something of a personal mantra and household joke—about the state visit to Rome of the Teuton ambassador, whose hosts are attempting to impress him with the glories of the metropolis.[49] In particular, he is asked what he thinks of a much valued picture of an old shepherd. Unimpressed, he replies that he wouldn't even want a *real* old shepherd in his house, therefore why should he be interested in a *painting* of one? In terms of the Hellenistic aesthetic,[50] such as embodied in the *Unswept Floor*, only a fool (worse: a German fool!) would fail to understand the immense gulf between things and the artistic representation of things. Statues of Aphrodite and paintings of gorgeous landscapes—let's call them the *usual* subjects of ambitious artwork—fail to tell this story (or fail to elicit the German ambassador's disfavor), because they make little or no distinction between the beauty of the real and the beauty of the representation; what we need instead are paintings of old shepherds and mosaics of table scraps to hammer home this point about the transformational quality of the aesthetic.

What does this all mean about food? The *Unswept Floor* floats between two ancient modes. On the one hand, there is the representation, in both mosaic and pigment, of edible treats that look good enough to eat; in this sense, food counts as a prime site for depicting the real, suggesting a seamless flow between actual experience and artistic imaging. (After all, the Teuton ambassador may not have a real old shepherd at home, but he doubtless does have a pork leg and some figs in the larder, and he probably wishes they looked half as mouthwatering as those decorating Roman villas.) This is, of course, the idealized version of the real, something like those beautiful Aphrodite statues and equivalent to today's industry of food styling.[51]

On the other hand—now we pass from pictures to words—there is also, especially in Roman antiquity, a near obsession with the abject; and food (along with sex, of course) is a guaranteed and inexhaustible source of matter to satisfy what was apparently the sophisticated public's need to be disgusted. Consider the narrative in one of Martial's epigrams (7.20): Santra, the greediest freeloader of them all, not only gorges himself at the dinners to which he has barely merited an invitation, but he also sneaks leftovers home, at first loading up his filthy napkin with oozing pomegranates and figs, the skin of a sow's udder, and limp mushrooms, and then, when the napkin can hold no more, stuffing his cloak with fish bones and the remains of a roast pigeon; he even collects the scraps that the slaves and the dogs have not managed to clear away.[52]

Along these same lines is a remarkable passage in Quintilian's *Institutio oratoria*. His subject is that ever elusive concept of *enargeia*, or vividness, which he defines in the conventional way—expressing something so that "it seems to be actually seen"— but also associates with such notions as ornament, polish, and finish. The definition soon gives way to examples, all but one of which are from the world of lofty Roman public action: the boxing contest in *Aeneid* 5, the Roman praetor in Cicero's oration *Against Verres*, and then what appears to be an invention of his own about the storming of a city. In the midst of these, however, he inserts a quite different example of successful *enargeia*:

> Sometimes, the picture we wish to present is made up of a number of details, as again by Cicero (who suffices on his own to exemplify all the virtues of Ornament) in his description of a luxurious banquet: "I seemed to see some going in, some going out, some reeling with drink, some dozing after yesterday's potations. The floor was filthy, swimming with wine, littered with wilting garlands and fishbones." What more could anyone have seen who had entered the room?[53]

The banquet scene enters the picture as the occasion when the abject, rather than the triumphant, is to be channeled through the device of *enargeia*. It's more than a different tone that this scene provides: the dystopic end of the banquet promises a broader band of sense experiences at the command of well executed language. But Quintilian is also engaging in a kind of intermedial sleight of hand. Cicero is praised for making words as vivid as a picture, but in this case, there *is* such a picture, widely diffused and well known in itself as an ekphrastic subject.

Together, then, the mosaic of the *Unswept Floor*, along with the abjection of a *real* after-dinner mess or Santra's filthy cloak used as doggie bag, offers us a portrait of the human being as the consuming animal. Via the conceit embodied in the mosaic, food effects its triumphant journey from the margins to the center, from the despised object of waste to the crowning glory of art. Food is about materiality; it is about quotidian experience. Further, as is clear from its operations in the mosaic's *jeu d'esprit*, food is subject to everything Johan Huizinga had in mind with the phrase *homo ludens*[54]— food is (at least potentially) playful. And then there are the more complicated implications: it is ugly and beautiful at once, which is to say that it is capable of being physical in the basest sense at the same time that it is subject to the highest degree of aestheticization. In addition, if it is material, it is also ephemeral (indeed, subject to swift and distasteful decay), well beyond even its decimated condition here—if one may allude (as the Romans loved to do) to further stages in the digestive process.[55] Yet at the same time there is a paradox in this highly artificialized mosaic that food, at its most ephemeral, is being immortalized.

Finally, I exploit the *Unswept Floor* as a source of permission for some of the more speculative flights of fancy in the present volume. In the brilliant conceit of this mosaic, food is represented by absence, by what is missing, what has already been consumed. What we're looking at here is in some sense the reciprocal of banqueting; we are reading the experience of consumption from its aftereffects. I also take note of the fact that objects on this floor are in a state of radical disconnection: though the ancient meal (as suggested by the *Symposium* and elsewhere in Plato)[56] may have possessed a rigorous set of ordering principles, the waste products that follow from the meal have no such order or else seek their own alternative order. If, in these pages, I sometimes take quite seriously things that are seemingly not there, and if I sometimes fail to respect traditional systems of ordering via calendar and geography, I hope that readers will grant me the privilege of my own occasionally unswept computer screen—itself, quite literally, a twenty-first-century mosaic. Mine is, after all, the hungriest eye of all, and it may not always be possible—or desirable—to serve up the feast in a perfectly traditional sequence of courses.

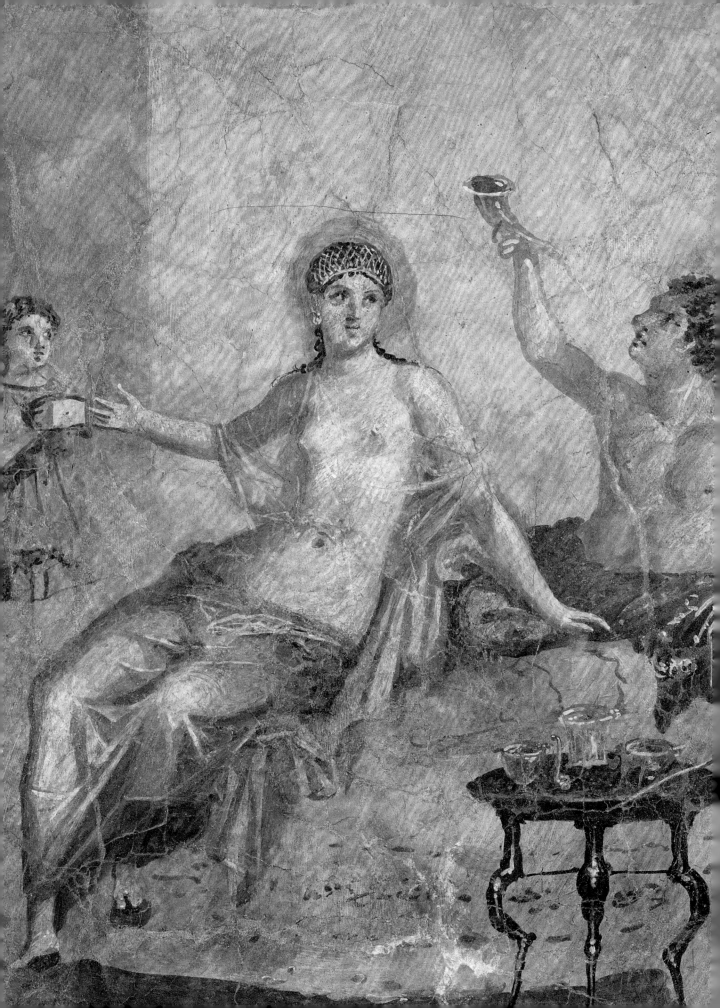

Rome Eats

Those of us whose Western antiquity is likelier to speak Latin than Greek have to reckon with something of an inferiority complex. Plato always wins out over Seneca, Aristophanes over Terence, Apelles over . . . no one, since Pliny the Elder in his *Natural History* does little or nothing to bestow upon any Roman artist the kind of mythic status that he grants to the Greeks, who become the heroes of his art history and therefore ours.[1] The inferiority complex has a long history, dating back to the Romans themselves, as is evident from the lines that Virgil puts into the mouth of Anchises, telling his son that "others" (he means Greeks, of course) will be superior practitioners of the arts.[2] Though this prophecy is in fact the windup to an even greater compliment (Aeneas's descendants will rule the peoples of the world in order and peace), the mark against anything Roman in the arts remains in place, as we know from the example of Cicero himself, for whom Greek culture counted as supreme.[3] Things did not change much in more recent times. Studying Latin, one was forced to march through Caesar's *Gallic Wars*, whereas those who took Greek could revel in the *Bacchae* of Euripides. Indeed, it seemed as though the only hope for us Latinists was to focus, as I did, on a historical moment—the Renaissance—when, at least for part of the time, the revivers of antiquity didn't know enough Greek to realize how much better everything was on the other side of the Ionian Sea.

Had gastronomy—rather than sculpture, philosophy, or drama—been considered the yardstick of cultural achievement, things might have been different. There can be little doubt that ancient Rome ate better than ancient Greece. Not only more elaborately (and the historical record being what it is, we'll hear more in these pages about grand than about humble eating), but also more plentifully, more healthily, and with greater variety. Rome had undeniable advantages in the diversity of natural conditions within Italy, to which it then applied its superior technical know-how. Roman

civilization revolutionized farming—indeed, more or less invented European agriculture as we continue to know it, both the specific crops and the ways of producing them. In particular, we owe the cultivation of countless fruits, including cherries and peaches, to Roman persistence and ingenuity. Not to mention the most important fruit of all, the grape, whose extraordinary range as the basis for a fermented beverage we owe to the Romans.[4]

If all this is being offered as a sign of Roman superiority, I should point out that it is precisely those alternative skills of world organization in Anchises's prophecy that are the cause. Romans were not better cooks than Greeks by some sort of genetic superiority or even by a mere accident of local geography. Their expansionist ambitions, first within the Italian peninsula and then beyond, resulted in the creation of an empire of previously unimaginable vastness, whose range of climates and terroirs remains to this day the basis for that highly eclectic mix of Mediterranean and "continental" edibles that has become normative as European cuisine. Not that the mere possession of territory guarantees gastronomic advancement; the Romans in addition knew how to organize lands and persons, how to create technologies, and how to transport goods over great distances, principally by building a system of roads and canals. If, in the twenty-first century, we are witnessing a locavore movement that deplores the many kinds of expenditures involved in the global transport of comestibles, it's ultimately the Romans who established that pattern.

Needless to say, all these Roman achievements can be traced to a set of social and political arrangements that we who have inherited this enviable buffet of edible delights would find intolerable: slavery, for instance. And, sad but true, the global market basket that we enjoy in the present day, thanks to those same Romans, may repose upon a repressive system of worldwide organization that resembles all too closely that of two thousand years ago. That is not our topic here; we can only swallow and repeat Walter Benjamin's pronouncement, "There is no document of civilization which is not at the same time a document of barbarism,"[5] and accept the fact that among those tainted documents of civilization are many of the delicious items that grace our tables.

Now all this Roman preeminence in the field of eating and drinking raises some problems for the present volume. It isn't just the hopeless task of trying to cover such a vast matter as the history of Rome and food in a single chapter; we are not writing a comprehensive history of gastronomy here, and there are a number of scholarly works that do that job well.[6] It's rather our premises themselves that feel—shall we say?—threatened by the example of Rome. As has been said, this book locates itself around a particular dynamic, where eating and drinking are tacitly assumed to be on the margins of high culture but prove to be exerting intense pressure toward the center. The trouble with Rome is that the ubiquity of food in any conceivable map of culture, high or low, makes it very difficult, even as an opening hypothesis, to claim a place for it on the margins. Consequently, though we have so far offered little more than Boucher's grapes and Alberti's dinner party by way of persuasion, we have to invoke a revision of the paradigm. Rome, it turns out, is not the place where eating and drinking are on the cultural margins; quite the contrary. And in the long run of the classical tradition, it tends to be the example of Rome that will inspire later European civilizations to nudge eating and drinking over from the periphery and in the direction of the center.

In the previous chapter, and in those that follow, our argument tends to focus on moments of tension or even contradiction, for instance, in the works of Vasari, Alberti, and Kant, as we've already seen, or, later in this volume, of Titian, Erasmus, and the makers of Christian theology and iconography; none of these is designed to be a document in gastronomy. Eating and drinking assert their importance when we, once again, read for the food. Rome, which in all respects accounts for much of the relevant European culture such as is depicted here, requires a somewhat different approach. What follows here, then, is a selective portrait of Roman civilization at table. If the *Unswept Floor* was the negative—an image of mealtime completely emptied out— then this chapter is the positive: an account of ancient Rome in which the cupboards are ever full, ever replenished, and in which the enterprises of power and culture both fuel and are fueled by a limitless supply of gastronomic sustenance.[7]

1

Consider Pompeii. When the poet Martial, in his most elegiac mood, composes an epigram about the eruption of Vesuvius (fig. 2.1)—he borrows from an extensive Greek tradition of *sic transit gloria mundi* usually applied to long obliterated cities but here transferred to a catastrophe that had taken place only a decade earlier—his vision of the disaster has nothing to do with the loss of buildings or lives. It has to do, first and foremost, with vineyards:

> *Hic est pampineis viridis modo Vesbius umbris,*
> *presserat hic madidos nobilis uva lacus:*
> *haec iuga quam Nysae colles plus Bacchus amavit.*

This is Vesuvius, but lately green with shade of vines. Here the noble grape loaded the vats to overflowing. These slopes were more dear to Bacchus than Nysa's hills.[8]

Most of the brief poem is in the mythological/fantastical mode: Venus is sorrowful because she was the patron goddess of Pompeii, and Hercules is grieving because he was the eponym of Herculaneum. The only touch of the real are those overflowing vats of wine. Whether Martial is referring to the once luscious abundance of Pompeiian viniferous production on the hillsides or to a nightmare vision of casks whose contents are brought to a boiling point by the heat of the volcanic explosion, his focus is upon the loss of wine.

For all that, Pompeii wasn't exactly a *grand cru*: Pliny the Elder, who would lose his life in the eruption, registers the wine's longevity but complains about the terrible headaches it produces.[9] (The fact that he characterizes these so precisely—lasting until the sixth hour of the next day—suggests that, as with so much in the *Natural History*, he is recording personal experience.) Still, the local wine was sufficiently plentiful to have some prominence on the export market, as is attested by the presence of a Pompeiian cask in excavations at the relatively distant port city of Ostia.[10] Wine was

2.1. Mount Vesuvius with vineyards, Campania, Italy

not the only gastronomic product of the region: both the cultivation of olives and the extraction of the oil were widespread. The fertile soil on the slopes of Vesuvius produced (then as now) excellent fruits and vegetables, whereas the flatlands were heavily utilized for the cultivation of grain.[11] The proximity of the sea made Pompeii a center for fishing, both for local fresh consumption and for one of the comestibles for which the city was perhaps most famous, the condiment known as *garum*, made from fermented fish guts.[12] Pompeii, among its other distinctions as an upmarket seaside town (ancestral home, for instance, of Nero's wife Poppaea, made famous more recently by Monteverdi's *Incoronazione*), was clearly a supplier of edibles all across the ancient Roman food pyramid.

None of this, however, is what makes Pompeii exceptional; in aggregate, this portrait of a prosperous town on the Italian peninsula heavily invested in gastronomic industries is probably more typical than unique. What makes Pompeii special for us is not how, or how much, they ate and drank, but how well the evidence of those activities is preserved, from the beautiful banqueting scenes that appear on dining room walls in the fancier houses to the minute composition of the inhabitants' diets that can be deduced from chemical analysis of their excrement. All this material culture is preserved owing to the same cataclysm, and all of it enables us to see Pompeii not as some sort of unique culinary boomtown but as typical for a certain moment among a certain cross section of ancient Romans on their home turf. The city preserved under ash offers a snapshot of them as eaters and drinkers.

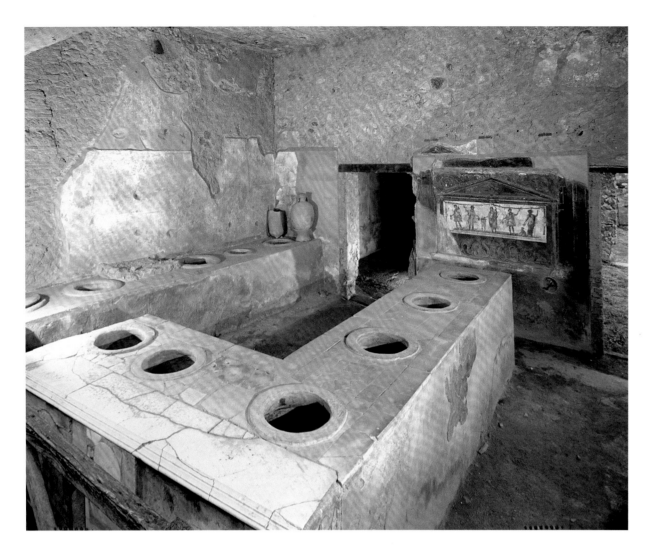

2.2. The counter of the Thermopolium of Lucius Vetutius Placidus, I.8.8, Pompeii

Pompeiians had plenty of opportunities to exercise their proclivities in these undertakings. The city's population of something like fifteen thousand could choose among well over one hundred public eateries (the number, at least, that have so far been excavated), called *thermopolia* (fig. 2.2).[13] Their principal business was the dispensing of hot food, which was ladled out of amphorae that were heated from underneath. It should be no surprise, given the experience of communal eating in all times and places, that many nonculinary forms of life transactions went on alongside mealtimes. The Pompeii fast-food establishments clearly had an active function as political bulletin boards with numerous electoral graffiti. Many texts celebrate a favorite candidate—for instance, "Genialis asks for Bruttius Balbus as duumvir. He will preserve the treasury" (*Corpus Inscriptionum Latinarum* IV 3702)[14]—while others pursue the time-honored practice of negative campaigning, the most notable object of which seems to have been a certain Marcus Cerrinus Vatia, who is ironically celebrated in various graffiti by those identifying themselves as late sleepers, late-night drinkers, and petty thieves (*CIL* IV 576, IV 575, IV 581). Whatever the political sentiment, the eatery is the place for maximum exposure.[15]

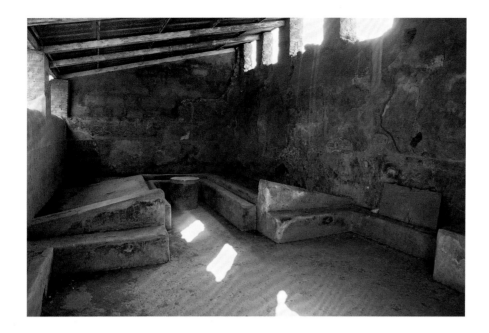

Which may become a little more surprising once one reads the other most popular strand of communiqués on thermopolium walls. Sometimes they are quite simple. For instance, on the structure known as the Caupona of Sotericus, "Futui copanam," or "I screwed the landlady" (*CIL* IV 8442); and at the Tavern of Verecundus, "Restituta, take off your tunic, please, and show us your hairy privates" (*CIL* IV 3951). At other times they turn into dialogues, as in the case of the Thermopolium of Prima, where Severus and Successus are fighting over the slave girl Iris, the one conveying his love-sickness, the other establishing his amorous credentials. It is as mysterious in 79 CE as in the twenty-first century exactly why expressions of this kind require public diffusion; what counts for us, though, is that the eating place in Pompeii is so often the site of dissemination. To be sure, there were many such claims and protestations over all the outdoor walls (and sometimes the indoor walls) in Pompeii. If the thermopolia have a privileged place for this material, it is not only because they were places of public haunt but also because they often doubled as brothels. About this matter there is much scholarly debate: experts in the past tended to consider all public places in Pompeii as pretty much bawdy houses; now the pendulum may have swung in the other direction, to scholarly efforts apparently devoted to rendering a more sanitized early history of restaurants.[16] What cannot be doubted in all of this is that whoever frequented these places as well as whichever kinds of appetites were satisfied there, the evidence of Pompeii locates the consumption of food and drink at the very center of both public and private life—indeed, as both establishing and blurring the distinction between the two.

The properly domestic sphere is, of course, different: more elite, more expensive, graffiti-free (mostly). But it also offers us a different *kind* of evidence about the centrality of eating and drinking in Roman culture, less about what actually took place and more about the ideologies and aspirations that surrounded the experience. What material archaeology tells us about the actual sites of family mealtime in private

2.4. Fresco from the House of the Triclinium, west wall, V.2.4, Pompeii. Museo Archeologico Nazionale, Naples

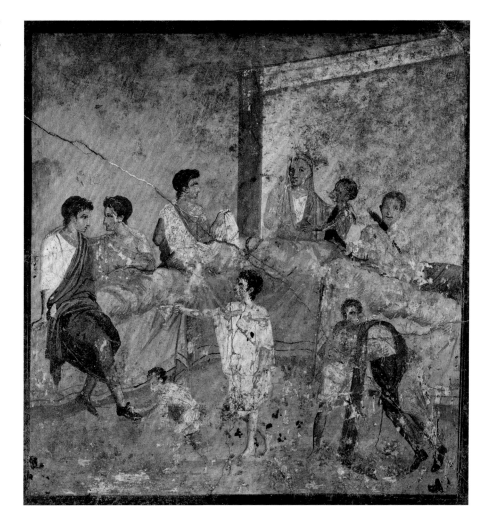

2.4. Fresco from the House of the Triclinium, west wall, V.2.4, Pompeii. Museo Archeologico Nazionale, Naples

homes is revealing but not exactly definitive. There are something like a hundred distinct locations in the excavated city that have, over two centuries of archaeology, been designated as *triclinia* (fig. 2.3), that is, spaces structured by couches forming three sides of a rectangle (though not necessarily at right angles).[17] In fact, they don't all possess actual evidence of the three-sided arrangement, as discussed in the previous chapter, and if *triclinium* has simply become a modern synonym for the Roman dining room, it should be recalled that wealthy Pompeiians actually took their meals in various different spaces inside and outside their houses. It should also be recalled that the term *triclinium* even in its own time was something of a hybrid. Its origins are in the Greek κλίνη, but the practice is distinctly Roman; and we may take that piece of Latin back-formation as a clue about the story that Romans wanted to tell themselves concerning their banqueting practice.

If this is a story, then the Pompeiians and their interior decorators clearly wanted to tell it frequently and in a variety of ways. Among the several mealtime-related frescoes in the House of the Triclinium[18] (now in the Museo Archeologico Nazionale in Naples) (fig. 2.4), for instance, we find something of the classic right-angle positioning of the couches, only two of which are included, with three persons at each

couch (though there is a fourth diner who has probably left his spot at the right-hand couch). The moment depicted is generally understood as the late stages of a banquet. The participants are all male, and the foreground activities—one diner is doubled over and being supported by a boy, while a second diner is being helped with his shoes and thus apparently about to depart, although he is being served what looks like one for the road—suggest we are witnessing activities that are, in the most inebriated sense of the term, symposiastic. A pendant to this composition (fig. 2.5), on an adjacent wall, sets the banqueting scene outdoors with a similar arrangement of couches (opinions differ on whether this is an all-male cast), but here the emphasis is not so much on drinking as on music, signaled by the text incised on the fresco, toward which two of the participants, perhaps the speakers, gesture pointedly: "Have a good time." "I'm going to sing." "Go for it."

As both parallel and contrast, we may consider a fresco (fig. 2.6) that was found in the Fullonica of Sestius Venustus. Here the participants are exclusively women and, as in the inebriated scene above, the slaves share the participants' gender. There is only the vaguest suggestion of a triclinium, and though drink is certainly present, there are no signs of drunkenness. Quite the contrary; orderliness appears to be the theme, with

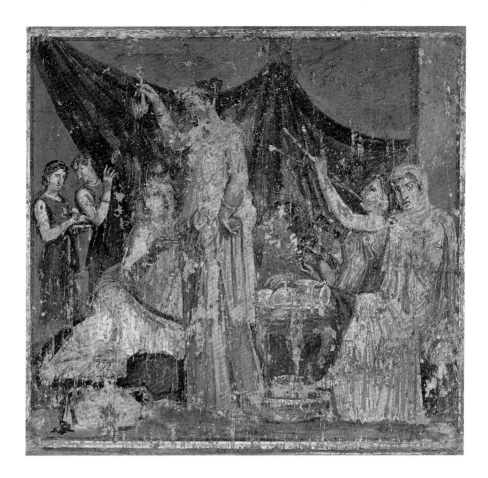

the principal lady in grand command of the enterprise. The device she is holding may be a *sistrum*, at once a percussion instrument (rather like a rattle) and an emblem of power, associated especially with the goddess Isis. There is no surprise in the fact that a female gathering would be represented as more decorous than a male one; yet the very existence of such a scene is notable. The nineteenth-century catalogue from Naples entitles the work *Symposium of Hetaerae*; whether such a category existed formally or not, it's clear that the scene of banqueting could be adapted to an all-female cast.[19]

An image found in the House of Chaste Lovers (fig. 2.7), offers yet another sort of contrast. Whatever may have inspired the naming of this domicile by nineteenth-century archaeologists, it turns out here that women did not need to be quite so abstemious as they appeared in the Sestius Venustus fresco, in regard to either drink or sex. The triclinia are once more in evidence; they are occupied, however, not by drunken gentlemen but by couples who, if not quite *in flagrante*, are certainly connected in an intimate manner. Meanwhile, the strongly eye-catching gestures of the left-hand couple draw our attention to another woman, who is in desperate, presumably alcohol-related, need of physical support, yet even in that condition she manages to hold on tipsily to a drinking vessel. Unlike the other women, she is not in close proximity to a partner, though there is the suggestion of a sleeping man at the back of the triclinium. Perhaps this couple was more bibulous than the other two; now she is rapidly fading, whereas he must have gotten started early and is already sleeping it off.

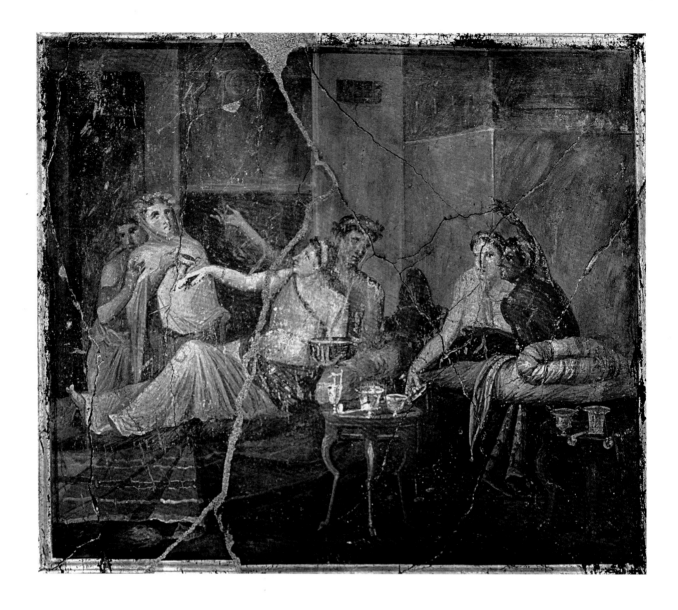

A pair of similar compositions from the House of Chaste Lovers (figs. 2.8 and 2.9) takes the banquet scene outdoors. The paraphernalia of drinking are considerable, including, in the one case, a particularly vivid and elegant representation of glassware and, in the other, an added figure of a servant who is mixing the wine in a bowl. But the triclinium appears to have lost all connection to the symposium, as it edges toward sex couch, upon which the human postures are closely related to more explicitly pornographic forms of illustration. One final condensation of this sort can be observed in a Herculaneum fresco (fig. 2.10) with only two personages engaged in anything like sympotic activity—the man is sipping out of a drinking horn, and the woman is gesturing toward the waiting slave—but the overall impact of the scene is decidedly erotic.

What we have in this anthology of frescoes is something like the principle enunciated by Fritz Saxl in his illuminating essay "Continuity and Variation in the Meaning of Images": the establishment of a visual icon that comes to be recognizable, within

2.7. Fresco from the House of Chaste Lovers, room 3, north wall, IX.12.6, Pompeii

2.8. Fresco from the House of Chaste Lovers, room 3, east wall, IX.12.6, Pompeii. Museo Archeologico Nazionale, Naples

2.9. Fresco from the House of Chaste Lovers, room 3, west wall, IX.12.6, Pompeii

2.10. Fresco of couple drinking, from Herculaneum. Museo Archeologico Nazionale, Naples

2.11. Fresco of a banquet of Cupids, from the House of Marcus Lucretius in Pompeii. Museo Archeologico Nazionale, Naples

2.12. Fresco of Nilotic scene, with Pygmies banqueting, playing music, and having sexual intercourse, from the triclinium in the House of the Physician, in Pompeii. Museo Archeologico Nazionale, Naples

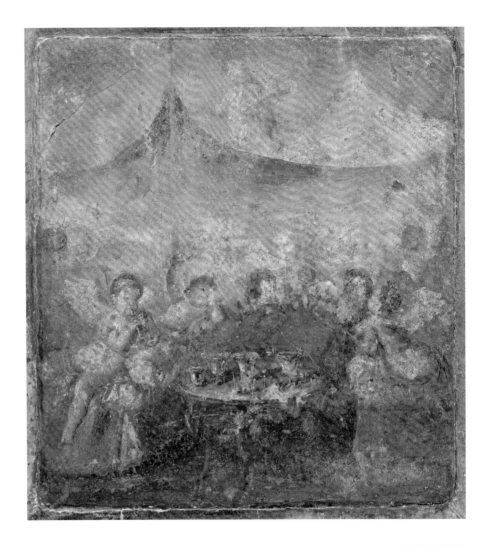

its culture and beyond, as the bearer of particular meanings while also being susceptible to a certain flexibility of meaning.[20] The continuity here is precisely that of what Saxl calls classic images: a set of shapes with the kind of consistency that enables its meaning—or at least its denotative meaning—to be instantly recognizable within its own culture or, under certain circumstances, beyond it. This iconicity is further confirmed by the existence of something like parodic banquets. At the House of Marcus Lucretius in Pompeii, the participants are Cupids (fig. 2.11), engaged in revelry and

music making, whereas in the House of the Physician they are Pygmies along the Nile (fig. 2.12) engaging in some decidedly nonculinary activities—combat with a hippopotamus, anal intercourse—but once again the canopy, the position around three sides of a rectangle, the music making, the upraised arm of one of the diners, and even a decidedly primitive version of a drinks table fix the denotative quality of the classic banquet.[21] Clearly, Romans who may or may not have ever witnessed an elite banquet knew what it looked like. Nor is it necessarily the case that banquets *really* looked like that, only that such an arrangement was a *sign* for the banquet.

That sign pointed back, like so much of imperial Roman elite culture, to Greece, whose civilization at its most prestigious expressed itself via the scene of philosophy and banqueting to be found in the pages of Plato, Xenophon, and Plutarch under the heading of "symposium." Among the Romans, the participants could be all men, all women, or a mixture; their principal activities could be philosophical, gastronomic (especially of a liquid kind), or musical. The triclinium could be the site where citizens expressed their elite status via the reclining posture, or else the reclining posture could metamorphose into a convenient position for sex. All these variations—and this is the most important part—could be contained within the continuity of that set of iconic positions that made them so unmistakable when rendered in miniaturized or parodic form. Like the word *triclinium* itself, it was a piece of aggressively adapted Greek.

Cicero, writing about banquets in his *De senectute*, helps us to understand the issues here. Speaking in the voice of Cato, he reflects on the pleasures appropriate to old age:

> I used to dine with these [club] companions—in an altogether moderate way, yet with a certain ardour appropriate to my age, which, as time goes on, daily mitigates my zest for every pleasure. Nor, indeed, did I measure my delight in these social gatherings more by the physical pleasure than by the pleasure of meeting and conversing with my friends. For our fathers did well in calling the reclining of friends at feasts a convivium because it implies a communion of life, which is a better designation than that of the Greeks, who call it sometimes a "drinking together" and sometimes an "eating together," thereby apparently exalting what is of least value in these associations above that which gives them their greatest charm.[22]

The distinction he is drawing, between the Greeks' "*drinking* with" and the Romans' "*living* with," points to one aspect of what we can see on the walls of Pompeii: the banquet, iconically represented, is understood as encompassing a whole range of lives as they are lived in company. Yet there is a problem in his assertion that eating and drinking are the least important part of it. Plutarch had made the same claim when he pointed out that Plato and the others included no recipes in their symposia, only records of the philosophical discussion.[23] Food and wine may be shunted to the margins (as we saw in the previous chapter), but the business of consuming them forms the occasion, indeed the sine qua non, for the loftier activities. The banqueting frescoes that were to be seen so frequently in the domiciles of high-class imperial Romans

cannot be seen as representations of philosophy or even friendship; what makes them recognizable and iconic is the depiction of persons who have come together for the purpose of dining.

There is an element in these representations that may draw them even farther from philosophy and closer to dinner. The matter, once again, is continuity and variation. Whatever the range of activities in the Pompeii dining frescoes, and whatever the specific composition of figures, there is an element that is almost precisely identical across some dozen or so frescoes. Judging from the visual evidence, every self-respecting domicile within the reach of Roman civilization possessed a piece of furniture called a *mensa delphica*, a small three-legged table with cabriole legs.[24] Even fanciful houses inhabited by Cupids and Nilotic pygmies (as witness decorations in the Houses of Marcus Lucretius and the Physician) seem to have been so equipped. Not that this element of design necessarily counts as a photographic record, of course. The *mensa delphica* has its origins in fourth-century BCE Greece and therefore doubtless appears here in part as a token of Hellenistic refinement. But it was a real possession as well, as evidenced by a nicely preserved specimen found in the Casa di Paquio Proculo in Pompeii (fig. 2.13) (see also the fine example in the foreground of fig. 2.10).

The *mensa delphica* is of interest to us because it is invariably the site for an array of drinking vessels. Indeed its remarkable prominence—front and center, closest to the viewer's vantage point—in virtually all these images and its inevitable display of accoutrements for the consumption of wine signal a kind of primacy for one particular aspect of the banqueting experience. The material culture of Pompeii sends the message that, whatever the overall cultural prestige that attached itself to the general business of mealtime in Roman civilization, its very epicenter lay in the business of consuming wine. Reflecting back on these dining frescoes, and not just that one piece of furniture, one realizes that there is in fact never any sign of eating, only of drinking. Indeed, though there are many images of foodstuffs throughout Pompeii (and elsewhere), we never see people eating them, almost as though the consumption of solid food were an indelicate pictorial subject.

Wine drinking, however, is not an indelicate subject, and the well-furnished *mensa delphica* suggests that, if wine was installed at the apex of cultural worth, its expression of value can be observed most distinctly in the devices within which it was mixed, poured, and—above all—served. Latin, we are told, had twenty-five words for drinking cups (a sampling: *ancon, batioca, calyx, cantharus, caucus, crustallus, culilla, modiolus, phiala, poculum, potorium, scaphium*);[25] and, even if casual claims about the many purported Eskimo words for snow have been largely debunked, there is no denying

2.14. Fresco from the Tomb of Vestorius Priscus, north wall, Pompeii

2.15. Silver cup with scene of the triumphal cortege of Tiberius, from Boscoreale, 1st century CE. Musée du Louvre, Paris

2.16. Silver cup, so-called cup of Emperor Augustus, from Boscoreale, 1st century CE. Musée du Louvre, Paris

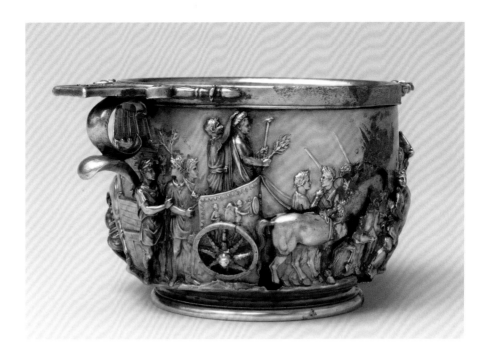

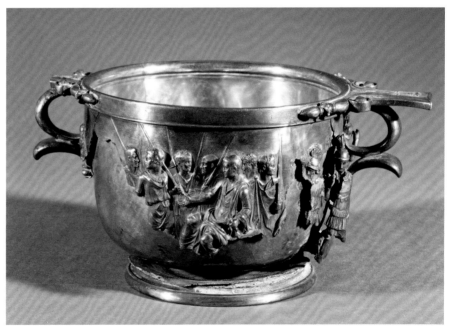

that linguistic density of this kind reveals something about a culture's need to specify meanings where the subject matter is of particular importance. A more graphic piece of evidence is the Pompeiian tomb of Vestorius Priscus (fig. 2.14), which included a beautiful fresco depicting the decedent's nineteen-piece collection of silver drinking vessels arrayed on what, in fact, is *not* a *mensa delphica* but a four-legged Greek-style table that was doubtless necessary given the quantities that needed to be exhibited.[26] It is an image that would communicate not only his family's wealth (Vestorius himself being only twenty-three at the time of his death) but also his promise as a budding

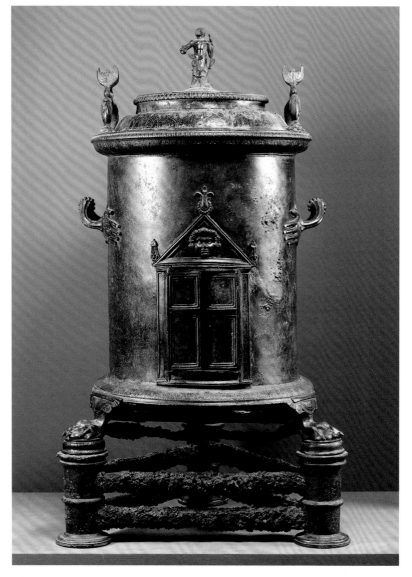

2.17. Terracotta pot with lid and two handles on a tripod, from Pompeii. Museo Archeologico Nazionale, Naples

2.18. Pastry molds, bronze, from Pompeii. Museo Archeologico Nazionale, Naples

2.19. Bronze cylindrical food warmer, from Pompeii. Museo Archeologico Nazionale, Naples

politico likely to make his way in public life via lavishly wine-fueled entertaining, as was the norm.

It's those sorts of cups themselves, whichever lexical choice may have been used to name them, that tell the fullest story about the cultural place assigned to wine drinking. Notable, for instance, are two pairs of vessels found in late nineteenth-century excavations at Boscoreale, near Pompeii.[27] (It is, by the way, another index to the value of such objects that they have tended to be found hoarded together, deliberately wrapped and hidden by their original owners, in the expectation either of burglars or of a natural catastrophe, such as the earthquake that preceded the eruption of Vesuvius by seventeen years.) The subject matters of the pairs of cups could not be more dissimilar: in one case, grand imperial themes involving Tiberius and Augustus (figs. 2.15 and 2.16), in the other case, a mysterious set of philosophical allegories illustrated with celebrated sages and dancing skeletons. We'll have occasion to discuss the latter pair more precisely (and see figs. 2.20 and 2.21); for the moment, perhaps the most significant detail is that these come in pairs. What that means is that in the most hallowed instance of communion with a single intimate friend, the host would bring out his best silver goblets, their surfaces of figural imagery bearing complex meanings suitable for lengthy discussion *à deux*, while together they would sip the wine contained within.

Drinking was not the only gastronomic activity whose significance was expressed by paraphernalia. Of the material objects so far recovered in Pompeii, a notable proportion are related to cuisine.[28] The quality is even more impressive than the quantity. There is a remarkable range of highly sophisticated cooking devices: heating vessels in pottery and bronze, pots in metal and terra-cotta, cake pans, and some elaborate sculptural food molds, evidently intended for pastry or pâté, with which I have no doubt that Brillat-Savarin would feel quite comfortable (figs. 2.17 and 2.18). Serving pieces are at a yet more stunning level of design, with ingenuity exercised for keeping food warm via internal heat sources akin to those in samovars, and—perhaps even more notable—an attention to elaborate decoration, even on rather utilitarian service items (fig. 2.19).[29] The example of Pompeii suggests a society that placed gastronomy at the very center of value. Not only are Romans, it seems, what they eat (and drink); they also spend a lot of money on the accoutrements for doing it.

2

Pompeii provides what must, in the most fundamental sense, be called mute evidence: we examine an astonishingly well-preserved set of inanimate objects, and we "read" them, if only in the figurative sense. Fortunately, though, the civilization of ancient Rome also provides a vast quantity of materials that are not so mute. Eating and drinking, it turns out, communicate their centrality just as loud and clear in the textual archive as they do on the streets of Pompeii.

Historiography, to begin with. In the chronicle that Romans composed about their own past, the account of what they ate and how those edibles were produced

plays a significant role. The master narrative in all these texts is fairly standard: the honest primitives of ancient times have turned into the self-indulgent sybarites of the present day. Columella begins his *De re rustica* with a lament (things not having changed much in the subsequent two millennia) that recent generations have abandoned the cultivation of the land. As his oration gathers steam, he picks up all the archaic occupations—tilling, planting, viticulture, hunting—that generated the basic honest food groups of the past, and he contrasts this way of life with a present day in which Romans have succumbed to such "contemptible vices" as "the seasoning of food to promote gluttony and the more extravagant serving of courses."[30]

Pliny, building on these sentiments, generates an entire early history of Rome out of primitive edibles:[31] the first crown ever worn in Rome was made from ears of corn; Numa Pompilius established the Feast of Ovens and propitiated the gods with salted cakes made from roasted emmer (understood as the most basic of all the grains; we generally use the Italian term *farro* for this grain, and we tend to buy it "pearled," because its husk is in fact difficult to digest, thus confirming its "primitive" quality); the earliest surnames came from association with agricultural products—for example, Fabius, Lentulus, and Cicero, from fava beans, lentils, and chickpeas, respectively. And he quotes Varro on the quantities of edible goods—again, he chooses those signifying the humble life—that, in olden times, one could purchase for a single *as*, the basic Roman coin of low value: a peck of emmer, thirty pounds of dry figs, ten pounds of oil, and thirteen pounds of meat. The historians chronicling Rome's decadence have the measuring rod of cuisine always at their fingertips.

Prevailing philosophical schools provide another archive, notably the centuries-long debate between Stoics and Epicureans;[32] here, too, food and drink will play a central role. The origins of these philosophies were, of course, in Greece, but the perceived contradictions between them, along with the reframing of them into alternative credos for daily living, become a significant tendency in Roman thought. We all know the simple version of the opposition: the Epicurean lives for pleasure, whereas the Stoic manages to be indifferent to pain. And we may also have been taught how the reality of the two philosophical traditions is more complicated than this. The "pleasure" of Epicureanism derives from careful control of one's desires (which makes it sound kind of stoic), whereas Stoicism is less about passivity in the face of adversity than aggressively developing a personal will that is stronger than the vagaries of fortune.

It is no surprise that the Epicureans would be food-conscious. After all, they gave us the term *epicure*, which is equivalent to "gourmet"; and the simplistic version of their philosophy is often associated with "Eat, drink, and be merry," even though the actual origins of that phrase are biblical. But the relationship to eating and drinking runs much deeper than catchphrases.[33] As we might expect, the culinary subject comes up in *The Learned Banqueters*, the fifteen-volume dinner party of Athenaeus. One of the philosophical gourmands declares,

> Reasoning that proceeds in accord with nature is entirely devoted to the belly. . . . The one who taught these people was Epicurus, who used to shout out loud: The pleasure derived from the belly is the origin and root of every good, and whatever is wise or exceptional is so by reference to

it. . . . I, at any rate, am unable to conceive of "the Good" if I remove from consideration the pleasure derived from the flavors of food.[34]

Though pleasure will go on to be derived from music, visual beauty, and sex as well, this strand of Epicureanism—the conversation itself taking place, after all, over a meal—will see eating and drinking as the defining instance of pleasure.

What may be more striking is the way in which the Stoics in Rome find it just as difficult to push themselves away from the dinner table as the Epicureans, as is particularly evident in the works of Epictetus (a Greek, but resident for much of his life in Rome). It is perhaps unremarkable that he would use mealtime as a metaphor for life's chances, both now and in the hereafter:

> Remember that you ought to behave in life as you would at a banquet. As something is being passed around it comes to you; stretch out your hand and take a portion of it politely. It passes on; do not detain it. Or it has not come to you yet; do not project your desire to meet it, but wait until it comes in front of you. So act toward children, so toward a wife, so toward office, so toward wealth; and then some day you will be worthy of the banquets of the gods.[35]

At other points, however, one has a sense that grand dinners are something more than metaphorical for Epictetus—when, for instance, the example of adversity toward which one is supposed to be stoical is not a child's death or the loss of one's fortune but the failure to be invited to a meal:

> You have not been invited to somebody's dinner party? Of course not; for you didn't give the host the price at which he sells his dinner. He sells it for praise; he sells it for personal attention. Give him the price, then, for which it is sold, if it is to your interest. But if you wish both not to give up the one and yet to get the other, you are insatiable and a simpleton. (25)

The example of this dinner party brings out quite a different form of "stoic" response to calamity. We are not being told, as in the previous quotation, to react passively in the face of opportunity, or lost opportunity; we are being told to put up or shut up, commit to the system rather than complain about it. The world of Roman public feasting, with which the Stoic appears to be deeply familiar, has strict and widely accepted rules of reciprocity, which are here encountered with considerable cynicism. Stoicism equals playing the game, and the game is dinner parties. It is a very few steps from stoic philosophy to Horatian satire, as we will see later in this chapter.

Athenaeus suggests that these opposing philosophies were actually discussed in the midst of the feasting that formed so central a part of their arguments. Even more remarkably, we possess a pair of material objects, as mentioned earlier, that evidence a literal show-and-tell on the subject.

A pair of silver cups found in the Boscoreale treasure is densely decorated with figures and texts.[36] A scene on one of the cups (fig. 2.20) depicts an elite of Greek

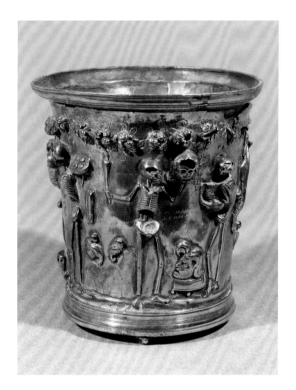
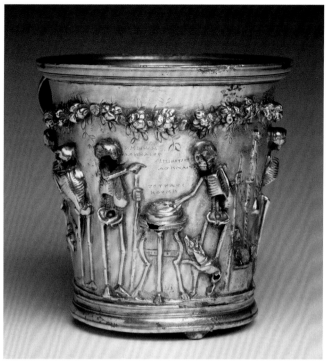

drama; their names—Euripides, Sophocles, Menander—are etched in. They are contemplating a giant theatrical mask, with another such mask on a pedestal. A scene on the other cup (fig. 2.21) features the founding Stoic Zeno and the eponymous Epicurus, also skeletons. In the surroundings are philosophical maxims, for instance, "rejoice while alive." The two philosophers are in a confrontation: the skeletal Zeno points, as it seems, reprovingly at his philosophical opponent, but Epicurus's attention appears diverted by a nearby piece of cake inscribed "pleasure is the highest good." The story the cups are telling clearly means to embrace two great media of cultural wisdom: philosophy and (dramatic) poetry. Both media entertain an ambition that they can reveal truths about life and death, the most fundamental of which—witness the fact that all the figures are skeletal—is the inevitability of death. The responding argument, to the extent that there can be one, is the existence of the cups themselves, vessels in which wine is sipped by a pair of friends.

In one sense, all the evidence presented by the cups appears to favor the Epicurean side, and yet the objects themselves seem to suggest ongoing debate and pleasure along the way. The luxurious and intimate circumstances in which the host and friend would drink from these cups summon up the kind of private occasion in which eating and drinking are not only experienced but also subjected to philosophical analysis, which is itself a kind of response to death's inevitability.

If we could listen in on that conversation between our hypothetical learned banqueters, whether in the pages of Athenaeus or at home with the Boscoreale cups in their hands, we might well discover that their language itself was curiously culinary, even when the subject wasn't food or drink. In a very suggestive article, William Michael Short has argued for a deeply pervasive strand of conventionalized

2.20. Silver goblet with skeletons and theatrical masks, from Boscoreale. Musée du Louvre, Paris

2.21. Silver goblet with skeletons, featuring Zeno and Epicurus, from Boscoreale. Musée du Louvre, Paris

metaphorics in Latin centering on cooking, serving, tasting, eating, and digesting.[37] Whereas modern languages are likely to model communication in terms of mechanisms and commodities—language goes through pipelines and gets delivered from a purveyor to a receiver—Latin speakers, Short argues, pictured their discourse as something that began in the kitchen and ended with ingestion.

There is no denying the extraordinary frequency and density of culinary language in certain kinds of Latin texts. Political conspiracies and comedy intrigues are *cocta*, *decocta*, *concocta*, *excocta* (Short, 249), or else they are *parata* or *adparata*, in contexts where "prepare" has culinary implications. Rhetorical language, itself characterized as flavorful, salty, sweet, and well seasoned, is *esa* or *devorata*, and once consumed, it is liable to be *ruminata*.

In fact, it is in discussions about language itself, or about the products of language, that these metaphorics are notably evident. When Romans write about words, books, or literature, verbs of consumption are rarely far from their minds. Not only does Quintilian in the *Institutio oratoria* have recourse to culinary activities when talking about writing; he also summons up this terminology to convey a sense of intellectual process that is analogous to digestive process.[38] To have a minimal awareness of literature is to have "barely tasted it with the lips" (*qui literas vel primis . . . labris degustarit* [12.2.4], including a self-conscious *ut aiunt* [as they say] in recognition that he is speaking figuratively). When he himself wishes to treat literature in a summary fashion, he is merely *tasting* the genres, not churning through whole libraries (*nos genera degustamus, non bibliothecas excutimus* [10.1.104]), with an implication that the alternative to tasting might proceed in the direction of vomiting. And the system of educating boys in reading must induce them to *swallow* the boredom of repetition by having them *rechew* the same food around and around; the verb in question, *remandere*, is used by Pliny in reference to the ruminating consumption of food by the Pontic mouse. Indeed, this whole vocabulary of process may well go back to a passage in the *Natural History*, where Pliny is raising the question whether animals have a sense of taste—his answer is yes—and he goes on to detail their methods of taking in food: *alia augunt, alia lambunt, sorbent, mandunt, vorant*, "some suck, some lick, some inhale, some chew, some devour" (10.91). The language of eating, whether used metaphorically or literally, begins to look like those many Latin words for drinking vessels: the culture requires a great deal of semantic specificity in the places that count the most.[39]

As with any transaction between words and things, semantic specificity is a property not only of language but also of that which it is meant to signify. There is, in fact, one culinary subject for which the Romans (literally) wrote the book with respect to specificity. We can observe it, for instance, in a cross-generational tussle between Virgil and Pliny. The second book of the *Georgics*, whose subject is fruit-bearing plants, includes an epic-style inventory of grape varieties in territories under Roman sway.[40] The passage begins, however, with the Greeks: our vines, says Virgil, are *not* like those of Methymna on Lesbos ("On our trees hangs not the same vintage as Lesbos gathers from Methymna's boughs" [2.89–90]). The reference is rhetorically ambiguous. The vineyards of Methymna were proverbial for producing both quantity and quality,[41] and, particularly given the fact that Virgil loves to play the Greek card when celebrating Rome, one expects after this gambit a gesture involving some sort of oppositional

comparison. But it never happens. "Not the same as Methymna" simply gives way to an encomiastic enumeration of some grape varieties, with varying degrees of detail. But this, too, fades rather quickly, the passage ending with a dismissal of the very gesture of enumeration with which it began: "But for the many kinds, or the names they bear, there is no numbering—nor, indeed, is the numbering worth the pains" (*Sed neque quam multae species nec nomina quae sint, / est numerus; neque enim numero conprendere refert* [2.103–104]).

And this is where Pliny steps in. In one of his many articulations of nostalgia for a better past age, he decries the oblivion into which ancient agricultural knowledge has passed, and he cites Virgil: "Happy and graceful poet as he is, he has only culled what we may call the flower of his subject: indeed, we find that he has only named in all some fifteen varieties of the grape."[42] The *Natural History* corrects this omission with a vengeance. It isn't just that Pliny goes on to discuss ninety-one varieties of grapes and 166 varieties of wine. Virgil's measly fifteen examples were accompanied by a largely formulaic set of descriptors: "soundest of wines," "royal," "swelling clusters" (*firmissima vina, rex ipse, timidis . . . racemis*), somewhat in the vein of epic catalogues whose epithets are more or less interchangeable. Pliny multiplies not only the quantity of vines and wines but, more significantly, the density of their individuation.

To begin with, Pliny departs from Virgil by producing rankings. Whereas in the *Georgics* the principle of description amounted to elegant poetic variation, the *Natural History* takes hierarchy as its organizing principle, both for grape varieties and for wines. (Of course, Virgil was writing poetry and Pliny prose.) The Aminnean grape is *principatus* and the Nomentanian has *proxima dignitas*; the wine of Setinum is crowned by association with the emperor, and the Falernian possesses *secunda nobilitas*. But this form of differentiation is externally determined—that is, not by Pliny himself. Setinum, he makes clear, has the top spot only because Augustus's successors have followed what was his personal taste. Falernian got its renown because of the excellence of its cultivation (modern wine experts might recognize this as a backhanded compliment, implying that its natural situation wasn't necessarily of the first rank). In fact, Pliny goes on to say, "the reputation of this district also is passing out of vogue through the fault of paying more attention to quantity than to quality" (14.62), again a circumstance as familiar today as it was in Pliny's time. Surrentinum comes in third, but here, too, Pliny has his doubts: the emperor Tiberius claimed its high ranking was merely a conspiracy of physicians; to him it tasted more like vinegar.

Taste, it turns out, is itself a contingent matter, as Pliny allows:

> Who can doubt, however, that some kinds of wine are more agreeable than others, or who does not know that one of two wines from the same vat can be superior to the other, surpassing its relation either owing to the cask or from some accidental circumstance? And consequently each man will appoint himself judge of the question which wine heads the list. (14.59)

What really counts is *difference*. Falernian comes in three varieties: "one dry, one sweet and one a light wine. Some people distinguish three vintages as follows—Caucinian

growing on the tops of the hills, Faustian half-way up them, and Falernian at the bottom" (14.62).

All this differentiation goes back to the very origins of the wine, and it depends on Pliny's special brand of thick description. A passage chosen almost at random:

> The people of Durazzo speak highly of the balisca vine, which the Spanish provinces call coccolobis; its grapes grow in rather scanty bunches and can stand hot weather and south winds; its wine is apt to go to the head, but the yield is abundant. The Spanish provinces distinguish two kinds of this vine, one having an oblong grape and the other a round one; they gather them last of all. The sweeter the coccolobis grape is, the better it is; but even if it has a rough taste it turns sweet with age, and one that was sweet turns rough. (14.30)

What becomes evident here is that, at the highpoint of Latin civilization, the production of wine resided upon a seemingly infinite mastery of the natural world, an encyclopedic sense of variety in regard to both natural substances themselves and the language used to name them, and a rich lore of experience concerning taste as it evolves through time, as well as the aftereffects once it has been consumed.

The wine grape is not, of course, the only subject that gets enumerated, ranked, and described in the pages of the *Natural History*, nor is Pliny the only (or even the first) Roman to perform this kind of encyclopedism on wine. But the conjunction of Rome, Pliny, and the grape will have lasting significance. It is no coincidence that this text looks so uncannily modern. If Pliny (as some say) invented art history in the latter books of his encyclopedia, we might say that here he invented the *Wine Spectator*. In fact, the whole matter resides upon a set of premises that have not changed across millennia: the wine grape is fundamentally a single entity; it is nevertheless subject to vast variation; that variation, despite its seeming boundlessness, is capable of being tabulated in repeatable ways that count in some sense as scientific knowledge; these agreed-upon sub-identities are susceptible to agreed-upon gradations of quality, which go hand in hand with alternative forms of nonhierarchical description; whatever the agreed-upon rankings may be, it is legitimate for individual tastes to differ, so long as they remain within certain bounds. We moderns speak in terms of *Vitis vinifera* as a single species, and we analyze the chemical properties of wine such that a glass of Château Pétrus and a glass of plonk turn out to be something like 93 percent identical. God is in the 7 percent.[43]

Not that it is all about the chemistry. Pliny and his contemporaries responded to these differences, once again, in the proverbial way that Eskimos responded to snow and in the actual way that they themselves related to drinking vessels. Wine was sufficiently important and sufficiently subject to difference that it produced a vast lexicon. Or it was produced *by* a vast lexicon. That depends on different theories of language, but for us the distinction doesn't matter.[44] Wine was a place where the culture located difference. But there was another requirement for this explosion of differentiation. Unlike the Eskimos, Rome possessed a vast and, for certain periods of time, a highly centralized empire. (In this respect not unlike the bourgeois West of our own time.)

Grapes are not the epicenter of difference if—to take a medieval example—one lives inside a single wine-producing monastery, though even there, distinctions may arise from changes in climate or soil. Given the long-remembered ages of Roman hegemony, Pliny's balisca grape, also known as coccolobis (to choose an example that was referred to above), could be confidently mapped with an imperial stretch of geography, from Dyrrachium in the Balkans (roughly, modern Albania) as far westward as Spain, all of it emerging from what was understood as the same grape, all of it subject to the cultural mastery of ancient Rome, all of it requiring discrimination by the senses and the application of a vocabulary.

Pliny is doing a balancing act between the empire at one extreme and the individual experience of taste at the other extreme. Where Rome writ large is concerned, however, the subject of eating and drinking is far more likely to be concentrated in the public sphere. On the one hand, we have Pliny traveling the world with his equivalent of a notebook and those Pompeiian gentlemen *à deux* clutching their heavily incised drinking cups; on the other hand, far more space in history and in the cultural imagination has been given over to Romans dining in public. It is difficult to go back far enough in the history of the city to find a time when public feasting, open to smaller or larger collectives of residents, was not a feature of urban life.[45] Religious festivals at least eight times a year, celebrations honoring particular districts in the city (of which there were as many as 265), single events staged and paid for by individuals seeking publicity, and increasingly as the territories expanded, commemorations of military successes: all of these contributed to a sense that, even in the days of the Republic, the city was ordered by the staging of festivities, almost all of which included eating and drinking.

But it is during the Principate and the Empire that all this consumption becomes proverbial. Julius Caesar, after his African victories, served a banquet to all the citizens of Rome assembled (on twenty thousand triclinia, according to Plutarch).[46] Nero, who operated via a mixture of private dining, public dining, and private dining in the public view, famously all but bankrupted the treasury with his construction of the Domus Aurea (fig. 2.22), intended for grand feasting in the round. Domitian sought to outdo this construction with *his* dining hall, which according to Statius had enough columns to support heaven.[47] Vitellius, the notorious glutton who reigned during the year of four emperors (69 CE) and who can serve as comic subplot to the great Caesars, spent a fortune on the world's largest casserole, which had to be fired in a specially built oven out in the countryside; he named it (blasphemously, one supposes) the "Shield of Minerva."[48]

Famously voracious emperors cross a line between public and private banqueting, but well before Julius Caesar and Nero, certain super-wealthy citizens of Rome are inventing their own extravaganzas. The traditional account, then and now, is that the expansion of the Empire around the first century BCE brought both the wealth and the taste for excess, which, as moralists never tired of pointing out, was all the more contemptible when it was used for private purposes. We owe to Plutarch the portrait of Lucullus (his name ever after synonymous with gourmet indulgence), whose culinary extravagance—precious stone-encrusted wine vessels; thrushes out of season— was *so* private that in fact he even dined alone in that grandiose style.[49] Pliny, not

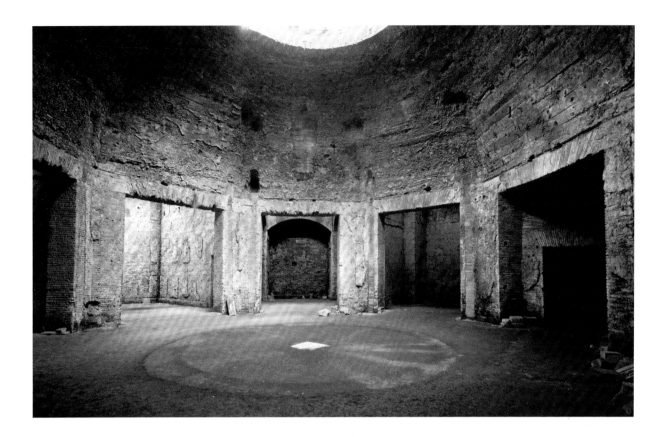

2.22. Octagonal Hall of the Domus Aurea, Rome, 64–68 CE, built by Nero

surprisingly, is the pitiless enumerator of private excess in the dining room, noting which citizen was the first to silverplate his triclinia or to serve an entire roast boar at dinner—though he adds that things have got even worse in the succeeding century.[50]

Our questions, as always, have to do with the way in which the scene of eating and drinking defines the larger culture—in this case, the political and social culture—around it. Two particular banquets, distant in time but both well documented, will serve to illustrate some of the central issues. One of the very earliest celebratory meals on the sort of occasion that will eventually dominate Roman public feasting was held in 214 BCE to honor the Roman army's success at Beneventum against the Carthaginian forces of Hanno, who had been attempting to bring his corps of reinforcements to Hannibal.[51] The circumstances of the Roman victory, as described quite minutely in Livy, are complex because most of the soldiers on the winning side were, in fact, slaves. This was, and remained, an exceptional situation, though it is representative of the fact that Rome's history will continue to be troubled for centuries by all the gray areas between slave and free. In this instance, the further complication is that, according to Livy, some of the slave soldiers had been valiant whereas others had not.

All these distinctions get folded into the celebration. Tiberius Sempronius Gracchus, the winning general, begins his victory speech by rewarding the regular citizen veterans handsomely and then proceeds to declare that *all* the slaves, whether they showed valor or not, will be freed. Thus he fulfills the promise of manumission that Rome had made to the soldiers, which evidently depended on general victory rather than on the courageous performance of each individual member of the slave army.

Even so, there are, as it turns out, distinctions to be made, and it is the dining table where this crucial matter will be made manifest:

> I shall order the names of those who, remembering their refusal to fight, left us a while ago to be reported to me; and summoning them one by one I shall make them swear that, excepting men who shall have illness as an excuse, they will take food and drink standing only, so long as they shall be in the service. This penalty you will bear with patience, if you will reflect that you could not have been marked with any slighter sign of cowardice. (12–15)

When the grateful citizens of Beneventum offer a celebratory feast, Gracchus consents on the condition that it be on public view, about which Livy goes on to say that the newly freed slaves were now permitted to wear the white caps of freedom; "they feasted, some reclining, and some standing served and ate at the same time." The banquet is open to all, irrespective of difference, but the banquet is also the marker of difference; and all the messages conveyed by the banquet, contradictory or otherwise, are themselves broadcast. In other words, the Roman banquet in public is both a participatory event and an advertisement to be watched by the participants. In this case, not only the participants: fittingly, as Livy reports, Gracchus orders that the scene— presumably including the signifying headgear and postures—be commemorated with a painting in the Temple of Liberty, where it was in a position to canonize the institution of victory banquets with all the mix of inclusion and differentiation that the original scene exhibited.

We have no other record of this painting, but everything about the scene will come to characterize many forms of Roman banqueting for several centuries: military victory, the grateful response of the (non-fighting) public, and most of all, the making of social distinctions within a format that simultaneously advertises equality. By the time of Emperors Domitian and Trajan, some three centuries after Gracchus's victory, the imperial banquet held in public, whatever its occasion, is a central instrument of social propaganda. To celebrate the emperor is to trumpet the fact that he dines with all classes of Romans; hence Statius on a banquet given by Domitian, "Every order eats at one table: children, women, populace, Knights, Senate. Freedom has relaxed reverence" (*Silvae* 1.6.44), and Pliny the Younger on Trajan, "Your meals are always taken in public and your table open to all, the repast and its pleasures are there for us to share, while you encourage our conversation and join in it."[52]

Yet there is an equally rich literature that reads these occasions strikingly against the grain of their claims for social leveling. One of the speakers in Plutarch's "Table Talk" notes nostalgically that when the victorious general Aemilius Paullus gave his victory party (two hundred years previously), the arrangements were as orderly and hierarchical as the battle plan itself. Nowadays, however, things have changed:

> We see for ourselves that extravagant dinners are not pleasant or munificent without organization. Thus it is ridiculous for our cooks and waiters to be greatly concerned about what they shall bring in first, or what

second or middle or last . . . yet for those invited to this entertainment to be fed at places selected haphazardly and by chance, which give neither to age nor to rank nor to any other distinction the position that suits it, one which does honour to the outstanding man, leaves the next best at ease, and exercises the judgement and sense of propriety of the host.[53]

Evidently—at least to those with anxieties about class mobility—the wish to preserve order has migrated from the organization of society, where it belongs, to the organization of the menu, where it is not worth bothering about. It's another of those insistences that food be relegated to the margins, like Plato's symposiasts disparaging drinking in favor of philosophy or Boucher's lovers certainly *not* thinking of the grapes. But so far as social order is concerned, we will witness this recognition once again, and even more vividly, when we consider Roman satire: whether at the emperor's table or at the tables of various urban grandees (even those who are themselves of mean birth), banquets are the places where both equality and inequality are performed.

The socially conservative speaker in Plutarch's *Moralia* who disdains the culinary aspect of the public feast is rather out of step with the times, as it turns out. According to Livy, when Gracchus held his victory celebration back in the third century BCE, the classifying of individuals may not have been democratic, but the menu most certainly was (see note 51, above). In fact, the very origins of the occasion were from the bottom up. The citizens of Beneventum, family by family, put out a spread in the forecourts of their houses and then "invited the men and begged Gracchus to allow his troops to enjoy a feast." But bounty thrown together for unexpected company is hardly the norm for feasting in later times. And that takes us to our second iconic banquet.[54]

Quintus Caecilius Metellus Pius (fig. 2.23) was a military and political figure of something like second-rank importance during the early first century BCE, at various times allied with Pompey the Great and Sulla, and rising to the level of co-consul and head of the College of Pontiffs. We would probably not remember him very much today were it not for a couple of well-documented mealtimes. First, at a moment of relaxation during the ongoing war against rebels in Spain, Metellus is deemed worthy of a celebration by the locals and, since his tastes for luxury are already famous, is treated to a fantastic reception worthy of a god or, at the very least, a victorious general (which, strictly speaking, he was not). This includes, we learn from Macrobius, in his *Saturnalia*, trumpet fanfares, performing actors, the strewing of saffron, a crown of victory, Metellus himself in a heavily embroidered toga, and the serving of "many varieties of birds and animals previously unheard of, brought not just from the whole province but from Mauretania across the sea."[55]

Four years later, Metellus himself is the host, and on an occasion perhaps even less earthshaking than the previous celebration—the installation of a new high priest of the god Mars, one Lentulus Niger—Metellus Pius goes all out, as Macrobius reports:

This was the dinner: as a prelude, sea-urchins, raw oysters (as many as they wanted), cockles and mussels, thrush over asparagus, fattened hen, a dish of baked oysters and cockles, white and black acorn-mollusks;

2.23. Denarius (silver coin), 81 BCE, issued by Quintus Caecilius Metellus Pius. American Numismatic Society, New York

mussels again, clams, jellyfish, fig-peckers, loin of roe-deer, loin of boar, fattened fowl wrapped in dough, fig-peckers, murex and purple-shell; for the main courses, sow's udders, boar's cheek, a dish of baked fish, a dish of baked sow's udder, ducks, boiled water-fowl, hares, fattened fowl roasted, gruel, and bread of Picenum. (3.13.12)

If the issue in Beneventum, and in countless celebrations that followed over the course of the next six centuries, was the question of social inclusion, here the issue—and it, too, will remain in force for a considerable future—is ostentation. The banquet is theater, whether that involves grandiose rituals or fancy costumes, as in the case of Metellus's earlier reception, or full-dress impersonations, as on the occasion when Octavian (not yet Augustus) had his guests dress up as the gods of Olympus, presiding himself as Apollo—a performance that did not go without some accusations of blasphemy.[56]

It should not be forgotten, though, that food is at the center of this spectacle, though its form of ostentation may be more subtle than those involving outright staging. The list of dishes offered at Metellus's banquet may look like a hodgepodge, but it embodies its own kind of spectacular theater. To produce this range of comestibles as offered here is, essentially, to have all but conquered nature, since the simultaneous presence of this far-flung menu defies both seasons and geography. At the same time, it follows a grand design. The text hints at this by separating the first and second set of dishes with *iterum* and then introducing the last group with *in cena*, as though everything preceding it weren't the real *cena*; and a larger structural principle governs the whole flow, from salty things (mostly shellfish) and then lighter cooked dishes (principally fish and fowl) to, finally, more elaborately stewed or roasted delicacies. But perhaps the most impressive part of this culinary spectacle is the presence throughout the meal of specially manipulated foods. Fattened poultry, which appear no fewer than three times on this menu, were understood as part of an industry whereby artifice intruded upon nature; and sow's udders, served twice in the *cena*, were similarly the object of a great deal of culinary attention, both favorable and unfavorable, because of laborious and cruel practices that made them particularly toothsome.

2.24. Tetradrachm (silver coin), minted in Cyrene, Libya. Reverse: head. Obverse: silphium. 12.29 g. The British Museum, London

2.25. Arkesilas Painter, Arkesilas Cup, c. 565–60 BCE. Black figure ceramic. Bibliothèque Nationale, Paris. It should be noted that not all experts agree that the material depicted in production here is in fact silphium. The king's presence in any event makes it clear that whatever it was counted as a highly valuable commodity.

Grand banquets, or occasionally private ones (as when Lucullus dined alone), also involve—as they do in our own time—expensive ingredients. Take the case of silphium (figs. 2.24 and 2.25): available to Caecilius Metellus (though not on his menu as we have it) but destined for extinction, so thoroughly was it overharvested. No surprise, since it apparently grew in one single corner of the land of Cyrene in Libya.[57] As far as we can determine, silphium was a relative of fennel. We judge it to have had a distinctively pungent flavor, a circumstance deduced from the fact that, once it had become unavailable, its substitute was asafetida, a foul-smelling herb also known as "devil's dung." Doubtless, it had the familiar status of what Hamlet calls "caviar to the general": that is, possessing qualities that the uninitiated (and unmoneyed) may find repellent but that drives wealthy connoisseurs to distraction and high expenditure. Doubtless adding a great deal to its allure were the medical properties that got ascribed to it, including contraception, which (along with promising a cure for erectile dysfunction, not apparently one of silphium's properties) always guaranteed the high price of any herb or spice.

2.26. Mosaic with an amphora, from the House of Menander, Pompeii. Inscription reads, "from the workshop of [garum importer Aulus Imbricius] Scaurus." Museo Archeologico Nazionale, Naples

Whatever the unreconstructable flavors or effects of silphium, it was already documented in detail as rare and choice by Theophrastus in the fourth century BCE.[58] But if the Greeks had discovered it, predictably it was the Romans who industrialized it, with the necessary technologies of gathering it (including ultimately futile efforts at controlling the harvest so as to assure renewability) and of transporting the valuable cargo by ship. Its iconic status is also celebrated in Latin writing. Pliny, who discusses it at length, declares that it was worth as much by weight as silver, and he narrates the ceremonial gift of a final silphium stalk to the emperor Nero (*Natural History* 19.15). From some repartee in Plautus's *Rudens*, we learn that it was proverbial for its cost and the perils of exporting it.[59] And in the cookbooks that come to us under the name Apicius, it is given careful attention as a special ingredient that needs to be stretched, including the suggestion that a stalk of silphium can be used to perfume a whole jar of pine nuts, much as truffles are now stored in a container of rice.[60]

Garum, one of those fermented-fish concoctions that have such cognates in the modern world as the South Asian fish sauce *nam pla* and the Scandinavian sun-aged herring known as *Surströmming*, is another of those food products that is unpleasant until one has acquired a taste for it.[61] It seems, though, that this conversion experience, as well as the substance itself, had a much broader socioeconomic profile than silphium. We have already noted that Pompeii was a center for its production, which explains the hundreds of garum amphorae (fig. 2.26) that have been found there (including what may have been a special cuvée made for the kosher market),[62]

but archaeology has confirmed its abundance all over the Roman world; Spain, for instance, was a major production center of the highest-quality garum. Such quantities may not suggest luxury status, and economic analysis has shown that in some forms, at least, garum was to be found at price points that made it available to persons of many different social levels.

Whatever its actual range of prices may have been, garum was widely understood as a sign of luxury. As a manufactured product (unlike silphium), it could be produced at different quality levels—which depended, for instance, on whether it was made from fish blood and entrails alone or from the whole fish. This latter, inferior product had a different Latin name, *liquamen*, but this distinction came to be elided as time went on; and, in a fashion we know well, over the years a fancier name got broadened to designate a less choice product. This play of hierarchy, I would hazard to say, places garum in something uncannily parallel to the situation of balsamic vinegar today. The raw materials have nothing in common, but there is some similarity of flavor, *umami*, playing a leading role in the appeal of both.[63] Yet more significant is the parallel kind of gradation between, on the one hand, a supermarket product that lends its name to dressings at salad bars everywhere, and on the other, the exquisite tincture of which a few precious drops are strewn on very special dishes at Michelin-starred eateries. Hence the fact that much is made in ancient writing of the differences between *liquamen* and *garum* (not to mention *allec*, the sludge of the process), and, even more, that writers are so careful to distinguish mere garum from something called *garum sociorum*, which was produced exclusively from mackerel in Cartagena and Cádiz and fetched a much higher price.

But the literary record is more revealing than the economic record in any event. Garum has a kind of proverbial status in Latin writing—like silphium, but with more complex significations. Pliny pays serious attention to it, citing its paradoxical qualities in a seemingly nonjudgmental way. On the one hand, its origins are from putrefaction, he tells us, and it is made from ingredients that would otherwise be thrown away. On the other hand, it is *liquoris exquisiti genus* of such high value that it honors the nations that make it; in fact, properly blended, it resembles *mulsus*, or honeyed wine, and in that form it can be sipped with pleasure (31.43). Given Pliny's penchant for decrying luxury, his very positive account of garum is something of a surprise. Quite different is the approach of his younger contemporary Martial, who lets the contradictions all hang out. Book 13 of the *Epigrams*, which once upon a time earned him the sobriquet Martial-the-cook, is composed in the mode of the *xenia*, each poem being a couplet designed to accompany the gift of food.[64] (The very existence of this fascinating work is yet another sign of the place eating and drinking occupy in Roman culture; I'll have more to say about it in chapter 5.) When the topic is dining, Martial speaks to the glories of this delicacy. In 13.102, he bestows a gift of it upon a friend, making clear that it is of that special prime grade, *garum sociorum*, and further praising it as coming "from the first blood of a mackerel still breathing its last." Elsewhere (13.82), he casts the poem in the voice of the gift itself, a self-proclaiming bivalve who maintains that he has the noblest of origins, from the famous oyster beds of the Lucrine lake. Already drunk with that special liquid, the creature declares, "nobile nunc sitio luxuriosa garum": now that he has become ennobled, he has the right to demand the very

best form of garum; by implication, the recipient of this present is impelled to provide it, at whatever price.

There is another side to garum, as Pliny also recognized, and when Martial is in a less culinary and more down-and-dirty mode, that is what emerges. A woman named Thais stinks in ways that resemble a whole list of unpleasant things, including, for instance, unborn chicken inside a rotten egg; the last item on the list—presumably the vilest—is "a jar of putrid garum" (6.93). In another poem, with a more complicated strategy, Martial begins with an address to his friend:

> *Ferreus es, si stare potest tibi mentula, Flacce,*
> *cum te sex cyathos orat amica gari.* (11.27)

You are made of iron, Flaccus, if you can get your cock up when your girlfriend has requested six ladlefuls of garum.

It's an exquisitely ambiguous moment, hinging on possible associations of garum. Will Flaccus hang limp because he is being obliged to spend a lot of money on a present, or because doing *anything* six times is exhausting? The conceit, it turns out, is based on a comparison between Flaccus's girl and the speaker's. The former requests not only garum but other fishy and greasy products; the speaker, by contrast, imagines his sweetheart as interested in loftier and prettier things like jewels and silks. So it's the garum of foul odors, not the garum of a month's salary, that is at the heart of this dirty joke. Yet when the speaker comes to the gifts that *he* might be obliged to provide—green gems and a hundred gold coins—the reader is reminded that there is a cash nexus here as well as a sex nexus. There is more than one reason why Flaccus might have a problem (his name, of course, tells us something about his problem: *nomen est omen*).

What silphium and garum teach us about food in Rome is a combination (like so many things) of economics and signification. In the simplest sense, and in modern

terms, products like these demonstrate how much of the Roman gross national product was going into some rather arcane bits of culinary conspicuous consumption. This is, in fact, a lesson easily learned from a food product much more familiar to us. We'll allow Pliny, our intrepid guide, to tell the story for us; he will be taking exactly that moral high ground that garum, for whatever reason, did not provoke in him:

> It is remarkable that the use of pepper has come so much into favour, as in the case of some commodities their sweet taste has been an attraction, and in others their appearance, but pepper has nothing to recommend it in either fruit or berry. To think that its only pleasing quality is pungency and that we go all the way to India to get this! Who was the first person who was willing to try it on his viands, or in his greed for an appetite was not content merely to be hungry? Both pepper and ginger grow wild in their own countries, and nevertheless they are bought by weight like gold or silver (fig. 2.27).[65]

The collective expenditure on this spice, which was nonnutritious and to which no very extraordinary medical/sexual powers were ascribed, was extraordinary, inspiring an entire chapter in the history of early navigation once it was discovered that the seasonal monsoon winds could speed the passage of ships, both east- and westbound according to the time of year, so that they could reach the Malabar Coast of India and return (as with silphium, but in much larger quantities) with suitable quantities of the luxury comestible. Pliny can offer a definitive word on the economics of consumption; describing the seafaring merchantry, he tells us, "There is no year in which India does not drain the Roman Empire of fifty million sesterces" (6.26). And the cookbooks of Apicius tell that same story from the point of view of the consumer: almost five hundred recipes require pepper.[66]

3

The information that comes down to us concerning elaborate banquets, fine wines, and (literally) far-fetched delicacies is never in itself pure reportage. Indeed, culinary productivity on a grand scale, like other forms of conspicuous consumption, lends itself to starkly opposed discourses when a culture describes itself: it can be seen as evidence of creativity, generosity, and progress beyond the primitive condition of mankind, or it can be seen as exploitation, inequality, and wretched excess. We can observe these oppositions sometimes in a single paragraph of Pliny's *Natural History*; alternatively, we can scrutinize the public utterances of our own present moment, which devote seemingly equal time to the celebration of lavish lifestyles and to the pressing claims of ecology and egalitarianism. As far as our portrait of the Romans is concerned, however, the most eloquent informants about eating and drinking range themselves almost entirely on one side of the question. It is the Latin satirists who tell us more than anyone else about the culture of consumption in Rome, and very little of it is complimentary.

The Latin tradition of satirical writing traces itself back to the second-century BCE figure of Lucilius—a filiation declared explicitly by Horace, who both honors and distinguishes himself from the earlier poet—and already in the fragments we possess of Lucilius's work we can see that food is a central matter of satire.[67] Lucilius was, we learn, a scourge of ostentation, aiming his barbs at one Gallonius, who, he claims, dined extravagantly on supersize sturgeons but did not actually eat well, which Lucilius defines as consuming food "well cooked and well seasoned" and enjoyed along with pleasant conversation (200–207).[68] He is also on the prowl for gluttons, who guzzle bacon fat (69), and he names a pair of notoriously overeating guests with a string of epithets (*gumiae evetulae improbae ineptae* [1028–1029]). On the other hand, he is furious when served substandard fare, such as "endive that is spread out before the feet of horses" (218). He is indeed himself a generous host—he begins one menu with tuna belly and sea-bream cheeks—and when it comes to a sumptuary law that limited certain food quantities, he says, "Let's avoid it" (599). He is rather an expert on food, in fact: a savvy shopper of figs and connoisseur of the right places in the Tiber for fish and the wrong places for oysters. Food, in fact, provides him with material for metaphor: parasites are "cibicidae," or munch-murderers (760); sudden changes in emotion are like an overturned wine carafe (132); persons who value you only for your wealth are like those who buy poultry for the showy tail rather than for the rich flavor of the meat (761–762).

Roman satire, then, begins with a rich culinary vocabulary applied both to food and to life in general—especially life in society. The fragmentary condition of Lucilius's oeuvre renders it impossible to construct a full narrative about eating and drinking in early Rome, but if we move a couple of centuries into the future, and from poetry to prose, we can locate a kind of primal scene for the conjunction of food and social criticism. Indeed, it will remain a primal scene for a couple of millennia and stands as one of the most famous banquets in all of literature. In Petronius's *Satyricon*, Trimalchio is an extreme parvenu with fantastic wealth and terrible taste.[69] He swings between fits of anger (though a freed slave himself, he is often cruel to those who wait on him) and eruptions of sentimentality. The meal he serves is grotesquely excessive, a mix of expensive products (e.g., acorn-fed wild boar, mushroom spores from India, 150-year-old wine) and elaborate concoctions that overturn the nature of things, like a fish made out of a sow's womb, or—yet more disturbing—that slightly skew the nature of things, like fish "swimming" in sauce. Even more contemptible than the menu is his conversation, a mix of cultural ambition and hilarious misinformation; in a scurrilous parody of the sympotic discourse that surrounded Socrates, Petronius has Trimalchio talk extensively about his bowel movements—which is, and is not, a culinary subject.

Petronius lays it on with a trowel: Roman society, as he presents it, is plagued with a tribe of nouveaux riches, freed slaves who contaminate genteel civility. The instrument of their assault on the refinements of traditional culture is the ostentatious dinner party, and the only thing that proper citizens of the old guard—persons with taste rather than wealth, who include the writer and his friends—can do is to hightail it out of there, having stayed long enough to gather material for ridicule and to collect a free meal. Two other dinner parties, both in verse, one earlier and one later than

Petronius, will offer a more finely etched portrait of Roman culture at the scene of eating and drinking.

Both Horace's final satire (2.8), which chronicles a grotesquely pretentious mealtime not unlike Trimalchio's, and Juvenal's fifth satire, which previews a banquet where radically different treatment will be accorded different classes of diner, offer acutely observed renderings of Roman public life, at their respective historical moments; and both have been read, properly, as social documents. Here, however, we are going to read them for the food.[70]

The dinner party hosted by Nasidienus in Horace's Satire 2.8 is narrated by the poet's like-minded friend Fundanius (we'll get back to this matter of multiple voices and secondhand narrations), and the poet wastes little time in asking what was served. The answer—and it is quite startling—is "In primis, Lucanus aper" (First of all, Lucanian boar). Among the satirists, as it happens, wild boar is the very emblem of conspicuous consumption. Martial (9.14) derides someone whose friendship can be bought by regularly serving him boar, mullet, sow's udder, and oysters (all Roman classics of *haute gourmandise*); and elsewhere, Martial's complaint against a meal at which *only* wild boar was served takes the form of cataloguing all the simple local dishes— late-harvest grapes, honey-sweet apples, olives from a particular rustic producer, in short everything a real foodie would cherish—that were *not* being served (1.43). But it's not only the choice of this menu item; it's the placement. That "in primis," with which Fundanius responds to the poet's question about the opening of the meal, adds up to a big joke on Nasidienus. The idea of wild boar, normally the pièce de résistance at the climax of a feast, as an appetizer sets us off in a particular direction of misguided grandiosity. Nasidienus, it turns out, wasn't alone in this folly; Pliny will, in fact, quite specifically rail against this practice. Once upon a time (again, we encounter Pliny's master narrative), wild boar was served sparingly, then later whole wild boars were trotted out, after that it became the fashion to deliver two or three wild boars at a single feast, and finally the parting shot: they are now being served not as part of the main dinner but—horrors!—*as a first course* (8.78)!

In fact, the Nasidienus menu goes one step past this particular cliché. The authorial speaker opens the satire by posing a question that turns out to be a loaded one: "Da, si grave non est, / quae prima iratum ventrem pacaverit esca" (Tell me, if you don't mind, what was the first dish to appease an angry appetite). It is a setup for every Roman's expectation of the *gustatio*, or appetizer phase of a banquet. Then, as now, this phase of the meal tended to be devoted to salty tidbits like olives, oysters, or preserved vegetables.[71] The joke is that wild boar would cloy rather than stimulate the appetite. But we have to read for the food rather carefully in this case. The garnish of the Lucanian beast, we're told, is

> Pungent turnips, lettuces, radishes—such things as whet a jaded appetite—skirret, fish-pickle, and Coan lees. (8.7–9)

Score a point for Nasidienus. Or perhaps half a point: he knows something about the appetite-provoking purpose of the tangy *gustatio* menu but imagines that surrounding a wild boar with a few pickles will turn that heavy beast into an appetite provoker.

And this sense of getting things not quite right, though meaning well, characterizes much of Nasidienus's banquet. He is generous with wine, and he knows the right labels, but he fails to display a Plinian understanding of difference, pouring both Caecuban *and* Chian, and in case that's not enough, offering to pop the cork on Alban and Falernian as well. He makes a fuss about the conditions under which the apples were picked but exhibits no awareness of what difference that makes. An extravagance of divergent proteins—*avis, conchylia, piscis*—gets served but so elaborately prepared that Fundanius fails to recognize what they are and needs to be informed by Nasidienus's monologue about them.

This monologue becomes the chief indictment of the pretentious host. It isn't just that everything involves excess and hybridity: too many things being served, along with things that don't belong together or that are hybridized out of any resemblance to themselves. It is the perpetual accompaniment of the host's descriptives:

> "This [lamprey]," said he, "was caught before spawning; if taken later, its flesh would have been poorer. The ingredients of the sauce are these: oil from Venafrum of the first pressing, roe from the juices of the Spanish mackerel, wine five years old, but produced this side of the sea, poured in while it's on the boil—after boiling, Chian suits better than anything else—white pepper, and vinegar made from the fermenting of Lesbian vintage. I was the first to point out that one should boil in the sauce green rockets and bitter elecampane." (8.43–50)

The overt message is clear and, transhistorically, quite familiar from one's own dining experience: it's not so much, or not only, the extravagant preparation of dishes that is the object of ridicule as the endlessly intricate discourse about them. It is poetic justice that the immediate aftermath of this speech is a catastrophe in which the table canopy collapses on top of the platter that has been shown to exhibit such infinite culinary care. And, also fittingly, the diction shifts into a mode of mock-heroic grandeur, when, in response to this calamity, Nasidienus's toadies turn either philosophical ("Fortune, what god is more cruel") or psychological ("To think that . . . you are racked and tortured with every anxiety").

Horace's severest attack on the pretentious gourmet, then, has to do with his language, a point that is later made even more explicit: "We saw blackbirds served with the breast burnt, and pigeons without the rumps—real dainties, did not our host unfold their laws and properties" (8.90–94). Serve the poultry, in other words, and hold the Lucretius. Horace, after all, is not a chef but a poet; and what this line of attack suggests to us is a particular relationship—indeed, a rather tense relationship—between the art of cuisine and the art of language. There are many strands to this relationship. We have already observed the persistent presence of cooking, tasting, and eating metaphors as applied to text, and we might add the particular case of *satura*, which seems to define satire itself as some kind of stuffed sausage.[72] But for a fuller sense of the relation between gastronomy and language, we must turn to yet another of the great banquet poems in Latin satire.

If, in the case of both Nasidienus and Trimalchio, the menu lay at the heart of the satirical project, we can multiply this phenomenon when there are *two* menus. In Juvenal's time, a century or more after Horace, rich and powerful individuals continued to extend their sway among circles of dependents, clients, hangers-on, and *amici* (and the notion of friendship here cries out to be treated ironically) via the staging of grand banquets, but the lesser invitees, though seated in the company of the great, didn't get the same menu. Or, to put the matter another way, the rhetoric surrounding the idea of equality among dinner guests promulgated by the emperors had become ever more transparent and in need of critique. For Roman social critics in the first or second century CE, this circumstance is almost too good to be true. The pretensions of the rich and powerful have been ground zero within the satirical genre for a couple hundred years; and banqueting has been the primal scene where those behaviors play themselves out. Pliny the Younger records the conversation he had with a fellow wrong-end-of-the-table diner at the home of a grandee, and he uses the occasion for a didactic point about his own more democratic practice. At Pliny's house, it seems, *everyone* eats and drinks at the bottom of the food chain, so the occasion manages to be at the same time more democratic and more economical for the host.[73] Martial, for his part (3.60), composes an epigram in which he complains to his host that, since he is no longer taking part in the ritual gift exchange, or *sportula*, he is being fed a sequence of far less tasty dishes than those served to the host himself; and he enumerates these differences in appetizing (or *un*appetizing) detail.

In his Satire 5, Juvenal builds an entire conceit around this difference.[74] A certain Trebius, an individual of no particular importance, has been invited to the dinner table of the rich, powerful, and (it turns out) repugnant Virro. Trebius has asked the poet's advice about this upcoming event—presumably whether to accept the invitation or not—and the result is a brilliant screed against the kind of exploitative client relation in which Trebius is finding himself. The social critique itself occupies the beginning and end of the poem: Trebius should not be so desperate as to pay for his food with humiliation; he should not imagine that there is any genuine friendship involved in this invitation; he should understand that, so far from any form of hospitality, this invitation is expressly designed as humiliation; and if he goes on like this, he'll end up with his head shaved like a slave.

The bulk of the poem, however, is not social critique (not *direct* social critique, at any rate) but menus: what Virro himself eats versus what Trebius will be served. Virro's wine comes from grapes pressed during the Social War—in other words, a century and a half earlier—not only rendering his beverage ancient (absurdly so) but also placing it in the context of the noble origins of Rome's dominance on the Italic Peninsula; in fact, it was bottled so long ago that the consuls still had long hair. It is served in a cup decorated with gems that might have adorned Aeneas's scabbard but are now put to degraded service in the banquet hall. Trebius, on the other hand, is given wine that gets associated with the grease from newly shorn sheep, and it's poured into a cracked vessel that bore the nickname of a notorious informer under the emperor Nero on account of its pointy spouts, said to resemble the informer's nose. (Disturbing associations: the wrong kind of connection between wine and nose.) Virro's lobster

is presented as a triumphator; Trebius has to suffer with a crab that belongs in a banquet of the dead. Virro, like Nasidienus before him, selects olive oil from Venafrum, whereas the gunk poured over Trebius's greens smells suspiciously like lamp oil.

Virro's dinner is insistently (if ironically) denominated along the lines of ancient history and Homeric mythology: his water is served by a boy who cost more than the entire fortune of the early Roman kings; his lamprey was snatched from the space between Scylla and Charybdis; his wild boar is worthy of Meleager; his dessert consists of an apple that could have come from Alcinous' orchard in the *Odyssey* or from the Hesperides of Herculean fame. What gets served to Trebius, on the other hand, seems always to be associated with Rome's worst neighborhoods: his lukewarm water is handed to him by a dark lad of the type one might meet late at night by the tombs on the Via Latina; his fish course is something blotchy from the Tiber spawned in the sewers of the Suburra; and the rotten apple with which his dinner concludes resembles the kind that gets chewed by performing monkeys plying their craft in the raffish street life along the embankment by the Colline Gate.

It is particularly apparent in this structure—and we have seen this phenomenon before—that food offers Juvenal the opportunity to communicate with his readers via a medium of extraordinary semantic density. Romans, in other words, can be made to understand cultural implications with remarkable force if the tropes of description are culinary. But we have gone beyond the point where Horace's Nasidienus does too much gastronomic name-dropping or where the reader is expected to chuckle at the vulgarity of offering four kinds of wine in the same meal. Most of Juvenal's menu alternatives—both the good ones and the bad ones—are impossible, even preposterous. We are, in short, no longer in any kind of real kitchen. We are not in the hands of the chef anymore; we are in the hands of the poet.

After all, unlike those of Trimalchio or Nasidienus, this banquet is not represented as having actually taken place. Not only are Trebius and Virro fictions, but even within the fiction this repugnant mealtime is staged in the future hypothetical. Juvenal is being not a describer but rather an inventor. Therefore, all this deployment of semantic density and differential definition emerges as a celebration of his skills as chef-in-words. In fact Juvenal's predecessor and model, Persius, had begun his book of satires with "Who equipped the parrot with his 'Hello' and taught the magpie to attempt human speech? It was that master of expertise, that bestower of talent, the belly."[75] That acknowledgment and gesture of filiation emerges here in the dinner chez Virro, whose twin menus represent this poet's expression of gratitude to his belly muse and to a culture like his, where eating and drinking have assumed such a powerful ability to signify. To invent a banquet—especially a grotesquely elaborate banquet—is to perform a particular exercise of poetic creation.

Which—to return from Juvenal to Horace—helps explain the insistent presence of the culinary subject throughout the second book of satires, well before we have attended Nasidienus's banquet. It seems that for Horace, in book 2, food has something to do with voice. There are a great many speakers in this book, and all of them move in and out of speaking for Horace. The book begins, after all, with a renunciation of the poet's voice. His first book of satires satisfied no one, he tells us, though for contradictory reasons; now he asks advice of his friend Trebatius, whose first response is:

"Quiescas"—give it a rest. Judging from the existence of the text in front of us, Horace has refused to take this advice, but the whole of the first satire in book 2 is devoted to the near impossibility of finding the right satirical voice: honest, meaningful, safe from danger. When he finds it, at least provisionally, in the second satire, it turns out to be that of a rustic philosopher, Ofellus, who talks almost exclusively about—guess what?—food. The simple life, we learn, is best embodied in distinguishing between proper and improper menus. No to peacock, giant sturgeons, and a bill of fare that intermingles boiled with roasted or shellfish with poultry; yes to eggs, olives, greens, and a chunk of ham; no mead or wine unless (is this a contradiction?) it's of the very best quality.

Is Ofellus really Horace? Are these prescriptions and proscriptions not just culinary but also poetic? The perplexities only deepen in Satire 2.4, when Horace summons up the voice of another culinary pundit, a certain Catius, whose advice is far more specific than that of Ofellus and far more gastronomically sophisticated. This is another of those occasions when reading for the food is instructive. Many accounts of this poem have taken it for granted that anyone who can orate for eighty lines about prawns and snails as a hangover cure, about recipes for the "compound sauce" and about the best places to find mushrooms, mulberries, and mollusks, is some kind of mock-heroic fool;[76] and the fact that Catius introduces all this as though he is the mouthpiece of an unnamable oracle helps confirm such an impression. (The *Symposium* parallels are particularly intricate and striking here.) Yet there is almost nothing in these lines that would contradict either first- or twenty-first-century gastronomy: rainwater produces better vegetables than irrigation; different species of fish need to be cooked differently, and expensive ones are not necessarily the best; pigs fed on acorns are the tastiest; grand wines are better when not filtered; the best-looking apples are not always the best-tasting; the healthiest way to end a meal is with simple fruit. And, further, when you think about most of these, it becomes clear that they bear as much authority in the ethical or poetic realm as in the gastronomic.

Among the various (allegedly) non-authorial voices that are summoned in the second book of Satires, there is one with whom Horace gets into a particularly fierce fight. "I have been listening for some time," says the interlocutor at the very opening of the poem, "and wishing to say a word to you, but as a slave I dare not" (2.7.1). It is none other than Horace's own slave, Davus, who has apparently been listening to a recitation of the previous six satires, and now he has a few challenges to mount. He turns out to be the perfect Stoic philosopher: "Who then is free? The wise man, who is lord over himself" (2.7.83). Horace is no such man, it appears, and Davus throws in his face a set of inconsistencies within his master's behavior. In this oration, worthy of a Cicero when he is attacking an enemy, Davus deploys the disparity in the way his own vices are punished, as over against Horace's, as his own weapon of correction.

Some of the vituperation is about sex, and some of it is about art appreciation. But the most pointed accusations are about eating. According to Davus, Horace claims to enjoy munching on herbs in his rural kitchen, but when he is there, he longs for the luxuries of the town, and vice versa. When left alone to dine, he extols the solitary life, but if there is an impromptu dinner invitation from Maecenas, he drops everything and screams at all the slaves to help him get ready quickly. Davus ventriloquizes yet

another auxiliary, the parasite Mulvius, who is quoted as saying, "'Tis true that I'm a fickle creature, led by my stomach. I curl up my nose for a savoury smell. . . . But you, since you are just the same and maybe worse, would you presume to assail me?" (2.7.38–42). Davus makes the same point in his own voice: "If I'm tempted by a smoking pasty, I'm a good-for-naught; but *you*—does your heroic virtue and spirit defy rich suppers? Why is it more ruinous for me to obey the stomach's call? . . . Is the slave guilty, who at fall of night swaps for grapes the flesh-brush he has stolen? Is there nothing of the slave about one who sells his estates at his belly's bidding?" (2.7.102–11). The format is Saturnalia, turning the class structure upside down, but the literary shape is the classic one in which the object most deserving of satire is the satirist himself. Horace is the real slave; Horace is the real glutton. Dining with Maecenas is double slavery: to food and to power. It's no coincidence that the one remaining satire—and the book seems to have been deliberately broken off after eight poems, rather than the ten of the first book—is a dinner at which Maecenas was present, Horace was not invited, and the menu, courtesy of Nasidienus, was grotesquely overwrought.

If the voices of some of Horace's speakers—Ofellus, Catius, Davus, each in his own way—can turn gastronomy into a discourse of good living, there is a particular lyric genre that moves in precisely that direction, using, once again, the medium of dinner. But it is quite a different sort of occasion. Over a couple of centuries, and probably with Hellenistic origins, there develops a remarkably consistent genre, usually in poetry but sometimes in prose, of the literary invitation to dinner.[77] These invitations perform so precisely as the antithesis of the overwrought banquet text that one must assume a self-conscious relation between the two genres. The paradigmatic banquet text pits the vulgar host against the gentleman of taste, who signifies his superiority by turning up his nose at the culinary excess on offer; the literary invitation, by contrast, promises simple fare and, at least potentially, happily secures the company of the addressee for the evening.

The tone of these invitations is invariably nonchalant. Martial, for instance, tells one invitee to come only "if the thought of a gloomy dinner at home" (5.78) depresses him, and to another he says, "if you have no better engagement, come along" (11.52). Virtually all of them ostentatiously display the lowliness of the menu. Petronius offers a chicken and eggs but cautions that this year's weather has ruined everything (*Satyricon* 46). Martial begins one invitation with cheap lettuce and smelly leeks (5.78) and another with "mallows to relieve the stomach" that were brought to him by his bailiff's wife, though his list of courses goes on to fancier fare, including in one case even the dreaded sow's udder, which we have already observed as a cliché of haute cuisine (10.48) despised by right-thinking persons as a cruel overindulgence. Catullus tops them all by telling his friend that he'll have a good dinner only if he brings the food himself (*Carmina* 13).[78] Quite often the humble menu stands not only as a particular set of culinary choices but also as an indicator that there are more important things than food dished up at a proper dinner among real friends. Catullus's friend will have "love's very essence"; Martial promises "merriment free of malice, frank speech that gives no anxiety the morning after, nothing you would wish you hadn't said" (10.48); and Pliny the Younger, writing to a friend who stood him up for dinner,

speaks of the "fun, laughter, and learning" that would have been enjoyed, if only he hadn't decamped for a fancier offer (*Epistles*, 1.15).

The claim in all of this—and it should be almost agonizingly familiar by now—is that the food is not important, and therefore it doesn't have to be fancy. What is important is true friendship and honest conversation, and such values are best embodied, culinarily speaking, in eggs, cheese, olives, and the other constituents of a simple menu. The paradox, also familiar, is that many of these texts cite menu items in rich detail: the simple ones that are being served, the fancy ones that are *not* being served, and in the case of Pliny the Younger, those offered at the competing dinner ("you chose to go where you could have oysters, sow's innards, sea-urchins, and Spanish dancing-girls" 1.15), on account of which his friend had not shown up. We are in a familiar place here, perhaps best typified by Juvenal's dinner with Virro: food may be rejected as the *summum bonum* in the good society (and woe betide the Nasidienuses who think otherwise), but it is essential for its semantic value in depicting that society.[79]

When Horace writes in this vein, however, it's all about the wine. In *Epistles* 1.5, he makes passing reference to a humble salad but nails down quite specifically the age and *cru* of the wine, and he goes on to extol the benefits of a beverage that "unlocks secrets, bids hopes be fulfilled, thrusts the coward into the field, takes the load from anxious hearts, teaches new arts" (18) and makes all drinkers eloquent. In the *Odes*, he is quite capable of citing many of the very same *grand cru* names that Nasidienus oversold—"ardent Falernian," "old Massic," "Alban wine upwards of nine years old," "Caecuban wines guarded with a hundred keys"(2.14.25)[80]—as emblems of permissible pleasure precisely because they are being enjoyed under the proper conditions of intimate congeniality. For even truer congeniality, however, in this case when the poet makes his own invitation to Maecenas, the rhetoric moves in a quite opposite direction:

> *Vile potabis modicis Sabinum*
> *cantharis, Graeca quod ego ipse testa*
> *conditum levi, datus in theatro*
> *cum tibi plausus,*
> *clare Maecenas eques, ut paterni*
> *fluminis ripae simul et iocosa*
> *redderet laudes tibi Vaticani*
> *montis imago.*
> *Caecubum et prelo domitam Caleno*
> *tu bibes uvam: mea nec Falernae*
> *temperant vites neque Formiani*
> *pocula colles.*

You will drink from modest cups a cheap Sabine wine that I stored away in a Greek jar and sealed with my own hand on the day when you, Maecenas, illustrious knight, were given such applause in the theatre that the banks of your fathers' river, yes, and the playful echo from the Vatican

Hill, repeated your praises. At home you can drink Caecuban and the grape that is crushed in the presses of Cales; my cups are not mellowed by the vines of Falernum or Formian hillsides. (*Odes* 1.20)

In Horace's formulation, this simple tipple is rechristened, not on the basis of its vintage year or its celebrated site of origin; rather its biography stretches from the date of Maecenas's triumph, at which moment the poet put it in cask, to the place where it is being drunk, namely Horace's own hearth. Its pedigree, in other words, consists of the people who are drinking it.

Wine then turns out to be a more flexible signifier than cheese, chickens, or olives. In the usual formula, food (especially fancy food) stands in opposition to good conversation; but wine, whether fancy or not, facilitates good conversation. And all those qualities that we nowadays extol as terroir, vintage, and vinification make wine into the symbol of a unique bond uniting the host, the guest, and the land.

For Horace, as it happens, these positive qualities are not limited to the scene of the dinner party, as witness two of his most famous lyrics. It is not often recollected that Horace's *carpe diem* comes with another injunction that is precisely parallel. In the context of reminding Leuconoe that we don't know what the future will bring, before he tells her to seize the day, he says:

Sapias: vina liques. (*Odes* 1.11)

It's not as easy to translate as *carpe diem*. The opening term of this injunction, which is something like "be smart," also contains the word for *taste*, in a double meaning that we have witnessed before. And the second part, explicitly parallel to *carpe diem*, refers to the process of racking, or straining, the wine in preparation for drinking it. Anyone who lives with the production and consumption of fermented grape juice knows that it is some combination of a battle and a love affair with time. To urge "vina liques" in the context of this poem's message is a much more specific, more daring, admonition than *carpe diem*. The wine might get better if you didn't strain it for drinking today; but the future's uncertain. And a wine drunk before its time, *pace* Orson Welles,[81] is better than no wine at all. Horace has placed *vina liques* and *carpe diem* in parallel. Though we and Hollywood have separated them, it turns out that both are a matter of time.

Which takes us to one final Horatian catch phrase. In his ode celebrating Rome's victory at Actium and the suicide of Cleopatra (*Odes*, 1.37), the story turns out, once again, to be all about wine. The mad queen was drunk with Mareotica, a famous *cru* from her native Egypt. Now that her body has imbibed the dark venom of the asp it is finally permissible for us Romans to break out those bottles of Caecuban that were being stored in our forefathers' cellars in anticipation of a worthy occasion. The period of terror is over, and, as the poem opens by declaring, *nunc est bibendum*—now there must be drinking. Despite the possible excesses of consumption personified by Nasidienus and his ilk, the fitting response to life's extremes—whether the recognition of inevitable death or the triumphant celebration of Roman supremacy—is to pop the cork.

2.28. Mosaic with skeleton, from the House of Polybius, VI.17.19, Pompeii. Museo Archeologico Nazionale, Naples

4

Not that eating and drinking succeed as an antidote to death; in fact, within the Roman cultural imagination they are often closely associated. The Emperor Domitian, as reported by Cassius Dio in gory detail,[82] staged a death banquet in which the guests were treated as though they were already in the afterlife (to which, of course, Domitian could easily dispatch them at any moment, as the terrified diners well knew). Everything was painted black, including the serving boys; the place cards were gravestones; and the guests were kept silent while "the emperor himself conversed only upon topics relating to death and slaughter." The conjunction of eating and dying could take a more benign form on the domestic front: one Pompeii dining room was decorated by a mosaic figure obligingly offering a pair of wine jugs to the thirsty diners; the butler in this case is a skeleton (fig. 2.28).[83]

The precise transaction between those first-century dinner guests and the combination of bountifulness and memento mori represented by the skeleton mosaic cannot be mapped. But we do have a quite different conjunction of banqueting and death, albeit fictional, whose terms are laid out richly by their author. In the last exhausted stages of his feast, after the tour de force of a goose made out of a pig, Trimalchio becomes sentimental.[84] First he goes all sloppy about slaves being human beings just like us and invites them to sit at the table, to the consternation of his genteel guests; and then his mind turns to his own death. The stonemason Habbinas has recently arrived at the party—appearing tipsy and stuffed, he offers a long speech detailing the wildly overwrought menu at the competing banquet he has just left—and that

becomes the perfect circumstance for Trimalchio to turn from dining to tomb design, as though the end of the banquet were itself a kind of death. He wants the tomb to be one hundred feet wide and two hundred deep; he wants fruits, flowers, and ships, a statue of his dog, his wife holding a dove, and another dog; in the center, where his name is etched, he orders a sundial. For Trimalchio this is a matter of personal advertising: it's a device to force people to read his name whenever they want to find out what time it is. For us readers, however, that sundial is a *memento mori*, like the whole feast itself.

Elaborate tomb instructions of this kind were indeed carried out in imperial Rome, and one of the most notable, though it may not have been conceived in the middle of a banquet, nevertheless stands in all its magnificence as a monument to food. The memorial of Marcus Vergilius Eurysaces, generally known as the Baker's Tomb (fig. 2.29), was erected a century or so earlier than the composition of the *Satyricon*.[85] Though it does not possess a hundred-foot frontage, like Trimalchio's, it nevertheless was designed to occupy a very prominent piece of real estate, at the corner of the Via Praenestina and the Via Labicana.

The association with Trimalchio aside, we do not know for certain what kind of citizen—free, freed, or foreign—Eurysaces was; for our purposes, what is significant is the fact that such a prominent and original memorial was erected by a baker and—more important—with the clear intention of advertising that his wealth and position derived from the culinary trades. Returning to the Trimalchio link, we might say that the two men shared a desire that their monuments be of gigantic size, highly visible, and heavily engaged in some kind of personal memorialization. These matters, it should be pointed out, are a topos in imperial Roman culture, both as a literary idea (for the purposes of ridicule or condemnation) and as an actual practice.[86] The notion of the tomb that exaggerated postmortem the accomplishments of the occupant during his lifetime is to be found everywhere, both in texts and in the actual practice of funereal memorialization. Indeed, so far as social inflation is concerned, it is very much a cognate to the topos of the exaggerated dinner party, and I have no doubt that Petronius is thinking of this parallel, bringing the matter of the overwrought tomb into the later stages of his overwrought banquet, whose ending will be explicitly represented as a kind of death.

Trimalchio wants to demonstrate his social rise and his wealth; what he *doesn't* do, however, is immortalize the sources of his wealth on his prospective monument. But many did, though more often in the inscription than in the imagery. And Eurysaces gives us something like "all of the above": upward mobility, ostentation as regards affluence, and—the rarest of these attributes—a very explicit account of how the occupant of the tomb made all his money.

All of which relates to the questions about food culture and high culture that are the subject of the present volume. No question where Eurysaces's profession fits on the social scale: we have Cicero's word in *De officiis*, "Least respectable of all are those trades which cater to sensual pleasures: fishmongers, butchers, cooks, and poulterers, and fishermen," a list that he himself references out of a particularly colloquial scene in Terence's *Eunuch*.[87] Following some of the persuasive recent scholarship on Roman monuments in general,[88] we can see a monument like this as a large-scale rhetorical

enterprise, carefully designed to send messages in perpetuity to a large public viewership. In the case of Eurysaces, the most general of these messages is conveyed by the obvious size and expense of the tomb and by its placement where those entering the city couldn't miss it: these are impressions that would be lost on no one.

For the literate viewer, there is then the inscription (fig. 2.30): EST HOC MONU-MENTUM MARCEI VIRGILEI EURYSACES PISTORIS REDEMPTORIS APPA-RET. (This is the monument of Marcus Vergilius Eurysaces, Baker, Contractor, Public Servant.) Philologists have pointed out that "Est hoc monumentum" is a virtually unique formula among surviving tombs; what we should especially notice about it, I think, is that it ends up calling attention to the monument rather than moving directly toward contemplation of the memorialized individual, as is more often the case. A similar effect may be read in the word *apparet*, which might lead to a translation of the whole thing as "this is the monument . . . *as is obvious*." It is possible, to be sure, that *apparet* is a misspelled version of *apparitor*, or public servant, which, along with *redemptor* (contractor), makes a quite direct claim that loftier enterprises than bread making were involved in the life of the decedent—in other words, that he was a contractor for something like large-scale distribution of baked goods. But, whether that was the case or not, the combination of the word order and the reading of *apparet*

as a verb point toward a quite explicit attempt at inspiring the viewer to notice that the tomb itself was seeking to make baking into something monumental.

The nonliterate observer won't have puzzled over "Est hoc monumentum" and "apparet" but will turn to the long frieze just below the cornice (fig. 2.31), where anyone curious as to the identity of a man rich enough to build this monument could follow the step-by-step process of bread making, from the milling of grain to the mixing of the dough, to the insertion of loaves on a paddle in the oven, to the collecting and weighing of the finished product.[89] A toga-wearing figure oversees the last stages of the enterprise, reminding the viewer that this is a rigorously honest operation and that it is not one of those vulgar pleasure-related trades enumerated by Cicero but rather an undertaking integral to the orderly system of public government in Rome, based on a most fundamental article of sustenance. But this effect doesn't just depend on one half-length figure in the long sequential strip: the visual narrative as a whole imitates the sort of heroic depiction of significant imperial achievements that was starting to appear on triumphal arches. It's not too much to say, then, that the Baker's Tomb is Eurysaces's *res gestae* and the foodie's Ara Pacis.[90]

But neither the inscription nor the frieze takes up most of the space on the tomb, nor is either of them instantly readable from the street level, where those major thoroughfares intersected and brought a large cross section of inhabitants to potential contemplation of the monument. What would most immediately strike any passerby—and would require neither literacy nor minute powers of narrative decoding—is the groups of more or less identical circular holes in the upper stories (fig. 2.32), plus vertical cylindrical shapes intermixed with similar, but oblong, supporting structures in the lower story. These wholly noncanonical, indeed strikingly unique, features of the Baker's Tomb are almost certainly meant to represent kneading machines, very similar

2.31. Frieze of bread making, Baker's Tomb, detail of fig. 2.29

2.32. Circular openings and vertical columns, Baker's Tomb, detail of fig. 2.29

to those that we know from excavations in Ostia and Pompeii.[91] As such, they perform a kind of stylistic counterpoint: if the inscription and the frieze represent Eurysaces's (or his agents') attempt to emulate high-style heroic representation, the big holes would seem to bring the monument back to the level of the tomb's occupant. It has indeed been persuasively argued that they weren't merely representations but spaces inside which the actual wooden and metal equipment of real kneading machines would have been memorially housed, and it's clear when you look inside that there is an indentation that would have housed a mechanism and left behind some residual rust stains. If that's the case, then these were in a quite literal sense *spolia* from the real-life trade of the baker, which would make them heroic and gastronomic at the same time.

But whether these were real kneading machines or merely intended to invoke the viewer's consciousness of such mechanisms, it's clear that the largest part of the whole decoration is a response from the culinary trades to all the high-style implications that come with monumental tomb design. And the gesture across differing levels of labor in the society turns out to be even more decisive. The vertical cylinders in the tomb's lower story—also highly prominent in any viewer's experience—have proven on closer inspection to consist of the same sort of kneading machine shapes stacked vertically. Given that this is the historical moment when grand tombs are beginning to include monumental columns, we may well be witnessing a kind of aspiration for colossal scale (or a mock-heroic joke on such aspirations), here reinterpreted via the tools of the baker's trade. It's the invitation to an act of recognition—not unlike those that take place in the response to the satires, but more widely available—that would give this monument its real communicative power for the man and woman in the street, who might find much more to recognize here than they did in the Ara Pacis—monumentality canonized in a grand memorial but whose value depends on the production of the daily bread.

One concluding link in Roman culture between food and death. Among Trimalchio's detailed instructions to Habbinas is the request that he "make a representation of a dining-room set of couches" (*Faciantur, si tibi videtur, et triclinia* [*Satyricon* 71]). Fantastical as some of Trimalchio's mortuary wishes may appear, this one turns out to be utterly canonical. The association between the tomb and the banquet has a provenance going back well beyond Trimalchio's time, and it appears in a variety of ways, beginning in fifth-century BCE Athens, spreading through the Hellenistic world as perhaps the most frequent of all funerary subjects, until it is thoroughly entrenched in the Roman imperial period (fig. 2.33).[92] At the fringes of the empire, there are local variations, including the whole family or exotic divinities or simply an arrangement of foods.[93] In the classic Roman instance, where this motif has been given the name *Totenmahl*, the decedent appears on his own in a reclining posture, as though at a meal. What may be most interesting about this persistent representation is its fundamental ambiguity. What, in short, did observers think of as the connection between death and dinner?

The answer will take us back to Fritz Saxl and his "Continuity and Variation in the Meaning of Images," which we last considered in relation to the Pompeian dinner frescoes. Saxl argued that "images with a meaning peculiar to their own time and

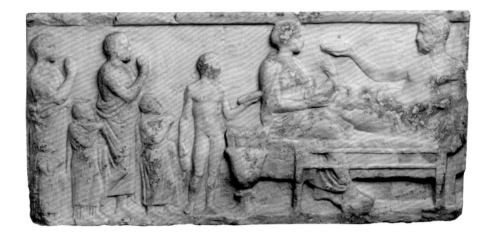

place, once created, have a magnetic power to attract other ideas into their sphere; that they can suddenly be forgotten and remembered again after centuries of oblivion." In the case of the *Totenmahl* (I employ that term to cover all these conjunctions of eating and burial, though archaeologists insist on restricting it to the Roman-style tomb figure), the issue isn't so much gaps of time as the differences among cultures. But the significant matter is that "magnetic power," which I take to be a living rather than a dead metaphor. In other words, a visual icon in which the consumption of food is fused with the burial of the dead possesses a kind of attraction that gathers to itself a wide variety of quite distinct, even contradictory cultural concerns.

To understand this, it may be best to approach the matter from the point of view of Saxl's "centuries of oblivion."[94] In 1626, when the foundations under Saint Peter's were being dug so as to install Bernini's amazing (and ponderous) *baldacchino*, an exceptionally well-preserved tomb was unearthed. Given that the basilica was supposed to be located on the original site of the apostle's grave, there was always a special sort of excitement about tomb discoveries there, along with considerable anxiety that the new construction activity might disturb what would be potentially the most sacred Roman relic of all. This set of remains did not belong to Saint Peter, however, but rather to a second-century Roman called Flavius Agricola (fig. 2.34), who is represented in the position of a noble citizen reclining at a banquet.[95]

If a memorialization in this posture wasn't bad enough for those seeking the relic of Saint Peter's body, their disappointment must have been further intensified by the inscription that accompanied the tomb. After identifying himself and his native town, Flavius Agricola extends pious wishes on behalf of his wife, who predeceased him, declares that he was never without plenty of wine, and finally, offers some advice:

> Friends, you who read this, I admonish you, drink wine, and drink deep,
> crowning your temples with flowers, and don't deny sex to beautiful girls.
> Whatever else is left after death, earth and fire consume.[96]

The culture war between pagan Epicureanism such as is represented in this inscription and the value systems of a Counter-Reformation papacy is certainly not

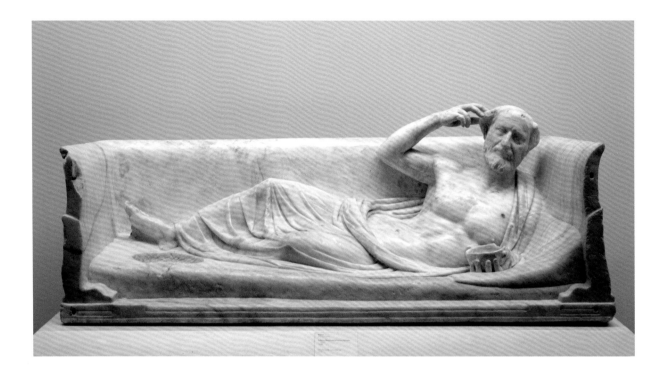

2.34. Funerary monument of Flavius Agricola, Rome, 138–93 CE. Indianapolis Museum of Art at Newfields

surprising. But the horror of discovering a celebration of drink and sex atop the shrine of Saint Peter is only the most extreme version of a set of cultural dissonances, or at least potential cultural dissonances, that is built into this form of funerary monument. However dissonant it might be in 1626, even within the cultures that produced it the conjunction of death and dining that is proclaimed in the *Totenmahl* is highly problematic. Not only are there many different ways to read it; more important, many different and even contradictory ideological understandings lie behind the choices that produce it.

In the case of Flavius Agricola, the inscription conveys a clear reading: *carpe diem*. I am picturing myself at a banquet so as to remind viewers that when they're dead there will be no more banqueting for them, just as there isn't now for me. More particularly—and the most revealing moment in the inscription may be "ego sum discumbens ut me videtis, / sic et aput superos annis"—he may be drawing some sort of connection between the position in which one dies and the position in which one dines. But there are many different pathways possible within ancient culture between the two points of this equation. For Flavius Agricola it was "gather ye rosebuds." For others, notably, the *Totenmahl* had nothing to do with this world; rather it was a picture of heavenly banqueting in the next world. For still others, it was (like many other tomb motifs) a representation of funerary practice among those mourning the dead, which included a ritual meal; indeed, some tombs contained actual dining rooms for this purpose, which appears to be what Trimalchio had in mind, since he is intensely focused on keeping his own memory alive. For yet others (and this partly covers Flavius Agricola as well), it carried no more sacred or moralizing purpose than to remind viewers that the deceased lived in gastronomic luxury, which we know from Roman satire *passim* was of immense social significance. Indeed, part of that emphasis

on his recumbency is doubtless due to Flavius Agricola's insistent social climbing.[97] He was by origin probably a freedman, and so the choice of portraying himself in this position (and emphasizing the *many years* in which he so positioned himself) constitutes an insistent claim that he had attained the lofty rank of those citizens who were permitted to dine in this posture.

Archaeologists and students of ancient monuments may wish to sort different versions of the *Totenmahl* along the lines of different underlying intentions. What interests us here, though, is to convey just how the entry of food into this form of ritual representation occasions a particularly labile set of conditions for the production of meaning. Even in 1626, this range of readings expresses itself. Upon hearing of the discovery, Pope Urban VIII ordered the inscription to be destroyed, and he proclaimed, "pene severissime e rigorosissima scomunica, ed orribilissime minacce del pontefice"[98] against anyone who revealed its contents. The philological humanists, on the other hand, reverently copied down the inscription (else we wouldn't have it). And the very same pope's nephew, Francesco Barberini, acquired the statue itself for his own garden, which hardly seems in keeping with his uncle's interdiction. If this suggests the errancy of a symbolic image as the seventeenth century looks back at the second century, it is equally the case that the cultural ambiguities that radiate out from the consumption of food show themselves within their own moments of time as well. After all, the most audacious element in this monument isn't the (now invisible) inscription, but the weird homology, or visual pun, that operates between the bowl of dinner that the decedent holds in his hand (fig. 2.35) and, directly across the way, the circular depression that would have held the container of his ashes. This final reading of Rome for the food is indeed about finality, though it is not the last time we will hear about death and dinner in the same breath.

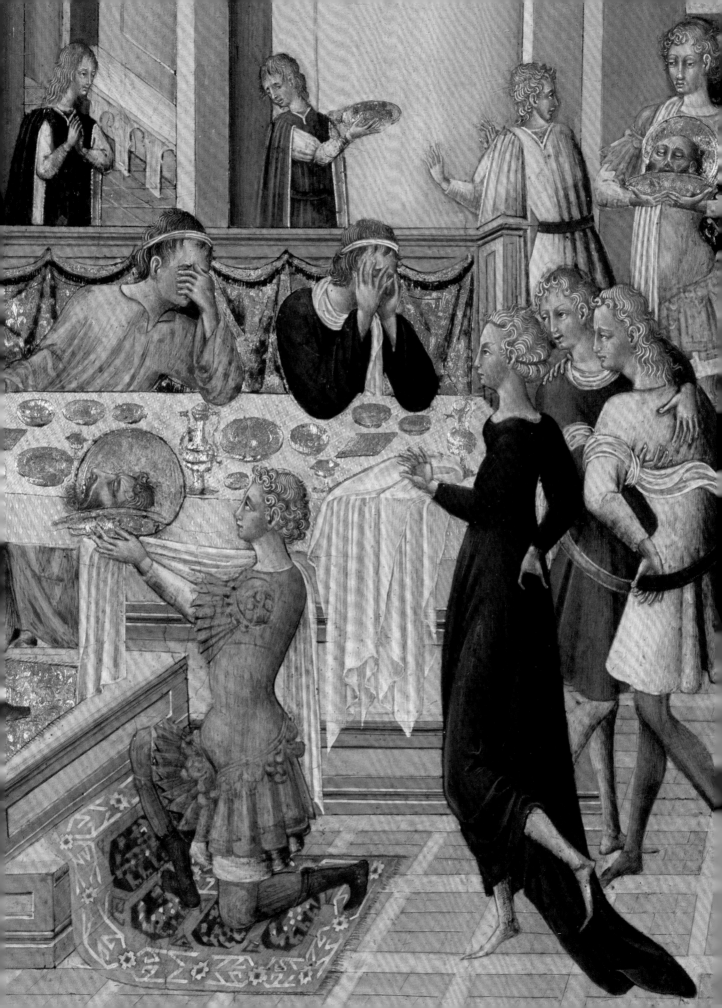

3

Fooding the Bible

1

The Presentation of the Virgin at the Temple is one of those sacred subjects that receives more attention in art than in scripture.[1] The New Testament is silent regarding Mary's childhood, but several apocryphal writings, including the Protoevangelium of James and the Infancy Gospel of Matthew, pad her scanty biographical background with a story in which Joachim and Anna, grateful for the fulfillment of their wish to have a child, deliver her to Jerusalem, where she will be brought up at the Temple in a manner befitting her messianic future.[2] Largely unknown as a pictorial subject before the fourteenth century, the Presentation of the Virgin takes on considerable popularity with the dawning of the Renaissance. Judging from the all but inevitable emphasis in these paintings upon the staircase that Mary is seen to be climbing, it appears that the source of the theme, and perhaps of its new popularity, was the *Golden Legend*, in which the fifteen steps leading to the temple are allegorized as "corresponding" to the fifteen Gradual Psalms.[3]

Though the subject receives masterly treatment from Giotto and Dürer, as well as from Baldassarre Peruzzi and Domenico Ghirlandaio, it appears to have had a particular flowering in and around Venice.[4] Among the examples of this theme, perhaps the most famous, and most extensively analyzed, is Titian's *Presentation of the Virgin at the Temple*, which can be seen today in precisely the location for which it was painted, now the Gallerie dell'Accademia but in the 1530s the Scuola Grande di Santa Maria della Carità, one of the city's several charitable foundations (fig. 3.1).

In its almost twenty-five-foot span, Titian's canvas includes every requisite of the narrative: a temple *all'antica*, a set of stairs approximating the canonical fifteen, the

3.1. Titian (Tiziano Vecellio), *Presentation of the Virgin at the Temple*, 1534–38. Gallerie dell'Accademia, Venice

Virgin as a little girl, and a high priest at the top offering a gesture of welcome. There is a great deal more than is requisite as well, including a procession of figures who may be identifiable from the textual narrative or from contemporary life in Venice or both, as well as a beggar woman, a pyramid, and a spectacular mountainous landscape. A consummately researched and reasoned article by the great Venetianist David Rosand provides immensely persuasive iconographic and stylistic readings of every element in the composition, both the necessary and the optional.[5]

We are visiting the painting here owing to one segment of the composition that, in my view, integrates itself less well—or, at any rate, differently—into the design. In the extreme foreground, alone and sharply outlined against the plain backdrop of the temple masonry, sits the massive figure of an old woman with a wicker basket (fig. 3.2). Her brilliantly white shawl is as luminous as anything in the whole work, its radiance replicated by the product peering over the top of the basket. She is evidently there to sell eggs.

There are, of course, no eggs in the canonical story, no more than there are obelisks or pyramids or mountains. We are, to be sure, used to such embellishments, and on the face of it there is nothing surprising that in a High Renaissance artistic milieu where artists and patrons delight in the fullness of ordinary life—often life as lived in their own time and place even when the subjects are ancient and sacred—foodstuffs should be among the materials that supplement the bare bones of biblical storytelling.[6] (Venice in particular excels at this sort of superfluity, as we'll see on other occasions.) It may even be considered perverse to focus one's analysis on a particle that amounts to something like 3 percent of the total surface area. But if those proportions seem too small for a revisionary reading of the picture, they seem rather large for a

3.2. Titian (Tiziano Vecellio), *Presentation of the Virgin at the Temple,* egg seller, detail of fig. 3.1

supernumerary item in the representation of a sacred moment in Christendom, the more so because the placement of the egg-selling old lady makes her appear by far the closest thing to the viewer and somewhat out of scale in respect to the rest of the scene.

Singling her out, then, is Reading for the Food. But what *kind* of reading? One sort of art historical approach would, properly, note that there are predecessors to this egg seller, some of them within Titian's own milieu. A childlike figure in Giovanni Battista Cima da Conegliano's version (fig. 3.3) of the subject, painted in the 1490s, for instance, dares to sit directly on the steps of the temple, offering up a variety of foodstuffs, including eggs. Another art historical approach would take the egg lady and her merchandise as significant in terms of iconography. Erwin Panofsky—surely the fountainhead for this tradition of analysis—sees the old woman as representing unconverted Judaism; and David Rosand, noting that a lamb and a chicken are also nearby, construes this side of the picture as structuring history between pre- and post-Incarnation.[7] These and other interpreters do, however, have a certain amount of trouble with the eggs, generally in an attempt to make them into something Jewish.

But sometimes—and this will continue to be a recurrent theme of this book—food places a demand on the viewer that it be read as the thing itself. What is utterly distinctive about Titian's egg seller is her extraordinary frontal position in the painting, utterly absent from the Cima canvas. This was well understood by Panofsky and Rosand, the latter declaring that "she is situated ambiguously in a spatial zone that belongs by implication to the world of the viewer" (70). For me, this is not so ambiguous, nor is it merely an implication. The pictorial unit highlighted by the brilliant white of the shawl and the corresponding gleam of the half dozen eggs *is* our world,

3.3. Giovanni Battista Cima da Conegliano, *Presentation of the Virgin at the Temple*, c. 1497. Gemäldegalerie Alte Meister, Staatliche Kunstsammlungen, Dresden

the world where we contemporary mortals, viewers of the picture, hunger and consume food. Indeed, when we take advantage of the rare status of this painting as still visible in situ, it becomes clear that the basket is virtually tumbling out of the picture plane into the room. This was, after all, the reception room of the Scuola Grande di Santa Maria della Carità.[8] What Titian was offering on behalf of his employers was, along with the representation of a sacred scene, some very familiar nourishment.

That vividly rendered figure with her strikingly foregrounded presence and her shiny offering signals something quite different from the works we considered in the previous chapter. "Rome Eats" was a study in a culture that frankly and passionately placed the experience of eating and drinking at its center. To turn now to the Bible is to move in a completely different direction. First, the obvious: the "Bible," at least as it is being understood in these pages, isn't one particular chronology or geography: it is a book, or a set of books, that are read, experienced, and interpreted over vast stretches of both time and space. More to the point—that is, to *our* point—it summons up a set of cultures in which eating and drinking, while no less central (indeed they will prove to be nearly as ubiquitous as they are in Rome), are more likely to exist as a problem, a question mark, an exile, even an enemy.

Placing that problem, question mark, exile in the spotlight (as Titian placed the egg lady) is a critical process to which I am giving the name "fooding." I offer the term

as a somewhat antic homage to the critical practice of "queering" (*Queering the Canon, Queering Ethnicity in Post-National Europe*, etc.),[9] which seeks to reconsider literary or historical matters from a perspective in which gender is less stable than has previously been assumed. I have no such revolutionary agenda; unlike queering, "fooding" does not, for instance, seek to reclaim a term of abuse and wear it proudly as a badge—or, if so, only to a very modest degree. What I am recognizing is that queering, at least in the realm of analyzing cultural objects, has a kind of double function: first, recognizing that the object in question is more full of "queer" (whatever that is taken to mean in a given context) than has been previously noticed, and second, proposing that these stray bits of queer might amount to a set of principles whereby the object can be read in new ways, indeed where, by the very nature of its previous exclusion, it might demand to be read in new ways.

So, making the appropriate substitutions, I would argue that the Bible, and the traditions of representation that follow from it, display an interest in eating and drinking that is more constant than might have been noticed, and furthermore that there are ways in which those instances, taken together, can be seen as systematic rather than merely accidental or marginal.[10]

2

There is, of course, a fundamental level at which any narrative of human life is bound to include food and drink. Many stories in the Hebrew Bible, for instance, are decidedly domestic. The consequences of Jacob being substituted for Esau (Genesis 27) may be cosmic, but they begin when Rebecca serves Isaac his favorite meal—roast kid, as the text specifically informs us—in order to soften him up for the fraternal switch she plans to perform. More often, or at least more memorably, food plays itself out on a grander plane than a family dinner. For the Israelites, the subject is often the lack of food. Famine is ever present in the early history of the Jews, including three separate instances in Genesis, but besides being a general condition of widespread suffering, it also becomes the occasion whereby culinary specifics enter scripture.[11] When Elisha and Elijah encounter starvation, the result is a pot of stew, in one case, and a never-ending supply of grain and oil in the other. When Ezekiel is directed to enact penance for the iniquities in the house of Judah, it is via the consumption of a particular bread. And when famine grips both Canaan and Egypt, Joseph offers to strike a hard bargain with the suffering Egyptians, whereby they will give up their livestock in exchange for something like grain, which can be turned into nourishment more swiftly. Behind that fable lies a significant distinction between foodstuffs that assure long-term production versus those that can feed the hungry right away.

No surprise, perhaps, that excess is the partner of scarcity in this historical narrative. David, for instance, seems to trail a vast market basket with him wherever he goes: when he lures Abigail away from her husband, she brings along two hundred loaves, two skins of wine, and five sheep, along with large quantities of grain, raisins, and figs; later, when he is at the head of the army, he is regaled with similarly copious provisions, including wheat, barley, honey, curds, sheep, and cheese (2 Samuel 17:29).

This is a mere snack in comparison with the reports of Solomon's larder; 1 Kings gives us quite precise statistics: "Solomon's provision for one day was thirty *cors* [one *cor* is 230 liters] of choice flour, and sixty *cors* of meal" (1 Kings 4:22), plus oxen, cattle, sheep, deer, gazelles, roebucks, and fatted fowl.

In these narratives, food appears largely not as the thing itself but rather as a sign of other things—the holiness of prophets, the grand status of a patriarch, God's favor or disfavor. One has to probe more deeply to notice what the present volume wishes to celebrate as the "foodness" of food. We can glimpse it in Ezekiel's penitential bread: "Take for yourself wheat, barley, beans, lentils, millet, and spelt; put them in one vessel" (Ezekiel 4:9). Food, in other words, is a human-made compound with a precise recipe, and not merely a symbol. Similarly, the stew that Elisha offers up in response to famine has quite specific ingredients (herbs, wild gourds), and his miracle is actually culinary: by adding flour to the pot, he neutralizes the strong flavors that have frightened the hungry souls whom he is feeding (presumably unaccustomed to spicy food) (2 Kings 4:38–41). This sense of the "melting pot"—the ways in which foodstuffs are diverse and require human intervention—is the theme of yet another hunger story. Joseph and his brothers must travel to Egypt to remedy the dearth of grain in their homeland, but they are instructed to bring with them, presumably for purposes of trade, a different order of edibles—"some of the best fruits of the land . . . honey, spices and myrrh, pistachio nuts, and almonds" (Genesis 43:11). The biblical lands, in other words, are home to a complex culinary ecology with prospects for something like long-distance commerce.

But the most telling episode in the Hebrew Bible that we can read for the food is the narrative that takes the Israelites through their forty-year wanderings out of Egypt and into the Promised Land. The sacred tale is fairly straightforward. The Jews are enslaved in Egypt, but their God, through the agency of Moses, leads them through to Canaan, thus sealing his covenant with them. The journey is anything but easy. There is a great deal of pushback from the Israelites along the way, nearly all of it having to do with eating. Ultimately, in Deuteronomy (after separate and somewhat inconsistent accounts in Exodus and Numbers),[12] the difficulties are explained away as a divine process of testing.

The language for this explanation takes us to perhaps the most familiar, and one might say the blandest, piece of food symbolism in the Bible (or anywhere else): "He humbled you, allowed you to hunger . . . that he might make you know that man shall not live by bread alone" (Deuteronomy 8:3). When we are actually on the road, however, the issue of hunger along with its potential alleviation is represented with considerably more particularity. At the end of the journey, the frustrated Israelites recollect, "We remember the fish we ate freely in Egypt, the cucumbers, the melons, the leeks, the onions, and the garlic" (Numbers 11:5). And at a stopping place in mid-journey, they have a similarly gastronomic complaint: "It is not a place of grain or figs or vines or pomegranates" (Numbers 20:5). When Moses foresees arrival at the promised destination, it is once again via a vision of diversified cuisine: "The Lord your God is bringing you into a good land, . . . a land of wheat and barley, of vines and fig trees and pomegranates, a land of olive oil and honey" (Deuteronomy 8:7–8). The sheer variety of this market basket takes it quite outside the transparently symbolic

realm of "bread alone" and locates it squarely on the actual dinner table of the Israelites, whether those on the journey from Egypt or those who are reading the scriptural account in subsequent ages.

But it's the principal means of sustenance during the forty years between Egypt and the Promised Land that tells the most revealing story about the "foodness" of biblical food. When Moses is obliged to report to God that the Israelites are complaining about lost opportunities to eat their fill of bread in Egypt, a powerful, though enigmatic, divine response is immediately forthcoming: "Behold I will rain bread from heaven for you" (Exodus 16:4), says the Lord. And with that we enter some of the most mysterious culinary passageways in the Bible. What does God mean here by "bread"? Is it the symbolic bread of "bread alone" or the metonymic bread of "give us this day our daily bread"? After all, when the cranky Israelite spoke nostalgically of having eaten his "fill of bread" in Egypt, he was probably referring to a more balanced diet than would be provided by mere baguette. So what would it mean to "rain bread," given that actual bread doesn't lend itself to raining? Before we're able to solve this conundrum, nutritional help appears to the Jews in a form that *does* resemble raining: "In the morning the dew lay around the camp. And when the layer of dew lifted, there, on the surface of the wilderness, was a small round substance, as fine as frost on the ground" (Exodus 16:14). To the Israelites it may suggest rain, but it doesn't yet quite suggest food. Perplexed by the sight of it, they say to each other, "What is it?" In their language, that is (roughly), *man hu*. Transliterated and rendered into our language, that expression becomes *manna*.[13]

So *manna* enters the Bible as *x*, the unknown, the thing for which we don't have a name because we don't know what it is, something like *whatchamacallit*. Very fitting for a substance that God refers to as bread but that looks to humans like dew. As manna weaves itself through the succeeding narrative of the wandering Israelites, it continues to play the role of *x*, where *x* is to be understood as a sacred (but comestible) placeholder in the exercise of divine law and human compliance: collecting it is an act of obedience to God; all individuals, whether they gathered more or less, end up miraculously with the same quantity; the divinely equalized daily allotment is magically doubled on the eve of the Sabbath, so that harvesting will not be necessary on the day of rest. But other properties of manna begin to nail it down as something more particularized, more within the realm of experience: "It was like white coriander seed, and the taste of it was like wafers made with honey" (Exodus 16:31). These are actual foodstuffs, even though, given the distance between coriander and honey (each of which is a flavor quite familiar to the Israelites, though coriander is referenced only in regard to manna), the substance remains mysterious, again the culinary whatchamacallit.

Such is the story of manna in Exodus. When manna reappears in Numbers (as often in the Bible, there are significant inconsistencies in repeated narratives), the balance starts to tip in a yet more experiential direction. Once again, the comparison to coriander seeds, plus a new descriptive concerning its color, which is said to resemble *bdellium*, a term that may possibly have nailed things down for the ancient Israelites, though modern scholarship is unable to determine whether it is animal, vegetable, or mineral.[14] Then we come to something completely different:

The people went about and gathered it, ground it on millstones or beat
it in the mortar, cooked it in pans, and made cakes of it; and its taste was
like the taste of pastry prepared with oil. (Numbers 11:8)

In Exodus, it will be recalled, the operations performed upon manna were simply
vehicles to express God's purposes and his law. Here, on the other hand, manna is the
raw material for the utterly quotidian work of the kitchen. And, similarly, the taste ex-
perience is specific and familiar. The sequence of harvesting, pulverizing (by two stan-
dard alternative means), boiling, and shaping into portion sizes follows quite precisely
what each Israelite, particularly each female Israelite, was accustomed to perform in
order to provide the daily staff of life. Manna is simultaneously the ineffable sign of
God's stewardship and the most fundamental ingredient in the ordinary business of
providing nourishment; in other words, whether metaphorically or literally, the daily
bread. The sufferings in the desert and their alleviation via a substance that is both
ineffable and culinary point to the fact that food is the meeting point between the
divine and the earthly.

The New Testament promotes a different meeting point between the divine and
the earthly. We may well take as a sign of this difference the reappearance of manna
in the Gospel of John. When Jesus (John 6:32) denies that Moses was responsible
for the miracle of the feeding in the desert and is quoted—notably by the perplexed
Jews—as saying, "*I* am the bread that came from heaven" (italic added), we have moved
decisively away from a culinary substance that can be ground in a mortar or baked in
a cake and toward some sort of sublime abstraction. (Significantly, the Jews question
this claim by saying, in effect, how could he have come down from heaven—we know
his mother and father? In other words, we place him in the bosom of a human family,
where grain is ground and cakes are baked.) And there are many more direct sugges-
tions in the New Testament that demote the business of eating and drinking—Jesus's
"Life is more than food" (Luke 12:23) and "Do not worry about your life, what you
will eat or what you will drink" (Matthew 6:25), or Paul's "Food does not commend us
to God; for neither if we eat are we the better, nor if we do not eat are we the worse"
(1 Corinthians 8:8)—though, of course, the very need to make these assertions partly
undermines them.

Whatever gets declared in these dismissive pronouncements, the culture of the
New Testament is nevertheless rich in the earthly business of eating and drinking.
We know John the Baptist's diet; we know that Jesus under quite normal earthly
circumstances got hungry and became furious when he couldn't find fruit on the
fig tree. We hear frequently about the questionable company—sinners, tax collec-
tors, Pharisees—in which Jesus took his meals. We hear more than once about the
need to feed large crowds. On a more micro level, there are detailed instructions from
Paul (1 Corinthians 11:17–33) about mealtime etiquette, touching on the sensitive
matter—not the last time we'll hear about this—of the relation between satisfying
one's hunger and engaging in the ritual of the Lord's Supper; and there are equally
precise dicta from Jesus regarding the significance of placement at the table, reminis-
cent of the hierarchies we observed in Horace's satires, though here it is the low end
of the table that is urged as preferable.

So this is a population that procures food, serves it, and determines standards for the company in which it is consumed and the arrangement of that company at table. It is also an environment in which—again, on a quite earthly plain—foodstuffs are fundamental heuristic materials, that is, the bits of common experience upon which lessons about life can be taught and learned. A quite remarkable proportion of Jesus's parables are based on the production and consumption of foodstuffs.[15] New wine in old bottles, the barren fig tree, the tiny mustard seed, the sower in different soils, tares among the wheat, toilers in the vineyard, the king's invitation to a wedding feast for his son, the kingdom of God as yeast, the Lord's invitation to a great banquet: it reads like the very DNA of the New Testament as it has passed into our ordinary vocabulary.

It is no surprise that the parables should have operated as fundamental heuristic material: that was their purpose as Jesus designed them. Many of them represent minutely accurate accounts of observation or practice in the domestic realm. Fig trees do take several years to produce fruit; new wine in old bottles (or, more accurately, wineskins) will, in fact, split its containers; weeds are indeed best harvested along with the wheat rather than pulled up separately in advance; the bad types of soil—under a well-trodden pathway, on rocky ground, or among thornbushes—are unproductive in just the way the parable teaches; mustard seeds are tiny but grow into large shrubs; a small quantity of yeast leavens a large quantity of dough. It isn't just that the effectiveness of these lessons depends on close observation; it is also the fact that the community shares this experiential knowledge and is therefore prepared to accept the lesson that is drawn from the analogy. As with any similitude—x, therefore, by analogy y—its persuasiveness depends on a universal and uncomplicated acceptance of x, which in this case equals shared gastronomic wisdom and experience.

Eating and drinking, along with the practices that make them possible, are not exclusively metaphors, of course. The New Testament never lets us forget that hunger and thirst are real. Miracles like the filling of the disciples' nets with fish or the feeding of the five thousand or the four thousand out of a diminutive supply of loaves and fishes, not to mention the rather less solemn instance of producing wine in water jugs when the booze has run out during the wedding at Cana, are significant because the functions of gaining nourishment and experiencing commensality are eminently worthy of the divine efforts undertaken by the Son of God. Similarly, on the mortal plane, it is equally worthy that Saint Paul, adrift in a storm with 276 men on their way to spread the gospel in Rome, prevents the starving Christian proselytizers from jumping ship. His method is to set an example by breaking bread and thus sustaining himself, at which point the men follow suit.

This question of the real versus the metaphorical is not merely an implicit issue for the reader. In one of the most revealing moments of Jesus's interaction with the disciples, recounted in all three synoptic Gospels, it places itself at the very center of his message; and the object at the center of hermeneutic debate is, once again, food. The narrative sequence is revealing. We have (in the version as told by Mark) just been hearing about the feeding of the four thousand, when Jesus and the disciples together leave the crowd scene in a boat. At which point we learn that the disciples had failed to bring bread; indeed, there is only one loaf for the whole group. Whereupon Jesus

tells them that they must beware of "the yeast of the Pharisees and the yeast of Herod" (or, in the Matthew version, the yeast of the Pharisees and Sadducees). However *we* may read this sequence, the disciples evidently pay no attention to the part about the Pharisees et al. and understand that they are being chastised for not having supplied proper provisions. The situation is almost comic. They have just witnessed their leader perform a miracle in response to insufficient bread; now, instead of magically solving the same problem, he seems to be getting on their case, and in response to his apparent displeasure, they are unable to get further than baked goods and their own failed responsibility. Now Jesus really gets riled up: "Why do you reason because you have no bread? Do you not yet perceive nor understand?" He takes them on a little interrogation through the numbers of the recent miracle and ends with, "Do you not yet understand?" (Mark 8:17). Or in the Matthew version (Matthew 16:11), rendered into my own modern vernacular, "Guys, it's not about the bread!"

One can't help recalling *Are They Thinking about the Grapes?* To demote food in preference to something grander is nevertheless to enshrine food as a key of entry to the loftier matter. Jesus *was* speaking about bread, and he frequently speaks about bread—for instance, a few chapters earlier in both Matthew and Luke, where the small dose of yeast (this time, however, representing a *good* thing rather than the bad doctrine of the Pharisees) leavens a large quantity of dough. The problematic here needs to be placed in the context offered a few verses earlier, when Jesus has his encounter with those same Pharisees and Sadducees and walks away in frustration, declaring that only "a wicked and adulterous generation seeks after a sign." The fact is that the narrative of Jesus's earthly life abounds in such signs, of which multiplying bread to feed the four thousand is a prime example. Indeed, bread is a sign—in fact, it will become *more* than a sign soon enough (a subject we'll return to in a later chapter)—and we are in a position to understand what the disciples don't understand and what Jesus puts temporarily aside, which is that signs are inextricable from signifieds, however far apart we may wish to place them within a hierarchy.[16]

Food has a privileged position in this hermeneutic operation. Later in the story (as well as in the present volume) the Eucharist will occupy that position in its own way; as the New Testament presents these matters prior to the Passion, though, there is a different culinary agenda. In the historical drama of early Christianity as it makes its way among Jews and non-Jews, there may be no more potent issue than the kosher laws.[17] I can hardly attempt in these pages to render consistent the position of the early church on Jewish dietary regulations. It was bound to be as paradoxical as all the other aspects of Jesus-as-Jew, who variously declares himself to be bound by the Old Law, overturning the Old Law, and fulfilling the Old Law. Paul in his Epistles spends quite a bit of time on possible proprieties and improprieties in diet (e.g., Romans 14, Colossians 2), but to the extent that Jesus himself offers a reasoning for the abrogation of kosher laws, it tends to appear as part of an attack on the Pharisees, who are defined by their fundamentalist legalisms. Invited by them to dinner, Jesus seizes upon the rituals of washing: "You Pharisees clean the outside of the cup and of the dish, but inside you are full of greed and wickedness" (Luke 11:39). The same line of attack is more specifically culinary in Mark, which once again begins with washing but soon gets more serious:

Do you not see that whatever goes into a person from outside cannot defile, since it enters, not the heart, but the stomach, and goes out into the sewer? (Thus he declared all foods clean.) (Mark 7:18–19, in the Revised Standard Version with Apocrypha)

Both of these pronouncements locate the consumption of food (by now this should be quite familiar to us) in a subordinate position to something more essential, more ethical, or more spiritual. And Jesus plays his trump card, that food ends in feces—always the ultimate denigration of eating and drinking.[18]

That parenthetical comment whereby the kosher laws are summarily set aside is itself a textual crux[19] (the King James version, for instance, does not include it), but whether or not the matter is stated so directly, it's clear that this argument locates the whole business of human consumption and nutrition as a kind of accident, a nonessential in the conception of human beings in the image of God. Like circumcision (which gets a similarly complex treatment throughout the New Testament),[20] culinary fundamentalism becomes a matter of the merely corporeal as opposed to the truly spiritual. The Pharisees' attachment to these ritual practices becomes, in fact, another case in which false religion consists in worshipping the sign rather than the signified.

All of which stands in an interesting relation to the kind of error in which the disciples find themselves when they are thinking of the bread. But the privileging of the sign in place of the signified—which Saint Augustine will elevate to a vast epistemological principle[21]—is not always so easily disposed of in the New Testament. "A wicked and adulterous generation seeks after a sign" (Matthew 16:4), says Jesus in response to the tauntings of the Pharisees, but he gets trotted out constantly to produce miracles, which would seem to be just the sort of sign to which the Pharisees were addicted. And what of the parables? The disciples are said to be able to grasp heaven's secrets directly; Jesus, on the other hand, speaks to the crowd in parables: "Without a parable he did not speak to them" (Matthew 13:34). So the parable is itself a kind of subaltern discourse, a set of signs through which individual hearers may or may not be able to deduce the signifieds. (There are a number of times when we're told that they fail.) Still, whatever the limitations of this delivery system, the parable, with all its problematic relations between sign and signified, is overwhelmingly the discourse by which Jesus speaks to us.

There is, in short, something equivocal in all these antinomies, some sense in which the hierarchical ordering seems plain but is also unstable, even possibly reversible. So far as eating and drinking are concerned, the best place to observe this ambiguity is in the last of all the frequent scenes of dining in the New Testament, recounted only in Luke. There are two meals in succession, the first at Emmaus (Luke 24:13–34), the second in Jerusalem (Luke 24:36–43); each is a climactic event, a kind of anagnorisis, or recognition.

Jesus's tomb has just been discovered as empty, the grave clothes lying on the ground. Two of the disciples (not identified) take a walk toward the village of Emmaus and encounter a stranger on the way. It is, in fact, Jesus, "but their eyes were kept from recognizing him." Chatting with the stranger, the two disciples are astonished to learn that he has heard nothing about the momentous events concerning Jesus of Nazareth,

and they proceed to fill him in on the news. The stranger begins to veer off on another path as they approach Emmaus, but the two disciples convince him to join them and take their evening meal together. Once they are gathered at the table, Jesus "took bread, blessed and broke it, and gave it to them. Then their eyes were opened and they knew Him; and He vanished from their sight" (Luke 24:30).

That is the first epochal meal. The second takes place shortly thereafter in Jerusalem among the full complement of disciples. Suddenly, Jesus appears to them; they are terrified and believe they have seen a ghost. Jesus moves swiftly and emphatically to prove otherwise. He urges them to look closely at his hands and feet (presumably exhibiting the nail holes from the Crucifixion) and to touch him. They remain skeptical. Then he places the matter beyond dispute: "Have you any food here?" he asks, and they hand him a piece of grilled fish.

In these very last scenes of the whole Jesus saga, there is no mistaking the pivotal position of food. However it is that his identity is obscured on the walk to Emmaus (and the text seems deliberately oblique on this point),[22] the moment at which the veil is lifted is quite earthly: they recognize him by the act of breaking bread. It is fraught with significances emerging from all the various feedings in the earlier phases of the story and especially by the instituting of the sacrament in similar language on the night before he died. But breaking bread is not a miracle. Jesus has not announced his presence with a *sign*, at least in the sense that the Pharisees want signs or even in the sense that he has frequently provided a miracle as a sign. He has merely done what the host does at every meal (and, of course, he has promoted himself literally from guest to host in the Emmaus supper), the most fundamental and at the same time most iconic gesture in the consumption of food.

At the subsequent meal in Jerusalem, a theological matter of the greatest importance is at stake. Though we are no longer believers in this system, most premodern cultures understood the postmortem appearance of a ghost as a real possibility, in particular when the circumstances of the death produced great unquiet (see *Hamlet*, in which there is much debate about the ghost, but nobody ever says that ghosts don't exist).[23] But if this deceased being who asks his friends to look at his hands and feet is merely a ghost, the whole mystery of the Resurrection goes up in smoke. Even his corporeal gesture is equivocal, however: ghosts, after all, could certainly come back from the dead with the marks of their suffering. What is not so likely is that they would come back hungry and accept the offer of a nice piece of flounder. It is an exquisitely paradoxical moment that references the most powerful paradoxes of Christian theology. How does Jesus prove that he possesses divinity as the Son of God whose resurrection is real? By an act that identifies him as definitively human. I suggested that in the Hebrew Bible food was the meeting point between God and man, but it is a meeting point in only a conceptual sense: God's manna and kitchen manna may be the same substance, but they exist in a state of opposition. Once Jesus is the bread that comes from heaven, the definitively human act of consuming food turns out to define God as well.

3

Though I have put them together in these pages, Titian's painting and the text of the Bible speak to quite different, indeed contrasting, aspects of our subject. In my readings of the Israelites and of Jesus's earthly life, I have been locating and bringing to sharper light the subject of eating and drinking within scripture, promoting it, as I've often done in these pages, from the margins to the center. What Titian's egg-selling lady demonstrated, on the other hand, was the choice of an artist to impose food in a sacred moment where there was no narrative justification for it. We might say this is the difference between food*ing* the Bible and food *in* the Bible. The present chapter strives for a convergence. The sacred text as it was available to the early moderns—and this, of course, includes more than the canonical scriptures, as witness the fact that the Presentation of the Virgin doesn't even appear within them—showed its Christian interpreters that the personages of sacred antiquity ate and drank, starved and feasted, produced edible miracles, expressed their relation to God via what they did and didn't consume, experienced revelations during dinners, and lived a domestic existence in which the family meal was as familiar and central a ritual as it was in their own contemporary lives. As early modern artists therefore looked at their raw material for sacred representation, they knew that they were in a gastronomic field. But, as we'll see, they often took it far beyond the comparatively meager culinary indicators in scripture. Titian's egg seller is only the beginning. Fooding the Bible will, around certain themes and in certain artistic traditions, end up being something like a willful intrusion—another photobomb—of edibles and drinkables within the portrait of the sacred.

One index of this phenomenon is the popularity of biblical mealtimes as subjects, particularly in sixteenth- and seventeenth-century painting. The banquet of Ahasuerus, the marriage at Cana, the supper at Emmaus (figs. 3.4, 3.5, and 3.6), the mix-and-match sequence of Paolo Veronese's gigantic feasting scenes (a subject we'll return to in chapter 5): their prominence seems out of proportion to their theological import. Even a story such as the seduction of Lot by his daughters, whose narrative depends specifically on drinking rather than dining, gets turned into a far more extensive spread by such an (admittedly) eccentric Mannerist as Joachim Wtewael (fig. 3.7).[24] Nor is this strand of visual prominence limited to Judeo-Christian materials. Feasts of the gods appear *passim* in High Renaissance art; and Cleopatra's banquet, at which she famously dissolves a pearl in her drink (fig. 3.8), gets plucked out from among the thousands of facts in Pliny's *Natural History* and receives quite outsize popularity among the painters.[25]

Some sacred dining occasions exhibit a more complex relation between originary text and painterly reproduction, however. Herod's feast, unlike the Presentation at the Temple to which Titian added culinary detail, comes ready-made as a potentially gastronomic occasion, though rather a strange one. It appears in Matthew, Mark, and more briefly, as a flashback, in Luke.[26] Herod Antipas (not Herod the Great of the Slaughter of the Innocents fame, rather his son), hearing for the first time about Jesus's ministry, imagines that this new itinerant prophet is in fact identical to the old one, John the Baptist, but come back from the dead. Which in turn summons up the

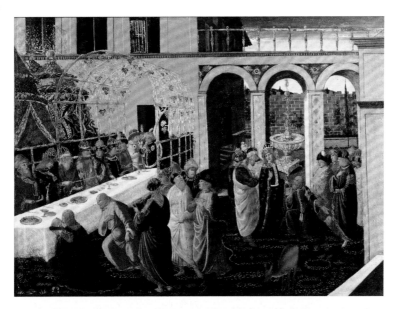

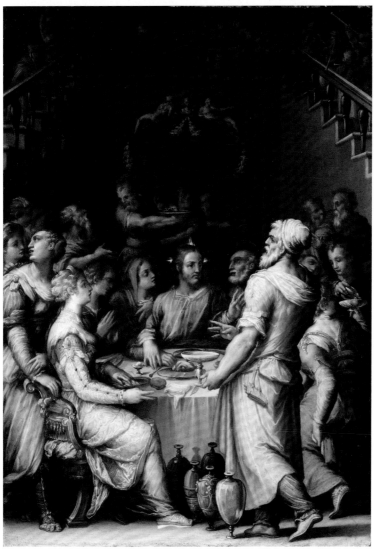

3.4. Jacopo del Sellaio, *Banquet of Ahasuerus*, c. 1490. Gallerie degli Uffizi, Florence

3.5. Giorgio Vasari, *Marriage at Cana*, 1566. Museum of Fine Arts, Budapest

3.6. Jacopo Pontormo, *Supper at Emmaus*, 1525. Gallerie degli Uffizi, Florence

3.7. Joachim Wtewael, *Lot and His Daughters*, c. 1595. The State Hermitage Museum, St. Petersburg, Russia

3.8. Jacob Jordaens, *Cleopatra's Feast*, 1653. The State Hermitage Museum, St. Petersburg, Russia

backstory about how John came to be dead in the first place. For the purposes of the gospel, the feasting itself isn't very important; what is essential is that there are two parallel prophets, one of whom Herod had put to death (indeed, Luke reports nothing more, mentions no celebratory occasion) and, further, that it might be possible for prophets to come back from the dead. But biblical banquets have a way of seizing later imaginations. This particular festive occasion, of course, offers plenty of juicy material: the accusation of incest by John against Herod, owing to the tetrarch's marriage to his brother's wife; the vengeful wife herself; the figure of Salome (named Herodias in the Gospel of Mark, though Herodias is actually the wife, as named in the Gospel of Matthew) with her alluring dance; and the folktale motif of the rash promise,[27] whereby Herod is trapped into ordering an execution that, at least in Mark's version, runs counter to his respect for the Baptist as a "righteous and holy man."

In itself, none of this depends very much on dinner. Yet the painterly tradition is decidedly gastronomic. Giotto (fig. 3.9) initiates this reading of the event with the prominent figure of a musician and several well-placed serving pieces in evidence; this setting is copied through the fourteenth century, though the table—for example, in the mid-fourteenth century altarpiece scene by Giovanni Baronzio now in the Metropolitan Museum of Art (fig. 3.10)—is liable to get more cluttered with dishware. A century or more later, in the large-scale treatments of the theme by Fra Filippo Lippi (fig. 3.11) and Domenico Ghirlandaio (fig. 3.12), there is no mistaking the fact that this is a grand Renaissance banquet, with a triclinium-shaped table and every form of *all'antichità* decor on display. Ghirlandaio, in fact, offers a display of

3.9. Giotto di Bondone, *Scenes from the Life of Saint John the Baptist: Herod's Feast*, c. 1315, detail. Cappella Peruzzi, Santa Croce, Florence

3.10. Giovanni Baronzio, *The Feast of Herod and the Beheading of the Baptist*, c. 1330–35, detail. The Metropolitan Museum of Art, New York

3.11. Filippo Lippi, *Herod's Banquet (Dance of Salome)*, 1465. Museo dell'Opera del Duomo, Prato, Italy

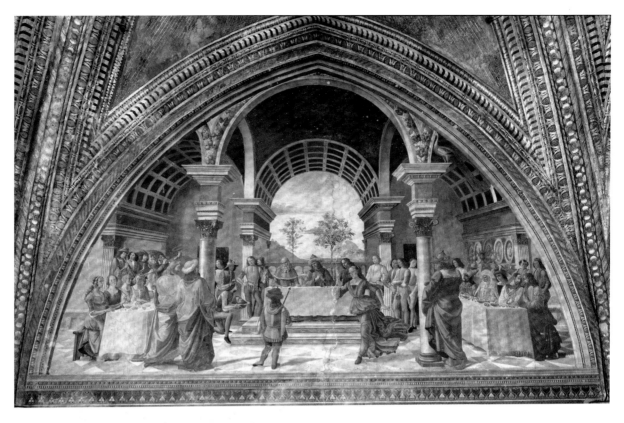

3.12. Domenico Ghirlandaio, *Banquet of Herod and Dance of Salome*, 1490. Cappella Tornabuoni, Santa Maria Novella, Florence

3.13. Domenico Ghirlandaio, *Banquet of Herod and Dance of Salome*, detail of fig. 3.12

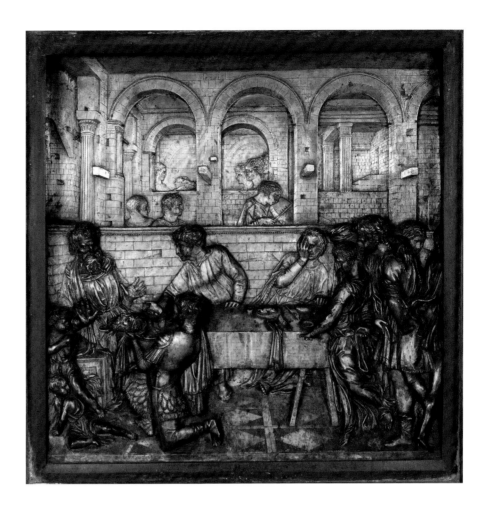

3.14. Donatello, *The Banquet of Herod*, 1423–27. Baptistery of San Giovanni, Siena, Italy

dinnerware (fig. 3.13) on the wall behind the principal diners, just as recommended by the philosopher–courtier–master of ceremonies Giovanni Pontano in his nearly contemporary volume *De splendore*: "Some [pieces] should seem to be acquired for use and for ornament, and others for ornament and elegance alone."[28]

No surprise that a painter like Ghirlandaio should be responsive to the idea of ornament as a means of defining princely power, since he is himself in the business of providing works of pure ornamentation that, unlike plates or chalices, have no practical use whatever. But in this painterly annexation of biblical material, what becomes of the decidedly non-convivial narrative itself? Donatello (fig. 3.14), in his relief sculpture for the Siena baptistery, recognizes the full horror of the scene as the banqueters lurch away from the monstrous spectacle. But such an emotive approach to the narrative drama is not inevitable in artistic representations of the scene. In Benozzo Gozzoli's version of the subject (fig. 3.15), the beheading and the presentation of the trophy to Herodias are tucked away from the main vista. In the Ghirlandaio, the Baptist's head is difficult to spot amid the glittering diversity of the scene, while in the Lippi, the dancing Salome is given far more prominence than is accorded to the proleptic presentation of the severed head.

In fact, though, something stranger than willful misreading of a tragic scene is going on here, and, as with many revisionary traditions in iconography, its impulse can

3.15. Benozzo Gozzoli, *The Feast of Herod and the Beheading of Saint John the Baptist*, 1461–62. National Gallery of Art, Washington, DC

be traced to the source itself. Let us consider the plot of the story, perhaps a little more closely than the Bible itself invites readers to do. Salome dances so alluringly that Herod offers to grant any imaginable wish, even, he says, half his kingdom. The girl herself shows no signs of having any wish in mind but defers to her mother. Herodias, in no state of uncertainty at all, demands the head of John the Baptist. In Matthew, we hear this only in Salome's voice; in Mark, Herodias says it, and Salome repeats it with a difference. In either case, it is Salome who frames the crucial form of the demand: the head of John the Baptist *on a platter*. Why on a platter? This curious supplement to the request for beheading has, so far as I can tell, excited rather little commentary, though it seems to invite such commentary. It does not appear to be a linguistic problem: the phrase itself, ἐπὶ πίνακι (in the Vulgate, *in disco*), is straightforward and gets translated variously as: on a trencher, a charger, a platter, or a plate. In short, the kind of flat disk on which food is served.[29]

What kind of intensification, whether arising from Herodias or magnified in Salome's transmission of the demand, is this? Not just dead but decapitated, the head not just severed but on display, not just on display but subject to the formalities of a social occasion—indeed, the sort of occasion at which Salome has performed the dance that set the whole chain of events in motion. Now that the head is to be presented on a platter, the occasion tips from a dance recital to a dinner. And, through the magic of narrative prolepsis,[30] propelled by Salome's further specification that it be

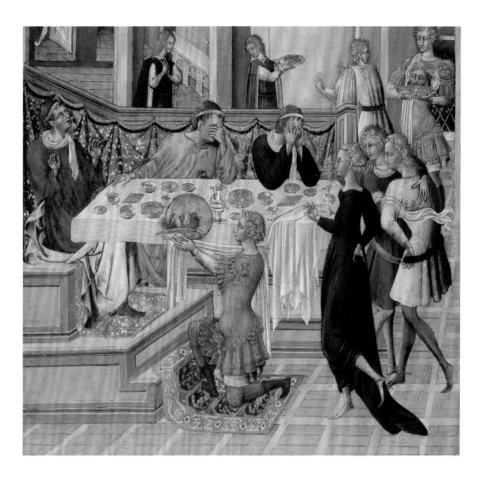

done at once (ἐξαυτῆς, *protinus* in the Vulgate), it turns into a fiction where everything can happen simultaneously. Before the evening's festivities are over, the Baptist can be located in his prison cell, beheaded, and, as it were, served.

Without the need to change a syllable (or a brushstroke), the Bible text offers instructions to the painter. It's a story where, in defiance of discursive logic, everything can happen instantaneously. Artists needn't defy the linear basis of plot by, say, squeezing Apollo's pursuit of Daphne *and* her subsequent metamorphosis into a single moment; the Bible text has already done the work for them. More important for our purposes, that platter has become, quite logically, the centerpiece of a banquet. The artists are reading Salome for the food.

And the reading is as shocking as it is inevitable. The Baptist's head is the evening's culinary pièce de résistance. The figure of the half-kneeling servant offering up the grisly platter, starting to make an appearance as early as Giotto and continuing into the fifteenth-century work of Giovanni di Paolo (fig. 3.16) and Filippo Lippi (see fig. 3.11), becomes almost canonical. It is exactly the posture for displaying some highly confected piece of culinary art—and we should recall that grand dining relied heavily on visual presentation—to the prince. And even though gestures of disgust are frequently (but not always!) apparent around the table, the offering of the platter itself betrays no sign that its contents are quite the opposite of appetizing.[31] (Painters, it should be recalled, have plenty of experience in the obsequious, metaphorically

kneeling, position of presenting their handiwork to a patron.) On some occasions, artists display an ironic self-consciousness about this juxtaposition. The Saint John Altarpiece, generally attributed to Rogier van der Weyden (fig. 3.17), depicts the decapitation of John, generally a quite separate iconographic subject, but places the newly severed head in a direct sightline with the distantly perceivable main course of the banquet. Lucas Cranach the Elder (fig. 3.18),[32] for his part, locates the serving up of the grim platter, complete with identifying halo, front and center, but positions behind it another servant with the next course, dessert, presumably to follow once John the Baptist has been disposed of; that servant, it should be noticed, is staring right out of the picture and giving us the eye.

The lesson here is somewhat different from that of Titian's egg seller: food is, to be sure, being imported into a story that scarcely requires it, but the story reveals itself to have invited and even provoked its presence. There is another New Testament episode, appearing in its complete form only in Luke, where the question of food or not-food turns into a central part of the hermeneutic conversation, as well as a vibrant element in the visual tradition. Jesus, Luke tells us, enters a certain village,

> where a woman named Martha welcomed him into her home. She had a sister named Mary, who sat at the Lord's feet and listened to what he was saying. But Martha was distracted by her many tasks; so she came to him and asked, "Lord, do you not care that my sister has left me to do all the work by myself? Tell her then to help me." But the Lord answered her, "Martha, Martha, you are worried and distracted by many things; there is need of only one thing. Mary has chosen the better part, which will not be taken away from her." (10:38–42)[33]

Interpreters have always recognized that a significant binary is being asserted here, which Saint Augustine influentially defined as between the active and the contemplative life:

> In these two women the two lives are figured, the life present, and the life to come, the life of labour, and the life of quiet, the life of sorrow, and the life of blessedness, the life temporal, and the life eternal. These are the two lives: do ye think of them more fully. What this life contains I speak not of a life of evil, or iniquity, or wickedness, or luxuriousness, or ungodliness; but of labour, and full of sorrows, by fears subdued, by temptation disquieted . . . this life, I say, examine as best you can; and, as I have said, think of it more fully than I can speak.[34]

No wonder that Augustine, given his checkered life story, cites the passage so often. We can hear in this exegesis the unmistakable voice of the *Confessions*, which embraces the this-worldliness of human life, in all its complexity and tension. (Nor is it a surprise that Augustine's humanistic follower Petrarch declares that the story contains the "mystery of life.")[35] Augustine goes so far here as to invite his listeners to pay more attention to the active/earthly than to the contemplative/heavenly life. He is in fact

3.18. Lucas Cranach the Elder, *The Feast of Herod*, 1533. Städelsches Kunstinstitut, Frankfurt

seizing upon a quite unusual feature of this pronouncement among Jesus's utterances, namely, a binary that, instead of resolving itself into right versus wrong, declares both opposites to be worthy, each in its own way.

Augustine may be approaching the episode with grand equanimity, but the text itself is not so serene. Martha—and what member of a couple accustomed to receiving visitors at their home has not felt exactly as she does?—is angry at an unfair division of labor; and Jesus declines to take her side wholeheartedly. The enigmatic quality of his response, less evenhanded than Augustine's verdict on the two disputants, becomes even more difficult to penetrate if one looks at its textual history.[36] What exactly constitutes Jesus's denial of Martha's request for an intervention? In the Greek, her complaint is countered with the statement that Mary has chosen ἀγαθὴν μερίδα (the good part, though actually μερίδα is more like *portion* than, say, *side*—in other words, a reference to choices made at the dinner table), whereas in the Vulgate it's *optimam partem*; and in the whole history of Bible translation there is a fluctuation between the *good* part and the *better* (or, more often, *best*) part. It has not gone unnoticed that Erasmus, when translating this passage for his Greek-Latin New Testament, changed the adjective regarding Mary's choice from *optimam* to *bonam*—from *the best* to *a good* part, thus radically altering the preferential nature of the hierarchy and—for some modern readers, at least—associating himself with the Reformation.[37] However the phrase gets translated or read, there is clearly an instability at the very center of what this story is supposed to be teaching us. By what degree exactly is Mary to be preferred, and on what basis?

If we're observing some millennia of ambiguity, beginning with the claims of the two sisters themselves, it's worth asking exactly what pair of activities are being so ambiguously set in opposition. Mary's is easy. She is sitting at the feet of Jesus listening to his teaching; and that endeavor gets preferred on the grounds that it is "one thing." Martha, on the other hand, is περιεσπᾶτο περὶ πολλὴν διακονίαν (in the Vulgate, *satagebat circa frequens ministerium*), which we might translate as "cumbered about much service"; it is deemed inferior because it is associated with "many things." The central term for Martha's activity, διακονία, doesn't clarify very much because its meanings (rather like those of the English *service*) can range from waiting at table to performing life-giving functions to ministry, whether in the metaphorical or in the specifically clerical sense. In short, not only is it unclear what Martha is busily doing, it is even potentially unclear on what grounds she should be considered less worthy than her passive, though clearly devout, sister.

The tale of the two sisters received enormous exegetical attention in the millennium after Augustine but scant visual representation. In the sixteenth and seventeenth centuries, however, when both Italian and northern artists, in their different ways, bestow lavish real-world settings upon holy narratives, it is inevitable that Mary and Martha would no longer merely stand for the contemplative and the active life but would also be placed in a fully staged domestic milieu.[38] The striking result is that there is no longer any ambiguity about Martha's endeavors: she is cooking. Augustine himself had already taken the narrative in that direction, declaring that Martha was "satisfying the needs of those who were hungry and thirsty; with solicitous activity she prepared what the Holy of Holies and His saints would eat and drink in her

3.19. Virgil Master (illuminator), Augustine, *La Cité de Dieu*, vol. 2, fol. 191r., translated from the Latin by Raoul de Presles (1410–12). Huis van het Boek, the Hague, Netherlands. Mary Magdalene appears in the *Noli me tangere* scene next to Martha doing kitchen work. The artist has conflated the Mary of the Mary and Martha story with Mary Magdalene; this was not uncommon.

house."[39] He makes it clear, of course, that this culinary business relegates Martha to a subordinate position: "It will not always be necessary to eat and drink, will it? . . . Here [on earth] you seek for food as for something important; there [in heaven] God will be your food." It cannot be a coincidence that the most pro-Martha, pro-cooking expression of all in the early modern period comes from a female saint, Teresa of Avila: "Both Martha and Mary must entertain our Lord and keep Him as their Guest, nor must they be so inhospitable as to offer Him no food. How can Mary do this while she sits at His feet, if her sister does not help her?"[40] There speaks someone—or so it seems—who has worked in a kitchen to feed hungry people.

However the theological debate may run, the painters who take up this story nevertheless plant themselves squarely on earth rather than in heaven, and often on that part of the earth where food is produced and consumed. As early as the illuminator known as the Virgil Master in the early fifteenth century (fig. 3.19), the subject occasions some quite realistic bread making (though in this case the Mary of this story has been conflated with Mary Magdalene). As the representation gets more articulated, this becomes an opportunity to present visual dialectic, offering the viewer a Hercules-style life choice but on the domestic scene. Hendrik Martensz Sorgh, in a work from the mid-1640s (fig. 3.20), presents a Mary who is seated alongside Jesus; she wears an elegant cloak and is turning the pages of a prayer book. Jesus, who rests his left hand on Mary's wrist, is gesturing toward Martha, who by contrast is in kitchen garb and is busy with baskets of greens and onions as well as a raw chicken; the pair of hand gestures between Martha and Jesus appears to be a nice rendering of his ambiguous judgment upon the pair of sisters, something along the lines of "yes, but. . . ." Alessandro Allori (fig. 3.21), though he incises on the wall the moral of the story (OPTIMAM PARTEM ELEGIT) that privileges Mary, offers a pair of sisters who are not so easy to place on a hierarchy. Both are lavishly dressed, both receive the close attention of Jesus,

3.20. Hendrik Martensz Sorgh, *Christ in the House of Martha and Mary*, 1645. The Cheltenham Trust and Cheltenham Borough Council, Gloucestershire, England

3.21. Alessandro Allori, *Christ in the House of Mary and Martha*, 1605. Kunsthistorisches Museum, Vienna

OPTIMAM PARTEM ELEGIT

3.22. Johannes Vermeer, *Christ in the House of Martha and Mary*, c. 1654–56. National Galleries of Scotland, Edinburgh

and the materials of dining, including grapes, bread, linen, and a lavish assortment of wineglasses proffered by Martha, occupy a position of greater importance and exhibit greater painterly skill than the presumably sacred tome that Mary seems to have pressed to the ground. Vermeer (fig. 3.22), in his largest surviving painting and one of his earliest, addresses the story with a complexity that overturns any simple hierarchy between the two sisters and their paths of life. In orthodox manner, Mary sits at Jesus's

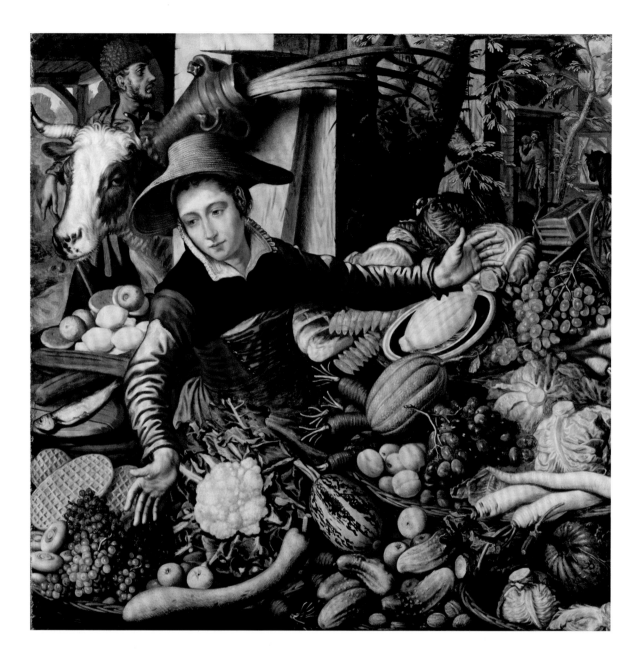

3.23. Pieter Aertsen, *Market Woman at a Vegetable Stand*, 1567. Gemäldegalerie, Staatliche Museen, Berlin

feet receiving the honor of a blessing from his right hand. But this appears almost an afterthought in the economies of the composition. The radiant central space of the picture belongs to Martha, who is holding a beautifully risen bread in a basket as she receives an intimate gaze from the divine visitor.

Well before any of these rather straightforward representations of the scene were painted, Mary and Martha had already emerged as a more paradoxical visual subject. Beginning in the 1550s and centering on Antwerp, there appears a kind of food picture such as had scarcely been seen before.[41] In the work of Pieter Aertsen and his nephew Joachim Beuckelaer (figs. 3.23 and 3.24), scenes of markets and kitchens take on extraordinary grandeur. The sizes of these paintings, some of them reaching six feet in width, are out of proportion to anything domestic that was regularly seen before.

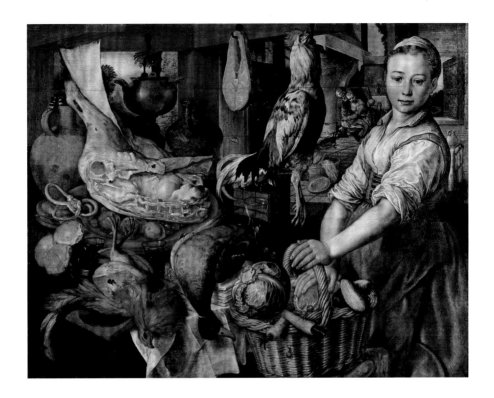

3.24. Joachim Beuckelaer, *Kitchen Interior*, 1566. Musée du Louvre, Paris

They are celebrations of painterly skill, which expresses itself in the minute, accurate, colorful, and alluring differentiation of familiar edibles. The principle above all is display: the fiction of perfect produce in the market yields to the reality of perfect artistry on the part of the painter.[42]

More often than not, these works contain quite extraneous narrative vignettes, most of which are episodes from the New Testament. The scenes tend to be tiny, shadowy, and relegated to a background, which places the gastronomic and the sacred in a curious relation. How shall we understand the steady production of unusually large paintings that are 95 percent food and 5 percent Bible? It is all the more remarkable since exactly in this time and place there is a heated discourse about the impropriety of mixing the sacred and the everyday. No less an authority than Erasmus, whose influence, via the paradoxical encomium of the *Praise of Folly*, has been widely observed in this pictorial tradition, spoke aggressively against the cheapening of the Christian story by mixing it with unbecoming revelry.[43] These sentiments, not surprisingly, were echoed by the Council of Trent.[44]

Why then include the Rest on the Flight into Egypt or the Woman Taken in Adultery while rendering them nearly illegible? Do the sacred scenes amid a display of edibles challenge orthodoxy or render lip service (or *real* service) to it? The answer may present itself when we note the frequency of one particular New Testament subject within this milieu—no surprise—Mary and Martha. Beuckelaer presents the episode in its classic miniaturized way when depicting a typically vibrant kitchen scene. The overall subject is the four elements (figs. 3.25–3.28), each of which includes a roughly appropriate New Testament episode tucked in amidst a riot of gastronomy. *Earth* showcases vegetable sellers, relegating to the background a barely visible Holy

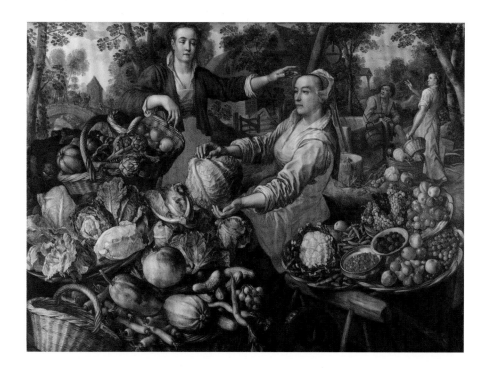

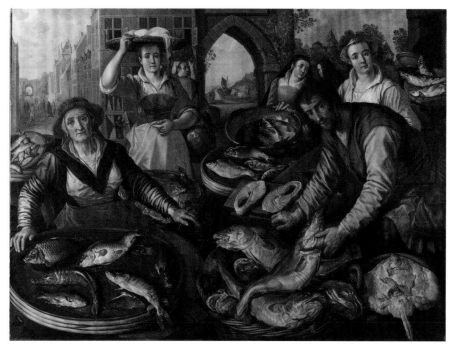

3.25. Joachim Beuckelaer, *The Four Elements: Earth*, fruit and vegetable market with the Flight into Egypt in the background, 1569. National Gallery, London

3.26. Joachim Beuckelaer, *The Four Elements: Water*, fish market with the Miraculous Draught of Fishes in the background, 1569. National Gallery, London

Family on its way to Egypt; *Water* is a fish market with a tiny Christ on the Sea of Galilee; and *Air* offers up a display of poultry beyond which it is possible to glimpse the Prodigal Son being prodigal (relevance of the element air is unclear). But the conceit operates quite differently for Mary and Martha. The kitchen is connected with fire, logically enough. But the scene of a young woman, with various helpers, hard at work among the contents of a well-stocked pantry, is not some sort of analogy to the

3.27. Joachim Beuckelaer, *The Four Elements: Air*, poultry market with the Prodigal Son in the background, 1570. National Gallery, London

3.28. Joachim Beuckelaer, *The Four Elements: Fire*, kitchen scene with Christ in the House of Martha and Mary in the background, 1570. National Gallery, London

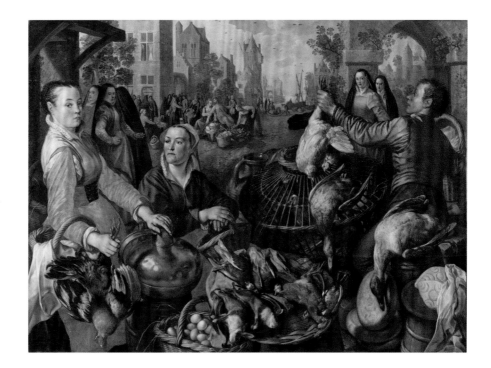

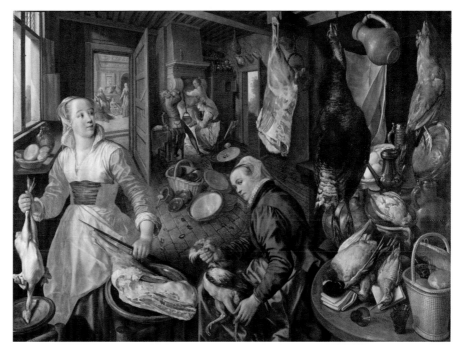

biblical story; it *is* the biblical story, reconceived as colorful, contemporary, and (once again) 95 percent gastronomic.

Beuckelaer embodies this curious little Antwerp subgenre in its most familiar form, but the practice of his master a decade or two earlier reveals a more complex approach. Pieter Aertsen was an accomplished painter of sacred scenes *tout court*, and he proved himself to be even more gifted in portraying the rich variety of markets and

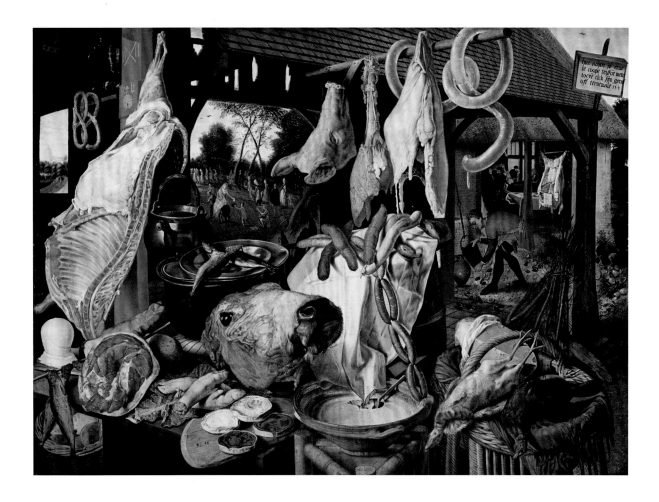

kitchens; he was also capable of mixing the genres, as in the marvelous *Butcher's Stall* (fig. 3.29) in Uppsala (sometimes said to be the first still life in the history of art), where a distant Flight into Egypt can be detected if we manage to take our eyes off the vast array of carnivores' delights in the foreground.[45]

Aertsen's approach to Mary and Martha tends to be somewhat different, however. The Rotterdam *Martha and Mary* (fig. 3.30) from 1553 plays itself out like a tease on the formula of the lush contemporary gastronomic scene in the foreground displayed against the differentiated sacred scene in the background. The elements are all there: on the one hand, fruits, vegetables, poultry, napery, cooking pots, utensils, and a vast hearth; on the other hand, minutely detailed classical architecture inside which Jesus blesses Mary with his right hand while reproving Martha with a forbidding gesture of his left hand. But the spatial relation is highly ambiguous. The biblical event is barely segregated from the contemporary scene. Background and foreground share a perspective and a floor pattern; the New Testament space is visible through beautifully rendered drinking glasses on the modern-day kitchen table; and the strikingly foreshortened gesture of Martha's left hand lurches forward out of biblical times as though to present the whole kitchen scene for Jesus's viewing in the here and now.

Aertsen represented Mary and Martha on two other occasions. The 1559 version (fig. 3.31), goes a step further than its predecessor by telescoping the sacred and the

3.30. Pieter Aertsen, *Christ in the House of Martha and Mary*, 1553. Museum Boijmans van Beuningen, Rotterdam, Netherlands

3.31. Pieter Aertsen, *Jesus in the House of Mary and Martha*, 1559. Royal Museums of Fine Arts of Belgium, Brussels

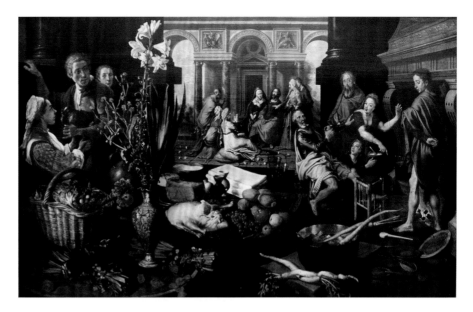

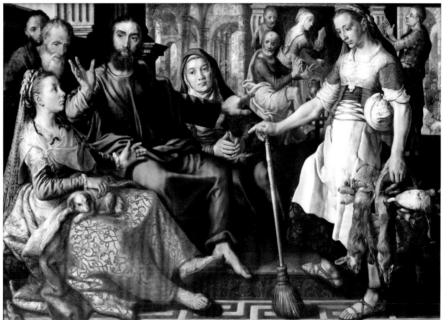

culinary spaces altogether. The scene is predominantly biblical, but it plays itself out among contemporary figures such as inhabit the marketplace, and Mary hardly seems to be Mary at all but rather a servant woman bearing a broom, a bulky cabbage under her arm, and various edibles, including two dead hares, in a wicker basket. The earliest of Aertsen's Mary and Martha paintings, quite different again, is generally referred to as a *vanitas* (fig. 3.32), though there is no skull and only the vague suggestion of the kind of worldly goods that generally tell the story of *sic transit gloria mundi*. The items whose ephemerality is designed to make us contemplate our end are almost entirely kitchen-related: baked goods, a leg of venison, and a number of handsome serving pieces. A curious inset, at once continuous with the main scene and separate from

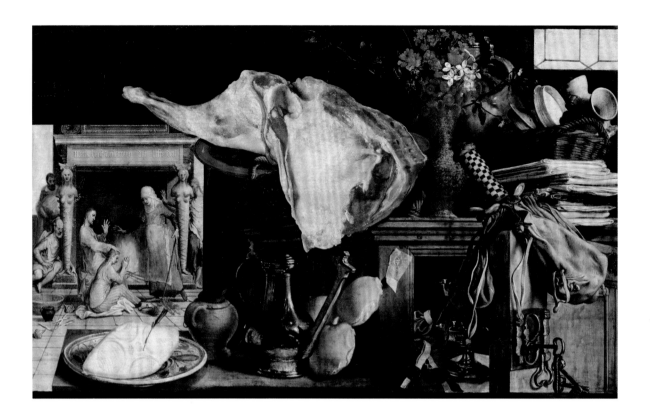

3.32. Pieter Aertsen, *Vanitas, Still Life*, with Jesus, Mary and Martha, 1552. Kunsthistorisches Museum, Vienna

it, contains a vignette of Mary and Martha. The architecture is almost parodically classical, with two multi-breasted female herms; and the narrative itself features an especially definitive blessing of Mary, with Jesus's right hand atop her head. But the whole scene is located inside a grand hearth, with the fire blazing, where Martha, dressed for the scullery, will presumably soon be cooking. Above the hearth we can read the biblical moral of the story: *Maria heeft uitvercoren het beste deel*. Mary has chosen the best part.

Laying out Jesus's verdict—actually, it's only *part* of Jesus's verdict—in so many words on the canvas may have the effect for some viewers of nailing down a moral lesson, just as might have been the case for viewers of Allori's painting discussed earlier. But the range of Aertsen's three Mary and Martha representations, and the whole Antwerp genre of which they are a part, refuses simple classification. Scholarship on the subject opens up worlds of relevant contexts: Renaissance humanism, Stoic philosophy, Erasmian paradox, attitudes toward worldliness either shared or contested by Catholics and Protestants, the growth of Antwerp as a vibrant center of merchant activity, along with the ethical and religious discontents that such wealth brings.[46] All of which are doubtless relevant, but such arguments do not take account of the fundamental ambiguities in the *querelle* of Mary and Martha, of (at least in one possible formulation) holiness and cooking. The 95 percent versus 5 percent patterning of these works, or in the case of Aertsen's two titular Mary and Martha paintings, the contamination between biblical space and modern kitchen, does not permit a simple moral of the story. Most particularly, it does not permit a reading that expects viewers to look at the gorgeously articulated, lifelike, and appetizing gastronomic subject

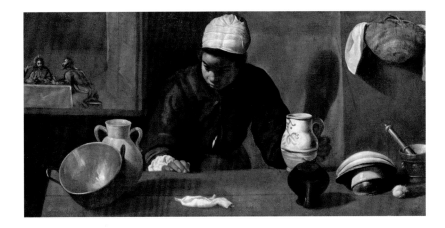

matters—the food itself, the instruments of its production, the society that surrounds it—and understand that they are being told to reject the pleasures of this world. Phenomenology must come before iconology, and food, along with its means of production, is the most fundamental of phenomena.

Along these lines, we must note as well that *optimam partem elegit* or *Maria heeft uitvercoren het beste deel* is not all that Jesus has to say in his verdict about the two sisters. Mary and Martha are a great exemplum, as Augustine well knew, because the story embraces this world and the next world both. Though it places them in a clear hierarchy, it is nevertheless true that Martha's work receives the Savior's honorable approval. On the one hand, Mary may have the *best* (or good, or better) part, and Christian Platonists may well wish to embrace her "one thing." Martha, on the other hand, is mistress of "many things." For European painters in the sixteenth and seventeenth centuries, "many things" offers God's permission to encompass the fullness of human experience in their work. The fact that fruits and vegetables, meat and poultry, hearths and frying pans are permitted to challenge the sacred space of the New Testament is a remarkable sign of what the present volume wishes to observe across wide stretches of European culture. Augustine, reading the Mary and Martha story, characterized the active life (approvingly, it seems) as full of this world's labors, sorrows, fears, and temptation; an alternative definition of the active life, it seems, is working in the kitchen.

Half a century after Aertsen and Beuckelaer, a young Spanish painter is initiating his career with (appropriately, for a beginner) studies of ordinary life. In keeping with the translation of the *vita activa* into food preparation, Velázquez makes his mark with a genre referred to as *bodegone*, the term itself heavily associated with food and the places where it is prepared and served.[47] We know that such trivial subject matter came under attack, for instance in Vicente Carducho's *Diálogos de la pintura* from 1633,[48] and that Velázquez's father-in-law, Francisco Pacheco, defended him by suggesting that he elevated such matters far beyond their lowly real-life status. Perhaps it was as a result of these concerns that Velázquez took careful note of the Antwerp genre we have been discussing (though it is not exactly clear how he would have had access to it). It is unlikely to be a coincidence, for example, that he inserts a scene of Christ at Emmaus, a favorite among the Flemish artists, in his painting of a kitchen

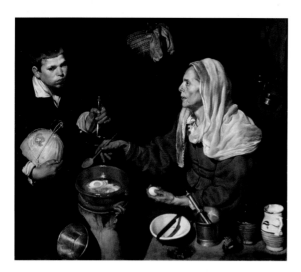

3.34. Diego Rodríguez de Silva y Velázquez, *An Old Woman Cooking Eggs*, 1618. National Galleries of Scotland, Edinburgh

maid, who is depicted amidst a rather showy array of culinary vessels (fig. 3.33). The human figure on that canvas is not actually performing any tasks, but another fascinating work of this early period, the Edinburgh *Old Woman Cooking Eggs* (fig. 3.34), with no biblical scene involved, depicts its subject performing a set of actions so gastronomically authentic that it has given rise to debates as to whether the eggs are being poached or fried.[49]

Velázquez, in short, is depicting domestic life; he is a faithful portraitist of cooking practice, is becoming interested in pictures-within-pictures, such as will become so central in his later masterpieces, and follows the Antwerp example in using visual doubles to import sacred materials into the scene of the kitchen. Hence the logic of his undertaking the subject of Mary and Martha (fig. 3.35). All that being said, it is nevertheless easier to lay out these contexts for this London picture than to explain precisely what we are seeing when we look at it. Who exactly are the two female figures who dominate the canvas? How should we understand the presence of the sacred scene (fig. 3.36) inside the larger space? A picture on the wall? An opening into the next room? A mirror reflection of action that is going on where we as viewers are standing? The only thing the painting makes perfectly clear is the recipe that this apparently unhappy young woman is being required to produce. She is grinding garlic in the mortar, to which she will add olive oil, egg yolks, and a dash of hot pepper, thus producing sauce for the fish, probably to be used in a fish soup.

Nothing in the repertoire of Aertsen or Beuckelaer takes cooking quite so seriously as this preparation of *aioli* for Jesus. To refer to it that way is, of course, to assume rather flippantly that the kitchen and the scene of the sacred encounter are somehow continuous. We are bound at least to entertain this possibility, owing to the fundamental Albertian rules that govern early modern pictorial space. Velázquez, to be sure, disturbs our acceptance of those rules, as he will do more spectacularly in later works, not only by the puzzling physical arrangement of the two scenes but even more by the jagged relation between the actions taking place within them.[50]

Mary's activity of piously sitting at the feet of the Master is iconic, universally legible, and transhistorical; it would not look any different between the first century

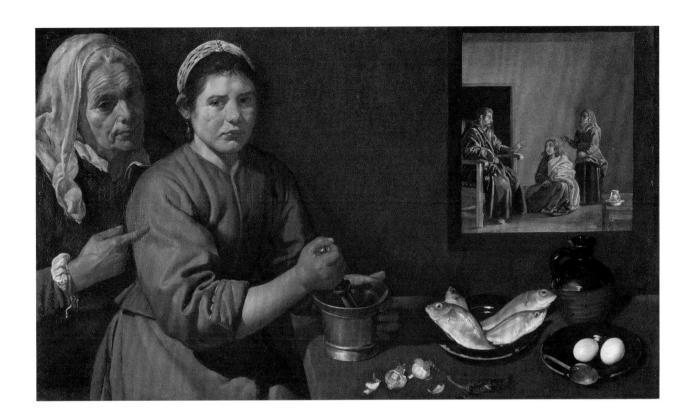

3.35. Diego Rodríguez de Silva y Velázquez, *Kitchen Scene with Christ in the House of Martha and Mary*, 1618. National Gallery, London

3.36. Diego Rodríguez de Silva y Velázquez, *Kitchen Scene with Christ in the House of Martha and Mary*, detail of fig. 3.35

and the seventeenth. Martha's activity is, on the other hand, highly time-specific and space-specific. In Seville in 1618, it looks like sauce making for fish soup. What is not so contingent, however, is the gospel account of Martha's mental state: "worried and distracted by many things." The Flemish artists concentrated on the "many things" and offered images of a gastronomic cornucopia. Velázquez, who is interested throughout his career in manual labor and in those who perform it, focuses rather on "worried and distracted." He knows that his viewers are likelier to be Marthas than Marys, living the *vita activa*, doing work, following Augustine's sequence of labors, sorrows, fears, and temptations, and blessed with few chances to sit at the feet of the Messiah. So he proportionalizes his canvas along those lines, giving the largest share of space to the food and to the disquiet. The present-day mortals who dominate the picture do not have to be iconographically decoded into some sort of identification as the biblical Martha. Instead, we have the brilliantly highlighted portrait of a kitchen worker and another figure, half in shadow, who is seizing our focus by pointing a finger at her. Mortal life, embodied in this figure, is the *via activa*; the *via activa* is cooking; and producing *aioli* several centuries pre-Cuisinart is the hard and slow business of taking *many* cloves of garlic and turning them into *one* sauce.

4

A concluding reflection on this matter of fooding the Bible. The story as I've told it here has been overwhelmingly about narrative: the hungry Israelites in the desert, bringing or not bringing enough bread to feed the faithful; Salome and John the Baptist; Mary and Martha entertaining their messianic visitor. I have had much less to say about sacred symbolism. Jesus's parables offered us a glimpse of the ways in which ordinary edibles—yeast, mustard seeds, figs[51]—could be turned into figurative instruments of instruction. The question about that process, itself enshrined in generations of sacred-symbol books and many modern studies in iconography, is what becomes of the culinary thing itself once it has been sublimed into theology. Granted, when Jesus tells his followers to beware of the leaven of the Pharisees, he doesn't want them to be thinking about a nice piece of buttered toast that will accompany breakfast, or at least he wants them to skip over that impulse as fast as possible. The question is, once we extract these consumable goods from allegorization and from particular narratives, does anything remain of the standard attributes of food—flavor, consumption, nutrition—that this volume has identified? In other words, what's in it for the hungry eye?

Here my argument must turn anecdotal. With that ocular notion in mind, I found myself some years ago at Berlin's Gemäldegalerie, struck by the enormous number of paintings that included food, the majority of which were not, contrary to my expectation, still lifes. In fact, one particular culinary presence stood out. Among representations of the Madonna and Child in the Gemäldegalerie, a quite remarkable proportion (nearly half by a rough count) included pieces of fruit.[52] Here, then, is an iconic Christian subject that stands, to a considerable extent, outside narrative; in the tradition of the *Andachtsbild*,[53] it is meant to summon up piety and to serve as a stimulus

3.37. Bernardino Luini, *Madonna with Child and Apple*, 1525. Gemäldegalerie, Staatliche Museen, Berlin

3.38. Lucas Cranach the Elder, *Madonna and Child beneath the Apple Tree*, c. 1530. The State Hermitage Museum, St. Petersburg, Russia

to prayer. It is not, generally speaking, the record of a biblical occasion on which these holy figures snacked.

So far as my hastily compiled statistic is concerned, I cannot claim that this frequency of accompanying fruit is true in the whole universe of such images, though further research has turned up a very large number of such instances, and it is unlikely that the Berlin collection was assembled from sources with disproportionately pomological tastes. It simply happens that in the fifteenth and sixteenth centuries, fruit has an uncanny way of turning up where the Holy Mother and Child are portrayed in the iconic manner and that this phenomenon seems to cut across accustomed art historical distinctions such as dates, styles, and geography.

Which fruits? Considering a personal database of around seventy-five paintings, from the Gemäldegalerie and elsewhere, the most frequent are (in descending order): apples, cherries, pears, grapes, pomegranates, peaches, and quinces, plus the occasional strawberry or fig. This ranking is, to be sure, somewhat unreliable, because many of these fruits are challenging to identify and easy to confuse. In a census such as this, it's also worth asking who is holding the fruit. Most often it is the Christ Child, but nearly as often it is Mary; there are also numerous instances in which both personages have their hands on it.

Locating apples and the Christ Child in statistical first place seems to promise a simple answer to the reasoning behind this pictorial practice: the apple is the Fall of Man, and the baby Jesus is holding it to signify the redemption. The early modern viewers of these paintings could well have received such a message, for instance from

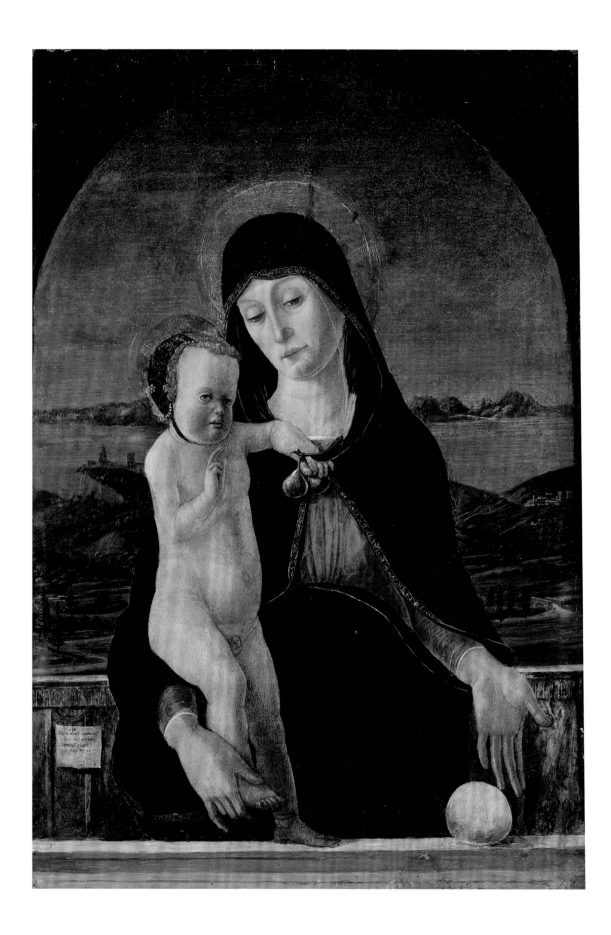

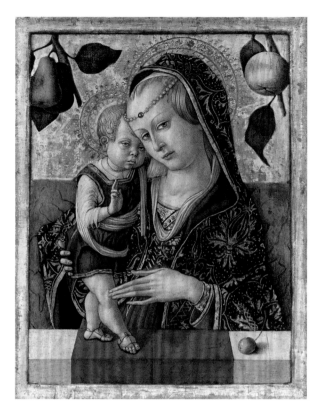
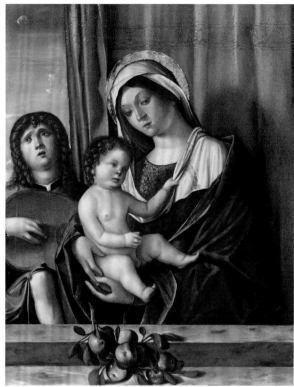

3.39. Domenico Morone, *Madonna and Child*, 1484. Gemäldegalerie, Staatliche Museen, Berlin

3.40. Carlo Crivelli, *Madonna and Child*, 1490. National Gallery of Art, Washington, DC

3.41. Niccolò Rondinelli, *Madonna and Child with an Angel Playing a Lute*, 1510. Private collection

Bernardino Luini's work (fig. 3.37) in the Gemäldegalerie, where the infant ostentatiously displays the fruit and Mary holds a prayer book, which presumably tells the whole story of fall and redemption. Or from Cranach's painting in the Hermitage (fig. 3.38), where, besides the requisite fruit in hand, there is a whole apple tree surrounding Mary's head; furthermore, the bread in the Child's right hand (a detail I haven't seen elsewhere) might well add a sacramental implication to the picture's messages. In other words, these pieces of fruit offer some sign that they are there because they symbolize something: the fruit isn't just fruit; in fact it's barely fruit at all.[54]

But it is difficult to generalize from these readings, or, indeed, from this *kind* of reading, across so varied a set of phenomena. After all, many different fruits appear in these paintings, and each one trails a set of potential sacred meanings. In addition to which, biblical and patristic literature offers so many symbolic readings—the pomegranate, for instance, is variously equated with the forbidden fruit, eternal life, the fall from grace, the sweetness of Christ's blood, fertility, and the Resurrection[55]—that it seems quite arbitrary to decide on a single decoding, especially since the relevance of a specific textual tradition to a particular painting is not often demonstrated. Allegory, in short, is not enough.

Consider a placement of the fruit that is actually more common than either Mary's or the Christ Child's hands. One might call it, somewhat anachronistically, the windowsill. In a long tradition, many of these works place the religious subject inside some sort of painted frame, generally visible at the bottom of the picture, thus allowing us to look upon the sacred scene as though across an optical threshold. The frame may be provided by a piece of architecture that is rendered logical through

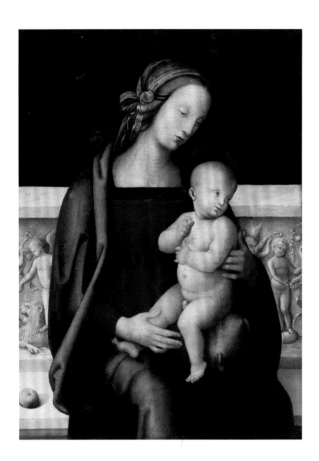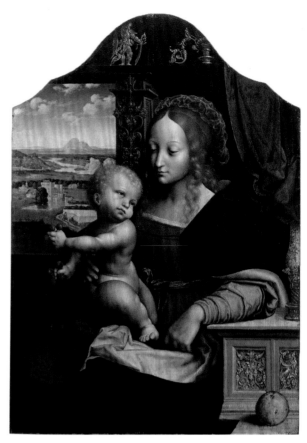

the whole setting, or it may be something quite arbitrary and external to the fictive scene; in either case, there is likely to be a kind of play as to whether it is or isn't actual space occupied by mother and child. With remarkable frequency, a piece of fruit gets placed on this threshold. In the work of Domenico Morone in Berlin (fig. 3.39), it is brought into the scene via a gesture, and at other times, as in the case of Carlo Crivelli's *Madonna and Child* in Washington, DC (fig. 3.40), it may be of a piece with some fruit-based set of decorations. Most often, though, it sits without reference to the scene, an object in its own right, upon which the artist has lavished great care, in the sort of painterly style (figs. 3.41, 3.42, and 3.43) that goes back to the independent representations on the *Unswept Floor* or to those classical xenia that were exchanged between hosts and guests, and which will be discussed below, in chapter 5. One might argue that this isolation turns it into a detachable emblem subject to allegorization. For me it has quite the contrary effect, of registering our world in our space, outside the picture (or both outside and inside the picture), summoned up by a familiar, tactile, and often highly appetizing experience in that world. Hence its liminality, its placement on the threshold.

When fruit is clearly inside the sacred world, it may yet insist on being viewed more as a thing than as a symbol, in a transvaluation achieved by the simplest of means: it is being eaten. The Christ Child feeds cherries to a bird (fig. 3.44), or picks at some grapes (fig. 3.45), or reaches out toward a bunch of grapes (fig. 3.46), or is distracted and distracts us from the holy scene—his mother inattentively riffling through

3.42. Circle of Pietro Perugino, *The Madonna and Child Seated before a Sculpted Parapet, an Apple Resting beside Her*, early to mid-16th century. Private collection

3.43. Studio of Joos van Cleve, *Madonna with Child*, first half of 16th century. Suermondt-Ludwig-Museum, Aachen, Germany, loan by the Peter und Irene Ludwig Stiftung

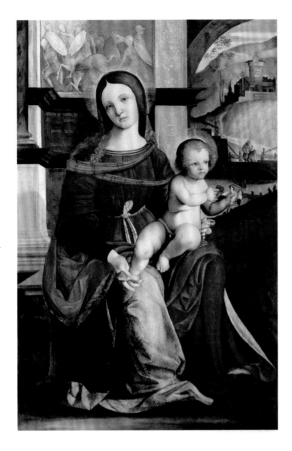

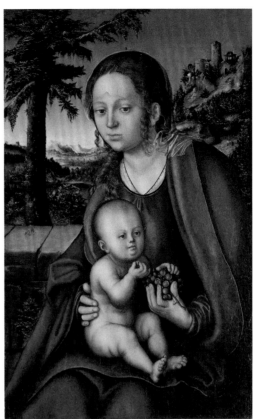

3.44. Ludovico Mazzolino, Central panel of *Triptych with Virgin and Child, Saints Anthony Abbot and Mary Magdalene*, 1502. Gemäldegalerie, Staatliche Museen, Berlin

3.45. Lucas Cranach the Elder, *The Virgin and Child with a Bunch of Grapes*, c. 1509–10. Museo Nacional Thyssen-Bornemisza, Madrid

3.46. Fra Angelico, *Madonna of the Grapes*, 1425. Private collection

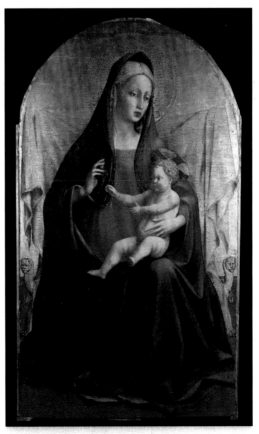

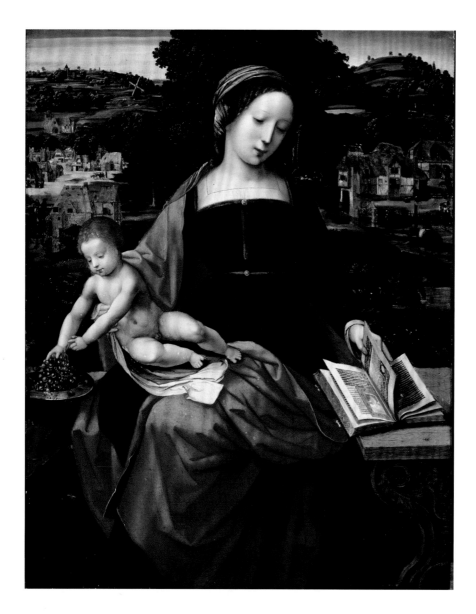

a prayer book—by grabbing with both hands at a plate full of grapes (fig. 3.47). No viewer, early modern or postmodern, religious or secular, could look at this gallery of images and think exclusively of the Eucharist. It is even more difficult to take a wholly sacramental view when the Mother and Child are presented with a diversified fruit offering (fig. 3.48) or a well-balanced snack delivered on a linen-covered tray (fig. 3.49). And when the food is laid out for display on the "windowsill" but arranged as display (figs. 3.50 and 3.51), the boundary between sacred space and the viewer's mealtime has been decisively crossed. Even in the presence of the Baby Jesus and the Virgin Mary, sometimes an apple is just an apple, a grape is just a grape, and, as we saw earlier, eggs, however sacred their setting, are nevertheless being offered up by the painter for sale. The Bible, together with all its textual and visual traditions, gets perpetually viewed by hungry eyes.

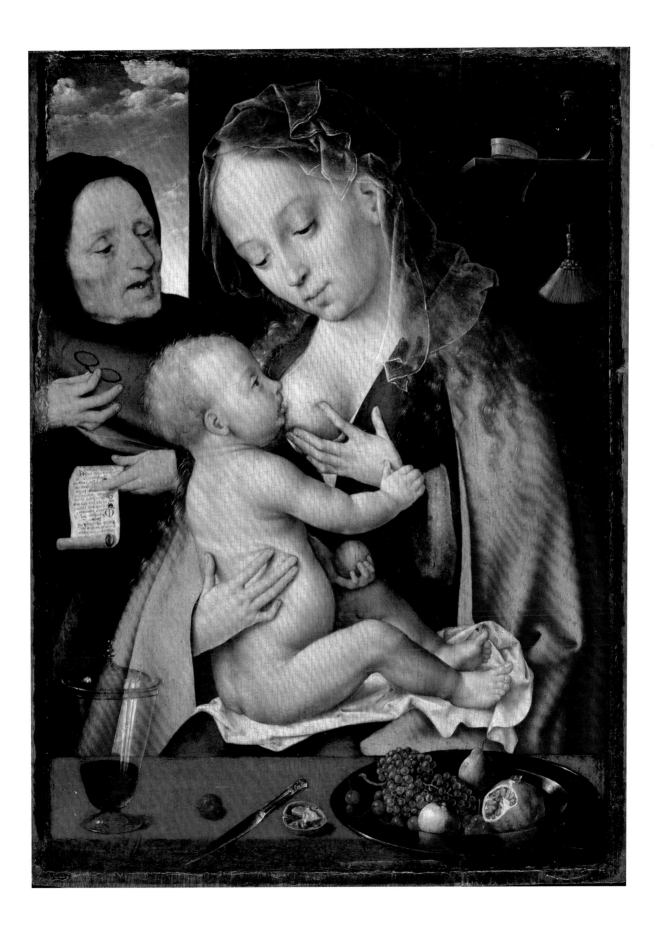

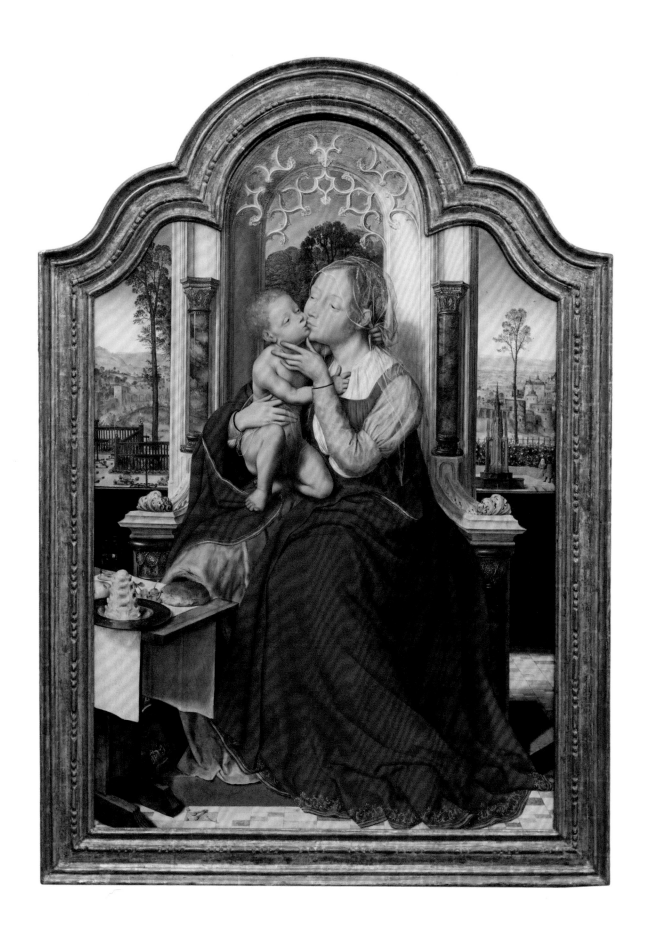

3.49. Quentin Massys, *Enthroned Madonna*, c. 1525. Gemäldegalerie, Staatliche Museen, Berlin

3.50. Studio of Bernard van Orley, *Madonna and Child with Apples and Pears*, c. 1530. Eskenazi Museum of Art, Indiana University, Bloomington

3.51. Anonymous Flemish after Jan Gossart, *Virgin with Veil*, 16th century. Musée de la Chartreuse, Douai, France

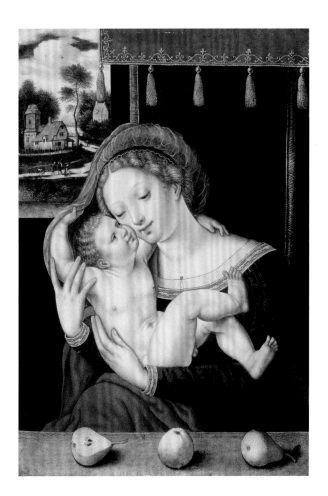

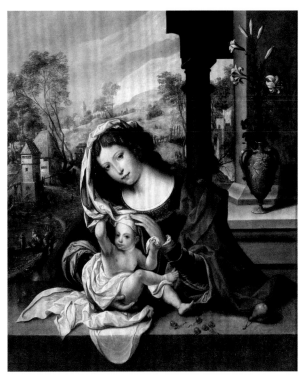

The Debate over Dinner

Each of the two previous chapters selected a unit of history and culture—in the first instance, a time and place; in the second instance, a document of transhistorical importance—and attempted to characterize the place of eating and drinking within those given spaces. Clearly, Rome and the Bible are not in themselves gastronomic categories. With that in mind, we now, for the final pair of chapters, flip the paradigm and select fields of analysis from inside the cultural, and sometimes actual, experience of eating and drinking. By the very nature of the subject (as was suggested at the end of the first chapter with the analogy of this book itself to the *Unswept Floor*), these categories won't have such clearly mappable outlines as did Rome and the Bible. In fact, they may feel more like searches for a definition rather than the definition itself. Ideally, the search will meet with some success.

What do we talk about when we talk about food? In the 1950s, Bertrand Russell and Roman Jakobson engaged in a much-cited debate on the subject of words and things. In the course of Russell's argumentation, he imagines a hypothetical circumstance whereby, "in the Hottentot language the noise 'Today is Tuesday' means 'I like cheese.'"[1] The Hottentots (leaving aside the term's racial and derogatory aura) serve Lord Russell's purposes in an interesting way, perhaps even more than he was conscious of, because they are presumed to have both no notion of the English language and no conception of Cheddar and Stilton. Which fulfills his central point of contention, namely, that "no one can understand the word 'cheese' unless he has a non-linguistic acquaintance with cheese." Jakobson declines to recognize any such literal referentiality: it isn't, in his view, taste or smell or memories of mealtime that make the word *cheese* comprehensible, it's "an acquaintance with the meaning assigned to this word in the lexical code of English." *Cheese*, in other words, signifies not via

direct experience of pressed milk curds but on the basis of a whole chain of other signifiers that are meaningful to English speakers. And Jakobson goes on to play the Slavic card by pointing out that in Russian, the substance that English speakers call "cottage cheese" is not viewed as a kind of cheese at all; he thereby throws the matter back into issues of translatability and untranslatability, which in the end is what really interests him.

What really interests me is the cheese. However it is bandied about between the two combatants, cheese enters the game as standard-bearer in the search for that thing which absolutely maintains its identity in spite of all the contingencies that might get attached to the sign. It stands as the "non-linguistic" fact (Russell's term) that can stop relativists and language philosophers in their tracks. An argument about language thus turns into an argument about experience, and ground zero for experience is food. And, as we shall see in this chapter, food and drink can scarcely enter cultural discourse without forming either the center or the outer periphery of an argument.

1

Let Jakobson and Russell serve as introduction to two more extensive conversations among philosophers where food is pressed into significant service. The opening of Plato's *Gorgias* is so *in medias res* that it is at first barely comprehensible:

CALLICLES. To join in a fight or a fray, as the saying is, Socrates, you have chosen your time well enough.
SOCRATES. Do you mean, according to the proverb, we have come too late for a feast?[2]

With some difficulty, we can reconstruct behind this exchange a proverb about the sort of person who, presumably with premeditation, manages to arrive, safely, when a battle is over; that individual is compared to a different latecomer who, far less satisfactorily for his or her own purposes, arrives when a feast, rather than a battle, has concluded. The perfect strategist of arrival times would appear late for a battle and early for a feast, but in the present context, neither of these undertakings makes it clear what it is that Socrates and Callicles have actually just been doing, or *not* doing. We soon come to understand, however, that the activity in question has been Gorgias's exhibition of rhetorical skill in the public marketplace. Socrates has missed it; and however such a presentation may relate to battles, it's clear from his reference to ἑορτῆς, or feast, that he chooses to characterize Gorgias's performance as a big meal for which he has come too late to get anything to eat.

Why should Gorgias's activity in the marketplace be construed—pejoratively, as it appears—as something like dinner? At a pivotal moment in his argument, Socrates is building a case for demoting rhetoric from the status of what is usually translated as an "art"—the all-important term τέχνη (techne)[3]—which is to say, an activity with its own abstract rules, independent from the contingencies of particular users or particular circumstances. Rather, it should be considered an ἐμπειρίαν, which is something like an "experience" or a "habit"; and later he will demote it further and refer

to a τριβή, or "knack." It is in the middle of making this argument that he induces his interlocutor to ask the innocent question, what sort of art is *cooking* (ὀψοποιία)? And *cooking* turns out to do a great deal of Socrates's work for him once he equates it with rhetoric.

What Socrates wishes to assert about rhetoric is something that he expects his audience to take for granted about cooking. (That is, after all, in the nature of Socrates's own rhetoric, which often consists of a bait and switch via analogy between two terms that he presents as though they are functionally equivalent to each other; the premise of this equivalence is itself generally debatable, even if his slower-witted interlocutors conveniently do not debate it.)[4] According to this process of argument, it is taken as axiomatic that cooking is the exemplar of an unanalyzed, habitual, quotidian behavior (it doesn't help that it's performed by women and slaves), rather than as an organized body of wisdom. What's important to Socrates here is to persuade listeners that his dialectical style of philosophy possesses this sort of universal validity, whereas rhetoric is something merely—dare one say?—*cooked up* for each occasion.

The problem about τέχνη and cooking, I should point out, won't go away: it remains alive and well in the revolutionary contribution of Antonin Carême's *L'art de la cuisine française dans le dix-neuvième siècle*,[5] which is credited with initiating the orderly schematization of gastronomy, or, closer to our own time, the Julia Child et al. volumes entitled *Mastering the Art of French Cooking*, which may as well have been called *Mastering the Techne of French Cooking*, given their focus on a structure and discipline that are intrinsic to the enterprise rather than the mere invention of one particular practitioner.[6] For Socrates, the question of system is merely a point of entry to the larger blow that the chef delivers to the rhetorician. Cooking for Socrates is part of a complicated—perhaps even creaky—syllogism in which the greatest good, namely, a government by philosophers, sits at the top of a pyramid in which body is distinguished from soul. By associating cookery with sophistry (he lumps cosmetics in there as well), he reduces Gorgias's style of speechmaking to an activity of mere sensuous gratification rather than the sort of oratory that would lead to proper action in the public sphere.

But the bottom line in this argument—and what may be the prime usefulness of cooking as analogue—is pleasure. Socrates is anxious that rhetorical language may generate more enjoyment than philosophical language. And—here's where we get to the main point—he is completely certain that the exemplar of a sensuous satisfaction that is utterly undeniable is food. He plays the food card because compared with anything else—say, justice or rhetoric—food seems like the most uncomplicated, the most incontrovertible, form of happiness. Which goes along with another crucial aspect of food, that it is the earliest and most childlike of all forms of pleasure.[7] Absent Sigmund Freud's infantile sexuality or Jacques Lacan's hermeneutics of breastfeeding,[8] talking about food is a way of talking about nonsexual pleasure and of linking it to the mind and tastes of the child. As we saw with Boucher's grapes, then, food is a means of representing pleasure, at once legitimate in a way that other pleasures may not be, but also subject to the criticisms that all pleasures incur. Socrates, as the later pages of the *Gorgias* make clear, is fighting a set of assumptions that philosophy is something one should grow out of as one matures, an idea that is the more poignant because of

the retrospective awareness that Socrates will be executed for corrupting Athenian youth. In this dialogue, he fights back on the battle line of the child by using the pleasure of food as an exemplar of the infantile and associating it with the sort of public speechmaking—that "feast" of the opening lines—from which he chose to absent himself, or at any rate to which he came late.

What further concerns him about this gastronomic/rhetorical form of pleasure is that it becomes *collective*. Rhetoric—which, after all, was the thing Socrates first dismissed as cookery—summons up crowds of people by giving them shared satisfaction, by "flattering" them, in his pejorative formulation.[9] If you don't like the instrument by which they were summoned up, and if you think such pleasure is bad, then the communal meal, which to most of us is a wonderful thing, turns into a nightmare in the polity. One man's commensality is another man's mob rule.[10]

Our third conversation among philosophers evinces no trouble at all with pleasure; indeed, as we'll see in this chapter, it can form a particular image of eating and drinking against which rule givers like Socrates will wage their wars of argument. The *Deipnosophistae*, the title of which has been variously translated as *The Philosophers at Dinner* or *The Learned Banqueters*, though it might also be rendered as *The Experts at Dining*, was produced in the second or third century CE by a massively erudite author of Egyptian origin, writing in Greek but setting his work in Rome (fig. 4.1).[11] It consists of fifteen volumes recording the conversation at one (or perhaps several) dinner parties, the bulk of which comprises long quotations from Greek literature, especially dramatic literature, with an emphasis on the comic tradition. Most of these quotations are from works that would be lost to us were it not for their preservation in the *Deipnosophistae*; and this happy circumstance of philology, along with the fact that the book includes thousands (perhaps tens of thousands) of pieces of information about the language and culture of late antiquity, has accounted for a tendency to consider the book largely as a resource to be mined rather than as a literary object in its own right.

Though one can learn much about sex and politics and material culture from reading Athenaeus, the largest portion of the material here is gastronomic: what these learned gentlemen mostly talked about at their dinner party (as at many of *my* dinner parties) was, in short, food. And it is a challenge to convey the copiousness of this reportage without imitating the elephantiasis of the work itself. Just to pick a few random indicators: a thirty-page anthology surveying the textual record of drunkenness; a catalogue of vegetables including an extensive natural history and literary history of turnips, cabbage, beets, carrots, leeks, and squashes, followed by another such catalogue of fowl, including pheasant, partridge, ring-dove, quail, duck, goose, and something that gets translated as "purple gallinule" (9.388). Or consider the twenty-five hundred words devoted to lentil soup, which includes such a recommendation as "Hyacinth-bulb-and-lentil soup in the winter season—damn! damn! . . . is like ambrosia when the weather's freezing cold" (4.158). And none of these things can compare with the kind of exhaustive attention that Athenaeus's learned banqueters devote to the subject of fish (book 7).

The primary lesson in all this is the lesson that is perhaps becoming all too familiar in these pages: food and wine may or may not belong at the table with high culture, but curious things happen when they are admitted there. The opening of the book

4.1. Athenaeus of Naucratis, Title page of *Deipnosophistae*, Leyden, 1657

makes it clear immediately that the work is a quite deliberate rewrite of Platonic dialogues—specifically, the *Phaedo* and the *Symposium*. The template for this imitation is not merely the dialogue form but more precisely the emphasis on the transmission of a set of past conversations from those who were present on that occasion to those who did not have the opportunity to be present.[12] Both the *Symposium* and the *Phaedo* begin with this framing material: in the former case the discussion that needed to go through channels of communication was about love (as we saw in chapter 1), whereas in the latter case it was about Socrates's death. Athenaeus follows that pattern by structuring the whole book as a response to his friend's insistence on recounting the evening's conversation, for which he was himself not present; but instead of love or death, the topic is food. The *Deipnosophistae* becomes, in effect, the reciprocal of Plato's *Symposium*. In the *Symposium*, as was mentioned in our first chapter, Agathon is so indifferent to the menu that he relegates it to the choices made by the slaves who produce and serve it;[13] no such attitude obtains in the world of Athenaeus. This dinner party, in other words, turns in on itself: what these gentlemen discourse upon at mealtime is mealtime.

And why shouldn't they? In the Platonic disposition of table talk, comestibles count for very little in comparison to the philosophical substance of the discussion.

Plutarch, as may be recalled, took as proof of this hierarchy the fact that we have no record of the menu at these symposia, only of the philosophy.[14] Athenaeus is redressing that imbalance with a vengeance.

In the most fundamental sense, the project is one of praise. Cuisine, far from meriting the kind of disparagement that Socrates takes for granted in the *Gorgias*, becomes the object of an encomium that locates it as a universal principle. With Plato's dialogue form retooled as a vehicle for gastronomy, cultural history swerves toward dining. Homer emerges in the *Deipnosophistae* as a culinary writer, a circumstance that can be deduced from a plot summary of mealtimes in the *Odyssey*, or from the fact that he knew how large fish are caught with long poles. The Homeric epics, it turns out, furnish dozens of quotations about eating and drinking, such as "Now go to your dinner, so that we can join battle" from book 2 of the *Iliad* (8.364), or "Let us think once again of our dinner," from book 4 of the *Odyssey* (9.366). And Athenaeus assures us that the sight of Homeric heroes "fixing their meals and stewing food inspires no laughter or shame. In fact, they deliberately did their own chores" (1.99).

Nor is Homer the only cultural icon retooled as gastronomic. We are told that intoxication was responsible for the invention of comedy and tragedy and that music and wine originated together (2.227–29); fishmongers are earnestly compared with both poets and painters (6.27); and poets are instructed to follow the example of an elegant dinner as they plan their work (1.39, 10.425). Epicurus, not surprisingly, comes in for a great deal of attention (7.285), but we are told that when he equated the good and the pleasurable, it was entirely in terms of food; the philosopher, it seems, repeatedly shouted out loud that "the pleasure derived from the belly is the origin and root of every good" (8.278). Nor is this gastronomic imperialism confined to poetry and philosophy. Great men like Alexander and Mark Antony (7.277, 4.148) are viewed through the lens of what they ate or said about eating. Food is the engine of world history: the Egyptian king Psammetichus used fish-eating slaves to discover the source of the Nile (8.345), and the very geography of Greece is defined by differences in cuisine across the map.

This is not just some sort of Erasmian mock encomium. If the Socrates of the *Gorgias* is belittling certain discursive practices by branding them as, in effect, culinary, Athenaeus is constructing an immense edifice that, to be sure, welcomes the analogy but transports it into positive terms and into realms of global significance. If Socrates was troubled by pleasure and especially collective pleasure, and if he betrayed that discomfort by invoking cuisine, then the riot of foodstuffs, congeniality, and discourse in the *Deipnosophistae* can be counted as a refutation. What is striking on the occasion of this long, long dinner party is that, with a basis in gustatory pleasure, eating and drinking have embraced or even usurped the world of discourse itself—and in ways that neither Jakobson nor Russell could envisage when *they* were talking about food.

The matter is announced at the outset when the epitomizer of the text (the opening books are lost, such that the work is presented to us in the third person)[15] refers to the book with the coined word λογόδειπνος—a "banquet of discourse." If some of the implications of this parallelism are obvious—speaking and eating are both oral activities involving lips, mouth, and tongue; the scene of dining is also the scene of conversation—other aspects of the equation are more subtle and revealing. The

whole book, after all, is a kind of grand substitution: neither the interlocutor to whom the whole story is being told nor the readers have had the privilege of attending this dinner party, and so the author becomes οἰκονόμος Ἀθήναιος—Athenaeus the butler—who is serving us words as lavishly as dishes were being served on that now unrecoverable past occasion.

But if speaking and eating keep finding themselves in something like interchangeable positions in the *Deipnosophistae*, no less significant is the tension between them. We as readers may be satisfied (or have to be satisfied) by the substitution of text for dinner, but the learned banqueters themselves are placed in a position where the talk keeps postponing the meal. As the interminable discussion of seafood seems to be wrapping up at the end of the seventh book, for instance, the speaker offers to conclude "unless," he says to his interlocutor, Timocrates, "you are hungry for more food" (7.330), by which he does *not* mean food but rather talk. Then, by the middle of the eighth book, when it is said that "we were at last about to begin dinner," the physician Daphnus of Ephesus orders food service to be held off yet again while he goes on for many pages about the medical properties of fish. Around the same time, an unidentified participant notices that "as a consequence of our enormous feast of speeches [a phrase that itself alludes to Plato's *Timaeus* 27B], the cooks [are] still working on the meal, so as to avoid serving us cold food" (8.354). Only one oral activity at a time; none of these gentlemen, it seems, ever talks with his mouth full, and the whole experience begins to look like some sort of Derridean act of culinary *différance*, foregrounding, just as it does in Derrida, the problem of words and things.[16]

Underneath all this particularity is a kind of response to Socrates's claims that food fails to possess system, method, or techne. Where foods come from, how they are prepared in their various habitats, in what ways they are different in respect to other foods that are thought to be similar, which peoples consume them enthusiastically as opposed to those who treat them as garbage, and the whole world's variety of table manners: all of this is a vast field wherein cultural anthropology and natural history express themselves in the *Deipnosophistae* as difference. But, precisely because of the vast volume of information, differences here are understood as entirely legitimate and not necessarily subject to placement on a hierarchy of approval or disapproval. Gastronomy, whose pleasures are on view among the evening's dinner guests, validates multiculturalism and stands as the basis of a system.

It is no surprise that the erudite dramatis personae of this dinner party would excel in the structures of learned discourse, whether on culinary or other topics. But at a quite significant moment, the tables are turned, and it is not the diners who display their skills as polymathic rhetoricians of praise, but the cooks. The immediate occasion is the serving of a dish involving special ingenuity in its preparation. The diners are presented with a whole pig that has been roasted on one side and stewed on the other. When the guests send their compliments to the chef, he becomes a speaker for the first time, with an almost uninterrupted fifteen-page monologue, only at the very end of which he explains the trick that enabled him to produce that *porc à deux façons*.

The unnamed chef turns out to be the master of as much bibliography as the guests he is serving. What he selects out of his storehouse of reading is, not surprisingly, the auto-encomia of various literary cooks, and the medium of praise is the

claim that cooks are masters of all possible skills. As he moves through quotations from Posidippus, Euphro, and Sosipater, he demonstrates that the cook must be a military commander and a ship captain. He must be an astronomer who can calculate the zodiacal signs under which various fish are best caught. He must be an architect who knows how to lay out the perfect kitchen and dining area, as well as a meteorologist who can determine the course of winds and weather.[17]

Like virtually everything in the *Deipnosophistae*, this rhetorical performance is both about the information it conveys and about the fact that it *is* a rhetorical performance. In fact, even before the cook develops these honorific *comparanda* for those of his profession, he declares that the most fundamental skill of all, quoting Posidippus, is ἀλαζονεία, generally rendered as something like "arrogant boasting," though Douglas Olson translates it as "bullshitting."[18] The Loeb Classical Library's choice of modern vernacular aside, the message is clear that the requirements for admission to this dinner table, on both sides of the kitchen door, are an inextricable combination of what people do and how they talk about what they do. And, once again, there is a relationship of deferral between these performances. Our cook promises to explain how he did the double-cooked pork, but only after his long encomium to the art of the chef does he reveal his secret. And there is a similar mechanism, even more climactic (or anticlimactic?) in book 14, when one of the cooks announces with great fanfare the imminent serving of a μῦμα.[19] No one has any idea what a *muma* is ("because the son-of-a-bitch had not given us any indication of what this was" [14.658]), but only after this chef's lengthy recital of yet another encomium to cookery does either the food itself or the verbal description of it get presented. And, after this typically logorrheic deferral, what a massive and ungainly thing it turns out to be: meat mixed with entrails, guts, blood, vinegar, cheese, silphium, coriander, poppy and pomegranate seeds, and on and on. By these nearly closing moments of the massive work, it becomes difficult not to think that the *Deipnosophistae* is itself some kind of *muma*, concocted by a group of Hellenophiles sitting in Rome and indulging themselves by concocting a stew that mixes together Plato, the full corpus of the Roman New Comedy, and the entire contents of the Library at Alexandria.

The issues raised in the *Gorgias* never quite leave Athenaeus's table. All these prolix passages in the *Deipnosophistae* are larded with terms like *techne* and *sophist*. It becomes undeniable, *pace* Socrates, that cookery *is* a system, with order, rules, tradition, and history. If he was wrong about that, he was, on the other hand, quite right about its being an extravagantly rhetorical exercise, not only in the speeches of chefs with their elaborate gastro-ekphrases but also in the production of the dishes placed on the table. The *muma* itself is as rhetorical—in all the senses that Socrates put into play—as the description of it. And all the persons involved in Athenaeus's festivity, whether cooking or dining, deserve the epithet *sophist*, as given them in the book's title. Yes, Socrates, sophistry *is* pleasure—but that's a good thing, at least when accompanied by dinner in several dozen courses.

For Jakobson and Russell, food was a mere rhetorical convenience (or inconvenience), a placeholder seized upon in a game about language. For Socrates—he, too, instrumentalizes food—it serves as a way of demoting what he considers an inferior or even dangerous mode of philosophical argument. Athenaeus takes us somewhere else,

however, by introducing us to a broad stream of cultural activity in which eating and drinking are not mere rhetorical expedients nor encumbrances to the lofty discourse of philosophy nor necessary evils that must be relegated to the margins when painting an idealized portrait of humankind. Rather they belong in the center of the picture; indeed, they *are* the picture.

2

What have we learned, then, from our three groups of disputatious philosophers? Food is the *real*; food-*as*-the-real, at least among certain philosophers, may be an object of suspicion, owing to the fact that it insists on kinds of pleasure that resist rational systems of control; and, by contrast, for other philosophers, it is precisely this waywardness, with all its implications of sensuality, that offers the most alluring challenge to the project of discourse, albeit of a kind that may lose its way, energetically and without shame, among the phenomena of lived experience.

Along this pathway, then, there is a strand of early modern European culture that, as one might say, operates under the sign of Athenaeus, with his sense that the whole world is a feast. Of course, if I am promoting Athenaeus as a presiding divinity for the Renaissance, it is a claim made with full awareness that the *Deipnosophistae* was hardly one of those classical works that found itself on every humanist's night table.[20] It's no great surprise, to be sure, that the book failed to attain the status of Renaissance best seller. It is long, Greek, and largely devoid of the prospects for golden age idealization that humanists liked to promote. When we put it next to its closest relative, Pliny's *Natural History*, it is easy to see why a book that tallies everything in the known world for the sake of something like pure *Wissenschaft* should win more favor than a book whose equally impressive scholarly content is channeled through mere dinner-table conversation. It is yet another indicator, as recorded so often in these pages, that eating and drinking get pushed to the cultural margins.

Still, there was an Aldine Press edition of Athenaeus as early as 1514, which had something of a Renaissance readership (as we will see). And, in a broader sense, there is a whole network of collateral relations between Athenaeus and the early moderns. The *Deipnosophistae* is, as has been pointed out, a tissue of quotations, especially from late Greek dramatic comedy. Neither in the Renaissance nor today are these texts accessible (except, of course, for quotations in this very text), but they were themselves closely imitated in Latin dramatic comedy, which formed the very basis for the early moderns' attempt to understand colloquial latinity. In that sense, the Renaissance could read the same kinds of material that Athenaeus's diners so generously quoted.[21]

In particular, Middle Comedy, whether in the Greek of Menander or the Latin of Plautus, delights in staging the figure of the cook. What emerges here is a decisive set of choices in regard to the *Deipnosophistae*. For Athenaeus, the erudition of the cooks themselves merely serves to intensify the sense that the whole of Alexandrian civilization is passionately attached to gastronomy in the pursuit of pleasure. In the more class-segmented world of comedy, however, the cook's expertise is material for mockery because a slave's erudition is itself something like a contradiction in terms. It

The second attack, which follows logically from that concerning excess, is yet more severe: these ridiculous practitioners imagine that they are framing their absurdly excessive activities in terms appropriate to a systematic discipline. They believe that—to use Montaigne's terminology—they are not mere servants of the *gueule* (the most dismissive term for the mouth and what enters there), but that they are practicing a *science de gueule*. Cardinal Carafa's steward fancies himself an expert who can plot the minute workings of the human body and superimpose that structure upon the plot of a banquet. Jonson's cook, for his part, claims that his expertise is both parallel to and integrated with two of the most prestigious of all contemporary disciplines: the art of war and the art of reading the stars.

It is that matter of copiousness, and all that comes along with it, which most particularly catches on when high-style Renaissance authors descend into—and, more particularly, demonize—the kitchen. The enormously influential volume *De copia verborum et rerum*, of Erasmus (himself an avid reader of Athenaeus, as we shall see), is a book about amplitude in language—elegant variation, figures of speech, and how to say the same thing in different ways—and not, of course, a book about cooking.[26] Yet it, too, can be read for the food. Perhaps the most famous, and certainly the most entertaining, passage in the book is the chapter in which Erasmus illustrates 150 ways of saying, "Thank you for your letter." The phrase that receives such an overkill of variation is not chosen at random. As the repetitions begin to take on the qualities of a mantra-induced trance, we start to notice, first of all, that his underlying theme is pleasure. For instance: "How much joy your letter has aroused in me. What laughter, what applause, what exultant dancing your letter caused in me. . . . Your pen has sated me with joys." And, secondly, we notice that the recurrent subject being churned through all these hedonistic outpourings is specifically gastronomic: the letter resembles "pure honey," "rich banquets," and is "more sumptuous than Sicilian feasts." The speaker is "drunk with excessive joy," and finally declares that "no luxuries titillate the palate more agreeably than what you wrote titillates my mind" (chap. 33).

Not that the analogy is always so positive. Well before those multiple expressions of "thank you for your letter," Erasmus concerns himself with the problematics of *copia*, and here the long history of gastronomic excess—perhaps Petronius's Trimalchio in particular[27]—offers him the perfect example:

> I want the furnishings of a rich house to be altogether in good taste, not with every corner crammed with willow and fig and Samian ware. At a splendid banquet I want various kinds of food to be served, but who could endure anyone serving a hundred different dishes not one of which but would move to nausea? (10)

The experience of the banquet is a flexible signifier for copiousness, operating on a scale all the way from maximum titillation to nausea.

We shall return to Erasmus as a producer of culinary text in his own right. First, though, let us consider one of his most dedicated readers who, as one might say, wrote the book on this gamut of gastronomy, with the notion of copiousness—and its discontents—as the very cornerstone in creating a masterpiece of fiction. Simply to

enumerate all the materials concerning food and drink in the grand multiform epic of François Rabelais's *Gargantua and Pantagruel* would require almost as much space as the book itself.[28] Each of the separate volumes of the work begins with solid and/or liquid consumption. Readers are drinkers, and the activity of reading is compared to a dog's dogged labor in extracting the inner deliciousness of a marrowbone—an activity that is presented as vastly preferable to a different practice of reading which consists of the non-gastronomic and nonnutritious search for allegorical meanings (*G*, prologue, 207).

The substance of the narratives is as vinous and/or culinary as the introductory materials. There are myriad wine recommendations and the occasional recipe. The powerful institutions in Rabelais's world are themselves seen as culinary. Offering the right decision in the law is equivalent to hunting a hare; religious service proceeds on its stomach; a war is fought over the *fougasse*, a kind of bread baked differently by Gargantua's people and the bakers of Lerné. In the grand battle of the *Quart livre*, the enemy forces are Andouilles, or tripe sausages. On the island of Tapinois, the opposing monarch is named Quarêmeprenant, or King Lent, whose every move turns out to have cookery (though meatless) implications. Panurge inscribes on Pantagruel's battle trophy verses that begin with warfare but soon turn to subjects like carp, saddles of hare, and thighs of leverets, to which Pantagruel himself replies, "We have mused here too long about food: rarely do great feasters feature in feats of arms" (*P*, chap. 17, 131).

Yet if soldiers are not supposed to be gourmets (or gourmands), there is another profession—as suggested in the prologue to the *Tiers livre*—that is permitted yet more focus on the dinner table:

> Ennius wrote as he drank and drank as he wrote; Aeschylus . . . composed as he drank, drank as he composed; Homer never wrote fasting: Cato never wrote before drinking: so [declares the voice of the author] you cannot say I live without the example of men praised and highly esteemed. (*3P*, prologue, 408)

And Rabelais follows that example in the closing words of the *Quart livre*, which counted as something like a conclusion to the whole work.[29] The grand ending is signaled with SELAH, the somewhat mysterious Hebrew word generally glossed as the kind of sonorous declaration of finitude that is to be followed by a celebratory drink.[30] He certainly earned it.

What emerges from this vast epic of consumption is that food and drink, with their tradition of copiousness from Athenaeus to Erasmus and beyond, become the underlying force that enables Rabelais to stage a world of excess. It is as though the very concept of gigantism as it emerges in the lineage of Pantagruel and Gargantua is the consequence of swallowing gastronomic textuality (and gastronomy itself) whole. The culinary story goes back to family origins. Gargantua's father, Grandgousier, liked to drink and, especially, to eat salty things, for which Rabelais gives us yet another copious listing (Westphalian and Bayonne hams, smoked tongue, eels, salt beef with mustard, mullet roe, sausages, etc., etc.). No surprise, then, that Grandgousier's offspring, Gargantua, should come out of the womb already as a big drinker.

bronze and lead weighing more than great anvils, at which Nature herself was aghast, confessing herself beaten by Art, despising as she does the practice of the Oxydracians, who, in the midst of the field, vanquished their enemies and caused them sudden death by exploiting thunder, lightning, hail, great flashes of light and storms. (*4P*, chap. 61, 849)

From this account of the carnage of modern war, still under Gaster's influence, Rabelais proceeds to technological science fiction with a series of inventions that freeze bullets in midair or turn them back on those who discharged them, followed by something more like botanical science fiction with the discovery and exploitation of herbs and trees that have various miraculous abilities to wound the enemy or to heal the injuries of combatants on one's own side of the struggle.

What we are witnessing is a dizzying series of turnings in this portrait of Gaster's powers. Having first demoted and degraded the god, Rabelais builds him up again as the very principle by which human civilization arises out of savagery. Then—the story is an old one, all too well known in post-Rabelaisian centuries—civilization proceeds to attain its greatest advancement in weapons of mass destruction that revert the human project back to a savagery worse than anything in its stone age infancy.

Why place Gaster at the center of this age-old fable? The example of Ficino's commentary on the *Symposium*, with its transcendent account of love making the world go 'round, offers Rabelais here a suitable object for parody. In effect, the substitution of the belly for both *eros* and *philia* derails the project of human history from any ladder of transcendence and transforms the subject of love into that of self-love, but a self-love understood in the crassest terms of satisfying one's own physical appetite and shitting out the results in the end.

However we are to understand the cosmic import of this Gaster-nomic world history, the chapters immediately following the visit to the belly god turn the business of eating and drinking in yet a different direction. Pantagruel's ship sails onward but soon finds itself dangerously becalmed, and a mirroring sort of lethargy seizes the whole crew, who occupy themselves first with useless and trivial activities and then with a series of questions that Pantagruel declines to answer on the grounds that "a hungry belly has no ears"—in other words, that in their current unfed state they will not pay attention to any answers that he may offer. But this mood of utter lassitude, in which time seems to stand as still as the becalmed ship, is about to be broken. Pantagruel asks what hour it is, Epistemon replies that it is nine o'clock, and Pantagruel declares, "That is the right time for dinner" (*4P*, chap. 64, 857). The belly, we are told, is the people's timepiece (since the people can't afford watches or clocks), and the condition of stasis—experiential for the characters and narratological for the readers—is soon remediated with a customarily Rabelaisian gastronomic spread. We are reminded that one of those earlier conundrums (a particularly pressing one, given their situation) Pantagruel declined to answer was "How to raise good weather?" And the answer is manifested: they have raised up good weather by the simple act of eating and drinking, a circumstance that is cinched by a "popular saying":

Good weather is raised and the bad weather passes,
Whilst round a big ham we all raise our glasses. (*4P*, chap. 65, 863)

Le temps mal passe, et retourne le bon,
Pendant qu'on trinque autour de gras jambon.

In the logic of the *Quart livre*'s narrative, it seems that the onward sailing ship acts as the experiential antidote to the theogonic vision of the belly god in the previous group of chapters. After all, we arrive at Gaster via a prologue of eight hundred pages under the rule not so much of Plato and Ficino as of Pliny and Athenaeus, which is to say, in a milieu where the fruits of the earth and the productions of gastronomy have counted as producing joyous (if grotesque) exuberance and communal well-being. And Gaster's title, Master of the Arts of the World—even if downgraded into the arts of (merely) *this* world—serves as a reminder that the production of all these consumables counts as a grand human adventure. Rabelais, whether he knew it or not, was providing another response to that Socratic problem in the *Gorgias* concerning the question of cookery and techne.

The matter becomes quite explicit, and gastronomical, in Rabelais's account of his young hero's education. Gargantua's tutelage includes didactic mealtimes spent discussing

the qualities, properties, efficacy and nature of all the things that had been served up at table: bread, wine, water, salt, flesh, fish, herbs and roots, as well as how to prepare them. In doing so they quickly learnt all the relevant passages in Pliny, Athenaeus, Dioscorides, Julius Pollux, Galen, Porphyry, Oppian, Polybius, Heliodorus, Aristotle, Aelian and others. When talking about such things, they would have the books of those authors brought to the table for greater certainty. (*G*, chap. 21, 280)

This account of the "arts of this world" is a scene not merely of excess or corporeality or idolatry, whatever dark implications may be attributed to Gaster and his worshippers. Rabelais is here offering us a glimpse of gastronomical humanism. And he is able to sketch this scene not only because all the authorities he lists are being rediscovered and scanned for their writings about food and wine (among other things) but also because gastronomy itself, and not just culinary moments inside larger narratives and natural histories, is at this early Renaissance moment beginning to assert its own right to the title of techne, its own version of the whole world (or, in this case, certain privileged parts of the world) as a feast. Athenaeus, let us say, stands as antiquity's hungriest eye; Rabelais, then, may deserve that title for the Renaissance, not only for the sheer quantity of space devoted to eating and drinking in his multivolume work but also for the radically contradictory ways in which he embodies this subject. In our sequence of gastro-philosophers debating dinner, Rabelais is the philosopher of cuisine arguing with himself.

4.2. Platina (Bartolomeo Sacchi), Title page of *De honesta voluptate et valetudine*, Cologne, 1537

3

If Rabelais in the 1550s is able to imagine a world ruled by the belly and Montaigne in the 1580s is able to imagine a garrulous chef who believes he possesses the key to a scientific master narrative, it is in part because gastronomy is notably making its own ambitious claims for comprehensiveness and mastery. There were, in other words, beginning to be voices whose copious discussion of food could not be so easily dismissed as that of the boastful chefs in the tradition of comedy. Some quite sophisticated texts devoted to the culinary arts, for instance the Latin *Liber de coquina* and the Italian *Libro per cuoco*, emerge by the early fourteenth century.[35] They are necessarily in manuscript rather than printed form, and they tend to consist simply of recipes. Exactly what kind of authority they claim and what sort of circulation they may have had as practical information for professionals in the field is not easy to determine. But at some point in the 1460s, a work is composed that can qualify, at least regarding the world of cuisine, as the sign of the Renaissance.

It may be no coincidence that the breakthrough work melds the voice of a philosopher with that of a chef. Bartolomeo Sacchi, called Il Platina, author of *De honesta voluptate et valetudine*, may possibly have never boiled an egg in his life, nor had he (unlike a number of those who wrote books of cuisine later in the Renaissance) ever managed a household staff among whom others boiled eggs (fig. 4.2).[36] He was in fact the *compleat* humanist; though others may be more famous in the many constituent

fields, he could certainly be considered the absolute Renaissance man. He was a soldier in the employ of condottieri; he was a student of Ioannis Argyropoulos, and therefore something of a Hellenist; he wrote an epitome of Pliny's *Natural History*; he operated for many years in the orbit of the Gonzaga family; he flourished so well as a classicizing scholar in the world of Pomponio Leto and Pope Pius II that he was suspected of paganizing tendencies; he served a time in prison once Pius was succeeded by Paul II and the winds started to blow in decidedly anti-humanist directions; his fortunes were revived under the more culturally liberal Sixtus IV, during whose reign he balanced his classical studies with the (ultimately incomplete) composition of a history of the Popes; and he finished his career as the prefect of the Vatican Library, his appointment to that office immortalized in a painting by Melozzo da Forlì (fig. 4.3) that stands as a masterwork of *all'antica* perspective. In sum, a scholar, a soldier, a courtier, a polemicist, a bibliophile, and a sometime victim and sometime victor in the dangerous game of politics as played in Renaissance Italy.

Nothing in this profile screams cuisine. In fact, when Platina speaks of the project's origins, he relegates it in the traditional way to the world of *otium* rather than *negotium*—the work that the public man does with his left hand while in a state of relaxation. "Do not scorn these rural musings of mine," he declares to the book's

dedicatee, "which I wrote in a Tuscan retreat while staying with the most famous and eminent Father Francesco Gonzaga" (103), thus not only reminding the reader of his social connections but also linking the project to the most famous "rural musings" of antiquity, Cicero's *Tusculan Disputations*, composed in the same bucolic landscape. Yet again, the culinary project is framed as marginal in relation to the earnest business of public and/or intellectual life. And yet again the margins turn central: his lives of the popes, his history of the Gonzagas, and his exposition *De vera nobilitate* never became widely known, but the rural musings about cuisine went through fifteen early editions in Latin plus countless versions in translation to Italian, French, and German.[37]

There may be no more important fact about *De honesta voluptate* than this account of its bloodlines. That the book is written by a humanist and—an extraordinary gesture indeed—in Latin gives it authority of a kind that no mere cook or steward can assert, as its active publishing history suggests (at least until cooks and stewards gain prestige some decades later, as we'll see). Even more important, it is written with what we might call a humanist epistemology. The knowledge that it claims does not derive merely from experience—once again, Platina has never worked in a kitchen, though we'll see that he has ways to circumvent this limitation—but from the authority of a long textual genealogy. From our perspective in the aftermath of the scientific revolution, that may seem like a backward or anti-progressive move, an emphasis on precept rather than experience, but at this moment of High Renaissance humanism a decisive gesture that binds the contemporary world of kitchen work to a history of canonized texts (whether culinary or not) makes its own kind of revolutionary and authorizing statement. Once again, it's the prospect of a techne in the art of gastronomy that bestows real prestige on it.

So what is Platina's humanist textual practice in the *De honesta voluptate*? The book presents itself in a pair of scientific traditions. It is a work of natural history: the taxonomy of stone fruits; classical perspectives on cinnamon and pepper; the life cycle of cranes, storks, and swans; the family tree of edible fishes and anecdotes about them as recorded in the canonical texts. And, secondly, it is a book about health: the dangers of too much salt; the difficulty of digesting melons; the humoral property of egg whites (cold) and yolks (hot), which determines their effects on the body; the usefulness of nuts in treating rabies or of wine-soaked polenta for sciatica or of elderflower in cases of chest pain, disordered liver, melancholy, and hemorrhoids. In this respect, Platina is ransacking the great classical tradition of writing about the physical world. He often advertises these legitimizing sources, reporting what Theocritus had to say about fruits or Galen and Valerius Flaccus about carobs, or Virgil about kidney beans. From Pliny, Varro, and Columella he liberally appropriates, and occasionally challenges, pieces of information—the proper classification of quinces, the possible toxicity of peaches— sometimes naming the source, sometimes not. All these experts converge upon what one might call the two more respectable disciplinary neighbors of gastronomy: natural history and medicine.

Two other important sources for Platina's work play a larger, and quite different, role, however. The text that was eventually given the name *De re coquinaria* and credited to Apicius, is the unique surviving example of an ancient cookbook.[38] The

authorial attribution is fanciful: Marcus Gavius Apicius was a celebrated first-century Roman gastronome with a lurid tale of suicide once he was reduced to poverty and unable to afford gourmet delicacies.[39] The text issued under his name was neither authored by him nor contemporary to him; it is generally thought to have been compiled in the fourth or fifth century and attached to his name by way of bestowing classical authority upon it. Its preservation—or rather the preservation of several overlapping texts with the same attribution—is owing to a particularly voluminous manuscript production, which suggests a quite fervent interest in cuisine among groups of medieval monks.[40]

The Apicius text is a remarkable combination of encylopedism and practical instruction. The several hundred recipes are composed in so user-friendly a manner that many of them can be executed quite easily in the modern kitchen. Not all the ingredients are available to us, of course, but the tone of address to the reader is encouraging and flexible in a manner that would do credit to the successors of Julia Child, or even Betty Crocker. "How to Make a Frittata of Anchovies If You Don't Have Anchovies" (4.12); "How to Make One Ounce of Silphium Last Indefinitely" (1.10); "How to Keep Meat Fresh as Long as You Like without Salting" (1.7; the text of which admits that in the summer the technique doesn't work very well). Even the inclusion of specific quantities for the ingredients—the matter that generally separates premodern cookbooks from those we are accustomed to using—is not unknown here: in the book's very first recipe, for *Conditum paradoxum*, nicely translated as "Spiced Wine Surprise," we are told the precise amount of honey, pepper, mastic, and sweet wine to use, and we are given advice about what to do in the event that the resulting concoction tastes bitter. At the same time, the text presents itself as anything but a casual compilation. There is a wealth of medical and agricultural information, a recognition of culinary difference along a wide swath of geography, and the use of fancy Greek subtitles, some of them apparently invented for the occasion—*Epimeles* (the diligent chef), *Sarcoptes* (chopped meat), *Cepuros* (the gardener), etc.—to suggest, sometimes with graceful indirection, the subject matter of each book.

No surprise that Apicius functions for Platina less by providing quantities of specific information and more as a model for larger matters of structure and classical authority. Like Apicius, Platina divides his work into ten books, four of which are on the same subject and in the same order as his classical predecessor. Detailed borrowings explicitly credited to Apicius are infrequent, but in one case—quite unique in the *De honesta voluptate*—the stakes of the relationship become clear. The subject is *cibaria alba*, or blancmange, and the entry includes an elaborate recipe that is followed by a personal observation:

> I have always preferred this to Apician condiments, nor is there any reason why the tastes of our ancestors should be preferred to our own, for even if we are surpassed by them in nearly all arts, nevertheless in taste alone we are not vanquished, for in the whole world there is no incentive to taste which has not been brought down, as it were, to the modern cooking school, where there is the keenest discussion about the cooking of all foods. (6.41)

The classical example of Apicius has given the humanist Platina the opportunity to exceed the greatness of classical examples. The choice of this particular recipe as the locus of Renaissance self-expression is not accidental. Platina's blancmange (see the Monty Python sketches alluding to its dreary ubiquity at children's fetes, though with—one presumes—rather different ingredients), given its strange mixture of pounded capon, boiled almonds, and rose water, owes far less to the saucing styles of antiquity than to medieval, even Arabic-influenced practices.[41] This, then, is the humanist project in tooth and claw: the ultimate purpose of our veneration in regard to antiquity is being able to assert that by invoking its example we can exceed its greatness.[42] We signal this golden age of ours in the gastronomic field by the fact that the one area in which we are superior is *gula*—here translated as "taste" but with a field of possible meanings that range from the exquisite discriminations of the palate to the excesses of gluttony;[43] we also signal our modern primacy by the fact that among us cuisine is "acerrime . . . disseritur," most keenly discussed.

It is significant that what immediately follows the above *obiter dictum* is Platina's grandiloquent assertion of his other principal source. That general milieu of intense gastronomic conversation soon devolves into one particular discussant:

> What a cook, oh immortal gods, you bestowed in my friend Martino of Como, from whom I have received, in great part, the things of which I am writing. You would say he is another Carneades if you were to hear him eloquently speaking ex tempore about the matters described above.

So significant is this individual that he merits a (polytheistic!) classical oath—*dii immortales*—and the association with an ancient prototype, though the individual Platina chooses for that purpose, who headed the Platonic Academy in the later second century BCE and in fact criticized Epicurus for being too interested in what he ate, is quite curious.[44]

The truth of the matter is that Maestro Martino's enormous contribution to Platina's work is at the farthest remote from classical example. He is, in fact, the missing link in the evolution of that prodigiously accomplished Italian chef whose conversation so irritates Montaigne. Pliny, Columella, and Varro provide highly relevant information relating to natural history and medicine, though their writings were not specifically culinary;[45] Apicius provides the model of an ancient cookbook with a properly rationalized structure; Platina himself is the Renaissance humanist. What is missing is someone who actually works in the kitchen, preferably with a reputation for exercising his skill among the same sort of princely clients as those in the milieu where Platina plied his more elevated humanistic trade. Martino abundantly fits the bill with a history of distinguished service to powerful figures across the Italian scene, notably Ludovico Trevisan, cardinal patriarch of Aquileia, as well as the condottiere Gian Giacomo Trivulzio, both of whom gave celebrated banquets.[46]

Given this princely pedigree, one might come to the reading of Martino's work expecting the secrets of extravagant banqueting such as he dispensed to his powerful patrons, and he does at one point offer "how to dress a peacock with all its feathers, so that when cooked, it appears to be alive and spews fire from its beak," a piece

of medieval culinary showmanship that may have been obligatory, like many recipes in modern cookbooks that are intended to be read rather than executed. But when Martino puts his reputation on the line in print, it is generally as the most patient of guides speaking to the most basic of kitchen workers: "remember to serve this meat in large chunks"; "do not stop stirring until you have said ten Lord's Prayers"; "be careful that you do not make the broth too salty"; "because such a pottage can easily burn, in case it does, remove the burned taste as follows . . ." In place of exaggerated expenditures, he thoughtfully explains how to make one squab appear as though there were two, a trick that is achieved by producing a stuffing and stretching the bird's skin into squab shape over the whole composite mess. It is ultimately this common touch that Martino's work offers. And he offers it liberally: of the 250 recipes that validate Platina's work as a cookbook, 240 are copied directly from Martino. On many occasions, Platina adds the missing elements from natural history or medicine to the otherwise verbatim text of Martino, thus helping to build his complete account of the gastronomic project. But Martino's part in the mix is the part devoted to the pleasure of *gula*, of good taste.

These importations are, of course, not really verbatim: Platina has to translate Martino's vernacular into Latin, a topic on which he discourses explicitly at the beginning of his penultimate book. His subject at that moment is the humble fritter, and his material is taken directly from Martino's fifth chapter, which begins with "Frictelle de fior di sambuca." Platina has made what would seem to be the wholly unremarkable choice of rendering the Italian *frictella* as the (identical) Latin *frictella*, and before even arriving at Martino's first example of the fritter, he meditates defensively on the question of translation, insisting that he is compelled "by nature and legal right" to "propagate his kind," which seems to characterize his reproductive activity as the procreation of new humanist Latin for old Italian. And, true to this tenet and to his humanist learning, he refers to the frequently cited lines near the beginning of Horace's *Ars poetica* concerning the right to create new words in Latin.[47] From there he goes on in the humanist vein of cascading classical allusion:

> I know that many will carp at me because I have introduced new names
> in this writing of mine, but I shall throw them rich morsels, as they say
> Hercules once did the barking Cerberus, so that, like rabid and starving
> dogs, those who are always hanging on to me may shift their dog's bites
> from me, for a time, to gluttony. (9.1)

The *offae praepingues* with which he is throwing his scholarly enemies off the track are, in fact, morsels of fatty food, which in effect construes his critics as rabid gluttons— that is, Cerberuses; and by heading this section "On Tidbits Which We May Call Fritters"), he turns the fritters themselves into diminutive pieces of culinary information. It may be only a step away from considering all readers of cookbooks as textual gluttons.

There is another way in which Platina imports the humanistic project to the cookery book. It will be recalled that in declaring that modern cooking deserved to stand alongside, or even exceed, that of the ancients, he made reference to the "keenest

discussion about the cooking of all foods." In fact, he weaves a voluminous quantity of that discussion into the pages of his recipe book, and the method is itself in the high humanistic vein.

Dozens of these recipe entries include references to Platina's friends, establishing a whole range of relationships between particular dishes and particular people. Often, as one might expect given the traditions of writing about cuisine, Platina is publicizing his friends' medical conditions as appropriate or inappropriate to certain foods. Voconius had better not partake of gelatin in a dish because of his difficulties with bile (6.24); polenta will only add to Hirtius's problems with gas (8.31); venison threatens to make Brutus and Caelius even more melancholy than they already are (4.25); Philenus Archigallus, who seems to suffer on many fronts, had best avoid herb pie, "for it digests slowly, dulls the eyes, makes obstructions, and generates stone" (8.28). On the positive side, Caelius *should* partake of elderberry pie because of his melancholy and of meat pies because he is so inveterately skinny (8.32); and Glaucus knows enough to devour fruit and vegetable pies because they can help in his struggle with painful urination and impotence (8.30).

Health is not the only personal matter that particular foods expose. Gallus and Germanicus reveal their gluttonous tendencies by their attachment to force-fed chickens (5.10); Bibulus, whose name says it all, likes barbecued appetizers because they stimulate thirst (6.26). Flaming peacock had best be left off the menu when timorous (possibly by implication effeminate) Gellius is present, because he is afraid of fire (6.14). She-goat and kid are suitable to Augustus, who lives the high life, but not to Pomponius, who imitates the Pythagoreans in his self-denial (4.24). In fact, the same Pomponius is so poverty-stricken that he had better not try a recipe in which whole eggs are thrown on hot coals, because if he should lose any eggs, he couldn't afford to replace them (9.34). For the same reason, Pomponius himself serves exceptionally humble fare, which Platina characterizes via a complex conceit based on the cannibal feast in Ovid's story of Philomela, in which the rapist Tereus is made unwittingly to eat his own son:[48] "The table of Pomponius lacks this crime of tragedy, for he serves onions and garlic and shallots to his guests instead of Itys" (5.14). A display, in other words, of humanist kitchen wit.

In all these respects, eating habits, for which Platina is furnishing both a how-to book and an anecdotal history, are a key to his community. He recalls with pleasure dining on quail with his friend Julius, on Catalan *mirrauste* with Valiscara, and on marzipan pie with Patricius (6.13, 8.48). He also recollects—and this points to something quite surprising in the realm of elite socializing—a particular kitchen scene during the preparation of a dish of eggs cooked like fritters: "You know they are cooked when they begin to turn white. While he is eagerly preparing these, Callimachus makes us laugh, as he clings spellbound to the pan" (9.25). It is one of the rare indications that these lofty gentlemen were not merely gourmets in the Athenaeus style of the idle rich but actually did some of the cooking, and the detail about recognizing when to take the fritters out of the oil bespeaks a special level of hands-on experience.

Most strikingly, at the beginning of book 5, the moment when the recipes of Maestro Martino begin to be heavily inserted into the text, Platina invokes a whole vision of commensality. It is all very well, he says, to consume peacocks and pheasants,

though he deplores their ostentatious use by the nouveaux riches who have risen to undeserved prominence, but

> let my friend Pomponius munch onion and garlic with me, and let Serenus and Settemuleius Campanus be with us, and do not let Cosmicus spend the night outside our dining room. Let Parthenius and Podagrosus Scaurus follow him. I do not reject Fabius of Narnia, Antonius Rufus, Glaucus, and Tacitus, who embrace poverty of their own free wills. And so that Callimachus will not be angry with me, let Demetrius invite him to a vegetarian meal whenever it is pleasing to fortune, which, as the tragic poet says, is hostile to the brave and good and smiles on scoundrels and the lazy. (5.1)

This passage in the optative vein allows us to glimpse behind this remarkable cookery book a whole set of contexts that may have lain historically hidden, and intentionally so.[49]

All these invented names are ostentatiously classical for the obvious reason that they designate members of the Roman Academy, that institution dedicated to the revival of antiquity, which was headed by Pomponio Leto (the friend who can't afford to lose any eggs) and whose members were given to the wearing of togas, the celebration of Rome's birthday, and the inscribing of names and texts on the walls of the catacombs, locations where they were said to be meeting in secret. But the made-up names are doing double duty; they act as protective cover, given the radical nature of the humanistic project among these individuals. Commensality, in short, was a mixture of pleasure and danger.

The pseudonyms did not in the end protect these individuals very well. At carnival time four years into his papacy, Paul II received what is now generally thought to have been quite dubious intelligence that there was a plot to murder him and that it included the prospect of an entry into Italian affairs by Mohammed II.[50] The pope's suspicions centered on the members of Pomponio Leto's academy and most particularly on Platina, who had already run afoul of the pontiff four years earlier and spent time in prison. The result was a general persecution and imprisonment of the humanist group, whose members, even if they didn't conspire to murder the pope, were understood to be guilty of the three Hs: humanism, heresy, and homosexuality. Some were lucky enough to take flight into exile just in time, others escaped but were brought back, and a considerable number, notably Pomponio Leto and Platina himself, were sent to the dungeons of Castel Sant'Angelo and tortured, in an attempt to extract confessions, though in the end no one confessed to anything.

What do these dangerous cultural activities have to do with *De honesta voluptate*? To the extent that anyone has asked this question, the cookbook has generally been understood as largely irrelevant—something produced earlier and with a subject matter too marginal and frivolous to merit association with political terror. There is evidence for a closer connection, however. Platina, it will be recalled, speaks of his summer in Tusculum as the happy occasion of the work's composition. This would appear to have been in July 1465, which locates the writing—or at least the beginning

of the writing—a mere six months after his release from incarceration in Castel Sant'Angelo. An undated letter to Cardinal Ammannati written from prison, most probably during the second and longer confinement of 1468–69, brings the book and the fortunes of the author closer together:

> Before my captivity I wrote that poor little book *De honesta voluptate* which I am sending to your Eminence. Its patron "captured," as you will see, it seems to have crawled through ointment-shops and taverns, for it is besmeared and dirty. If it has been directed toward cooking, it has not departed from talent, since it has been composed in great part about preparing foods, and has reached the point to which it knew it was called. It finally came to me filthy and besmeared; while I am wiping away the stains, I realize some even have to be dug out. Really because in our own works we generally use judgment, being men who are out of tune with our times, I decided to send this terrifying little book (surely it is animated with the keenest of talent) to the threshold of Your Eminence even if you are unwilling.[51]

There are the usual humble claims that go with any such ritual gift—the letter goes on to urge Cardinal Ammannati to change anything in the manuscript that needs improvement—but what is unmistakable is, first of all, the insistence that cooking can go with talent and, second, the close association between the catastrophe of Platina's downfall and the state of the "terrifying little" book itself, with the severely damaged manuscript being a stand-in for the author.

Wherever we are to place the composition of the book (or of this letter) in relation to Platina's political fortunes, there seems no doubt that the evocation of glorious dinner parties among his academy friends is a very direct response to the recent (or imminent) collapse of all that humanist affection and commensality. By early 1468, the world had changed.[52] Petreio, who doesn't like elderflower even though it would be good for his health, and Glauco, who cooks his ham in water because he doesn't drink wine, have fled Rome; Marsi, who should eat porridge in order to cure his cough, is in chains in Castel Sant'Angelo; and Callimachus, who made them all laugh by the way he flipped his fritters, has quite possibly been the person who ratted out the whole group.[53] Platina himself, who has dutifully accepted the sentence left over from the previous incarceration that he not leave the city, is therefore arrested at the home of Cardinal Gonzaga—irony of ironies—while at dinner. That imaginary banquet of garlic and onions with a long list of wished for companions turns into something like those Platonic dialogues in which Socrates is brought back to life after having been executed by order of the state;[54] and Platina's choice of publishing a long, scholarly, and affectionately witty book about food and friends begins to look, whether in the moment of its composition or in retrospect, something like a revolutionary act.

I have discussed Platina's text at length—and there is yet more to come—because I believe it to be the most important work on the subject in the Renaissance, both in itself and in the way it demonstrates the broad possibilities for placing food and drink on the table of the humanists, in both the literal and figurative senses. Not perhaps

Athenaeus's table of sophists, who enfolded gastronomy in layer upon layer of literature (though Platina is certainly indebted to the *Deipnosophistae*), but a group of individuals who, under the tutelage of a *magister ludi* who was as learned in the correct manner of producing blancmange as he was in the culture of the ancients, labored to install food and drink at the center of their academic and social project.

There was never again—and certainly not in the early modern period—a gastronomic text with the same sort of cultural breadth that characterizes *De honesta voluptate*, with its blend of Renaissance humanism and practical instructions. The future, as in so many disciplines and so many historical epochs, belongs rather to the more narrowly focused professionals than the philosophers. After all, the exemplary encounter that Montaigne chronicles was not with a wandering classical scholar but with a chef in the employ of Cardinal Carafa. And it is those professionals, typically in the service of either princes or else princes of the Church, who take over the business of producing the kind of books that confirm the encyclopedic gravitas of the art of cuisine.

The consequence is that during the middle and latter years of the sixteenth century there is born a fully fledged and voluminous discourse about gastronomy composed by individuals who heavily advertise their majestic credentials and produce massive, frequently illustrated volumes to prove it.[55] In 1552, for instance, Cristoforo di Messisbugo publishes his *Libro novo*, which sports a thirty-six-word title that promises recipes for every sort of food, selected by the right occasion, and also how to organize banquets, produce table settings, furnish palaces, and decorate chambers for great princes. The book declares its utility for *maestri di casa*, *scalchi*, *credenzieri*, and *cuochi*, which affords us a glimpse of the burgeoning professional diversification in this industry: masters of the household, stewards, pastry chefs, and cooks. Domenico Romoli, known as Il Panunto, publishes his *Singolar dottrina* (1560), whose even more prolix title page speaks of flavoring all foods, following the seasons, discussing the nature of meats, fish, and all animals, as well as offering expert advice on health; it will be, he says, "utile a tutti."

But the monumental work that perhaps more than any other Renaissance text cinches the status of cookery as a discipline of immense breadth and systematization, is the *Opera* of Bartolomeo Scappi, which went through at least nine editions between 1570 and 1646 (fig. 4.4).[56] The sheer bulk and breadth of this volume is mind-boggling: the moral and technical education of an apprentice kitchen worker; 281 recipes for meat days, 286 recipes for lean days; a roster of more than a hundred specific dinners, detailing the occasion and the most important guests, each meal with its menu numbering as many as ninety separate dishes, including the quantities of each; a discussion of kitchen equipment, including what is required when meals have to be served on the road; 237 recipes for pastry; 218 recipes suitable for the sick. In addition, one appendix detailing the caterer's-eye view of Pope Paul III's funeral and the subsequent conclave that elected Julius III, and another appendix with twenty-seven quite spectacular engravings covering the architecture, the equipment, and the operations proper to the kitchen and its service (figs. 4.5, 4.6, and 4.7).

That inclusiveness tells its own story; again, one might speak of operating under the sign of Athenaeus but now in real practice. At the grand princely court, every

4.4. Bartolomeo Scappi, Title page of *Opera di M. Bartolomeo Scappi, cuoco secreto di papa Pio V*, Venice, 1570

detail of every formal meal is worth recording and tracing back to its origins, both in the raw materials and the technology used to transform them. Culinary operations have developed their own specificities as appropriate to the seasons, the liturgical calendar, and the state of health among the diners, this last matter suggesting that the chef is something of a physician. Most important of all—at least if we assume that politics is the master narrative—the entirety of this gastronomic production is so essential to statecraft that it is legitimate for a "mere" steward/chef to produce his own account of papal succession as seen from the kitchen. And succession is very much in the forefront of Scappi's own milieu. There is a barrage of dedicatory letters in the opening pages—Pius V, Cosimo de' Medici, Don Francesco de Reinoso, Pius V's *scalco*, and therefore Scappi's boss—but once the text proper begins, it is staged as though the whole thing is a conversation with his apprentice Giovanni. The premise returns intermittently, and it clearly serves to locate the entire subject of Scappi's profession as worthy of guild status and of being passed along through the generations. The wider stated premise—since it was hardly necessary to publish a book just for Giovanni—is presumably the formation of multiple Giovannis, and therefore eventually Scappis, throughout the world.

I have made a distinction between professional humanists and professional chefs even though Platina's text fuses them, but there is a further indication of just how permeable this border could be in the words of a learned and articulate contemporary observer, the Paduan humanist Sperone Speroni, who composes a lengthy paean to "the *virtù* of the cook."[57] He must be temperate in not eating his lord's food, powerful in carving meat and fish without fear, just in assigning portions, prudent

4.5. Bartolomeo Scappi, Main kitchen, from *Opera*, plate 1

4.6. Bartolomeo Scappi, Scullery, from *Opera*, plate 3

4.7. Bartolomeo Scappi, Cooking utensils, from *Opera*, plate 10

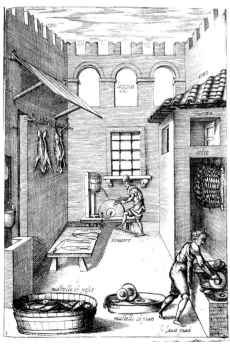

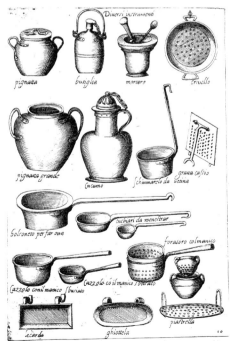

in determining cooking times, generous with spices and sugar, and eloquent when defending himself from criticism. "A poet for singing verses, . . . a geometrician for shaping tarts, . . . an arithmetician for keeping track of his pots and pans, . . . a painter for giving the right color to roasts and sauces, . . . a physician for knowing what is easy and difficult in the digestion of foods." There is no sign of mockery here, such as we saw when Ben Jonson took advantage of this trope, only respect and awe.

Yet one more thread in this complex weave: the professional philosopher, leading us back to debates over dinner. An unspoken first cause lies behind this explosion of gastronomical *virtù* in the Renaissance and its energetic sponsorship at centers of power. To understand it, we must address ourselves not to the chef but to the humanist, and we need go no further than the title of Platina's book. It has recently been energetically argued that the discovery of a manuscript of Lucretius's *De rerum natura* by Poggio Bracciolini in 1417 had a world-changing effect on Renaissance culture—indeed, on modernity itself.[58] Whatever the global consequences may have been, there is no question that within the world of Italian humanism, the doctrines of Epicurus, which had formed the basis of the Lucretian world view, exploded on to the scene at this time, as is evidenced by the publication in 1431 of Lorenzo Valla's dialogue *De voluptate*.[59] The body of the text includes several points of view on the legitimacy of pleasure, but the opening salvo, in Valla's own voice, makes his position brilliantly clear. Having recognized how controversial his position may be, particularly in the view of his "sage and serious friends," and having established, albeit somewhat obliquely, that his own behavior in life has been free of grossly hedonistic behavior, he makes his support of *voluptas* completely unambiguous:

> At this point this friend of mine might object: do you really mean to say that *voluptas* is the highest good? Yes, I say it and I affirm it and I affirm it to the exclusion of any other good except *voluptas*. Such is the thesis that I have decided to prove. If I shall succeed, as I hope and pray, it will not seem absurd that I have taken up this subject matter, or that I have so entitled my work. (151)

It is of course the language of fierce polemic, a shock tactic designed to catch the reader's eye with a breathtakingly unorthodox, even forbidden, set of claims. And it is noteworthy that not only is this paragraph excised from subsequent versions of the work but the title itself mutates into the more cautious *De falso et vero bono*.[60] In fact, all versions of the dialogue include speakers who do not subscribe to the radical premise about *voluptas* that Valla so clearly asserts as his own viewpoint in 1431, and scholars have ever since argued about his real opinion.[61] Nonetheless, the deliberately controversial opening, whose rhetoric seems to allow for no ambiguity whatsoever on the question of pleasure as *summum bonum*, will leave an indelible mark on the humanist conversation in the fifteenth century.

Epicureanism is thus suddenly on (as well as *at*) the table, and, as we saw many pages ago, a significant strand in that line of thinking would suggest that eating and drinking represent not merely one instance among many of *voluptas* but rather constitute the paradigm case. (As is also suggested by our use of the term *epicure*, which

applies not to the appreciation of sculpture or sonatas or sex but only to gastronomy.)[62] Thus when Platina plants *voluptas* in his title, he is entering a heated conversation. The discussants, including Platina's close friend Filelfo, have been following the example of Valla in parsing the concept of pleasure so as to remain within the limits of orthodoxy while also stretching those limits. Platina's own contribution to this delicate operation begins with his opening remarks, which are somewhat more cautious than those of Valla in 1431:

> I know well enough that the spiteful will speak out vehemently that I ought not to have written about pleasure for the best and most continent of men [his dedicatee, Father Baptista Roverella, cardinal presbyter of Saint Clement], but let those voluptuaries who pretend to be Stoics . . . say what evil well-considered pleasure has in it, for the term is neutral, neither good nor bad, as is health [*voluptas . . . ut valetudinis vocabulum medium*]. Far be it from Platina to write to the holiest of men about the pleasure which the intemperate and libidinous derive from self-indulgence and a variety of foods and from the titillations of sexual interests. I speak about that pleasure which derives from continence in food and those things which human nature seeks. (Milham, 101)

What we can perceive from this apologia is the very careful work that Platina has done in choosing his title and navigating in the difficult byways of gustatory pleasure (or any other kind). *Voluptas* is not a bad quality, it is a neutral term, just like *valetudo*. Pleasure and health, in other words, are not opposites, as whole traditions of moral learning may have suggested, but partners—thus linking this culinary book to a long history of texts in which the subject of cookery is validated by its association with medicine.[63] And *honesta* qualifies *voluptas* with the meaning "legitimate" or "permissible," further specifying the question of good and bad pleasure that had arisen out of Valla's radical treatise.

This conversation about pleasure will become central to Renaissance culture[64] and should be understood as the destination of culinary materials going back to Socrates's suspicions in the *Gorgias* and to the passionate culinary hedonism of the banqueting sophists. For many expressions of early modern culture, eating and drinking, whether under circumstances of grand elegance or of affectionate company (or both), will come to be understood as the paradigmatic circumstance wherein *voluptas* is deemed *honesta*.

4

In the debates over dinner, this notion of honest pleasure will find one of its great exponents in the perhaps unlikely person of Erasmus.[65] A group of friends, variously identified by their invented names as devout, learned, and eloquent, are gathered for a meal at the country house of Eusebius, where the surroundings are characterized in the traditionally sensuous terms of the *locus amoenus*, though the loftiness of the enterprise is signaled by the pious title "The Godly Feast." As their host describes his sequence

of interlocking gardens, they are revealed to be very much in the antique style, except that pagan elements in the traditional design have been replaced or reinterpreted via a Christian equivalent. Observing the bucolic scene, one of the guests, Timothy, comments approvingly, "Oh! These must be Epicurean gardens I see." To which the host replies, "This entire place is intended for pleasure—honest pleasure, that is" (178). As with so many moments in the *Colloquies*, the significances here are densely layered. The great Greek philosophers were identifiable by location. Plato had his academy, Aristotle his lyceum, and Zeno his location in the stoa. Epicurus met his followers in a garden.[66] In this way, the whole controversial baggage of Epicurean *voluptas*, as soon as it enters the discussion, is immediately characterized and portrayed as *honesta*.

In what direction Erasmus travels with this project of permissible pleasure will have much to do with his reading, which was (if possible) even more voracious than his writing was voluminous. What he has clearly absorbed on his way to producing the culinary occasions of the *Colloquies* is a whole set of late antique writings that were becoming the database for early modern views on ancient eating. Plutarch's *Moralia*, especially a group of dialogues under the rubric "Table Talk," and Aulus Gellius's *Attic Nights* are both rich with information about the systems and structures of the dinner table, and both were widely read in the Renaissance.[67] Neither of them gets us very close to the full culinary experience, however. And here Erasmus seems to have given himself access to what has become in these pages a familiar text, indeed a master text in the debates over dinner.

Our earlier discussion of Athenaeus's *Deipnosophistae* suggested that the work could tell us much about Renaissance inheritances on the subject of eating and drinking, even though it couldn't be proven that it was widely read in that period. There is one great exception to this silence. As Deno Geanakoplos has shown, Erasmus was afforded a warm reception during his stay in Venice in 1506 and was given access to a number of Greek manuscripts that had been seen by few other Western Europeans and were not yet in print.[68] Among these manuscripts was the *Deipnosophistae*. During this same period in Venice, Erasmus was also welcomed into the circle of the great Aldine printing house, from which the *editio princeps* of Athenaeus's work emerged in 1514, with a second edition appearing in 1517. In fact, we possess Erasmus's voluminously annotated copy of this second edition, and the payoff of that close reading is evident in Erasmus's gigantic enterprise of cultural recuperation, the *Adagia*, in which Athenaeus is mentioned by name or quoted on hundreds of occasions.[69] There is no author, before or after Erasmus, with anything like that density of citation of the *Deipnosophistae*. Anyone who read those volumes as closely as Erasmus did was either reading for the food or, at least, soaking up a great deal of food lore on the way to whatever other cultural searches he or she may have been undertaking.

So the pleasure that gets enacted in "The Godly Feast" (and, as we'll see, in several other colloquies) is less about gardens and *loci amoeni* than it is about dining. The occasion may be "godly," but the meal—again, we hear from Timothy on the subject—is "Epicurean . . . nay, Sybaritic." And we are not spared the details: eggs and greens to begin with; then, when the guests show some hesitation in digging into the principal courses, Eusebius, like any good host, issues an alluring set of encouragements:

I see you're slow to help yourselves, so with your permission I'll have the roast served. . . . You behold the main course of our little luncheon: a small but excellent shoulder of mutton, a capon, and four partridges. Only the partridges were bought at market; my little estate here supplies the rest. (189)

He proceeds to speak on behalf of wine and later to fuss over the fact that nobody is indulging in the dessert.

If the feast labeled as "godly" nevertheless advertises its menu, other less specifically sacred colloquies revel even more in their gastronomic materiality. "The Poetic Feast" features a culinary guessing game in which the shrewish maid Margaret tries to pass off beet greens as lettuce on the theory that poets can't tell the difference (she proves to be mistaken); this is followed by a discussion of the best medium in which to fry eggs (396–97). "The Profane Feast," a conversation among friends who are clearly long accustomed to communal festivity, begins with a question-and-answer session about Stoics and Epicureans that is clearly partial to the latter group: "The Stoics are a certain morose, stern, sour set of philosophers who measure man's highest good by some sort of moral virtue or other" (135), declares Augustine. And, later, Christian argues against philosophy in general, clearly preferring the pleasures of the table, to which Augustine replies, "You philosophize beautifully. Farewell, then, philosopher—not of the porch [i.e., where Zeno the Stoic philosophized] but of the kitchen" (139). Score one more against the Stoics. Along parallel lines, Augustine declares, to a general chorus of agreement, that "if I had to do without one or the other, I'd take cookery rather than rhetoric" (138), thus both revisiting and revaluing Socrates's viewpoint in the *Gorgias*. Yet it's no surprise that the entire discussion follows a rigorous training in the scholastic style of theological disputation, even if the Sorbonne, where they might have learned it, gets turned into a pun on "ab*sorb*tion"—that is, the soaking up of wine.

It's not all philosophizing about dining, however. It's also the food itself: the relative merits of beef, mutton, pork, and *foie gras*, the tastiest part of the hare, the exact means of carving a capon, including the age-old question about white meat versus dark meat, the possibility of identifying the exact location where different oysters were harvested. These are learned and discriminating diners, as is clear from Augustine's response to the roast goose: "I've never in my life seen anything drier; it's drier than pumice or even Furius' stepmother, whom Catullus makes so much fun of. Seems just like wood to me" (142). And wine, always the supreme gastronomic instance of discriminatory expertise, receives careful analysis by Christian:

CHRISTIAN. There are famous gourmets who deny that wine deserves approval
 unless it pleases the four senses: the eyes by its colour, the nostrils by its
 fragrance, the palate by its taste, the ears by its name and fame.
AUGUSTINE. Absurd! What does reputation do for drink?
CHRISTIAN. So much that many men of taste have been loud in their praise of
 a native Louvain wine they'd taken for Beaune. (136)

The connoisseur who composed these lines (Erasmus makes dozens of references to the wine from Beaune in his writings)[70] knows how to distinguish between one of the

world's greatest red wines and some insipid local plonk, even when the label is missing; and he also knows how easy it is to be fooled.

Yet more gastronomic data are to be found in the "Feast of Many Courses," which has no other subject than the planning of a dinner party. The expert, given the name Apicius (an allusion that Erasmus sprinkles quite liberally through his work, with the clear expectation that it will be recognized), instructs his interlocutor Spudus (a lawyer, hence perhaps by implication a culinary philistine) on the seating arrangements, the plating and serving of different foods, the diverse ways in which the host should address his different guests, and what to do if, despite all these efforts, quarrels break out (answer: send in the clowns, and if your guests speak different languages, hire pantomiming clowns). Two items from the barrage of Apicius's commentary that will hit home for those of us with a lot of hosting experience: "Nothing is more boorish than to call attention to what kind of food you have, how it's cooked, how much it cost. The same goes for the wine" (806). (Horace's Nasidienus and Petronius's Trimalchio cannot be far from Erasmus's consciousness.) And, from the host: "If I had spent as much time and labour on either branch of the law, on medicine and theology, as I have on this art, I'd have won LLD, MD, and DD degrees and been at the head of my profession long ago" (805).

Of course, as in many other cases, when we read Erasmus for the food, it becomes clear that there is more than food on his mind. To what extent Erasmus was a radical and where he stood on the broad and perilous spectrum of early sixteenth-century religious reform is a subject that cannot be easily nailed down, certainly not here.[71] What is clear, however, is that for him and his partly fictionalized friends, essential issues about Christianity itself, whether in its theology or in its practice, are to be explored via questions of eating and drinking.

The doctrinal point of entry, which was discussed in the previous chapter, is the argument between Jesus and the Pharisees. The insistence of the Jews that fidelity to God express itself via the following of elaborate rules, most of them dietary, comes to be read as a slavish relation to the sign rather than to the signified.[72] In these early moments of the Protestant Reformation (allowing for all the complexity of Erasmus's stand on these matters), it is the Catholic church that stands accused of a similar pharisaical attachment to the sign.

As Erasmus makes clear, the sign at issue here is what you may eat or not eat, and when; and, among the multiple voices of the *Colloquies*, there are many that express serious (if cautiously phrased) reservations about the rigors of this system. For instance, from "The Profane Feast":

AUGUSTINE. If I were pope, I would urge everyone to perpetual sobriety of life, especially when a feast day was near. But I would decree that a person might eat anything for the sake of bodily health so long as he did it moderately and thankfully, and I would labour to have the decrease in corporal observances of this kind offset by increased zeal for true godliness.

CHRISTIAN. This is so important, in my judgment, that we should make you pope. (146)

And, from "The Godly Feast":

SOPHRONIUS. Some find the priesthood to their liking, some celibacy, some marriage, some withdrawal from the world, some public affairs, according to their different constitutions and temperaments. Again, one man eats anything he likes; another discriminates between foods; another, between days; to another every day is the same. In these matters Paul wants everyone to enjoy his own preferences without reproach from anybody else. (186)

The experience of taste—literal taste, in this case—becomes an anchor for a notion of pluralism that goes far beyond the dinner table, while being anchored by that example. Along the way, Sophronius's argument cunningly sidesteps the dictates of the church regarding the operation of these differences, substituting personal choice. In fact, it matters little what real identities may be assigned to "Augustine" or "Christian" or "Sophronius": the eloquence in which these very liberal sentiments are couched is unmistakably that of the author himself. This fact was not lost upon many of his sterner contemporaries, including the theology faculty at the University of Paris (the Sorbonne, of ab*sorb*tion fame). In the 1526 edition of the *Colloquies*, Erasmus defends himself by declaring that "I do not condemn the ordinances of the church concerning fasts and choice of foods, but I expose the superstition of certain persons who attach excessive importance to these matters while neglecting those that contribute more to godliness" (1101). The Paris theologians remained unpersuaded, however, declaring in 1526 that sixty-nine passages in the *Colloquies* had the tendency to corrupt the youth.[73]

What is even more significant for our purposes than this dispute itself is the extent to which Erasmus pursues his argument on highly particularized grounds of food, diet, flavor, and taste. Before we arrive at any discussions of the law in "The Profane Feast," the talk is all about personal preference:

AUGUSTINE. Christian, do you prefer beef or mutton?
CHRISTIAN. I'm much fonder of beef, but I suppose mutton would be better for me. That's human nature; we're fondest of what is most harmful.
AUGUSTINE. The French are marvellously fond of pork.
CHRISTIAN. The French love what's cheap. . . .
ERASMIUS. I'm equally fond of mutton and pork, but for different reasons. Mutton I eat freely because I love it; pork I don't touch, out of love—lest I give offence.
CHRISTIAN. You're a fine fellow, Erasmius, and a merry one. Yes, I often wonder to myself how there happens to be such an immense variety of tastes. (139–40)[74]

As we have seen before, the subject of taste—with all that duality of meaning that troubled Kant—inevitably opens the door to a freedom from enforceable hierarchies of value. In short, the gastronomic equivalent of the priesthood of all believers, and a potential armistice in the debates over dinner (and over other subjects as well).

From this point of freewheeling individualism—*chacun à son goût*; *de gustibus non est disputandum*—the discussion slides over into something similar and yet with the potential for much graver import: meat versus fish.[75] There is no mistaking the

5

For others south of the Alps during these decades, "honest pleasure," with all its res-onances of embracing while also purifying the excesses of Athenaeus or Epicurus, arises in the context of a different sort of mealtime. When Platina entitled his culinary treatise *De honesta voluptate* and began it with the rehabilitation of Epicurus, he wasn't merely operating as a literary humanist; he was acting as the servant of a princely family, the Gonzagas, who were establishing their primacy and power in part via the staging of grand banquets. In the same vein and during the same years, the productions overseen by Cristoforo di Messisbugo on behalf of the Este family and those overseen by Bartolomeo Scappi on behalf of the pope and the cardinals were expressions of an ideology in which all the circumstances of dining—the carefully chosen company, the labor of the cooks, the theatricality of presentation, the magnificence of the visual array, and (perhaps to a lesser extent) the taste experience itself—were not only instru-ments of politics but also understood under the rubric of permissible pleasure.[80]

In a palace belonging, as it happens, to the nephew of the cardinal who was Plati-na's patron when he wrote his treatise, the issue of an Epicurean ideology gets spelled out explicitly, though with some twists. In April of 1530, the recently crowned Holy Roman emperor Charles V paid a state visit to Mantua, during which he bestowed the title of duke upon Federico II Gonzaga, who had hitherto been only a marquis. Courtesy of a contemporary Gonzaga courtier,[81] we have an extensive description of the festivities, which took place in the freshly built and decorated Palazzo del Te, Federico's suburban pleasure palace that was created under the supervision of Giulio Romano.[82] The climactic dinner—unfortunately, we have no specific record of the food, as it is described in merely formulaic terms as providing so much abundance and variety that it lasted for three hours, during which no one lacked for anything—took place in the banqueting hall of the palace,[83] upon whose walls there appeared (and still appears) the following inscription:

FEDERICUS GONZAGA II MAR[CHIO] V S[ANCTAE]
 R[OMANAE] E[CCLESIAE]
ET REIP[UBLICAE] FLOR[ENTINAE] CAPITANEUS
 GENERALIS
HONESTO OCIO POST LABORES AD REPARANDAM
VIRT[UTEM] QUIETI CONSTRUI MANDAVIT

> Federico II Gonzaga Fifth Marquis Captain General of the Holy Roman Church and Florentine Republic ordered its construction for his honest leisure after hard work to regain his strength in peace. (See figs. 4.8–4.11.)

The general import is clear. The building is itself a monument to relaxation, with the implication of past military service (Pope Leo X had appointed Federico a captain of the Church, owing to combat against the French in northern Italy), and this space in particular embodies the notion of well-justified repose.

For our purposes, it is the conjunction of banqueting space and *honestum otium* (in Italian, *onesto ocio*) that merits attention. Platina's *honesta voluptas*, including its own associations with dining, runs in the Gonzaga family, we might say; but its iteration in this alternative form may require a genealogy of its own. It is a feature of both phrases that the noun, whether *otium* or *voluptas*, embraces a wide range of implications, not all of which are positive. As a result, the adjacent modifier has some hard labor of its own in order to nail down the positive implications of the neighboring noun. In the case of *voluptas*, it is Christian moral theology that needs to be confronted, but in the case of *otium*, the negative pressure comes largely from *this* world—from the imperative to engage tirelessly in the sphere of public action. From the very beginnings of Latin literature, in the *Iphigenia* of Ennius, *otium* is contrasted with *negotium*, and that pair of rhyming opposites resounds through the ages.[84] In Roman antiquity, the *locus classicus* for this opposition is Cicero, who dreams of an escape from the contradictions of being a public man (with a career that, after all, ends catastrophically) and at the same time a philosopher; it is an escape he envisions via a condition he calls *cum dignitate otium*, under the assumption, one presumes, that imperial and senatorial Rome needed quite a bit of convincing that there was any dignity at all in retirement from political action.[85]

The issue of *otium* is no less of a hot potato in the years leading up to its installation on the walls of the Palazzo del Te. When Ariosto's Ruggiero is led away from heroic action by the witch Alcina and fails to reach Logistilla's kingdom of Reason, he is confronted by a fat drunk moving slowly atop a tortoise—the embodiment of *Ozio*, or Otium. And soon thereafter, Ruggiero is himself such an exemplar, in the words of Melissa:

> *stava in giuoco e in ballo*
> *E in cibo e in ozio molle e delicato,*
> *Né più memoria avea del suo signore,*
> *Né de la donna sua, né del suo onore.*

> he sport, dance, and banquet plied,
> And lapt in idleness and pleasure lay;
> Nor memory of his lord nor of the dame,
> Once loved so well, preserved, not of his fame.[86]

Not only the constituent activities of *otium* ("sport, dance, and banquet") but also its consequences (failure in feudal obligations, failure in amorous obligations) are clear from Ruggiero's case. If *ozio* here seems to be anything but *onesto*, the matter is even more decisively confronted in the work of Machiavelli, for whom it is a central principle that political power of the kind he values is at its most vulnerable when confronted with an ethos of leisure:

> *Perché avendo le buone e ordinate armi partorito vittorie, e le vittorie quiete,*
> *non si può la fortezza degli armati animi con il più onesto ozio che con quello*
> *delle lettere corrompere.*

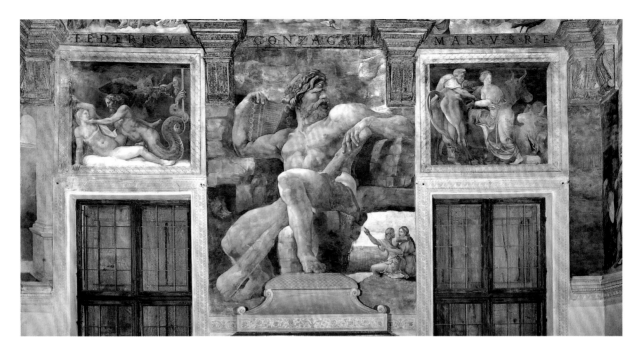

4.8. Giulio Romano, Zeus and Olympia (left), Polyphemus (center), and Pasiphaë (right), 1525. Sala di Amore e Psiche, east wall, Palazzo del Te, Mantua, Italy

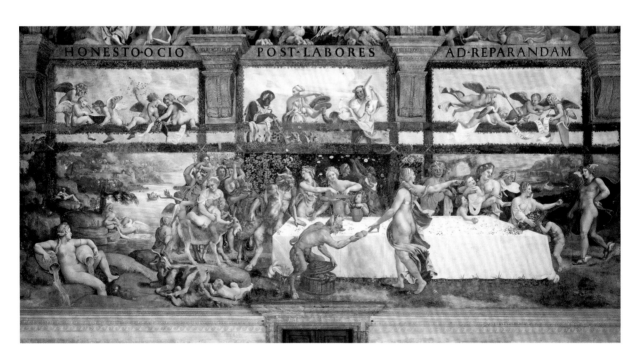

4.10. Giulio Romano, Banquet table and part of dedicatory inscription to Federico Gonzaga, 1525. Sala di Amore e Psiche, west wall, Palazzo del Te, Mantua, Italy

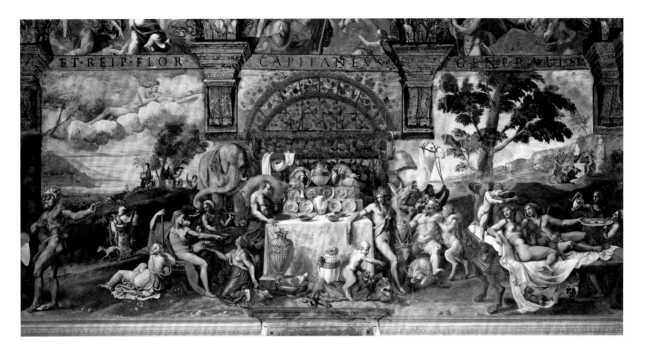

4.9. Giulio Romano, Banquet scenes and part of dedicatory inscription to Federico Gonzaga, 1525. Sala di Amore e Psiche, south wall, Palazzo del Te, Mantua, Italy

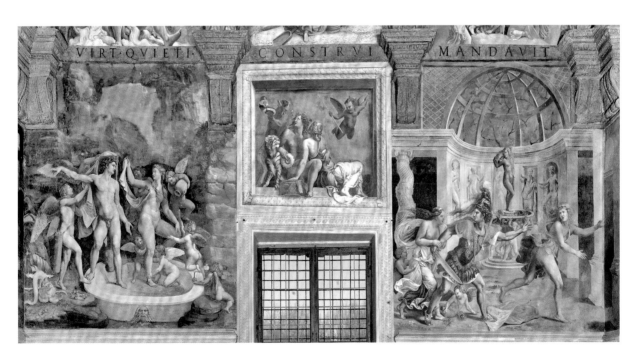

4.11. Giulio Romano, Adonis bathing (bottom left), Bacchus (Dionysus) and Ariadne (bottom center), Venus and Mars (bottom right), 1525. Sala di Amore e Psiche, north wall, Palazzo del Te, Mantua, Italy

Arms having secured victory, and victory peace, the buoyant vigor of the martial mind cannot be enfeebled by a more excusable indulgence than that of letters; nor can indolence [*il più onesto ozio*], with any greater or more dangerous deceit, enter a well regulated Community.[87]

He goes on to tell the story of Cato, who observed that when Athenian philosophers showed up in Rome, they garnered followers among Roman youth. And so, "knowing the evils that might arise to his country from this *onesto ozio*," he allowed no philosopher to enter the city of Rome. What renders Machiavelli's attack particularly forceful is that he condemns not just *ozio* but *onesto ozio*. Clearly, that term is already a catchphrase for a group of pursuits that are generally viewed positively but that Machiavelli finds supremely dangerous. In his opinion there is nothing *onesto* about it; in modern parlance, we might say "*so-called* honest leisure."

There are, needless to say, no quotation marks around the phrase in the Palazzo del Te. Federico Gonzaga's self-presentation flies daringly in the face of these critiques of *otium*, and the counterargument is staged with an ambitious visual program arising out of the story of Cupid and Psyche (figs. 4.8–4.11). The debate over dinner is given, in short, architectural form. What confronts the observer upon entering the banqueting space is some thirty or more narrative scenes in frames of half a dozen different shapes and sizes, the whole scheme united via complex geometry including a smattering of mythological narratives that have nothing to do with Cupid and Psyche.

No surprise that this brilliant and perplexing ensemble has given rise to energetic and diverse efforts at iconographic decipherment, especially given the Platonic and Neoplatonic complexities that readily attached themselves to a story from late antiquity in which (by one fairly obvious allegorization) the human soul rises upward to heaven on wings of Love.[88] And similar scholarly exertion has concerned itself with biographical decoding, since Federico was engaging in a very public affair with Isabella Boschetti, who was married to one of his courtiers and whom he at various times seemed on the verge of marrying, to the great consternation of his mother, the indomitable Isabella d'Este—a circumstance that lends itself to placement in parallel relation to the Apuleian triangle of Cupid, Psyche, and Venus.

If, however, we imagine a more naive contemporary observer—perhaps even Charles V himself—who may not be schooled in Neoplatonism nor interested in the gossip of the Mantuan court, it will nevertheless be unmistakable that the room is ablaze with erotic imagery, as the original story itself demands.[89] A beautiful young woman falls in love with Love; she is put through appalling trials, and her persistence is rewarded when she attains both heaven and her beloved. If we apply that simple account of the images around us to the less ambiguous element in the design—the words celebrating the marchese's attainment of virtuous *otium*—it becomes clear that *onesto ocio* may well involve more than the departure from the battlefield, suburban retirement, or the contemplation of beautiful art; it may also involve the fulfillment of erotic desire. If, in other words, by one reading of the myth Federico is equivalent to the highly desirable marriage prospect Cupid, he is by another reading the Psyche who achieves *onesto ocio* in suburban heaven as a reward for travails.

But there is a more commonsensical response available to our hypothetical (or imperial) observer. Why has our onlooker entered this particular space? Because this is the banqueting hall, and so *honest leisure* is not merely a term with various possible referents from philosophizing to chivalric pageantry, it is eating and drinking; further, it is not merely a phrase or an abstract idea, but, in the very space where the words are inscribed, it is a performed fact. The supremely permissible example of *onesto ocio*, in other words, is dinner. During his stay in 1530, Charles V did, in fact, dine in the company of Cupid and Psyche—possibly even alone, the better to contemplate this gastronomic form of *otium*.[90] But when, as on almost all other occasions, the room is fully populated, the Duke of Mantua has provided his guests with a triumphant image of an *otium* that could be publicly celebrated, whatever private—that is, erotic—forms might be subtextually understood. And dining is of the essence in the narrative itself. Within Apuleius's story, the triumph of Psyche is not just her entry to Olympus but a banquet among all the heavenly deities that is staged in honor of her marriage. That is the fitting conclusion to the story and the supreme logic whereby, so long as the dukedom of Mantua flourishes, the courtiers and guests assembled at the table amidst these frescoes will perform the role of the Olympian gods, at a dinner that is free of debates, having embraced *onesto ocio*.

To observe that logic in its purest form, we should consider the other great Renaissance banqueting space with a Cupid and Psyche program. The Loggia of Psyche at the Villa Farnesina in Rome is in every way the ancestor of the Mantuan chamber (fig. 4.12). Completed ten or fifteen years earlier, it was the collaborative work of Raphael and artists around him, notably Giulio Romano, who then took the lead in producing the later work for Federico Gonzaga.[91] In this case, the patron was not a member of the princely nobility but a supremely wealthy banker, Agostino Chigi, who had moved his operations from Siena to Rome near the end of the fifteenth century and managed to become economically instrumental to a succession of popes.[92] It is well nigh irresistible to draw a comparison between these two grand spaces—for instance, along the lines that separate a banker from a duke. Mantua boasted imperial visitors; Rome boasted expensive ostentation. Witness the oft-repeated anecdote about a Chigi feast in 1518 honoring the baptism of his son, at which the silver and gold dining vessels were tossed nonchalantly into the Tiber at the conclusion of each course, an act of (literally) conspicuous consumption combined with budgetary prudence, since Chigi had carefully arranged for nets to be stationed below the level of the water, thus allowing his servants to retrieve the valuable property once everyone had gone home.[93] As we'll see, tableware plays quite a different role in Mantua; we'll also see that in each case there is something more than Cupid and Psyche—and something quite different—that encourages reading for the food.

The presentation of Cupid and Psyche in the Farnesina loggia is in every way more straightforward than the Mantuan version. Considering the involvement of Giulio Romano in both projects, we might even speculate that the artist, having been an assistant in Rome and taking part in a quite linear rendition of the Apuleian narrative, has decided to orchestrate a more creative mash-up in Mantua some years later. Whatever the causes of this change may have been, the story of Cupid and Psyche that greeted diners in the Farnesina is as lucid as it is beautiful, with bright clarity of

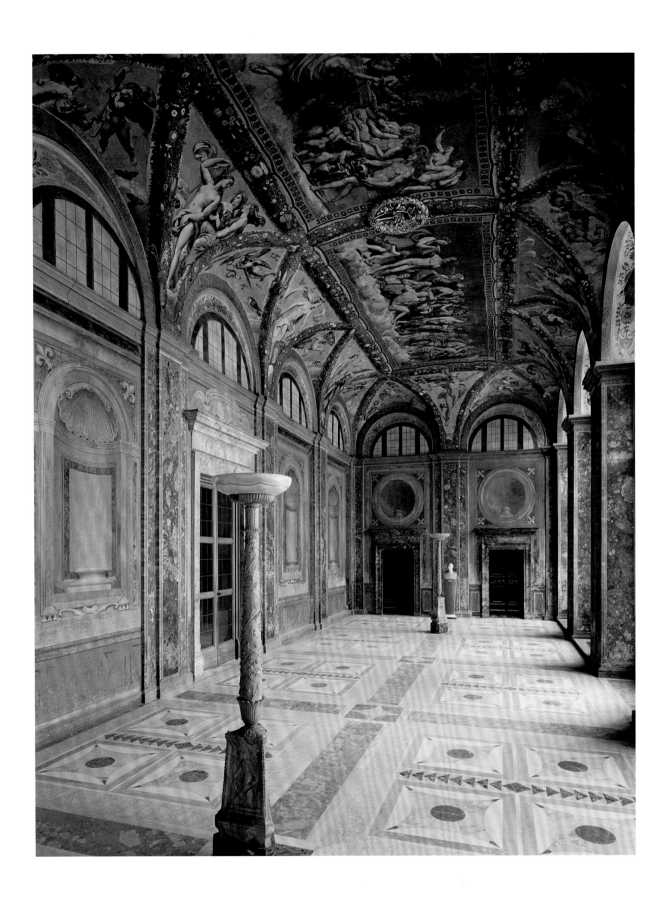

colors against a blue sky (very different from the prevalent chiaroscuro in Mantua) and an orderly sequence of plot points that might be decipherable even by a viewer who had never read nor heard of Apuleius. Regarding the arrangement in Mantua, as suggested above, there is a great deal of inventive scholarship attempting to elucidate the narrative implications of the story's episodes as they are placed on the ceiling, as well as the presence of quite extraneous materials, all reflecting the need for hard labor among the viewers; no such ingenuity is required in Rome. It may well be that ducal Mantua was a more learned milieu than bankerly Rome, or that the Raphael team was establishing a normative mode of telling its story that enabled the later team to engage in elegant variation; it is difficult to say.

Especially significant regarding this difference as we read for the food is (among other things) a certain clarity regarding the eventual destination of the story, in which Psyche is admitted to Olympus and then celebrated in a grand heavenly feast. This is, after all, what makes Cupid and Psyche dining room fodder: if you are invited to a meal in such a space, you feel you have been admitted to heaven. (Admittedly, pagan heaven, but we are in the most syncretic moments of the Renaissance, and this is a heaven that you don't have to be dead in order to access.) When Agostino Chigi's guests look up from their possibly soon-to-be discarded silver salvers, they see, at one end of the room, a pendentive (fig. 4.13) in which Cupid and Venus are looking downward from heaven toward (presumably) the earthbound Psyche and, at the other end (fig. 4.14), a gloriously upward-floating Mercury, the figure who is capable of transporting mortals to Olympus. Then, occupying the vast middle space at the apex of the ceiling, they see two fictive tapestries. On the right-hand side (fig. 4.15), the council of the gods, each Olympian rendered easily identifiable via familiar iconography, most of their faces pointed to the right, where Cupid is making his case to Jupiter. On the left-hand side (fig. 4.16), the case having been successful, they see a riot of banqueting festivity, with the awesome emblems of the divinities mostly discarded in favor of elegant dress or seminudity; even Cupid and Psyche are off to the side (in an amorous position that will be closely copied in Mantua). All of which makes the scene a little easier for the guests to enter imaginatively and for the party on the ground level to blend into the party on the ceiling.

The guests who look upward in Mantua, on the other hand, see twenty-odd scenes framed in four different geometric shapes (fig. 4.17). Upon close examination it is possible to locate episodes of the story, but close examination is scarcely invited. It is true, as in the Farnesina, that a central place is given to the official union of Cupid and Psyche (fig. 4.18), set off inside the sole rectangle in the whole design. It is a spectacular achievement in perspective, chiaroscuro, and *di sotto in su*, but it is almost impossible, even in an enlarged reproduction, to decipher the exact features of the event; a banquet it certainly is not. The comfortable flow between real-life guests and Olympians at a heavenly dinner party, which was the straightforward business in

4.15. Raphael and his workshop, Council of the gods, c. 1517. Loggia di Psiche, ceiling, Villa Farnesina, Rome

4.16. School of Raphael, attr. to Giovan Francesco Penni, Marriage of Cupid and Psyche, c. 1517. Loggia di Psiche, Villa Farnesina, Rome

4.17. Giulio Romano, Ceiling of the Sala di Amore e Psiche, Palazzo del Te, 1525. Mantua, Italy

Rome, is on this ceiling quite impossible. That may well be because Giulio Romano and his colleagues, presumably at the request of his Gonzaga patrons back in Mantua, have something else they want to show us.

Two of the camera's four walls have tall windows that limit the possibilities for large-scale decoration; the other two have mostly unencumbered space. The mythological materials, particularly those not relating directly to the Apuleius story, are depicted in the available segments of the windowed walls. The south and west sides of the room, with more space, are, on the other hand, given over to something not so mythological (see figs. 4.9 and 4.10). The standard caption given in the literature for these two enormous scenes—larger and more striking than anything else in the room—is "Preparations for the Feast." (When they are captioned at all, that is; in Frederick Hartt's thirty pages of learned and persuasive analysis they go almost entirely unmentioned.)[94] This description is generally given without comment, as though it were perfectly normal to use 60 percent of the space in a large *all'antica* fresco composition for behind-the-scenes activity in which no mythological action is taking place.

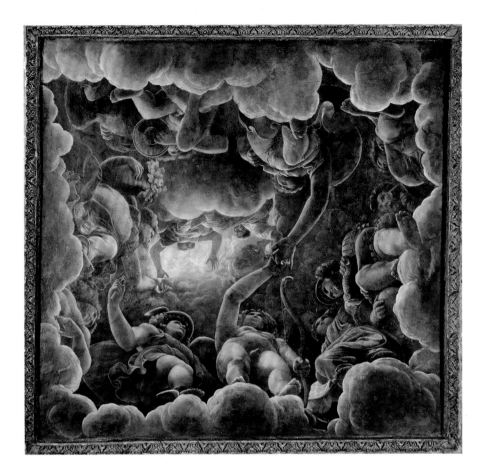

4.18. Giulio Romano, Wedding of Cupid and Psiche, 1525. Sala di Amore e Psiche, vault, Palazzo del Te, Mantua, Italy

In fact, what is being celebrated here is the real purpose of the room and the ways in which that purpose can be brilliantly fulfilled. The centerpiece of the south wall is a magnificent display of the Gonzaga banquet plate collection (fig. 4.19). It would be impossible to overestimate the importance of these material objects in every facet of grand dining as it operated within Renaissance political culture. We have already heard about Agostino Chigi's showy piece of theater in "discarding" his plate: with the Gonzaga example in our minds, Chigi's stagy gesture reveals at once the significance of these objects and (dare one say?) the vulgarity of treating them as flagrantly disposable trinkets rather than as property to be passed down through the generations. All the spectacular pieces of food-as-theater that characterized these grand meals themselves were ephemeral; indeed, as the example from Vasari's life of Rustici suggests, their destructibility was an important part of their ostentation.[95] The platters and trenchers and jugs that contained these exquisite comestibles, on the other hand, were *not* ephemeral. They were kept as family treasure, with much expenditure devoted to the personnel who took care of them and much vigilance in regard to their security.

Above all, these collections of plate, though supposedly intended for practical mealtime use, were treated as objects for display. Our best informant on this matter is Giovanni Pontano, like Platina, a humanist courtier with a great interest in the scene of dining, along with what he called the *virtù sociali*. Pontano seizes on the Aristotelian virtue of Magnificence, which has both an ethical and an interpersonal

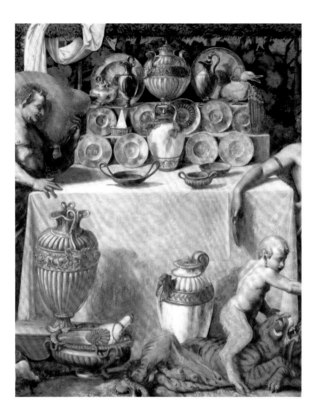

4.19. Giulio Romano, Gonzaga plate collection, 1525. Sala di Amore e Psiche, detail from south wall, Palazzo del Te, Mantua, Italy

dimension, and he turns it decisively into the grandeur of princely public life. Banqueting, in his account of it, operates in the category of Splendor, which describes the private form of princes' displays of grandeur (private not in our restrictive modern sense but more in the sense of grandeur when entertaining at home). Pontano discusses serving pieces quite specifically:

> It is not necessary, indeed, that there should be many cups resplendent on the sideboard, but these should be of various types. Some should be in gold, silver, and porcelain; and they should be of different forms, some as chalices, some as bowls for mixing wine, some in the form of a jug, or as plates with long or short handles. Of these some should seem to be acquired for use and for ornament, and others for ornament and elegance alone.[96]

It seems almost a program for a painter like Giulio Romano. Grand princes, Pontano is telling us, should acquire these objects whether they are useful or not, and they should display them ostentatiously; indeed, their nonutility as functioning tableware is a crucial part of the ostentation. The gold and silver vessels so brilliantly represented on the south wall of the Psyche banquet hall confirm the acquisition by the Gonzagas of this cultural property, and their representation in the painting (in addition, presumably, to their presence as real objects on a credenza) acts as a further degree of ostentation—that is, one more step removed from mere utility as containers of food and drink.

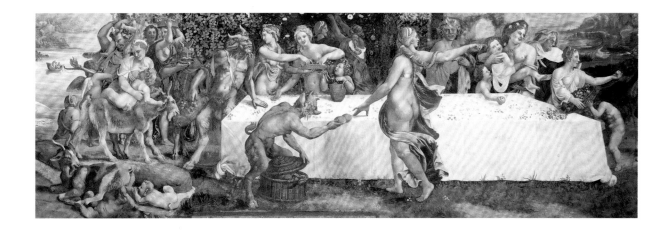

4.20. Giulio Romano, Banquet table, 1525. Sala di Amore e Psiche, detail from west wall, Palazzo del Te, Mantua, Italy

The other large panel excluded from specific narrative purpose occupies the west wall. If those entering the space are reading the images in the order of the Gonzaga inscription, this would come last, just after the wall with the display of plate. What confronts us here is, finally, the banquet table itself, spotlessly napped in floor-length white linen, thus giving this space exceptional luster (fig. 4.20). No one is sitting at the table, but it is surrounded—in a modified version of the triclinium form, leaving the viewers' side mostly unoccupied—with a lavish inventory of classical figures, including Graces, putti, and characters from a Bacchic procession. In what seems to be a brilliant joke on the normal Dionysiac functioning of such a crowd, these figures from a reborn antiquity are, essentially, setting the table. The message, then, of this fourth wall is that dinner is about to be served, and everyone's places are being made ready. What we have come to is a magnificent instance of that *mise en abime*, which we observed as far back as Pompeii: the dining room decorated with images of a dining room.[97] But this is also a playful turn on that most daring instance of the trope, the *Unswept Floor*. Here it is the inverse of the inverse: rather than the ignominious garbage-strewn conclusion of the feast awaiting the (presumably nonplussed) real-life diners, we have the invitation to the feast with everything about to be immaculately in place so that the banqueters can slip into the roles of the Olympian guests at the wedding of Cupid and Psyche.

In effect, the conjunction of Cupid and Psyche with banqueting space turns into a kind of overdetermined position for dining itself, with political ideology and classical revival, however potent in the design of such spaces, challenged for primacy by the business of eating and drinking. Much the same is true at the Villa Farnesina, but it comes about in a quite different way. The Mantuan project, as one might say, fetishizes the tableware; the Roman project has its own fetishes, but they point in a different—though still gastronomic—direction. Each of the panels that tell Apuleius's story is framed with festoons of lush greenery, the work of one of Raphael's most gifted team members, Giovanni da Udine. Emerging from the greenery are approximately two hundred different species of fruits and vegetables, each of which is represented anywhere from one to sixty-six times (figs. 4.21, 4.22, and 4.23).[98]

Giorgio Vasari, as so often, provides eloquent contemporary testimony to this assemblage, declaring that Giovanni painted "all the kinds of fruits, flowers, and leaves,

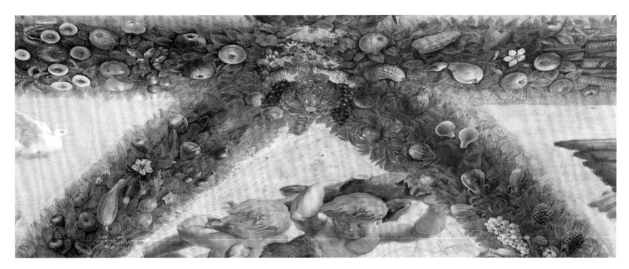

4.21. Attr. to Giovanni da Udine, Vegetal festoons, detail, c. 1517. Loggia di Psiche, Villa Farnesina, Rome

4.22. Attr. to Giovanni da Udine, Miscellaneous fruits, detail, c. 1517. Loggia di Psiche, Villa Farnesina, Rome

4.23. Attr. to Giovanni da Udine, Gourds, grapes, hops, and other fruits and vegetables, detail, c. 1517. Loggia di Psiche, Villa Farnesina, Rome

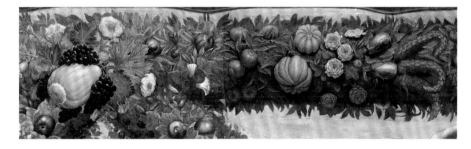

season by season, and fashioning them with such artistry, that everything may be seen there living and standing out from the wall, and as natural as the reality."[99] (He also notices the phallic presentation of a cylindrical gourd with two adjacent eggplants and a large purple fig bursting open, which even today continues to amuse the Farnesina's better-informed, or more eagle-eyed, visitors; fig. 4.24.) And he fills in the artistic genealogy of faithfully representing nature—in conformity with his triumphal account of High Renaissance art—by locating Giovanni among those who climbed down into Nero's Domus Aurea, where they got their first glimpses of ancient painting, notably the *grotteschi*, themselves mixtures of flora and fauna, both real and imaginary. At the Farnesina, the emphasis is definitely upon the real—and the edible.

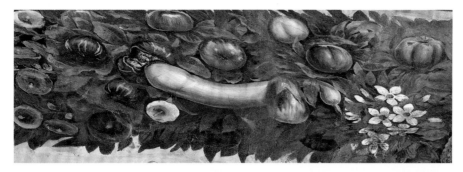

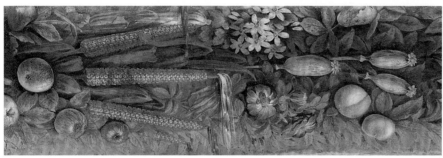

4.24. Attr. to Giovanni da Udine, Erotic vegetables, c. 1517. Loggia di Psiche, Villa Farnesina, Rome

4.25. Attr. to Giovanni da Udine, Corn, detail, c. 1517. Loggia di Psiche, Villa Farnesina, Rome

The range of species is astonishing: five types of grains, five types of legumes, eight forms of nuts, seven forms of drupes, nineteen forms of berries, six varieties of apple, and four types of aggregate fruits. And this does not cover the vegetables, which include turnip, artichoke, and mushroom. What is even more remarkable is that we are able to identify each of these species—in other words, that Giovanni and his colleagues have operated at the most sophisticated and up-to-date level of scientific illustration, even when many of the individual results on the ceiling may be minuscule. Up to date, it turns out, in the most radical way, as is clear from the presence of several species from the New World, including multiple types of squash or gourd; *Phaseolus vulgaris*, or the common green bean; and, most astonishing to inhabitants of the Western Hemisphere, *Zea mays* (fig. 4.25), or corn on the cob. As these representations appeared just over two decades from the date of Columbus's first voyage, it seems that gastronomic news has traveled quite fast.[100]

The Cupid and Psyche story as presented by Raphael and his colleagues, then, includes the customary welcoming into heaven via the immortalizing consumption of nectar along with the celebratory banquet, but something more. The experience of the fortunate guest in this milieu partly takes place on the register of the mythological (Apuleius), partly on the symbolic (Love bringing the soul to heaven), and partly on the real—that is, dinner. It's not an unprecedented combination. What is more remarkable, though, is an additional level somewhere between heaven and dinner— that is, the hyperreal, but still painted, presence of a gigantic market basket of nature's riches. It is another sign of the copiousness that both the act and the materials of dining seemed to promise to certain privileged strands of early modern culture, as though nature's bounty were endless, and the human capacity via gastronomy to turn that bounty into pleasure were unlimited, thus potentially silencing the debates over dinner in the collective act of dining itself.

6

No such debate-free utopia, of course, could exist on the ground. All this discussion of plenitude, from the table of Athenaeus to the table of the Gonzagas, should not be taken as a sign that there is no other kind of food story to tell: a story, that is, of scarcity. Because this is a book about the way in which eating and drinking infiltrate the imaginative consciousness of European high culture, and not a book about sustenance and nourishment, there is bound to be a shortage of indicators regarding the history of hunger that might be set alongside the history of bounty. It hardly needs repeating that only an infinitesimal proportion of the population was in a position to dine lavishly among learned sophists or attend a grand banquet under a frescoed ceiling. And even those few who were literate enough to read Rabelais or Erasmus were not likely to be partaking in anything like the gluttonies of Gargantua or the idyllic commensality of the *Colloquies*. This is an instance of a much broader issue—the fact that study of the past is trapped within those cultural expressions that elites produced and memorialized[101]—and if the issue seems especially prominent when the subject is food, that is probably because it is easier for us to think about being denied meals than being denied epic poems or marble sculpture. The direst debate over dinner, in short, is whether there is enough to eat.

Not that there isn't a history to be recounted of the relations between high art and deprivation, precisely in the realm of food and nourishment. It has always seemed noteworthy that two of the grimmest periods of suffering in early modern Europe, occasioned by mixtures of plagues and famines, coincide with two of the most glorious epochs of literary productivity. The fourteenth-century moment in Italy of Dante, Petrarch, and Boccaccio is also the moment of the Black Death; and the late 1580s in England, when Shakespeare and Spenser were beginning their careers, are also witness to grave limitations in the grain supply.[102] There is no use in speculating on causal connections between these phenomena. It is nonetheless worth noting that these disturbances in material well-being have afforded great subjects for high art. One thinks, for instance, of the *Decameron*, in which the plague in Florence, described by Boccaccio with terrible realism, becomes the occasion to invent a paradise of well-being, signaled by escapist storytelling—and, though less emphasized, by fine dining.[103] Boccaccio stages the problem of scarcity and suffering, but locates the reader at a safe distance. Readers are, of course, at a safe distance by definition, but the *Decameron* frames catastrophe with such elegance that the experience may end up rather like an inoculation, offering protection through a touch of vicarious exposure.

A somewhat different artistic expression of the tension between scarcity and bounty in the medieval and early modern periods is the phenomenon of the land of Cockaigne.[104] The late Middle Ages, particularly in northern Europe, witness a series of cultural fantasies about a particular kind of golden world in which all physical needs are readily satisfied. What is particularly striking about this construct, also called Cuccagna or Luilekkerland or Lubberland or Schlaraffenland, is that the physical satisfaction in question is overwhelmingly food-related. The inhabitants may be snoozing or having sex, but the vast majority of the joys presented to them are in the form of

food; and the emphasis is not on the beauty of the food nor on its flavor but rather on the ease with which it can be procured:

> The benches and chairs, I tell no lies,
> Are all made of the best meat pies.
> And all the attics overhead
> Are of the finest gingerbread.
> The rafters are grilled eels, what's more,
> The roofs are tiled with tarts galore.
> And a spectacle that never fails to delight
> Are the rabbits and hares always bounding in sight.[105]

The menu itself suggests that, unlike most of what we have been considering in these pages, this scene of plenty is decidedly proletarian—or at least one that is ascribed to common people. Whatever the real origins of this vision, it is being understood as a kind of imaginative compensation for the sorts of suffering brought about by famines and plagues and visited disproportionately on those at the bottom of the social scale. The form it takes, exemplified by Pieter Bruegel's masterpiece (fig. 4.26), is of a world abounding in foodstuffs that seem to have their own agency, like the pies ready to propel themselves from a tilting roof or the soft-boiled egg, complete with feeding utensil and provided with limbs to walk toward one of the sprawled and passive humans.[106] Bruegel's brilliant stroke of depicting individuals who are already exhausted from overindulgence suggests a never-ending plenitude, while also making available to the viewer both the temptations of the gluttonous fantasy and the confirmation of its enervating aftereffects. Bruegel's canvas, and the tradition that gave rise to it, represent yet another world built on food.

There is another other world, though, weighing perhaps more intensely upon the European early modern imagination, where the availability and procurement of sustenance are even more problematic than they would have appeared to Bruegel's sleeping peasants had they been real. Columbus's transoceanic voyages, and those of the other Europeans who followed, are completely circumscribed by the question, what's to eat?[107] It begins with the matter of how much ocean needed to be traversed, a central issue in persuading any European monarch to subsidize the voyage and almost entirely a question about food and water supply. (Columbus radically underestimates this distance, perhaps on purpose, as part of his sales pitch.)

The matter of sustenance only becomes more complicated when the transoceanic passage is completed, as becomes clear from the documents surrounding Columbus's four voyages. Necessity, and not just an interest in natural history, causes the voyagers constantly to ask the question, what do the natives eat? From the European point of view, everything appears on a grid between the familiar and the unfamiliar. The travelers report, with varying degrees of justification, that they have found rhubarb, aloes, and wild cinnamon, as well as a tree "whose leaves had the finest scent of clove I have ever tasted" and which they identify as laurel (132). They develop a taste for bread made from certain root vegetables (subsequently identified as yucca [156]) and for something resembling hazelnuts. As for the unfamiliar, they discover that it can

4.26. Pieter Bruegel the Elder, *The Land of Cockaigne* (*Land of Plenty*), 1566. Alte Pinakothek, Bayerische Staatsgemaelde-sammlungen, Munich

be surprisingly welcoming. In some respects, the strange climate benefits the hungry explorers: vegetables grow more in eight days here than in twenty back home in Spain, and fresh fruit can be picked well into November. On the other hand, the heat makes it impossible for fish to remain edible beyond a day (153). And even when foods look familiar, they may have unexpected consequences: "There were wild fruit of different kinds . . . , but no sooner did the men taste them but their faces swelled so much they nearly went out of their minds" (132).

But the European consciousness swerves quickly beyond this grid of familiar and unfamiliar toward the abject, substances that no amount of hunger or scientific curiosity will induce them to consume: "they [indigenous people] eat snakes, lizards, spiders and worms: their habits seem to be more bestial than those of any beast in the world"; and "they eat many such things that would not only make any Spaniard vomit but would poison him if he tried them" (81). And, of course, there is one menu item that is even worse than snakes and lizards and that gets proverbially ascribed to barbarians: "They say that human flesh is so good that there is nothing like it in the world; and this must be true, for the human bones we found in their houses were so gnawed that no flesh was left on them except what was too tough to be eaten" (136).

What all this means is that food, whether it is desperately needed or surprisingly delicious or disagreeable or taboo, is in every way as significant a factor in the New World project as wealth or conversion or conquest. Spices, after all, were among the principal attractions in the first place: they are indeed the reason Columbus wanted to believe, and make others believe, that he had reached India.[108] And food becomes a central object of contention and/or exchange in the highly volatile relationship between the voyagers and the indigenous peoples. Friendly natives prepare root vegetables that are acceptable to the Europeans (they "tasted like chestnuts" [78]) or wine "not made from grapes" (213); unfriendly natives may refuse to help them find food just as they refuse to reveal the location of precious metals. The Spaniards show some

signs of adaptation, either learning from the natives or at least developing an ability to be better nourished by unfamiliar foods. But this adaptation—not surprisingly—gets turned into a strategy of control. At one point, when the Europeans are suffering from extreme hunger and in the midst of a pitched battle with an indigenous tribe, cannons fired from the Spanish ships cause the natives to abandon their houses, whereupon

> the Christians then entered these houses pillaging and destroying every-
> thing. Knowing the Indian way of making bread, they seized their dough
> and began to knead it, thus providing themselves with the food that they
> needed. (196)

From pillaging to kneading: culinary skill, itself acquired from the natives, turns out to be as potent a weapon of domination as gunpowder, and equally, or more, essential.

These documents from the time of Columbus's voyages all speak to a moment of exploration: a handful of men traveling in a small number of ships journey westward with a mixture of motives involving acquisition, conquest, and conversion, but the point of reference remains decisively European. A century later, though those original purposes remain significant, there arrives the moment of colonization.[109] Men, and now women, journey westward and plan to remain in the New World for good. The question of sustenance, and with it the measurement of scarcity and plenitude, looms ever larger. Food, in short, transforms itself from persistent leitmotif into ruling obsession.

It should come as no surprise that this degree of engagement in the question of sustenance can be discerned most intensely in times of trouble—most particularly, in fact, when the trouble is documented. Those who are promoting New World ventures, from the time of Columbus and his coterie onward, accentuate the positive, but there are occasions when the circumstances on the ground, and the political situation back home, make it possible for the reports to be more detailed and realistic. In these cases, all aspects of the food problem tend to take center stage.

The English experience focuses upon colonization, with the appropriate dangers and demands.[110] Such is the case with a well-known document that emerges from an English expedition that set sail for Virginia in 1609.[111] It is a story that embodies all the ambitions and disasters of the colonization project. Two years earlier, the investors of the Virginia Company of London had managed to pursue their mercantile venture by establishing the Jamestown colony, which from the start was highly fragile, both because of the intrinsic difficulties of the unfamiliar space and its indigenous inhabitants and because those who came as settlers were not always the individuals who were best furnished with the skills and trades that were needed. (Hence the testy letter sent a few years later by Captain John Smith to his London investors, who were planning to ship more settlers: "I entreat you rather send but thirty Carpenters, husbandmen, gardeners, fishermen, blacksmiths, masons and diggers up of trees, roots, well provided; than a thousand of such as we have.")[112] The 1609 venture was the third and most ambitious attempt to bolster the Jamestown settlement, including seven ships and individuals like Admiral Sir George Somers and Sir Thomas Gates, who was designated as the new governor of the colony. The entire *nomenklatura* seems to have

been housed in the lead ship, the *Sea Venture* (commercial language never being far from this enterprise), which was blown off course by a hurricane near the end of the Atlantic crossing.

The admiral managed to beach the ship on a group of islands already known as the Bermudas. The rest of the fleet reached Jamestown, but a group of some 150 individuals, including the whole elite, were shipwrecked on an island whose prospects for human habitation appeared even more dire than those experienced by the Jamestown settlers. Among this elite was one William Strachey, a classic figure in early modern English society: born to a social stratum somewhere on the borderline between gentry and nobility, highly ambitious, a dabbler in international ventures (he had already been part of an embassy to Constantinople), and fundamentally lacking in clear social status or financial security.[113] It is Strachey's report on the disasters of the *Sea Venture*, the ten-month stay in Bermuda, and the eventual arrival at Jamestown that affords us a detailed and revealing picture of life under these remarkable stresses.

The story that Strachey has to tell[114]—both the narrative of his experience and the rhetorical message that he wants to send—is all about food and in a continuous oscillation between scarcity and bounty. The wreck spells catastrophe for their supplies: they have jettisoned beer, oil, cider, wine, and vinegar, and the water that the ship's hull has taken on makes it impossible to cook with fire. Further, they have landed on islands that are legendary for their uninhabitability and for the demons who occupy them. On the other hand, they discover that it is only the approach to the Bermudas that has generated these stories; once on the islands themselves, they discover them to be commodious and habitable. Within a short space of time, they sow muskmelons, peas, onions, radish, lettuce, and "many English seeds" (23), which sprouted in ten days, from which it was determined that other crops from western islands, such as grapes, lemons, oranges, and sugar, would also thrive. They discover tasty indigenous fruits (berries, coconuts, currants, wild palms) as well as a great variety of fish, including salmon, bonito, stingray, snapper, pilchard, eel, lamprey, and mullet; a similarly plentiful menagerie of fowl, such as sparrows, robins, bitterns, snipes, crows, and hawks; and that there were less familiar species that were nonetheless quite toothsome, like prickly pears, wild hogs, a web-footed bird something like a plover that was as fat and tasty as a partridge, and even tortoises, whose identity was uncomfortably stuck between fish and meat, but one of which would go further at the mess table than three hogs.

But all this success reposes on a shaky foundation. Eventually the Bermuda group and the mainland group are reunited, but Jamestown turns out to be in dire straits. It is the time of year when seeds are only barely planted; there are no fish in the streams or game in the forests, and the natives—there had been no such group in Bermuda—are suffering themselves and therefore unhelpful at best. On top of which, brackish waterways—again, not the case in Bermuda—are causing widespread disease. Strachey reports this desperation, but at the same time he reflects a ruling ideology whereby the exploratory ventures insist on promising limitless reward if and when colonies can be established. The debate over dinner turns into a kind of self-contradiction: in the midst of his account of near starvation, he also declares that there is no reason Virginia, with its "large fields" for corn and "thousands of goodly vines," cannot be as fertile as England. "Let no rumor of the poverty of the country," he goes on to say,

dash anyone's hopes regarding the "many fair births of plenty and increase and better hopes than any land under the heaven to which the sun is no nearer a neighbor" (69).

Fascinating as Strachey's experience and his reportage are, they would scarcely have attracted the world's attention as much as they have were it not for one particular reader. Strachey, it turns out, had a quite different life back in England. Immediately prior to his Virginia venture, he appears as an active participant on the London literary scene, and especially in the theater; he is a friend to Donne and Jonson and a shareholder in Blackfriars. In fact, it is his presence in this milieu that must in some way account for what most scholars take to be the certainty that Shakespeare was familiar with the events recorded in the letter, even though it does not seem to have been published in any form prior to the writing of *The Tempest*.[115] Shakespeare's romance in fact enables us to see what happens when a genius gets hold of all the issues regarding Old World and New World, scarcity and bounty, that are to be found in the Strachey letter.

Reading *The Tempest* for the food, then: A duke, along with his daughter, is banished from Milan in a leaky boat, and the two of them would have died onboard had they not been secretly furnished with food and water; they arrive on an island, where they are aided by a native in the business of locating good things to eat; they also—but perhaps only at first—give said native some tasty treats of his own. Another group of individuals get shipwrecked on the same island. The upper-class members of the group wander around in a state of desperate hunger and are teased by the appearance, and then disappearance, of a lavish banquet. For their part, the lower-class members of the group, one of whom escapes courtesy of a jettisoned cask, have managed to make off with a supply of wine from the ship, and they get increasingly drunk as the play goes on. This latter group meets up with the aforementioned native, who now shifts his allegiance and promises *them* the finest gourmet fare that the island affords; his deluded visions of newfound freedom consist principally of not having to do KP anymore. In a separate action, the duke, for reasons of his own, imprisons one member of the high-born group who got separated from the others, and the punishment consists in part of being fed inedible food. All, however, ends happily, a circumstance that is signaled by a pageant celebrating nature's fecundity. The final joyous recognition scene takes place at what gets, at least slantingly, referred to as a sort of wedding breakfast.

Such are the mere outlines, but there are strands of the play's action where the problematics of the New World encounter find themselves densely articulated through the issue of eating and drinking. No surprise that Caliban, the native par excellence, should be at the top of the list. To begin with, he is, in Shakespeare's redaction of the colonial experience, the native informant and island feeder, the source of nourishment for the desperately needy displaced Europeans:

> When thou cam'st first
> Thou strok'st me and made much of me; wouldst give me
> Water with berries in't, and teach me how
> To name the bigger light and how the less
> That burn by day and night; and then I loved thee,
> And showed thee all the qualities o' th' isle,

The fresh springs, brine pits, barren place and fertile—
Cursed be I that did so! (1.2.332–39)[116]

The reciprocal gestures of feeding in this social contract describe a relation between, on the one hand, a primeval state in which there is the potential for food production without any systems for accomplishing it and, on the other, a whole set of civilized mechanisms that can turn nature into nourishment, such as the division between fresh water for drinking and salt water for preserving, the exploitation of the land for growing crops, and the transformation of raw materials into something like cuisine.

The past scene is replayed twelve years (and one act) later, with a difference, when Caliban, in his frenzy of giddy subservience, offers to feed the drunken butler Stephano:

> I'll show thee the best springs; I'll pluck thee berries;
> I'll fish for thee and get thee wood enough. . . .
> I prithee, let me bring thee where crabs grow;
> And I with my long nails will dig thee pignuts;
> Show thee a jay's nest and instruct thee how
> To snare the nimble marmoset; I'll bring thee
> To clustering filberts and sometimes I'll get thee
> Young scamels from the rock. (2.2.152–53, 161–66)

It is another of those oscillations between scarcity and plenty: Stephano is (presumably) starving; Caliban offers him a gourmet feast (of sorts). Food sourcing has become more sophisticated since Prospero's arrival time, but Caliban's proposed menu proves ambiguous. Are these delicacies designed for the imagined epicurean tastes of the pseudo-royal Stephano, which is certainly the impression Caliban wishes to convey, or do they rather represent his own savage vision of high gastronomy? Pignuts, after all, are generally animal fodder; jays are famous for the plumage rather than their flesh; and as for those agile monkeys, courtly, and perhaps even *faux* courtly, Europeans would have pretty strong taboos about consuming them.[117]

Even more complex is the consumable that the clown-royals will offer Caliban in return. One of the trickiest aspects of the encounter between Europe and the New World had to do with intoxicants.[118] The natives had tobacco and spirits made from corn, as well as various potables for which observers used inexact terms like "wine" and "beer." Meanwhile, the Europeans eagerly sought locations to plant vines (even the northern Europeans, who had little viticulture back home), as well as bringing plenty of wine with them; they also set about to produce their own grain-based beverages. In narratives like Strachey's, these substances, whether indigenous or transplanted, tend to be a class index, separating the gentry from either the lower-class Europeans or the natives.

So it's worth paying attention to the whole alcohol thread in *The Tempest*, beginning with the mariners, whom Antonio in the first scene unjustly accuses of being drunkards and ending with the craven Sebastian's only expression of interest at being (as it appears) miraculously reunited with his butler, Stephano, "Where had he wine?"

>Now I will believe
>
>That there are unicorns; that in Arabia
>
>There is one tree, the phoenix' throne, one phoenix
>
>At this hour reigning there. (3.3.21–24)

Antonio assents eagerly, and goes even further, saying, "What else does want credit, come to me / And I'll be sworn 'tis true. Travellers ne'er did lie, / Though fools at home condemn 'em" (3.3.25–27).

But Shakespeare is about to elevate the game of literary self-conscious, from documents like Strachey's letter to works of grander history and scope. After a little discussion, in which the king needs to be persuaded by Gonzalo to overcome superstitious hesitation (our final debate over dinner), they all prepare to satisfy their hunger. But it proves impossible:

>*Thunder and lightning. Enter* ARIEL, *like a harpy, claps his wings upon the table, and with a quaint device the banquet vanishes.* (3.3.s.d.)

Shakespeare is replaying something of much more cultural weight than a contemporary shipwreck pamphlet. A crucial turning point as Virgil's heroes' journey from Troy to Italy occurs on the island of the Strophades.[121] The starving band of warriors manages to find a harbor in a place where herds of cattle appear to be there for the taking. As Aeneas and his men prepare to dine on these tasty treats, a flock of terrifying harpies descends on the banquet and befouls it; Virgil is a bit bashful about the specifics here, but the mention of a foul odor suggests something quite unpleasant. The harpies inform them that this is not the place where they will find rest and sustenance, that they must rather go to Italy. But, they are told, they will be plagued with hunger even there—to such an extent that they will have to eat the very tables on which their food is served. Four books later, upon their arrival in Italy, suitably famished, they pluck some local fruit—produce of the goddess Ceres, Virgil tells us—and place it on top of the coarse wheat cakes that they have brought with them. So hungry are they that after finishing the fruit, they go on to consume the wheat cakes. At which point, they realize that the prophecy has been fulfilled; and a literary model is established for a journey in which both deferral and destination get defined by mealtime.

In fact, commentators have long recognized that *The Tempest* reposes on a rich Virgilian subsoil. What interests me in particular is the surprising intersection, specifically around the subject of food, between the *Aeneid* material and the New World material. It begins with Strachey himself, who, having reported the decision to leave Jamestown in the search for places where they would have better luck with the fishing, announces triumphantly,

>At length, after much and weary search (with their barge coasting still before, as Vergil writeth Aeneas did, arrival in the region of Italy called Latium, upon the banks of the river Tiber) [they arrived] . . . within this fair river of Paspahegh, which we have called the King's River. (78)

Whether courtesy of Strachey or not, Shakespeare glimpses the power that hunger—its satisfaction, non-satisfaction, or postponed satisfaction—can exercise in the story

of homecoming. The banquet denied becomes the occasion for a kind of theophany in which the Italian nobles are made to confront for the first time their culpability—"You are three men of sin," says Ariel, following his master's script—and, just as important, Prospero's knowledge of it; they cannot experience any sort of homecoming, cannot experience the blessings of Ceres, or whatever the equivalent would be of eating *their* tables, without this confrontation. During the whole of this terrifying episode, the empty table—a banquet now stripped of edibles—remains onstage.

In fact, in the course of this famously single day's action—an almost unique Shakespearean gesture toward the Aristotelian unity of time[122]—it's not clear that, for all the discussion of sustenance, anyone ever actually eats anything (though a few characters do get drunk). To the extent, then, that this is a play about the possibilities for life on a barren island across the sea, whether Strachey's or Shakespeare's Bermuda, all the signs point toward scarcity.

Or rather they would point toward scarcity were it not for an enactment that Prospero modestly refers to as "some vanity of mine art" (4.1.41). Within the conventions of the love story, such as it is, that must conclude with the union of Ferdinand and Miranda, the pagan deities who are summoned up for the wedding masque are mostly concerned (as Prospero vociferously demonstrates in his own voice before the pageant begins) that there be no sex before marriage; and the goddesses reassure us all on that point by certifying that the wayward Venus is busy with another engagement elsewhere. In fact, what the episode mostly celebrates is not love or virginity but the bounty of nature—more specifically, edible nature. Iris summons up Ceres with an incantation of "Wheat, rye, barley, vetches, oats, and peas," and the goddess herself speaks the final words that we hear (Prospero will break it off when he recollects the Caliban conspiracy) with a celebration of plenty:

> Earth's increase, foison plenty,
> Barns and garners never empty,
> Vines with clust'ring bunches growing,
> Plants with goodly burden bowing;
> Spring come to you at the farthest,
> In the very end of harvest!
> Scarcity and want will shun you;
> Ceres' blessing so is on you. (4.1. 110–17)

The relevance to Ferdinand and Miranda is at best glancing and by association, but the relevance to a whole set of cultural anxieties about New Worlds that are poised between the Edenic fantasy of limitless bounty and the real prospect of starvation is unmistakable. The story told in this chapter, so focused on plenty and pleasure, is always poised against a reality of insufficiency, of plagues and famines; reality, and the case of the newly encountered western lands, offers the most inescapable debate over dinner. Shakespeare produces a notably up-to-date reading of this opposition, realizing that the great drama of scarcity in his era was the attempt to find sustenance in the lands beyond the sea where Europeans were expanding their empires. That is why he ends his hunger play with a pageant of limitless bounty.

Mimesis, Metaphor, Embodiment

In chapter 1, the *Unswept Floor* was invoked as a way of celebrating the capacity of food to be both glorious and abject, to encompass at once the lowly materials out of which art (or dinner) is made *and* the exquisite refinements that are possible once all that making (or eating) has taken place. I also invoked the mosaic in its seeming randomness of design as a kind of model for my own method in this book, which, as the reader will have noticed, sometimes takes a winding or associative course. Now, by way of entry into this final chapter, I summon up the mosaic with a different set of associations, as an embodiment of the *real*.

We know by now that food has a way of being nominated as the thing itself, but that thing can readily dissolve into some sort of contradiction or become a transparency through which the hungry eye is meant to glimpse something else, something perhaps of grander significance but with little capacity in itself to satisfy hunger. Plato's drinking party outlawed drinking; Boucher's grapes weren't just grapes (or at least didn't bear thinking of *qua* grapes); Alberti's dinner party was a how-to device for those creating scenes from the life of Jesus; and Kant's *taste* attempted to evade association with anything inside the mouth. Eating and drinking, in short, seem to have often entered high culture via a denial, or a sublimation, of eating and drinking. Even the *Unswept Floor*, one might say, was conveying some decidedly nonculinary messages, for instance about such matters as the host's wealth, wit, and generosity. Still, more than most of the consumables we have considered, it can be viewed as an object whose phenomenal aspect—its *thingness*—leaps into the foreground well in advance of any viewer's attempt to translate it into meaning.

The present chapter locates itself precisely at the problematic of thing and meaning. To be sure, much of this book has been dedicated to controlling the drift from the

gastronomic thing itself to its extra-culinary meaning. Hence the insistence on such matters as the culinary labor of turning manna into foodstuff, the parodic qualities of serving wild boar as an appetizer, the hankering of the risen Jesus for a piece of fish, the disturbing flavor of garum, the menu choices at Erasmus's or Gargantua's feasts, the various edible species represented in one form on the ceiling of the Farnesina or in another form among the waste products on the *Unswept Floor*. What we will be considering by contrast in these final pages is, essentially, the opposing ends of this hermeneutic spectrum. There is, of course, no pure thing and no pure meaning—least of all when the subject is food and drink—yet, if we place these extremes next to each other, we may learn something that neither end of the continuum can tell us by itself.

1

First, the Real.

The Egyptians, we know from abundant archaeological evidence, placed actual foodstuffs in the tombs of their most honored dead; forty-eight cartons of edibles, for instance, appear on the roster of materials unearthed in the Tutankhamun hoard.[1] The presence of fruit, vegetables, meat, and fish among the other daily necessities with which individuals were buried has to be taken literally, or as literally as we can imagine their notions of life after death: the deceased would get hungry in the afterlife and therefore need dinner. And the fact that some of these foods were subject to exceptionally elaborate forms of preservation suggests, again approaching the matter with a certain literalism, that the postmortem voyage was construed as quite genuine, only rather longer, say, than the trip from Cairo to Thebes. And at the end of a long and arduous journey, no one wants to consume meat that has gone off.

The Egyptians also painted representations of food on the walls of tombs, sometimes as part of a scene from daily life but at other times simply as a market basket unto itself, as in the case of the fish, fowl, eggs, and such depicted in the tomb of Menna (fig. 5.1).[2] What was the relation between real food and painted food inside these tombs? That actual edibles, no different from what we daily ingest, might be consumed in the afterlife involves some leap of the imagination, even if one takes it wholeheartedly as an article of faith. Once that leap has been made, does painted food become equally useful for the nourishment of the decedent?

Brainteasers of this kind are worth pursuing because these depictions stand at the origin of several millennia worth of food pictures, and they begin to frame some quite fundamental questions that are among the concerns of the present chapter. The issues surrounding food for the Egyptian dead, whether real or pictured, turn up in a more lighthearted context if we move a millennium and a half into the future, when Vitruvius offers a notably revealing aside in the course of discussing household buildings, among both Greeks and Romans. His subject, which hovers between architecture and the language of architecture, is the elaboration of domestic structures designed for no other purpose than the housing of guests—the architectural means, in other words, of enabling them to feel at home:

5.1. Tomb of Menna, Scribe of the Fields, Food to sustain the decedent in the afterlife, detail, New Kingdom, 18th Dynasty, c. 1400–1352 BCE. Sheikh Abd al-Qurna, Thebes, Egypt

When the Greeks were more refined and more wealthy, they outfitted dining rooms and bedrooms with well-stocked pantries for their arriving guests, and on the first day would invite them to dinner, subsequently they would send over chickens, eggs, vegetables, fruit, and other rustic produce. For this reason painters who in their pictures imitated the things that were sent to guests called such paintings "hospitalities," xenia [*Ideo pictores ea, quae mittebantur hospitibus, picturis imitantes xenia appellaverunt*].[3]

In Egypt, food pictures were offered up to the dead; in Vitruvius's Greece, they were offered to those merely traveling far from home.

Vitruvius's purpose here is to describe a feature of domestic architecture; along the way, he touches upon the practice of hospitality within those spaces, and he pauses

to explain the otherwise mysterious term *xenia*, answering the question why a certain sort of picture should derive its name from the concept of hospitality accorded to foreigners.[4] The term *xenia* bears all the Homeric resonances of guest friendship and the circumstances of conducting a life among strangers, and in this context, it focuses them upon food (as, in fact, they often are in the island-hopping episodes of the *Odyssey*).[5] In later antiquity, as a matter of fact, xenia are involved in an even wider circle of exchange than is suggested by Vitruvius's mini-narrative about hungry travelers. Martial graces a whole book of the *Epigrams* with that same term, *Xenia*, as its title.[6] Each of these very brief texts takes the form of what is essentially a gift card, an inscription designed to accompany the presentation of something comestible. The verses may celebrate the foodstuff they present, or they may offer it up with coy self-effacement, or they may simply relay the kind of technical information that can be found in Pliny or Athenaeus.[7] In all cases, however, the gesture is purely poetic. There is no actual gift, only the textual accompaniment, which stands in place of the sturgeon or leeks or Falernian wine that might be more burdensome to produce than a couple clever lines of verse. At the same time, Martial's poetic xenia as a whole strive to exceed the generosity of the edible material that they render poetically, notably by being arranged precisely in the sequential form of a grand dinner, so as to present (to the reader, if not to some hypothetical host) a complete banquet in verse.

It is the heritage of the gifting practice Vitruvius describes that inspires Martial's conceit. Xenia are pictures of food. They operate, as we learn from *De architectura*, in a circle of substitution: when visitors arrived, first there were invitations to dinner, then there was the gift of actual foodstuffs (in raw state and not at table), and alongside these substantial gestures of hospitality there existed a genre of visual representations memorializing those edible gifts in a form that provided both a simulacrum and an alternative, much as Martial's *Epigrams* did. Which is the grander act of generosity—a dish of brussels sprouts, a picture of brussels sprouts, or a poem about brussels sprouts?—matters less than the fact that xenia are to be understood as signaling a special form of exchangeability between images of food and the thing itself, indeed one that calls attention, at times triumphally, to the mimetic process per se. When we tally up what passes between host and guest—invitations to dinner, fresh food baskets, and images of comestibles—we must, in addition to the familiar categories of the *raw* and the *cooked*, now add the *represented*.

As evidence of this third medium of culinary transmission—the only one that can endure through time—we possess dozens of typically small-scale images from late antiquity in which articles of food are depicted.[8] Few, if any, are likely to be the actual hospitality tokens that gave the genre its name, but the diffusion in paint and mosaic of such representations makes it all the more evident that cultures from the eastern Mediterranean to North Africa and onward to the Italian cities buried in the eruption of Vesuvius wished to memorialize a certain kind of gastronomic gift exchange, even nostalgically when the literal practice had become displaced or was no longer in fashion. A dining room mosaic consisting of meat and vegetables enclosed in square frames or a fresco of fruit and fishes covering a more expansive bit of wall space could signify guest friendship as clearly as the passing of individual gifts from hand to hand, and more enduringly, especially as it bore the mark of a living tradition.

5.2. Pink flamingo prepared for cooking, Roman mosaic from a triclinium at El Djem, Tunisia, 2nd–3rd century CE. Bardo National Museum, Tunis

The resulting artistic work, besides being extraordinarily beautiful, has a great deal to tell us about the representation of food. One striking feature of this very considerable body of work is the extent to which comestible objects are likely to be placed in the context of cuisine rather than that of nature—in other words, as stages in the labor of the kitchen and the pleasures of the table. Fish are not swimming in the sea, they are piled up or suspended from a hook in readiness for cooking, fruit is less likely to be on the tree or bush than in a bowl. Asparagus is tied up in a bunch and placed next to other foods with which its connection is not botanical but culinary. Rabbit, boar, and salmon are represented alongside vegetables or herbs—onions, mushrooms, and sage, respectively—with which they will be cooked or served. A flamingo is depicted as already trussed for roasting. Instruments of the kitchen, such as a mortar and pestle or a wine decanter, have an honored place amongst the foodstuffs themselves (figs. 5.2–5.7). No one is being allowed to forget the material gesture of dining as commensality, along with the kitchen activity that precedes it, which underlay the original notion of xenia.

The other noteworthy characteristic of this genre is the extraordinary attention that artists paid to the achievement of verisimilitude. In this respect, the techniques of mosaic and those of fresco are radically different, but in either case the artists accomplished effects that later ages would call photographic or trompe l'oeil.[9] To begin with—and this may be the most important point of all—the culinary materials

5.3. Xenia with food for a banquet,
mosaic, 2nd–3rd century CE. Galleria
dei Candelabri, Museo Pio Clementino,
Musei Vaticani, Vatican City

5.4

5.5

5.6

5.7

5.4. Xenia with bottle and goblet, mosaic, 2nd–3rd century CE. Bardo National Museum, Tunis

5.5. Xenia with a rabbit, mosaic, 2nd–3rd century CE. Bardo National Museum, Tunis

5.6. Xenia with fish and ducks, mosaic, 2nd–3rd century CE. Museo Archeologico Nazionale, Naples

5.7. Xenia with a boar and mushrooms, mosaic, early 4th century CE. Sala degli Animali, Museo Pio Clementino, Musei Vaticani, Vatican City

themselves are often minutely observed. The features of individual kinds, whether flora or fauna, are represented with accuracy that would do credit in pictures to what Pliny's *Natural History* did in words. The fish in a pile and the fruit in a bowl are not identical to each other but often minutely individualized (figs. 5.8 and 5.9). Some specimens look like the Platonic perfection of that species, while others show signs of picturesque bruising. Fruits are elegantly arrayed in a handsome vessel, but some have fallen out and lie carelessly arrayed on the table. And the artistic techniques themselves, quite apart from the efforts of scientific accuracy, are at their most realist in artistic style, often with consummate attention to perspective, the play of light, and the suggestions of shadows, even where this required the laborious application of mosaic tesserae with minutely distinct coloration. During a moment in the history of art when portraits of people tend to look alike (to us, at any rate), portraits of fish do not.

Given this penchant for the *real*, it should come as no surprise that xenia figure so prominently in the *Imagines* of Philostratus the Elder, a series of elaborately rhetorical descriptions of (probably imaginary) paintings.[10] In this collection, xenia have a privileged place, selected as the concluding vignettes in each of the work's two books. The

5.8. Xenia with fish, mosaic, early 4th century CE. Sala degli Animali, Museo Pio Clementino, Musei Vaticani, Vatican City

pictorial photo-realism of the real xenia suits perfectly with the underlying thematic of ekphrasis throughout the *Imagines*, which plays on the notion of absolute similitude between the painted work and the reality it depicts. More than absolute similitude: it is the premise of these exercises, and of many succeeding ekphrases along similar lines, that the text not only describes the (to us, invisible) picture but also delivers realities that are beyond the capability of any actual picture. In the case of the xenia, those hypothesized realities are overwhelmingly gustatory, with the faux visual translated swiftly into texture, taste, and mealtime experience. At the end of book 1, the figs are "just cracking open to disgorge their honey, some split apart, they are so ripe," the apples and pears are ripening not from the painter's pigment on the outside but from natural processes within, and the grapes are bursting with "winey juice" (1.31).[11] The xenia description that concludes book 2 depicts an assemblage of game, and the emphasis here is on culinary process. The hare has already been gutted, the ducks have been plucked, and the viewer is put in mind of the seasonings with which they will be cooked; the invisible future that the scene is made to suggest—another characteristic element in this sort of ekphrasis—consists in the latter stages of the meal beyond what can be seen here, including fruit and dessert. If the *Unswept Floor* is the artifactual detritus of a past dinner, these ekphrases are the textual fantasy of a future dinner.

There is, of course, one prominent ancient tale in which painted food is not a fantasy of dinner but more like the thing itself, at least for a certain specialized group of consumers. We have heard this story before: Parrhasius defeats Zeuxis in the contest of verisimilitude because Zeuxis merely deceived the birds, whereas Parrhasius deceived Zeuxis.[12] But what if we grant the second-place contestant Zeuxis his due and take seriously the proposition that a painting of grapes could be so persuasive to the eye that it stimulates the appetite? After all, the first-place triumph of the curtain, which deceives Zeuxis, is a piece of metaphysical trickery, reminiscent of that in the *Wizard of Oz*: pay no attention to the thing behind the curtain because there is no thing behind the curtain. The triumph of the grapes, on the other hand, is real, at least

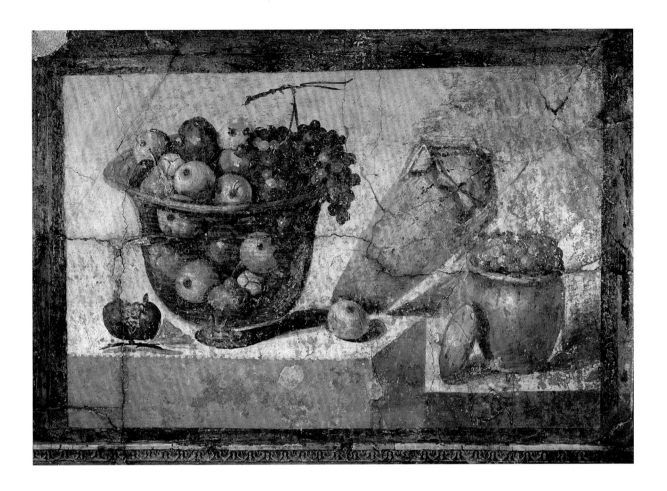

for one audience; the birds, who don't possess a complex understanding of mimesis (or metaphor), believe the food picture to be literally exchangeable for the thing itself. Granted, this is a category mistake (akin to the error of the benighted soul who left a telltale stain on Praxiteles's *Aphrodite*),[13] but isn't it simply the logical endpoint of the whole rhapsodic history of mimesis? Food, it seems yet again, has a special relation to the real. In fact, one might say that it is precisely the notion of perfect mimesis as achieved by visual artists that resists the nearly overwhelming human tendency—Boucher, Kant, Alberti, and others, as above—to look at food and see something else.

We have, then, a late antique repertoire of images, texts, and texts about images, all of which bring together the representation of food and the matter of representation itself, notably including the possibility (or fantasy) of perfect mimesis, which—given the culinary subject matter—promises, however fancifully, something like an edible picture. This conceit is by no means limited to late antiquity. What form of actual influence, if any, may lead from those charming Hellenistic miniatures depicting foodstuffs to the grand flowering of still life in the early modern period is difficult to say, nor is it within the purposes of the present discussion to offer up that whole history.[14] It is nevertheless the case that all those works from the seventeenth to the nineteenth century, from the Low Countries to Spain, by artists from Aelst to Zurbarán (not to mention Cézanne, perhaps the greatest of them all), have something important to tell us about the representation of food as The Thing Itself.

What is this thing itself that we call "still life"? A comparison to Supreme Court Justice Potter Stewart's oft-quoted position regarding obscenity—I can't define it, "but I know it when I see it"[15]—seems to fit the bill. Objects that don't move or don't speak: hence the Dutch term *stilleven* and the English *still life*; objects from the natural world that are no longer living: hence the French *nature morte*. A particularly eloquent, even ecstatic, definition is offered by Charles Sterling in his treatment of the subject:

> A genuine still life is born the day that a painter makes the fundamental decision to choose as subject and to organize as a visual entity a group of objects. Whatever the time period or the medium in which the artist works, nothing alters his profound artistic design: that of imposing on us his poetic emotion before the beauty that he has brought together with these objects and their assemblage.[16]

Sterling's definition does not describe the contents of these paintings. Rather, he tells the story of how the contents got there, reminding us that they have been deliberately arranged and that this arrangement answers above all to some kind of aesthetic law. Such an approach may seem a little too poetic and sentimental for our age, and yet Sterling's definition does point to some universals about still life: it is not wholly accountable to the visible world as the artist happens to find it (though it pretends to be, I would add), and it seeks to inspire emotion in the viewer without recourse to any representation of the human form.

If we are more literal-minded than Sterling and attempt to define still life paintings by what is actually represented in them, we have many possibilities to choose from. Yet the predominance of food as the subject of still life is so decisive that a definition like Sterling's, which doesn't mention food, begins to seem almost perverse. Some statistics casually amassed from online museum catalogues: of the approximately 200 paintings in the category of still life at Amsterdam's Rijksmuseum, 122 depict food; of 200 works labeled still life at the Musée du Louvre, 75 depict food.[17] Sometimes food shares the frame with flowers or signifiers of memento mori or emblems of the hunt (most often themselves edible), but food of one kind or another is the single most frequent subject.

What do we make of this? To put it another way, plugging food into the approach suggested by Sterling's definition, why should it be that edible matter plays such a leading role in the "profound artistic design" that still life painters wish to realize, and why should all these melons and cheeses, hams and oysters function as the bearers of such powerful "poetic emotion" in the face of beauty? What happens, in short, when we read still life for the food?

One might begin by asking what these artists might be painting *other* than still lifes—say, portraits, history pictures, or sacred subjects. In most cases, the "real" that stands as the ultimate referent of the painting is inaccessible to the viewer; the picture is a necessary substitute for that real. And, except in the case of portraits, one might say the same inaccessibility applies as well to the painter, who has had to *imagine* the Rest on the Flight into Egypt or the Battle of Lepanto before painting it.

Then, too, courtesy of Sterling, there is the fact of the artist's complete power to invent, or at least design, the subject—again, not the case with those other genres, where either historical data, theological orthodoxy, features of landscape, or both the looks and the demands of the sitter dictate significant features of the composition. These two circumstances are, of course, a package. Still life painters' subjects are accessible to the painters because, to a significant extent, they created the subjects themselves. And they are accessible to the viewer because they consist of familiar materials from the most universal of human experiences—the dining table. Put the two together, though, and we are reminded that the painter's absolute freedom, while it may apply to the *arrangement* of the objects (and we'll see that it does), does not apply to the objects themselves, which are precisely of the kind that viewers from their own daily experience are in a position to judge as to their verisimilitude—again, unlike the Holy Family or the Battle of Lepanto. And this verisimilitude, what we might call the perfection of its mimesis, is expressed in a painterly circumstance that is nearly unique to the genre of still life: the painted objects tend to be the same size on the canvas as they are in real life.[18]

What does this partly logical and partly paradoxical mix of verisimilitude and artistic freedom of choice actually look like, particularly if we insist on a literal report of the viewing experience? Let us consider a work of Clara Peeters that is now in the Los Angeles County Museum, and let us read it for the food, in the narrowest (to my mind, truest) sense (fig. 5.10).[19] The scene is dominated by a mound of casually heaped dairy products. At the top are curls of butter that have been cut with a comblike apparatus; their limp shapes reflect the precise limits of seventeenth-century refrigeration. The opalescent shallow bowl in which the butter is being served is casually, rather than securely, placed atop a long-aged, dense, probably sheep, cheese with a darkened rind. It in turn has a moderately secure positioning atop a half circle of a somewhat less aged cheese, probably of the Gouda variety. In front of the Gouda is a wedge of a third cheese, this one darkened with an additive like parsley.[20] All three cheeses show evidence of repeated knife hackings; the pieces thus shaved off would not have been particularly shapely. And the process seems to have been a little haphazard: there are four or five tiny crumbs littering the shiny metal platter that is the base of this construction. The knife that did this work is also visible, reflecting some glints of light. Part of the foreground is occupied by a roll that was baked on a sheet pan that became crowded as the yeast did its work in the oven; in clear evidence are the several points at which it touched the other rolls during the oven-rising process, remaining pale in those areas.

So far everything makes sense within a fairly narrow culinary framework: bread, butter, and cheese. It is narrow in chromatic range as well, but things change in the remainder of the foreground. Two groupings of casually placed cherries bring a splash of color. Their bright hue suggests that they are the sort of sour, or morello, cherries that remain popular to the Dutch sweet tooth to this day.[21] In their natural state, they are typically cooked in a pie, and yet in front of them on the canvas we see striking evidence of recent (presumably raw) consumption: a completely stripped cherry pit still attached to the stem. This suggests an almost virtuoso act of mouth work (try it

sometime). Sharing space on another metal charger with one group of the cherries is the greatest act of painterly bravado: an artichoke that has been split down the middle, exposing the heart, the choke, the purple thistle at the center, and the interiors of the green outer leaves. One narrow segment, presumably from the other half of the artichoke, trimmed down to the part that is edible, lies directly on the table. There is a sort of isomorphism between the little wedge of artichoke and the detritus of the cherry; though one is the only edible part and the other the only nonedible part, they both require some effort to separate the edible from the inedible, which in turn testifies to the fact that all this food is made for eating and not just for viewing, and that the human hand (and not just that of the painter) has been at work here.

The artichoke, unlike any other foodstuff in the painting, is somewhat exotic, this vegetable having made its way up from Italy to France in the then-recent past.[22] Correspondingly, it summons up the boldest display of the artist's *maniera*, with its meticulously differentiated shapes and colors. The left-hand edge of the picture is framed with a different piece of bravura, devoted more to tableware than to food: a plinth-like saltcellar with carvings and design *all'antica*, in different metals catching varying reflections of light. At the top of the column is a radiant mound of sea salt, reminding us that this was something of a precious commodity still in the seventeenth century.[23]

Peeters's work is representative of a flourishing genre across the Low Countries, and beyond, within the seventeenth century. Or, more accurately, a set of related genres. It is noteworthy, in the first place, that there is a lively contemporary discourse about these genres and the proper placement of individual works within them, and, in the second place, that these genres are characterized for the most part gastronomically.[24] The painting we have been discussing was identified as an *ontbijtje*, often translated as "breakfast piece" but more accurately as something like "snack piece," referring not to the hour in which it is to be consumed but to the restricted range of what is on offer. Other works were referred to as *banketje*, or "banquet pieces," aesthetically not so very different from the *ontbijtje* but displaying more extensive dining options. Yet another contemporary designation, *pronkstilleven*, or ornate still life, with much grander range of edibles on view, suggests once again that the categories of these works were being defined by their culinary contents.

Among the varied expressions of this genre, the Peeters painting that I have chosen to read so closely is exceptionally centered on foodstuffs themselves. Other "snack" pictures—for instance, Pieter Claesz's *Still Life with Wine Glass and Silver Bowl* (fig. 5.11), in Berlin—introduce us to an artistry that focuses on the tableware almost to the exclusion of the food. This work is almost ostentatiously sparse regarding mealtime: a single olive, though given something like epic prominence by its solitariness and the painterly effects lavished upon it; a few nuts shading off into nothing; and a couple of oyster shells, at least one of which appears to be empty. The scale based on the tiny edibles sets off all the more dramatically the monumentality of the glass goblet and the silver serving dish. The play of light on these glistening objects reveals a mastery typical of the whole genre. But especially noteworthy is the fact that the silver *tazza* (the Italian term is generally used in describing this vessel) is overturned. It turns out, in fact, that the *tazza* is very frequently seen in this position, presumably because only at this angle does it afford artists the opportunity to replicate the vessel's

5.11. Pieter Claesz, *Still Life with Wine Glass and Silver Bowl*, 1625. Gemäldegalerie, Staatliche Museen, Berlin

fantastic Italianate metalwork. But the position also signals an absence of contents; indeed, the overturned *tazza* is found more often in works, like those of Pieter Claesz, with limited foodstuffs on display.[25]

The materials represented in these paintings nearly always operate around a dialectic between works of nature and works of art. Both are dedicated to the pleasures of the table, but it is a relationship of opposites—or rather, they would seem opposite if this pictorial genre had not so thoroughly naturalized their side-by-side presence. Peeters's bread and cheese and cherries impress us by their radical accuracy in summoning up objects from our familiar experience; Claesz's *tazza* and goblet, on the other hand, are likely to impress the viewer because they operate grandiosely outside or, if we are very rich, at the limits of our previous experience. Where these acts of representation come together is that each of them affords the artist a chance to display mastery, covering at once the opposing realms of art and nature; the painter's art superintends both opposites.

That mastery expresses itself via series of themes and variations. So far as table settings are concerned, linen, as in many other genres of painting, is often of ostentatiously fine quality and presented in folds and wrinkles via elaborate painterly techniques. Chinese porcelain, another sign of prosperous acquisition, also makes particular demands on artistic representation.[26] We have already observed the goblet, or *Roemer*

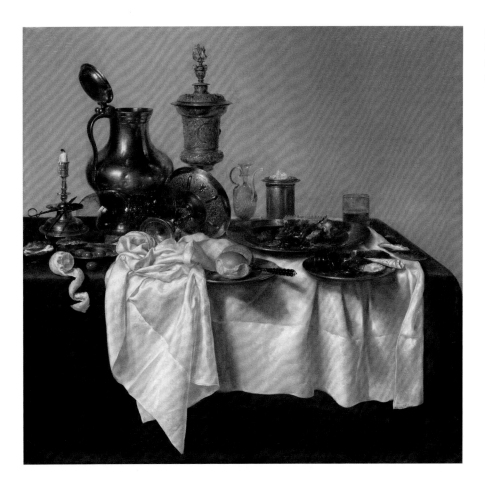

5.12. Willem Claesz Heda, *Banquet Piece with Mince Pie*, 1635. National Gallery of Art, Washington, DC

(in English, occasionally, "rummer"); there is also the closely related *Berkemeyer*, which has a conical rather than a spherical bowl; they are a staple of still-life compositions. Like so many other household items in these pictures, they are a sign at once of lavish expenditure on the part of the householder and of brilliant technique on the part of the artist. Across large numbers of still lifes, they are presented almost identically upright and filled to about a third with clear liquid—presumably white wine, possibly water. An unusual variant can be observed in Willem Claesz Heda's Washington, DC, *Banquet Piece with Mince Pie* (fig. 5.12), where there are two Roemers, one lying on its side and the other broken into pieces on a pewter plate. Among other formulaic items of table setting are richly decorated metal pots, presumably for hot liquid (not coffee or chocolate, though, as these were yet to become staples of European consumption). Sometimes they are depicted with a Berkemeyer goblet poised upside down on their long spout (fig. 5.13); this would appear to be a piece of witty, elegant variation having presumably more to do with the composition of pictorial shapes than with any sort of mealtime practice.

On the food side, it is no surprise that peaches and pomegranates, oysters and lobsters would make frequent appearances: they are luscious, pictogenic, and demanding on the painter's technique. But there are other, less expected members of the feast. The arresting representation of a meat or fruit pie appears almost identically across the work of several artists (fig. 5.14; see also fig. 5.13). In the midst of so many

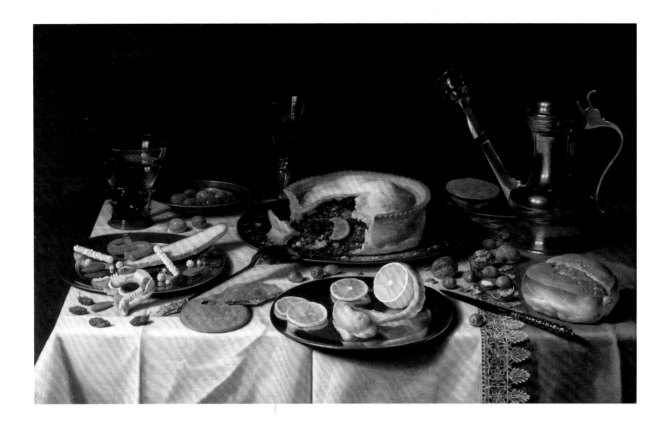

5.13. Pieter Claesz, *Still Life*, 1625–30. The Art Institute of Chicago

near-perfect shiny objects, this dark circular mound, broken open and with mostly unidentifiable contents deep inside, its crust sometimes including military-style ramparts, strikes a very different note.[27] (The mouth of hell springs to mind.) It is often the food item in the picture that shows by far the most elaborate human intervention; indeed, some of these—I'm now speaking of real rather than painted food—were the special province of professional bakers serving wealthy clientele in centers like Haarlem.[28]

A gentler and different sort of intervention, somewhere between the kitchen and the studio—that is, between the cook and the artist—is a culinary object that appears even more frequently. A citrus fruit, usually a lemon but occasionally an orange, has been partly peeled, presumably with a knife (figs. 5.15 and 5.16). The peel, the removal of which is somewhere between half and three-quarters complete, is still attached to the fruit, and it generally describes a long spiral descending elegantly, often extending beyond the surface on which the lemon sits. As anyone who has ever purposefully peeled a lemon knows, there are actually two substances involved: the yellow zest, which is full of intense flavor that is enormously useful in both cooking and distilling, and the white pith, which has no flavor and rather an unpleasant texture. If one is seeking purely the fruit of the lemon, both of these must be discarded, but it is a tricky business to produce perfect lemon and perfect zest—and, of course, impossible to harvest them together, since the nasty pith lies between them. The whole operation, even in the age of Williams Sonoma, is quite demanding.

Which is precisely the story that these extraordinarily skillful painters are telling with their lemons. Or, better yet, reenacting: more often than not, these lemons are

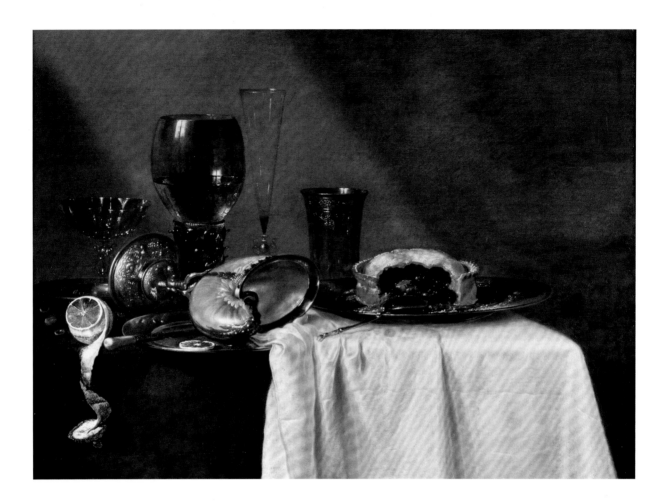

themselves performances of artistic ostentation—the yellow and the white; the shiny side and the shadow; above all, the luxuriant play of the coiling serpentine rind as it detaches itself from the lemon and on occasion flows improbably almost out of the picture plane. Or it is subject to even cleverer placements, parallel to a similarly coiling knife sheath (fig. 5.17), or it mounts upward out of the Roemer in which the fruit is suspended and then coils downward alongside the carvings on the goblet (fig. 5.18).

It's tempting to juxtapose the meat pie and the half-peeled citrus, as artists did on a number of occasions (figs. 5.19 and 5.20; and also fig. 5.17). One is all about exterior, the other about interior; one is engaged in an act of disclosure, the other in an act of enclosure. What they have in common may be more significant, however: they are sites where both the art of the painter and the art of the cook find themselves ostentatiously exhibited.

What this hyper-close reading demonstrates is that it is possible to do such a reading, because these works take us to something like degree zero of the literal; hence, a reading of these paintings purposely excluding nearly everything but the phenomena themselves and taking them as that which they literally seem to be: representations of food and the paraphernalia that surround it.[29] Rather like the xenia, which I characterized as triumphally mimetic while also calling attention to the process of mimesis, these seventeenth-century paintings are designed to produce a double pleasure. Like

5.14. Willem Claesz Heda, *The Blackcurrant Tart*, 1635. Musee des Beaux-Arts, Strasbourg, France

5.15. Georg Hainz, *Still Life*, 1680. Rijksmuseum, Amsterdam

5.16. Pieter de Ring, *Still Life with Golden Goblet*, 1640–60. Rijksmuseum, Amsterdam

5.17. Maerten Boelema de Stomme, *The Truffle Pie*, 1644. Musée des Beaux-Arts, Nantes, France

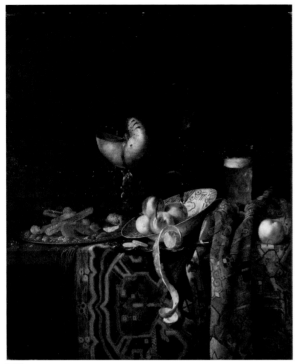

5.15

5.16

5.17

5.18. Willem Kalf, *Still Life with Silver Bowl, Glasses, and Fruit*, second half of 17th century. Staatliches Museum, Schwerin, Germany

Pliny's birds, we allow ourselves to be completely persuaded by the verisimilitude of the food—to be present at these displays and, as it were, to salivate. Unlike the birds, however, we don't chew: we stop short of consuming the painted fruit, because a second, uniquely human (or even human*istic*), pleasure kicks in, a kind of aesthesis whereby the artifice of making grapes out of pigment inspires a certain *jouissance* that temporarily, at least, transcends the boundary separating rectangles of canvas from human taste buds.

I have been recounting this experience as a story about details, but there is a larger act of persuasion going on here. Charles Sterling, it will be recalled, spoke of the still-life painter as an all-controlling figure who operates out of a "profound artistic design," suggesting, in other words, that these are works, more than any other, whose composition is subjected to the absolute will of the artist with the least dependence on circumstantial reality. The paradox of these Dutch still lifes, then—their "reality effect," as it were[30]—is that in a great many cases, their composition is made to appear so accidental—even, by the normal standards of elegant social practice, disorderly. In fact, they almost never look like a real banqueting arrangement; if they were, we would presumably praise the chef and not the painter. Foods are jumbled together or piled askew; oyster shells and bread crumbs fall where they may; bowls of fruit are perched at impossible angles; linen is immaculately pressed but also bunched and crumpled; grand serving pieces sit halfway off the furniture on which they are placed; the partly eaten is up against the exquisitely pristine. If it is not quite the *Unswept Floor*, it is certainly the Unkempt Table.

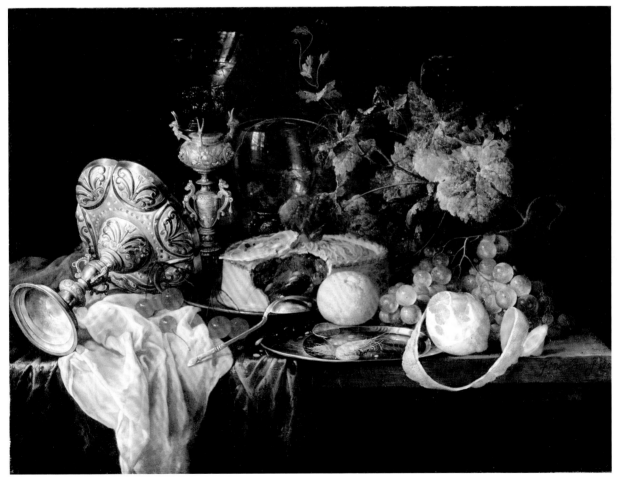

This meeting ground between a painted surface and a human appetite, between the aesthetic of the eye and the aesthetic of the taste buds, is, I would argue, as absolute as representation itself can hope to be. The works themselves seem to demand this kind of viewing. Precisely along the same lines as the ancient xenia, these works deliver

the immediacy of edible subject matter with a corresponding representational realism, which, in both the ancient and the early modern instance, seems more striking than contemporary styles of painting applied to other subject matters. It's almost as though food itself draws artists into a more absolute rendering of visual experience, which is itself a refusal of metaphor: taste buds rather than taste, real (that is, painted) grapes rather than allegories. Perfect mimesis is the equivalent of the absolutely literal: the photographic style of these representations is part of the demand they make upon the viewer to stop at the real and not to look for some figuration beyond the real.[31]

Not that that demand has been universally met. I refer to these works as insisting upon this sort of literal gastronomic reading, but the truth of the matter is that they have often (indeed, *most* often) been read quite otherwise. By focusing as exclusively on the phenomena as I have, I am deliberately setting aside some major traditions of interpretation with respect to this same body of work. And in reflecting on the distance between these sorts of approaches, I hope once again to suggest what it means to read for the food.

There is a lovely small still life by Adriaen Coorte in the National Gallery of Art in Washington, DC, depicting a bunch of asparagus along with two sprigs of red currants (fig. 5.21); both rest upon a shadowy stone base whose principal adornment is the artist's signature. The encyclopedic and indispensable guide to the National Gallery's Dutch painting collection praises the painter's work in the following terms:

> The simplified and idealized shapes of the asparagus and currants give them an enormous presence—something greater than mere morsels to be enjoyed at a meal. Coorte simultaneously emphasized their organic qualities by juxtaposing them against the strongly geometrical shape of the gray stone ledge, in which *cracks remind the viewer that life, indeed all matter, is transient* [emphasis mine].[32]

Arthur Wheelock, the author of this superb catalogue, has an infallible eye and thus recognizes the remarkable quality of presence in the two culinary subjects. It comes naturally to him to declare that such a painterly triumph would transport these gastronomic representations outside the realm of "mere morsels to be enjoyed at a meal" into a loftier zone of abstract truths. Then, with a reading of some rather indistinct representations of masonry, he identifies the zone in question: the cracks in the stone announce to viewers the fact that asparagus, red currants, and stone slabs all disappear in time; the painting, in other words, becomes an allegory of mutability.

It will be apparent from the spirit of the present volume that we don't see the brilliant painterly strokes that render culinary objects preternaturally present as necessarily removing them from their association with "mere" food. (In these pages, food is *never* "mere.") Nor does it seem reasonable to move quite so swiftly from the realist representation of imperfections in the shadowy base underneath the foodstuffs to a message about eternity. Which is not to say that issues of the here and now versus the life beyond are absent from this body of artistic work. As Professor Wheelock has himself persuasively argued, domestic still life labored under an inferiority complex in respect to other genres of painting, and it sought prestige by inscribing itself into the

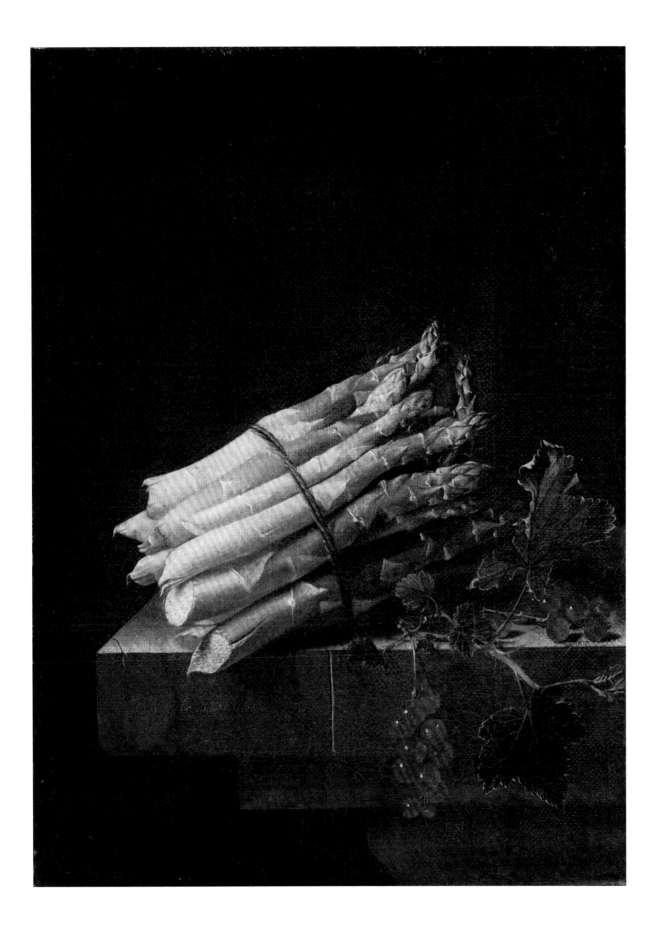

realm of grand theological pronouncements about transience, to which its materials, such as fruits and flowers, were in fact quite appropriate. There is no denying the presence and significance of this message, to be sure. And such a point of view is confirmed by the fact that a notable proportion of these works include skulls, dead animals, snuffed candles, and other unmistakable emblems of *sic transit gloria mundi* and *respice finem*. Indeed, this is a sufficiently well-populated subgenre that it has its own name: *vanitas* painting.[33] Occasionally that word is actually inscribed on the canvas.

Yet, however we choose to read the cracks in this particular painted stone, the Dutch still lifes of the kind we have been considering here do not advertise death so boldly as do the explicit *vanitas* works. Quite the contrary, it would seem: they consist of meticulous renderings of the edible world, everything at the perfect moment for its tastiest consumption and surrounded by consummately fabricated objects designed to house them. Of course, it is possible to look at a picture of a moist ripe peach begging to be slurped or a finely carved goblet waiting to be held in the hand and to leap immediately to the conclusion that fruit withers, glass smashes, and those who enjoy these things will soon themselves be food for worms. The issue is how to balance the mixed messages of succulent edibles and decaying masonry, both as we look at the pictures and as we interrogate our own assumptions about them. We can narrate the cultural debate about present pleasure and ultimate reality, a debate that was quite active in the lifetimes of these artists. But we must also understand that the kinds of paintings we have been considering here—those that do not scream *vanitas* or *sic transit*—leave viewers, whether in the seventeenth century or now, free to engage in the gustatory pleasure of the eye, with or without the message of transience. Indeed, such messages may act as a moralizing excuse for those ocular pleasures in just the way that, say, the message about the biblical Daniel's juridical wisdom renders all those half-naked Susannas voyeuristically licit.[34]

This debate over the "meaning" of these paintings—indeed, over whether "meaning" is the right thing to be looking for—is itself a species of the question as to whether one understands food as a metaphor for something else or as the thing itself, the matter indeed around which the present chapter turns. It emerges that this is a question that was being asked in the precise milieu of these artists. Gérard de Lairesse was a painter who, after going blind, began to lecture on the art of his contemporaries. He was himself anything but a still-life painter, favoring instead the kind of mythological and allegorical scenes that possessed more market prestige. And the terms in which he discusses the work of his older contemporary Willem Kalf, one of the most renowned of the still-life painters, remind us just how possible—as well as dangerous, in de Lairesse's terms—it was to concentrate (using the example of the Coorte painting in Washington) on the asparagus and the red currants rather than on the possible messages ascribed to the masonry. Establishing that Kalf was the very best among the artists of his genre, de Lairesse nevertheless bewails the fact that along with all

> his predecessors and followers [he] never explained the reason for his
> compositions, why he depicted this or that; but only painted that which
> fancied him—such as a porcelain pot or bowl, a gold chalice, a flute or
> roemer with wine, in which dangled a lemon-peel, a pocket-watch, a

horn of mother-of-pearls mounted on a gold- or silver base, a silver plat-
ter or plate with peaches, or perhaps sliced oranges or lemons, a tapestry,
and similar common objects—without ever having considered whether
to create something important that had a significant meaning, or that
could refer to something.[35]

This may be the best final word, for our purposes, about this moment in the artistic
representation of food. If we wish to observe food as the thing itself, in all its sen-
suousness, whether of the eye or the tastebuds, we would do well to observe it as de
Lairesse observed Kalf, ascribing to him the renunciation of importance, meaning,
and—outside of the culinary phenomena *an sich*—even perhaps reference itself.

2

Now, the Not So Real. "Some books," says Francis Bacon in his essay "Of Studies,"

are to be tasted, others to be swallowed, and some few to be chewed and
digested; that is, some books are to be read only in parts; others to be
read, but not curiously; and some few to be read wholly, and with dili-
gence and attention.[36]

Once more, the human as the consuming animal, but the objects are not so appetizing
as those offered by Clara Peeters and her colleagues. Bacon's semantic field should re-
mind us of the ways in which Latin writers associated the processes of language with
those of feeding, a practice that operated all the more powerfully because they pos-
sessed such a heavy concentration of vocabulary (e.g., Pliny's *augunt, lambunt, sorbent,
mandunt, vorant,* i.e., suck, lick, inhale, chew, devour) to cover this territory.[37]

Bacon has need of all this metaphorical density because he wishes both to praise
studiousness and to map out its limits. Excessive study, or ostentatious study, or study
without reference to experience is bad. And even where study is good, it must be care-
fully fractioned into separate groupings: reading, conferring, writing; history, poetry,
mathematics, etc. So the image of tasting, swallowing, and chewing with which books
are characterized here brings this matter forcefully into a realm of intricate, though
wholly familiar, practice. Its familiarity, in fact, maps out a hierarchy of worth. The pin-
nacle of that hierarchy—in a pattern that we will see observed elsewhere—is complete
bodily absorption, with the sequence of voluntary motions culminating in nutrition.
The actual eating of books is kept in the realm of the absurd, or unthinkable; dining
functions here as a figure of speech, and the boundary lines of figuration keep the real
and the metaphorical safely separate.

Bacon's essay is written in a particular rhetorical style that uses metaphor for the
purposes of persuasion but does not wish the reader's mind to stray into alterna-
tive ways of unpacking its metaphors, or into forgetting that they *are* metaphors;
hence the very careful grid of three-part units that leaves us in no doubt as to the
meaning of each figure. But metaphors involving food and drink, of tasting, chewing,

and digesting, are not always so carefully partitioned. Near the beginning of Shakespeare's *Troilus and Cressida*, the hero is about to renounce the pursuit of his seemingly unresponsive beloved. Pandarus, fulfilling his eponymous role of go-between, responds, "He that will have a cake out of the wheat must tarry the grinding"[38]—in other words, with respect to the project of seducing Cressida, Rome wasn't built in a day (to indulge in an unrelated metaphor). But they're not talking about Rome, they're talking about cake. Troilus says he *has* tarried the grinding, to which Pandarus responds, how about the *boulting* (i.e., the sifting); Troilus says he's tarried that, too; Pandarus moves on to the *leavening*; and from the leavening he goes on to the *kneading*, then the heating of the oven, then the baking. Not only are they, of course, not really talking about food; it also turns out that every one of these bakery terms is—no surprise—also about sex.[39]

It is still relatively simple and, as it were, Baconian; it's clear that no one is producing a cake. In this case, however, the metaphorical sequence is more arcane, and it is not actually spelled out to us which phase of the slowly unfolding love affair corresponds to each step of the recipe, though in time-honored tradition we are being nudged toward a search for erotic double entendres, a conclusion that is confirmed with the last piece of culinary advice, when Pandarus tells Troilus to wait until the cake has cooled lest he burn his lips. Advice that, inevitably and catastrophically, Troilus does not follow.

What happens, though, when there *is* a cake, or at least something like a cake? Early in the play that bears his name, Hamlet feels called upon to explain to his friend Horatio the brief interval between his father's death and his mother's remarriage. It has not yet been presented to him that his father was murdered by the man his mother married, but that doesn't quite matter because, as we will learn throughout the play, it's really the brevity of that gap in time, and the attempt to grapple with his mother's swift transition from widow to bride, that forms the center of his agony. Horatio is too diplomatic to inquire about it, of course, but Hamlet answers the unasked question about the brevity of the interval by veering toward the kitchen: "Thrift, thrift, Horatio. The funeral baked meats / Did coldly furnish forth the marriage tables" (1.2.179–80). In other words, we did it to save money, so we could use cold leftovers from the funeral to serve hungry guests at the wedding.

At the other end of the play, when Hamlet has himself committed murder and hidden the victim's body, Claudius interrogates him:

KING CLAUDIUS. Now, Hamlet, where's Polonius?
HAMLET. At supper.
KING CLAUDIUS. At supper? Where?
HAMLET. Not where he eats, but where he is eaten. (4.3.17–20)

This double invocation of food places us in a more complicated realm of figuration than the double entendres in *Troilus* or the quotation from Bacon about reading. Neither of Hamlet's speeches is really about eating, but they are not entirely metaphorical either. Instead of really being about books or about sex, they're about the measuring of human life. What is for Hamlet the terrifyingly rapid turnover between funeral and

wedding is figured in the common term between them, which is party snacks; but the term isn't altogether common because, between the time of the funeral and the time of the wedding, brief as it is, the food has gotten cold—presumably at the same rate as the body in the ground. And exactly the same sort of 180-degree relation exists later in the play, when Hamlet declares that Polonius is "at supper." The living body that sits at the dining table—engaged in one of the essential activities that defines it as living—is the same body that provides, as Prince Hal will declare in a different play, food for worms.[40] The subject of life and death, along with the surrounding rituals, turns the food metaphors real.

One final Shakespearean culinary figure. How shall we understand the phrase "milk of human kindness," which is so thoroughly naturalized in our language that we forget that it is Shakespeare and we forget that it is about food? Only by weaving it back into *Macbeth* do we begin to appreciate the intricacy of its inscription. Lady Macbeth uses it to refer to her husband's reluctance to commit the murder that they have plotted: "Yet do I fear thy nature; / It is too full o' th' milk of human kindness / To catch the nearest way" (1.5.14–16), that is, to seize the opportunity to murder King Duncan afforded by his presence in their castle. In that sense, it amounts to a demasculinization by Lady Macbeth, as though to imply that her husband is so effeminate as to be somehow lactating. *Kindness* is here understood not only in the modern sense as benevolence but also in the earlier sense of appropriate to one's species, or *kind*. In a complementary gesture, Lady Macbeth establishes her female credentials ("I have given suck"), while declaring her willingness, in spite of her gender, to beat the brains out of a suckling infant provided she had previously sworn to do so. Not much milk there.

We have traveled from Bacon's books, with a merely rhetorical relation to eating, to Troilus's cake, which was rhetorical but intricately so, to Hamlet's *Totenmahl*— we live, we die; we eat, we are eaten, all literally true—and finally to the lactation in *Macbeth*, which appears wholly figurative but only until we remember the fact of breast milk, which counts as food to a (hypothetical) infant. Each step in that progression goes further to complicate the question of how food might become metaphorical. If we place Clara Peeters's cheeses next to this sequence of figures, thereby also moving from pictures to words, a proposition seems to emerge, at least as the present volume and its author construe this complicated subject: it is easier for literal, or mimetic, food to resist, or at least marginalize, the notion of figuration than it is, contrariwise, for figurative food to marginalize the real—that is, the actual experiences of consumption and taste. I can, in other words, more readily overlook the messages of mortality implicit in Coorte's stones than I can fail to notice the familiar culinary properties of snacks, cake, or milk in Hamlet's canapés or Troilus's cake.

Is it just that we spend more time eating than doing hermeneutics? Let us seek a more textured line of explanation. The theme of this volume has been the relation between food culture and what I've called high culture—poems, pictures, philosophy, statecraft, and so forth. Now we've come to the property unique to food and not shared by any of those other activities: food enters the body and—in a variety of ways—exits the body. The body in short is the place where food refuses to be constrained into the

role of mere figuration and insists on some form of reality, offering up something like a sign at the entrance to the gullet that reads, "the metaphor stops here." This is the process that I'm calling embodiment. Which, as may be recalled, proved to be the moment when Bacon's metaphor could go no further, when books needed to be quarantined from the digestive tract.

For Hamlet, who lives in a world where one eats snacks and is eaten after death, and for Lady Macbeth, whose body either does or does not produce the milk of nourishment (and either does or does not have babies who require such nourishment), this quarantining is not so easy. It is a process whose lineaments can be followed with particular richness in a much later text than those we have generally considered:

> Many years had elapsed during which nothing of Combray, except what lay in the theatre and the drama of my going to bed there, had any existence for me, when one day in winter, on my return home, my mother, seeing that I was cold, offered me some tea, a thing I did not ordinarily take. . . . She sent for one of those squat, plump little cakes called "petites madeleines," which look as though they had been moulded in the fluted valve of a scallop shell. . . . No sooner had the warm liquid mixed with the crumbs touched my palate than a shiver ran through me and I stopped, intent upon the extraordinary thing that was happening to me. An exquisite pleasure had invaded my senses, something isolated, detached, with no suggestion of its origin. And at once the vicissitudes of life had become indifferent to me, its disasters innocuous, its brevity illusory—this new sensation having had the effect, which love has, of filling me with a precious essence; or rather this essence was not in me, it *was* me.[41]

Clearly, though Proust's story has the same kind of plot as Bacon's—tasting, swallowing, digesting—it's not metaphoric in the same way. For one thing, real food is involved, and as soon as that happens, we enter the realm where physical sensation—hunger, thirst, the satisfaction of desire, and their aftereffects—necessarily impinge on whatever larger-scale narrative is being constructed. In fact, this is yet another instance where food shadows or surrounds an experience that is construed as more significant than eating. This inequality is, after all, the economy of metaphor itself, with the vehicle (in the familiar formulation) relegated to a subordinate position as compared to the "real," or tenor.[42] Eating the madeleine is a "mere" figure for the substantial matter that will occupy the whole novel, which is the summoning of memory. But, once again, how "mere" can food ever be?

Marcel downs the pastry, has an extraordinary, and apparently nonculinary, experience that he doesn't understand; eventually he remembers something he had forgotten, which was a much earlier experience, of a parallel culinary kind, and from there a flood of non-gastronomic recollection engulfs him. But if this account of madeleine-as-mere-metaphor is not altogether satisfying—and it isn't—that's because taking a substance inside the body literally has the effect of breaking apart the compartmentalized structures of tenor and vehicle. *Cette essence n'était pas en moi, elle était moi.*[43]

It's in the nature of this equation via ingestion that it is troubling and unstable. Between the taste of the madeleine and the full-blown appearance of the memory, Marcel is at great pains to do the thing that we have seen done countless times in the course of these pages; he keeps saying the food is not the important part: "Whence could it have come to me, this all-powerful joy? I sensed that it was connected with the taste of the tea and the cake, but that it infinitely transcended those savours, could not, indeed, be of the same nature" (60). Yet once the childhood recollection has resurfaced, he is forced to declare, "When from a long-distant past nothing subsists, after the people are dead, after the things are broken and scattered, taste and smell alone, more fragile but more enduring, poised a long time, like souls, remembering, hoping amid the ruins of all the rest; and bear unflinchingly, in the tiny and almost impalpable drop of their essence, the vast structure of recollection" (63–64). What essence, then, wasn't *in* him but *was* him? The very mechanisms, whether of metaphor or of body-and-mind, of physical nourishment and mental activity, lose the distinctive structures we ascribe to them of cause and effect, or tenor and vehicle. When the possibly real, possibly metaphoric, possibly real *and* metaphoric substance is taken into the body, who can tell the taster from the taste?

This matter of ingestion with consequences that go beyond metaphor has a long pre-Proustian history, as for instance:

> When the woman saw that the tree was good for food, that it was pleas-
> ant to the eyes, and a tree desirable to make one wise, she took of its fruit
> and ate. (Genesis 3:6)[44]

A sequence of motivations is ascribed to Eve, and they are arrayed in an ascending order of significance, so as to culminate in the fatal decision. Put in proper hierarchical order (though the text reverses that order), they are: wisdom, beauty, physical nourishment. Never mind, for the moment, that in the present case the whole hierarchy is corrupt, since the object that God has forbidden cannot truly deliver these goods, no matter how worthy they may be in themselves. We must, however, notice that the point of entry to this mentality of the Fall—in effect, the mentality that we continue to possess—is "good for food." No coincidence that Eve, whose gender is believed to define her kind via the kitchen, is first hooked by something culinary, and indeed by that most basic piece of culinary wisdom: what is safe, rather than unsafe, for human consumption.[45] Kudos for Eve that she recognizes something that is edible rather than inedible (Adam probably doesn't even know how to boil an egg); what she doesn't know, however, is that there exists in God's plan a far more dangerous form of the inedible than that which disqualifies something for inclusion in a fruit salad.

In all of this we may recognize the familiar gesture of relegating the whole matter of food to inferior status: Eve rather than Adam as principal actor; human hunger rather than God's plan; edibility rather than either beauty or wisdom (themselves in ascending order). And yet, stepping back from these details, we are struck by the enormous starring role that Genesis assigns to a fundamental act of consumption. There has been much discussion, among both religious and secular commentators, of the question of the apple,[46] and we will get back to it, but rather less discussion of the

question why the medium of original sin—the vehicle, as it were, of a cosmic metaphor about the universality of human corruption—should consist not in seeing or hearing or touching (why not sex, after all?) but in eating.

We have, in short, eaten our way to original sin, which takes us back to the realm where the metaphorical meets the corporeal, where a substance enters (and exits) the body, where Marcel is driven to say that it filled him, that it wasn't just *in* him, it *was* him. Here we may learn from another authority with ambitions at providing a master narrative of origins. In a brief paper from 1925 entitled "Negation," Freud writes,

> The function of Judgement is concerned in the main with two sorts of decisions. It affirms or disaffirms the possession by a thing of a particular attribute; and it asserts or disputes that a presentation has an existence in reality. The attribute to be decided about may originally have been good or bad, useful or harmful. Expressed in the language of the oldest—the oral—instinctual impulses, the judgement is: "I should like to eat this," or "I should like to spit it out"; and, put more generally: "I should like to take this into myself and to keep that out." That is to say: "It shall be inside me" or "it shall be outside me."[47]

Genesis, too, it seems, bases its account on "the oldest—the oral—instinctual impulses." Freud does not cite the Bible, and yet the passage seems almost a gloss on Eden. Separating the bad from the good—the originary act of judgment—consists of a decision whether to allow a substance to enter the body via the mouth. It harks back to Kant's claim (echoed by many others) that sought to objectify the notion of good taste by grounding it in healthful as opposed to noxious acts of ingestion, as though things that were bad for us automatically identified themselves as such by tasting bad (if only!).[48] The experience of taste, whether it's the apple, the madeleine, or whatever it is that Kant liked to eat, is, in fact, a floating signifier in these stories of consumption, a potentially dangerous pleasure principle that has landed in a space where matters of necessity—God's will, memories of lost time, sophisticated aesthetic judgment, healthful diet—are understood to be more essential. But it is in the nature of food, whether literal or metaphorical or in some corporeal space encompassing both, that it provides multiple satisfactions. The serpent did not choose to lure Eve with Vitamin C, of which an apple provides 14 percent of our daily requirement; the pleasure principle can never be left out of the equation.

At least for English speakers, the master text of this act of consumption will always be *Paradise Lost*, and the circumstance that most forcefully anchors this act as culinary is Milton's choice of designating the edible object as an apple. Such an identification was anything but inevitable.[49] Genesis, as we have seen, does not get specific at all, rather using a term (פְּרִי, or *peri*) for fruit in general. It is no surprise that the particular Miltonic identification is absent from Genesis, since apples were by no means native to the region of the Bible. Over the centuries, exegetes and translators have felt the need to nail the matter down, and the result has been a whole greengrocery full of possibilities—apricots, figs, grapes, peaches, along with terms like the Latin *pomum*, which designates a class of fruit rather than one species in particular.

For painters, whose need to specify is more pressing than that of exegetes, the range of choices, from citrus to pomegranate, reminds one of the pieces of fruit that we saw adorning Madonna and Child paintings in chapter 3 (perhaps not by coincidence).[50] The special claim of the apple, besides the prestige of Milton in popularizing the scene, is the double meaning of the Latin *malum*, which is both "apple" and, with a different length of vowel, "evil" (though *fructus*, not *mālum*, is the word the Vulgate uses). Indeed it may have been irresistible to connect the *mālum* with the knowledge of *bonum* and *malum*. Doubtless relevant, too, was the apple of discord that performed as the central prop in the judgment of Paris and thence helped initiate the Trojan War: its inscription "to be given to the most beautiful" would resonate in regard to the putatively narcissistic Eve.

What counts perhaps most of all, however, in Milton's choice of the apple is simply the fact of its utter ordinariness as part of his audience's culinary experience. Northern European painters, including Rubens and Bruegel, tended to opt for exotic fruits redolent of the far-off Holy Land; Milton makes the opposite selection, landing on what may have been the commonest edible in the whole English diet. Even the word *apple* itself, with its diminutive-style suffix, points toward the homely. No choice, in other words, could have better rendered this act of cosmic significance more radically domestic, which is to say more radically culinary, as a piece of universal experience.

From the opposite perspective—the *eater* rather than the *eaten*—this same appeal to universal human experience in the midst of cosmic drama is apparent as we approach Eve's fatal choice:

> Fixt on the Fruit she gaz'd, which to behold
> Might tempt alone, and in her ears the sound
> Yet rung of his perswasive words, impregn'd
> With Reason, to her seeming, and with Truth;
> Mean while the hour of Noon drew on, and wak'd
> An eager appetite, rais'd by the smell
> So savorie of that Fruit, which with desire,
> Inclinable now grown to touch or taste,
> Sollicited her longing eye. (9.735–43)[51]

There had already been, to be sure, all of Satan's slick persuasiveness, but "mean while" there arises a set of motives that do not depend on rhetoric but are rather completely normative and gastronomic: it is lunchtime, hunger is aroused, and when delicious food is presented, all the senses (but especially those low-liers, touch and taste) are engaged and demand their satisfaction.

All this association of Milton and the apple notwithstanding, it is noteworthy that in fact he uses the word very sparingly indeed. The consumed object is at the very center of the epic from the beginning. God creates the prohibition; Adam and Eve spend a couple of books discussing the dangers of eating from the tree of knowledge of good and evil; Satan eventually inhabits the tree, and there ensues extensive conversation between the serpent and Eve about it; Eve eats it, convinces Adam to eat it, whereupon they fall and go into lengthy recriminations about having eaten it; finally,

they are punished for having eaten it. Through the entirety of this narrative, the term *apple* is all but totally withheld. The poem's opening lines point us rather in a different direction:

> Of man's first disobedience, and the fruit
> Of that forbidden tree, whose mortal taste
> Brought death into the world, and all our woe
> With loss of Eden, till one greater man . . . (1.1–4)

The word for that pivotal prop in this story—a word used sixty-one times in the course of the poem—is not *apple* but *fruit*. And the fact that it has enormous resonance should be apparent in that initial enjambment: if we stop reading at the end of the first line, we understand the word *fruit* to mean *result*. We know what the result of humankind's first disobedience was: it was the Fall. If, on the other hand, we continue without stopping at the line break, *fruit* turns out not to be the effect but the cause. God has us coming and going.

The relationship between the initial meaning of the word *fruit* (as result, the consequence of the Fall and all of human history) and the meaning that emerges across the line break (i.e., the culinary object of consumption) exists in the same sort of hierarchy as Proust's memories and the madeleine that sparked them—that is, between a mere happenstance and a vast result, their relation in both cases literalized via an act of consumption. For Milton (as for Proust), it is a troubled hierarchy, which emerges on a climactic occasion when the word *apple* does get used (one of only two times in the whole poem). Once the terrible deed is done, Satan returns in triumph to exult among his legions of fallen angels. Milton offers up some of his best epic pastiche, as the Enemy of Mankind grandly dramatizes the heroism of his universe-spanning accomplishment. He will recount, he says,

> how I found
> The new created world, which fame in heaven
> Long had foretold, a fabric wonderful
> Of absolute perfection, therein man
> Placed in a paradise, by our exile
> Made happy. (10.480–85)

In order to celebrate his own achievement, Satan must aggrandize everything, until he gets to the central event:

> him by fraud I have seduced
> From his creator, and the more to increase
> Your wonder, *with an apple*. (10.485–87)

It's a comic punchline for Satan's audience ("worth your laughter," he goes on to say to the devils); he is such a brilliant hero that he accomplished the damnation of humankind with something from the produce section. But it's precisely that shift from the

nearly ubiquitous "fruit," to the near *hapax legomenon* "apple" that brings the discourse crushing down to the level of the "mere" madeleine. Or rather lower: for Milton, to concentrate on the food—locating the events, as it were, at the supermarket—is to perform a satanic reading of the Fall. (In fact, the only other instance of *apple* is also in the voice of Satan, while he is tempting Eve.) Milton well knows, of course, that a satanic reading is always possible—just as William Blake famously knew[52]—but the bathos of suddenly inserting the unmistakable sign of *mere* (!) food into the story stands as a corrective. Such a reading, in Saint Augustine's terms, consists in failing to recognize the proper hierarchy of the letter and the spirit,[53] the apple and the fruit. But when it comes to food, that hierarchy is never quite secure.

Nor is food ever, in the design of the whole poem, *mere* food (even less so than in the case of Dutch still life). Well before the fatal events of book 9, Milton has staged a scene in which God makes every possible effort (futilely, as God already knows, of course) to prevent those events from taking place. He sends the Archangel Raphael down to Eden for the purpose of rendering Adam and Eve completely knowledgeable (so to speak) regarding the sole prohibition that operates in the garden and what it would mean to defy it. But before the scene is theological, it is gastronomic. Readers of *Paradise Lost* and commentators upon it tend to be charmed, and slightly surprised, by the culinary aspects of the little table-for-three lunch party in book 5.[54] Everyone remembers, and chuckles over, the phrase, "No fear lest dinner cool,"[55] which seems like a throwaway but actually refers to the paradisaical fact that, since nothing has been cooked—that is, altered from its natural state—nothing needs to be served hot.[56] The consequence being that the exigencies of the kitchen will not intrude upon the holy conversation—in other words, no such problem as we observed among the food-obsessed yet dinner-deprived sophists of Athenaeus.

But the poet himself *does* intrude with quite a lot of culinary information. Milton proves to be as learned and theologically scrupulous about cuisine as he is about more sacred matters.[57] He knows the geography—*future* geography, of course—of the far-off places where the best fruits and spices are grown, and he approves of Eve's choices for a multicourse meal ("not to mix / Tastes, not well joynd, inelegant, but bring / Taste after taste upheld with kindliest change" [5.334–36]). He even tackles the thorny problem of how to imagine the culinary consequences of simultaneous spring and autumn, which is a fundamental condition of paradise. In Eve's gentle dis-agreement with Adam's request for an especially bounteous bill of fare with which to honor their heavenly guest, she points out that "small store will serve" since everything is available to them, presumably in its perfect moment of ripeness, but she adds,

> Save what by frugal storing firmness gains
> To nourish, and superfluous moist consumes. (5.324–25)

In other words, even with no seasons she possesses the technique to age those fruits that become even more tasty and nutritious when they are preserved properly past their original time of ripeness.

There are still grander issues about eating and drinking that lie below the sur-face of this scene, however. As has often been pointed out, Milton is here operating

> So down they sat,
> And to their viands fell, nor seemingly
> The Angel, nor in mist, the common gloss
> Of theologians, but with keen dispatch
> Of real hunger. (5.433–37)

So much for the Raphael of the Book of Tobit (Apocryphal, as we may recall), whose culminating denial labors to cancel any impression that the heavenly intake of mortal food was possible.

It soon becomes quite clear why Milton should be going out on this particular limb: his entire cosmology is alimentary. "Whatever was created needs / To be sustained and fed" (5.414–15), he tells us, and he builds the whole hierarchy of the universe from lower to higher via that verb *to feed*. Earth and sea; earth and sea together with the air; the air to the moon, the moon to the Sun, "that light imparts to all, receives / From all his alimental recompense." When Raphael then goes on to rephrase this hierarchical vision in a more abstract and Platonic key, describing how body turns to spirit and the merely good turns to perfection, the whole cosmic machine has already been thoroughly imbued with the culinary. The present moment, in which an angel and two mortals are having lunch, becomes not just an accident on the way to heaven but its essential starting point. And, *mutatis mutandis*, the ending point:

> Time may come when men
> With Angels may participate, and find
> No inconvenient Diet, nor too light fare. (5.493–95)

From fruits in the Garden, human history will progress to the heavenly supper of the lamb.

What is most important to recollect here is that all this Miltonic invocation of mealtime is not about cuisine or flavor or the sense of taste—all matters that have been significant in the present volume, to be sure—it is about ingestion, about a body taking inside itself less-refined substances than itself and thereby becoming one step more refined. This is why he has to reject the denouement of the Tobit story, which, in the usual manner by which Christians co-opted but also set aside the tenets of the Jews, insisted on placing an insuperable barrier between the human and the divine. And why it is that eating should be the mechanism of transcendence becomes apparent in one of Milton's most shocking images. We have already seen how he declares the archangel to have "real hunger," and he will go on from there to touch delicately—and, from the angelic perspective, reassuringly—upon one of the grittier consequences of satisfying hunger: "What redounds, transpires / Through spirits with ease." In between the eating and the excreting, however, he uses an uncharacteristically technical term. It will be best to quote the whole passage:

> So down they sat,
> And to their viands fell, nor seemingly
> The angel, nor in mist, the common gloss

Of theologians, but with keen despatch
Of real hunger, and concoctive heat
To transubstantiate; what redounds, transpires
Through spirits with ease. (5.433–39)

It is that most particular act of ingestion that counts as Milton's ultimate destination, and it is ours as well.

3

When Milton nonchalantly drops that very technical term *transubstantiate* into this account of Edenic commensality, he is pointing toward the most radical of all these culinary metaphorics.[62] So we go from Bacon's metaphorical ingestion to Marcel's equivocal ingestion, somewhere between being *in* him and *being* him, to Adam and Eve, who eat a piece of fruit that is simultaneously a vast cosmic result. That in turn takes us to the most famous and most perpetually reenacted instance of ingestion. In this act, and in its millennia of re-performance and reinterpretation, we find ground zero of the relation between metaphor and embodiment that lies at the heart of the human experience of eating and drinking. We may identify it from its earliest biblical expression, in Paul's letter to the Corinthians. The scene is the first night of Passover:

> The Lord Jesus on the same night in which he was betrayed took bread; and when He had given thanks, he broke it and said, "Take, eat; this is my body which is broken for you; do this in remembrance of me." In the same manner he also took the cup after supper, saying, "This cup is the new covenant in my blood. This do, as often as you drink it, in remembrance of me." For as often as you eat this bread and drink this cup, you proclaim the Lord's death till he comes. (1 Corinthians 11:24–26)

Christianity, in other words, is instituted via a particular act of eating and drinking; it is to be repeated by every believer, and that repeated act will measure the time between Christ's death and his second coming.[63] But what exactly does this instance of consumption *mean*? Where does it fit, in other words, along the scale of figuration as drawn by Bacon, Proust, and Milton? We can see the problem already in Paul. "This is my body . . . my blood" points in the direction of the literal act—*moi*, not *en moi*—whereas "do this in remembrance of me" points toward eating and drinking as figural versions of the believer's faith in Christ.

What kind of relation, then, might we postulate, in regard to food and wine, between the literal and the metaphorical? There are, after all, seven sacraments, at least in the Catholic church. None of them has undergone the wars of interpretation that the Eucharist has: that, I believe, is because it involves eating and drinking, because it consists of literal ingestion. Once again, it's the sign at the entrance to the gullet that reads, "The metaphor stops here."

And if it does stop there, it stops in a scary place: the comestible object is not a cookie, it's not an apple, it's the body of Christ; Christians are cannibals—and not just eating their fellow humans but eating their God.[64] Now, these questions of interpretation, and all the food-related disquiet that they summon up, have been part of this story from the beginning. In Paul, the whole thing is glossed over in such a way as to make simple sense, and the same is more or less true in the three synoptic Gospels. But in John, grave anxiety about the literal and the metaphoric bursts into the open. The lead-in to the instituting of the Eucharist is the story about feeding the five thousand. This literal act of nourishment gives Jesus the chance to perform some quite straightforward metaphorizations: "Do not labor for the food which perishes, but for the food which endures to everlasting life, which the Son of Man will give you, because God the Father has set His seal on Him" (John 6:27); "I am the bread of life" (John 6:35). So far, he's not asking us to take the figurative literally. But then he takes that crucial next step: "I am the living bread which came down from heaven. If anyone eats of this bread, he will live forever; and the bread that I shall give is my flesh, which I shall give for the life of the world." At which point, his audience behaves in a way that we don't see elsewhere in these accounts: "The Jews therefore quarreled among themselves, saying, How can this man give us his flesh to eat?" And later, after he has repeated the claim in no uncertain terms ("For my flesh is meat *indeed*, and my blood is drink *indeed*"), they murmur among themselves, "This is a hard saying; who can understand it?"[65]

Millennia heard it, and centuries of debate focused on exactly this question of figuration. At every stage in the development, and then the diversification, of religious doctrine, no subject in the whole universe of Christian theology received more tortured argument than the question of what exactly communicants were ingesting when they consumed the consecrated bread and wine. Biblical origins are, as usual, enigmatic. The synoptic Gospels are explicit in their reference to the first day of the Passover feast, and that occasion would certainly contribute to the notion of a ritual menu whose elements were explicitly symbolic; but the central symbolic act of this particular feast, the drinking of wine-as-blood and flesh-as-meat, is so alien to Jewish law that we can only conclude it was designed to obliterate any relation to previous practice.[66] And, clearly, the central fact of the Last Supper, which is the sacrifice of Jesus, has only a very oblique relation to the meanings of the Jewish Passover.

The early Fathers of the Church were indeed up against opponents troubled by the notion of a Messiah who, as Matthew phrases it, looking at it from the perspective of his enemies, was "a glutton and a drunkard" (Matthew 11:19). Worse yet, they were confronting heresies that had altered the Christian story so as to simplify the impossible paradoxes of the God-man whose body and blood the faithful are supposed to consume. As a consequence, they struggle in their writings to make some kind of sense out of the fearsome injunctions of the Last Supper. Irenaeus glosses over the ingestion aspect and sees the bread and wine as sacrificial offerings. Tertullian glosses "This is my body" as "the *figure* of my body," and, since that is precisely *not* what Jesus says in the Gospel of John, he goes on to theorize that there could not be a *figure* of a body unless there were a *real* body, thus, as it were, deriving Christ's consumable body from the process of figuration.[67]

In a later generation, Ambrose shifts the focus to the magical power of Jesus's words: they were ordinary bread and wine until Jesus named them as his own body and blood, "so you see in what ways the word of Christ has power to change everything."[68] Augustine, true to his genius in the operation of hermeneutics, slides away from Jesus's own uncompromising equations concerning the Eucharist and toward his own metaphors of instruction for the Christian life:

> "One bread," he says. What is this one bread? Is it not the "one body," formed from many? Remember: bread doesn't come from a single grain, but from many. When you received exorcism, you were "ground." When you were baptized, you were "leavened." When you received the fire of the Holy Spirit, you were "baked." Be what you see; receive what you are. This is what Paul is saying about the bread. So too, what we are to understand about the cup is similar and requires little explanation. In the visible object of bread, many grains are gathered into one just as the faithful (so Scripture says) form "a single heart and mind in God" (Acts 4.32). And thus it is with the wine. Remember, friends, how wine is made. Individual grapes hang together in a bunch, but the juice from them all is mingled to become a single brew. This is the image chosen by Christ our Lord to show how, at his own table, the mystery of our unity and peace is solemnly consecrated.[69]

In effect, Augustine does something of a bait and switch, turning the matter away from the impossible—that is, the cannibalistic—reading of the sacrament and toward the common experience of the foodstuffs themselves. In his own way, Augustine reads the sacrament for the food.

In fact, it is in some considerable part owing to the heritage of Augustine that the hermeneutic space in this transaction between signifiers and signifieds becomes so highly charged in the Middle Ages, at which time the whole question surrounding these acts of consumption and their relation to divinity turns fierce, even violent. The ninth century witnesses a debate between two monks—each of whom in turn would become the abbot of the monastery at Corbie in northern France—that sets the terms for the medieval discussion of the Eucharist.[70] Paschasius Radbertus, in a treatise entitled "On the Body and Blood of Christ," takes what comes to be called the "realist" position: the body of Christ in the sacrament is the selfsame body that was born of Mary, that suffered on the Cross and died. Contrariwise, his fellow monk Ratramnus writes his own treatise under the same title in which he begins with a simple philosophical position: "Things that differ from each other are not the same." The body of Christ, "which died, which rose again, and being made immortal 'dieth no more,'" is eternal, whereas the body that is celebrated in the sacrament is "temporal."[71] The sacramental body is real, but in a "veiled" form.

The Gordian knot will be, at least partially, loosed by the assistance of the pagan philosopher Aristotle, via Thomas Aquinas.[72] The Aristotelian doctrine of substances versus accidents, itself born out of Plato's forms, holds that any entity possesses an essential unchanging nature, but it may also vary in its attributes (Aristotle counts

nine categories of this variation) while still possessing the same essential identity. If we slip into this discursive structure the body and blood of Christ, on the one hand, and the sacrament on the other, we possess at least the philosophical outlines of a solution to the mysteries of the Eucharist. And it is this emphasis on "substance" that will produce the ruling Catholic answer to all these questions, the notion of *transubstantiation*, promulgated at the Fourth Lateran Council in 1215 and, as we saw above, echoed in Milton's Eden.[73]

But this determination, whether we are looking at it as solving a problem in logic or a problem in church unity, hardly puts an end to the bickering. The Reformation is yet another, and particularly violent, chapter in these debates.[74] Martin Luther regards transubstantiation as a figment: he views it as a *philosophical* solution, whereas the real solution should come by faith—specifically the idea that God is everywhere and therefore can be present in the material sacrament, in whatever times and places it is celebrated. Zwingli cannot tolerate the idea of a literal presence of the body; and when the Zwinglians and the Lutherans attempt to reconcile at Marburg in 1529, Luther inscribes on the desk in front of him, *Hoc est corpus meum*, by way of asserting a non-negotiable demand. John Calvin, for his part, has no taste for transubstantiation, or its later variant consubstantiation; he swears off a solution—again, philosophy is treated as the enemy—and declares, "Not Aristotle, but the Holy Spirit teaches that the body of Christ from the time of his resurrection was finite, and is contained in heaven to the Last Day. . . . I rather experience than understand it."[75]

Which, though it is certainly not the end of the story, is probably a good place for cultural history (and *gastronomic* cultural history at that), rather than theological history, to leave the technical understanding of the Eucharist from its beginnings to the early modern period. But what happens if we observe this whole matter from a different perspective and, in the habitual way of the present volume, read for the food?

What happens in essence is that the whole sacred process—whatever form of transformation or substantiation is understood within it—finds itself surrounded, one might even say bedeviled, by the fact that it is anchored in the utterly earthly and natural business of human eating and drinking. There can be no doubt, to begin with, that the origins of the rite go back to quite ordinary mealtime practices, whether these were Roman banquets, Jewish celebrations, or early Christian gatherings of the faithful. Before the bread and wine attained their status as the body and blood of Jesus, they were variously the shared gifts, the gestures of hospitality, the leftovers, or the charitable contributions to the poor that accompanied ancient feasting.[76] And once their significance as dogma had been (in varying ways—which is part of the problem) proclaimed, their material food-and-drink-ness could not be made magically to disappear.

We have already observed how Augustine inserts the practical mechanics of bread and wine production into a sermon about the Eucharist. But that is, along the lines of Shakespeare's Pandarus on the subject of wooing Cressida, just a useful heuristic metaphor. As Eucharistic practices become more widespread, and more contentiously debated, their culinary materiality finds itself at the center. Is ordinary bread identical to the communicants' daily experience, is it unleavened bread in honor of the supposed reenactment of the Jewish Passover, or is it, as the *Book of Common Prayer*

will specify, "bread such as is usual to be eaten at the table with other meats, but the best and purest wheat bread that conveniently may be gotten"?[77] The culinary intrudes upon the theological. As do simple matters of housekeeping: What is to be done with waste, or with leftovers? Once these substances are, via whatever priestly magic, consecrated, what is to be done when Christ's body and blood turn into crumbs and droplets on the floor? This requires special equipment and procedures.

In short, all the questions of real presence and all the debates on that subject from the time of the Church Fathers to the time of the Reformation will be subject to the insistent problem of culinary materiality. The matter can be illustrated with a pair of *reductio ad absurdum* cases. At any moment when the church veers toward the "realist" version of the Eucharist, the official position is vulnerable to objections that depend on taking food literally. Hence, among other things, the so-called stercorian heresy, taking its name from the Latin *stercus*, meaning feces.[78] The term was coined in the early Middle Ages by way of attacking a supposed theological position that no one may have ever espoused. Essentially, it is a caricature of belief in the real presence so absolute that it traces the body of Christ from the sanctified host all the way to the toilet. In its limited, straw man sort of way, it possesses some potential authority from a passage in Matthew. Jesus is explaining his revision of the law regarding—not surprisingly—the rules concerning diet, and his larger point is that, as far as oral activity is concerned, what one speaks is far more important than what one eats. Speech, he declares, comes from the heart; on the other hand, "whatever enters the mouth goes into the stomach and is eliminated" (Matthew 15:17).[79] He was not, of course, thinking of the Eucharist, which hadn't yet been instituted, but medieval theologians were in a position to make the connection. It was therefore necessary to argue around this piece of culinary and sacramental literalism by distinguishing "foods that are ingested to sustain the life of this mortal body" from those ingested for the Eucharist.[80]

The other *reductio ad absurdum*, with an even more illustrious history than the problem of the sewer, again testifies to the issue of culinary materiality; the abject in this case, however, is not the human digestive system but rather the animal world. It is not quite clear at what moment theologians started worrying about what happens when a mouse eats the consecrated host, but it is apparent from very early times that there was a practical problem, somewhere on the border between housekeeping and theology, that mice were infiltrating stores of Eucharistic materials and that local church authorities were being hounded by their ecclesiastical superiors on the grounds that these substances were to be understood as possessing a vulnerability with graver consequences than that of other edibles that might be found in cupboards.[81] Guitmund, Bishop of Aversa, a partisan of the "real" real presence (see note 80) turns out in this case to find a way of maintaining his convictions with some modifications. Yes, the literal body of Christ enters into a lowly animal, but given the Savior's three days in hell, what's so terrible about having to inhabit, briefly, the digestive tract of a mouse? Anyway, Christ is risen and therefore eternally immune to the depredation of rodents' insides.

A century and a half later, the mouse problem has not gone away, but, given the advent of scholasticism through Aristotle and Aquinas, the issues are to be subjected to hermeneutic reasoning. Saint Bonaventure, writing in the middle of the thirteenth

century, devotes many pages to the question, with whole tree diagrams of possibilities as to the presence of the bread in the stomach of the recipient (in which case there is not much distinction between mice and humans) as opposed to the sacramental consequences of such consumption, where the two species radically differ.[82] The efficacy of the sacrament consists in the fact that humans—not all of them, of course: consider pagans, heretics, Jews, and those in a state of mortal sin—potentially possess the full understanding of the sign, whereas mice don't. For our purposes, what this means is that food and drink have a privileged place in the whole universe of Christian semiotics.

The simultaneity of sign and substance becomes far more than a problem in rhetoric because, once again, this multiple, potentially contradictory package is actually ingested. But rhetoric of a more modern kind may help explain what is at stake. One of the fundamental polarities posited by twentieth-century theoretical thinking has been the distinction between metaphor and metonym.[83] Both involve the substitution of one thing for another: in the case of metaphor, one thing is chosen in place of another owing to some kind of conceptual parallel; in the case of metonymy, the substitution is based rather on actual contiguity or overlap. What is relevant here regarding this distinction is the kind of thinking that takes place in the space *between* versus the space *shared*. Whether, in other words, the substitution points to some cause *outside* the realm of the two entities (call it arbitrary, imaginative, imposed, symbolic) or *inside* their respective properties (call it experiential, evolutionary, mimetic). When Jesus says that the bread is his body and the wine is his blood, he appears, at least, to be making a metaphoric substitution. When I sit at the table and eat bread and wine, having listened to the words of Jesus, however, I am bound to see the act of substitution as metonymic, because I have in front of me bread and wine and because I am going to ingest them by way of nourishing my body (and soul). So the distance between metaphor and metonym is rather terrifyingly collapsed. The Eucharist becomes the most extreme instance of embodiment challenging figuration. If I'm eating Jesus, my body is itself God's metonym.

Let us bring this discourse radically down to earth, from theology to experience and from medieval debate to twenty-first-century cyberspace. One has only to google the question "Should I chew the host?"[84] to discover that hundreds, possibly thousands, of Christians—mostly Catholics, it seems—have spent their time at the altar rail in a desperate state of uncertainty, not about the transcendental meaning of the sacrament or the precise reality of the real presence but about what they should be doing with their teeth and tongue. The answer to the question (spoiler alert) is that the church has made no definitive pronouncement on the chewing question, hence communicants are free to do whatever comes naturally to them. But the reason for this quandary takes us back to all the culinary problematics that arose at the Last Supper: the bread and wine, instituted in the midst of a meal, whatever sacred function they may perform, are also ordinary objects of consumption and nourishment. To chew or not to chew is to raise the question whether I am eating Jesus or eating dinner. And the church is silent on this point. Or, alternatively, it offers up multiple volumes, and now bytes, of unresolved debate.

4

Returning from Google to premodern culture, we can locate an artistic exercise of the greatest significance in this question of how, confronted by the occasion of feasting, we distinguish the Eucharist from mealtime, the sacramental from the alimental.

The answer is, only with a great deal of difficulty. And we can best observe this answer by moving from theology to phenomenology, or, to put it in more down-to-earth language, from words to pictures. Theologians can theorize the ways in which Christ's body and blood are experienced in the course of the Eucharistic meal. Visual artists, for their part, may perhaps be imbuing their work with signals pointing to such pieces of technical orthodoxy, but what they are inevitably producing is a picture of a bunch of men at dinner. This has consequences, first of all, on the work they produce: they are responsible for creating a scene that is experientially recognizable as a meal. And it has consequences on their viewers: centuries of Christians, when confronted with the mysteries of the Eucharist, will necessarily begin with the belief that it looks like dinner—perhaps no dinner they have ever had the privilege of attending but dinner nonetheless.

We can proceed from the simple to the complex or, rather, let us say from the harmonious to the problematic. What is probably the earliest representation of anything to do with the Eucharist (several centuries before the mosaic in Ravenna that is generally considered, as it were, the first *Last Supper*) is a fresco in the Catacombs of Priscilla, located in the Roman Via Salaria Nova (fig. 5.22).[85] It dates, most probably,

5.22. Paleo-Christian, *The Eucharist* (*Fractio Panis*), 2nd century CE. Catacombs of Priscilla, Rome

5.23. Paleo-Christian, *The Last Supper* (*Miracle of the Loaves and Fishes*), *Cubicula of the Sacraments*, 3rd century CE. Catacombs of Saint Callixtus, Rome

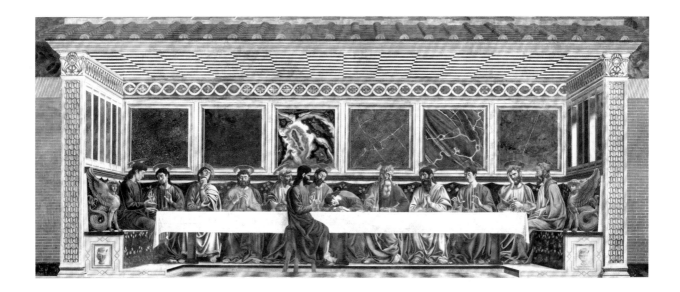

from the early second century, and it represents seven individuals seated around what is either the corner or the arc of a table. All but one of the individuals—some or all of whom may be women—appear to be reclining at table in the customary Roman way. On the table are a cup and several large plates containing fish and loaves of bread. The nonreclining figure appears to be holding a piece of bread. Also visible at the scene are baskets containing loaves of bread. At another site, not far away, is the Catacombs of Saint Callixtus (fig. 5.23), dated sometime later, which depicts a similar but less well-preserved scene, also with seven individuals around a table and with plates and baskets containing bread and fish.

There is no question that these are both Christian scenes, but what scenes are they? The later image has been labeled "Miracle of the Loaves and Fishes."[86] The earlier has been given the name "Fractio Panis,"[87] which refers to the phase of the Eucharist when the bread is broken so that it can be distributed; in fact, the canonization of that term within the practice of the Eucharist dates to many centuries after the production of this fresco. To begin with the obvious: both of these scenes—the earlier of which, after all, dates from only a few decades after Pompeii—absolutely resemble representations of ancient Roman, which is to say pagan, dining. We may consider this resemblance simply a matter of style. But at the same time it tells us that the repertoire of recognizable images for the audience of early Christians blurred the distinction not only between Christian and pagan but also between sacred and secular, reminding us that the activities we lump together under terms like *Eucharist* and *Last Supper* were coterminous with all sorts of feasting in pagan practice, as a result of which the visual record, so far as it goes, makes no hard and fast doctrinal distinction across what one might consider the vast gulf between pagans and Christians. And one final point about these images and the presumptions about how they were read and recognized in this early moment: the names we give them, which we presume to be historically accurate, are not theological but culinary—bread, loaves, fishes.

A millennium later, when the boundary lines between Christian practice and everything else were more absolute than in the time of the catacombs, there are

5.24. Andrea del Castagno, *The Last Supper*, 1445. Convent of Sant'Apollonia, Florence

5.25. Domenico Ghirlandaio, *The Last Supper*, 1480. Church of the Ognissanti, Florence

5.26. Perugino, *The Last Supper*, 1495. Cenacolo di Foligno, Florence

5.27. Franciabigio (Francesco di Cristofano), *The Last Supper*, 1514. Convento della Calza, Florence

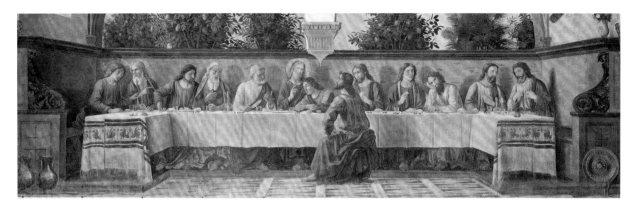

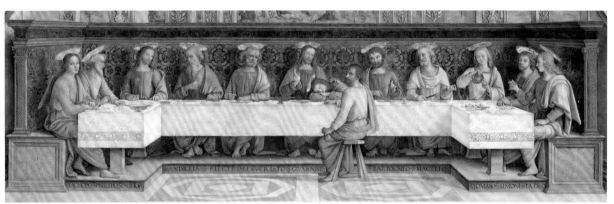

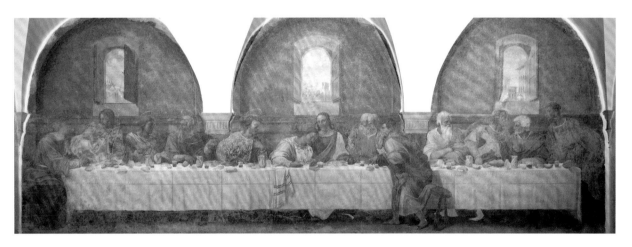

nonetheless ways in which images of the Lord's Supper shade off into the earthly world where dinner is served. In fifteenth- and sixteenth-century northern Italy, for instance, a striking number of Last Supper paintings are commissioned for the refectories of religious foundations.[88] In and around Florence alone, it is possible to see six such works: by Andrea del Castagno (1445) (fig. 5.24), made for the convent of Sant'Apollonia; by Domenico Ghirlandaio (1480) (fig. 5.25), made for the convent of the Umiliati at the church of the Ognissanti; by Perugino (1495) (fig. 5.26), made for the convent of the Sisters of Fuligno; by Franciabigio (1514) (fig. 5.27), made for the Convento della Calza; by Andrea del Sarto (1527) (fig. 5.28), made for the

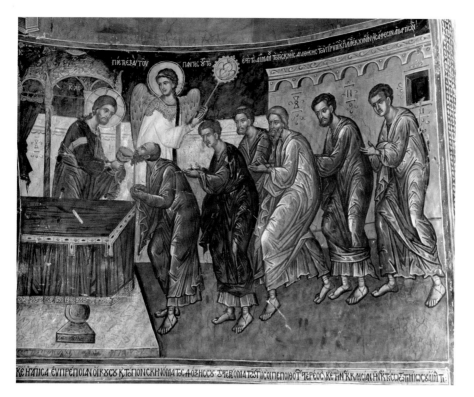

5.31. *Communion of the Apostles*, 15th century. Church at Saint Neophytos Monastery, Paphos, Cyprus

5.32. Early Byzantine, paten with Communion of the Apostles, 565–78. Byzantine Collection, Dumbarton Oaks, Washington, DC

5.33. Salerno Ivories, Communion of the Apostles (upper square), Last Supper (lower square), details, 11th–12th century. Museo del Duomo, Salerno, Italy

5.34. Luca Signorelli, *Institution of the Sacrament* (*Communion of the Apostles*), 1512. Museo Diocesano, Cortona, Italy

5.35. Joos (Justus) van Ghent, *The Communion of the Apostles*, 1473–74. Galleria Nazionale delle Marche (Palazzo Ducale), Urbino, Italy

subversive. Insofar as these are representations of commensality, they contribute to a profound sense that the good Christian life involves an imitation of Christ's life and that any act of dining in company fulfills the command: "do this in remembrance of me." But as we have seen repeatedly, there is a boundary line as regards ingestion; in this case, it involves the same problem as plagued all those twenty-first-century Catholics who didn't know whether they should chew the Communion wafer. Sitting at table with one's friends may operate quite comfortably as both earthly and heavenly. But what about the menu? Even monks and Protestants don't subsist on a diet consisting exclusively of bread and wine.

One way out of this problem is evidenced by the development in the visual tradition of a version of the story in which the sacrament is instituted without any mealtime at all. From quite early, the Christian churches in the East cover this territory with an image that comes to be known as the Communion of the Apostles or the Institution of the Sacrament, sometimes grouping them in a tight clump; much later, in the Cypriot church of Panadia Podithou, they form an orderly line (fig. 5.31). In some cases, for instance in a sixth-century paten now at Dumbarton Oaks (fig. 5.32), there is a strong emphasis on the sacrament's division into two kinds, with a doubled Christ, standing at an altar handing out wine on one side and bread on the other; for emphasis, there are separate representations of the two kinds below the Communion scene. In somewhat later Byzantine representations, there may be scenes of both the Communion of the Apostles and the Last Supper in close proximity (fig. 5.33). In the East, the Communion of the Apostles is the overwhelming favorite in representing the scene of the sacrament. In the West, no such scene appears until the thirteenth century, and then it remains far less common than the Last Supper as we know it,

5.32

5.34

5.33

5.35

though there are striking examples in the West, including Luca Signorelli's *Institution of the Sacrament* in Cortona (fig. 5.34), itself influenced by Justus van Ghent's altarpiece produced for the confraternity of the Corpus Domini in Urbino (fig. 5.35). It is probably no coincidence that among the versions of this scene in Western art, many—for instance, a work by Fra Angelico at the convent of San Marco in Florence (fig. 5.36)[91]—include some clear reference to the Last Supper table, evidence that the import of the scene depicting the Communion of the Apostles might not be recognized without a Last Supper nearby.

5.36. Fra Angelico, *Communion of the Apostles* (*Institution of the Eucharist*), from doors of silver cabinet, c. 1450. Convent of San Marco, Florence

The very existence of the alternative scene illustrating what is roughly the same biblical material ought to remind us that, though we may think of the Last Supper dinner table, courtesy of Leonardo and others, as the canonical moment, it is actually a rather striking—not to say shocking—displacement of what, by any version of Christian theology, would seem to be the central subject matter. Whatever it is that Christ is doing by sitting at the head of the dinner table, it is not instituting the sacrament—that is, performing a sacred action about which he might be saying, "do this in remembrance of me." As was clear from those Florentine refectories, the *this* to be understood from those paintings was rather the act of sitting at a dinner table. (The fact that in some compositions Jesus is *both* administering the sacrament *and* sitting at the head of the table serves to illustrate the problem.) So the Last Supper as we know it, pictorially at least, already represents a kind of hijacking of theology into commensality.

We have, then, on the one hand, a totally non-biblical scene, of the apostles awaiting the bread and wine, and, on the other, a scene narrated *passim* in the New Testament, which nevertheless omits the sacrament, except by the metaphoric implication (and, as we have seen, it can be a rather explosive implication) that dinner somehow *is* the sacrament. To be sure, the lineup of disciples has its own authority—that of the actual practice in churches of handing out the sacramental materials to the faithful. Either scene amounts to a kind of *imitatio*, only the Institution of the Sacrament is more literal: the congregants can receive the body and blood of Christ from their priest precisely as the apostles did from Christ and in front of a scene depicting that occasion—but not in the context of a meal. Perhaps it is no coincidence that the Western church, with origins that include some version of Roman-style feasting, as was apparent in the catacombs, should prefer to model the sacrament on the banquet

rather than the one-on-one vision of Christ dispensing substances that do not so readily count as food.

Of course, as we saw in chapter 3, both the Hebrew and the Christian Bible are permeated with substances that *do* readily count as food, and in the context of the Last Supper these can serve to sanctify a holy mealtime. We can observe as early as the Codex Rossanensis in the sixth century or as late as Dieric Bouts's Leuven altarpiece of the Holy Sacrament in the fifteenth century a flurry of references to biblical food on the margins of the Last Supper scene. The Rossano Gospels (fig. 5.37), in which one can observe both the Institution of the Sacrament and the Last Supper, surround these subjects with an anthology of food references out of the Hebrew Bible, divided along the lines of bread and wine.[92] Bouts's altarpiece (fig. 5.38) presents a gorgeous Gothic version of the Last Supper scene perfectly framed by four smaller images: the meeting of Abraham and Melchizedek, at which Abraham is presented with bread and wine; the feast of Passover; the gathering of manna; and the scene of Elijah in the desert, when an angel brings him—no surprise—a loaf of bread and a jug of wine.[93]

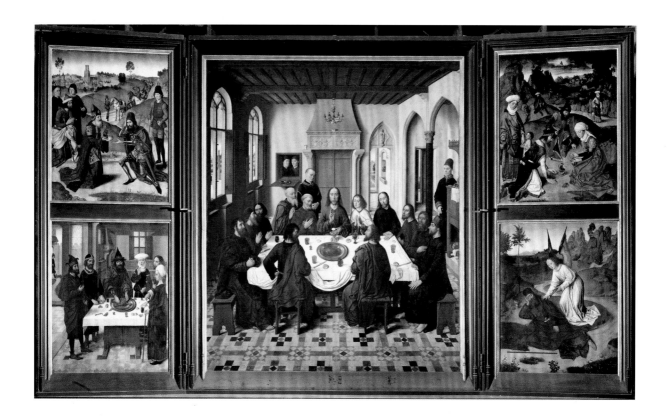

5.38. Dieric Bouts the Elder, *The Last Supper*, with four donors, members of the Brotherhood of the Holy Sacrament (center); Abraham and Melchizedek (top left); Passover feast (bottom left); gathering of manna (top right); and the angel waking the prophet Elijah (bottom right), from the Altar of the Last Supper, 1464–68. Sint-Pieterskerk, Leuven, Belgium

This is not merely an exercise in typology as between the Hebrew Bible and the New Testament. It is evidence of a struggle to find the algorithm that will enable us to connect our daily intake of nutrition and our experience of taste with the worship of a God who has told us to eat his body and drink his blood.

There is no definitive algorithm, of course, and surrounding the Last Supper with references to other occasions when biblical figures received divine aid in the form of consumables hardly seems adequate to the task of placing Eucharist and dinner on the same grid. There is, however, a space within the sacramental scene itself where every artist was obliged to confront this question. Let us, then, observe that space—the space of the table itself—and undertake the thought experiment of not privileging artistic style or school or period and simply viewing a few centuries of artists all grappling with the same question: "What's for dinner at the Last Supper?"

As a baseline for our investigation, we may take a predella panel by Lorenzo Monaco (fig. 5.39), from around 1390, made for the church of Santa Caterina in Florence and now in Berlin.[94] The composition is in the refectory style, though antedating the large-scale works in that genre discussed earlier. Call it the Platonic ideal of the Last Supper, in the sense of being truest to the sacramental purpose of the occasion: there is nothing on the table but bread and wine, plus the very chaste addition of a small knife, which is presumably needed to cut the bread. The bread goes so far as to distinguish itself from a normal bakery product by emitting golden rays of holiness. This is certainly not unique: Cosimo Rosselli's *Last Supper* in the Sistine Chapel (1481) (fig. 5.40), for instance, includes only a chalice, and Andrea del Sarto's version in the Florentine church of San Salvi (1527) (see fig. 5.28) reveals nothing but

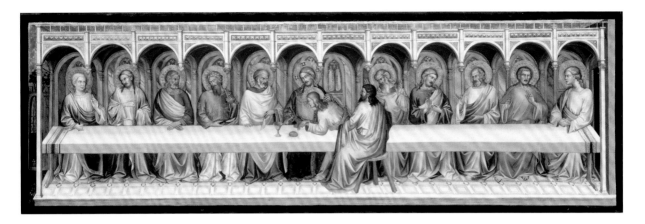

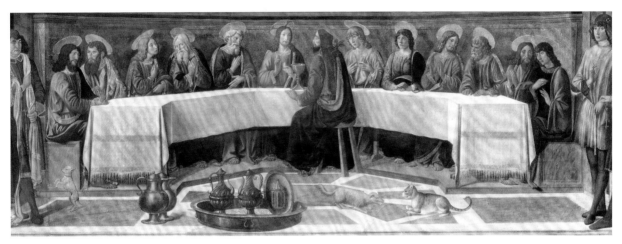

5.39. Lorenzo Monaco, *The Last Supper*, predella from altarpiece in San Gaggio, Florence, 1389–90. Gemäldegalerie, Staatliche Museen, Berlin

5.40. Cosimo Rosselli, *The Last Supper*, 1481. Sistine Chapel, Musei Vaticani, Vatican City

the bread and a few empty plates. But even this theologically motivated approach to the composition can edge its way toward gastronomy: witness a small panel by Ercole de' Roberti from the 1490s (fig. 5.41), now in the National Gallery in London, which attempts to render the Last Supper and the Communion of the Apostles simultaneously. Here, as in the Lorenzo Monaco, there is nothing in evidence but bread and wine, yet despite the classic sacramental gesture of Jesus, the Eucharistic materials have gravitated toward something like dinner party position. The wine has found its way into decanters, which are placed on both sides of the table for convenient service, and the bread is now distributed at each guest's place setting.

In fact, a survey of several hundred Last Suppers reveals that this pure sacramental form of the subject is surprisingly rare. And it is not merely a factor of period styles. It is true that Tintoretto, painting his last *Last Supper* in 1594 (fig. 5.42), loads his table with an emporium of edibles, but we should also consider the 1390 *Last Supper* (fig. 5.43) attributed to Agnolo Gaddi and now in Altenburg (also discussed above in chapter 1, where it appears as fig. 1.8). Though the style is spare, in a Giottesque sort of way, the table is crowded with the elegant appurtenances of a feast. And even a ninth-century illumination of the Last Supper table, in the Sacramentary of Marmoutier (fig. 5.44), includes what appear to be (wholly non-sacramental) ladles beside a tureen, along with the inscription CENA DOMINI.

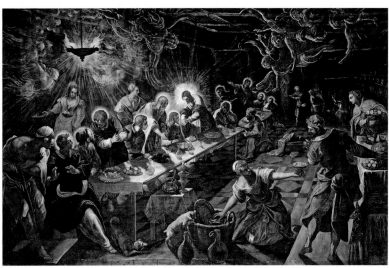

5.41. Ercole de' Roberti, *The Institution of the Eucharist*, from a predella, c. 1490s. National Gallery, London

5.42. Tintoretto (Jacopo Robusti), *The Last Supper*, 1594. San Giorgio Maggiore, Venice

5.43. Agnolo Gaddi, *The Last Supper*, c. 1390. Lindenau Museum, Altenburg, Germany

5.44. Sacramentary of Marmoutier, fol. 19v, 9th century. Municipal Library, Autun, France

5.45. Pietro Lorenzetti, *The Last Supper*, 1320. Lower church, San Francesco, Assisi, Italy

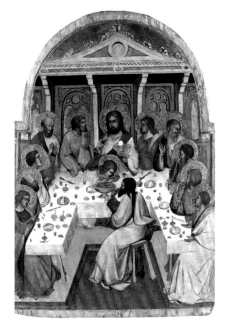

5.43

5.44

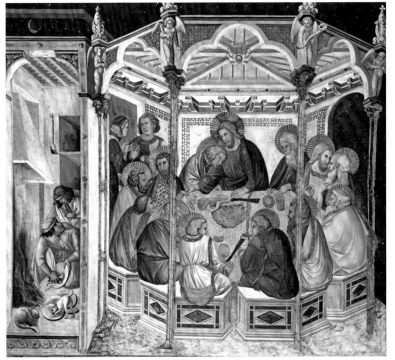

5.45

It is also true of this late medieval period that the idea of a grand princely meal could stimulate artists' imaginations as to the domestic scene backstage, particularly in works from the manuscript tradition or inspired by that tradition: hence the work of Pietro Lorenzetti in the Assisi lower church (1320) (fig. 5.45), in which, next door to the canonical scene at a round table, we glimpse the labor of the kitchen, where plates are being cleaned and scraps are being left for a cat and a dog.[95] In a similar vein is a manuscript illumination from the *Hours of Philip the Fair* (fig. 5.46), in which the

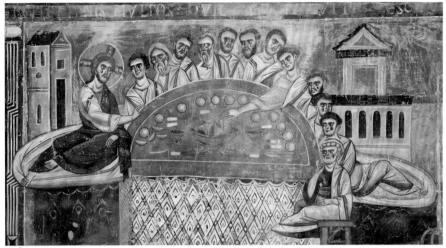

5.48

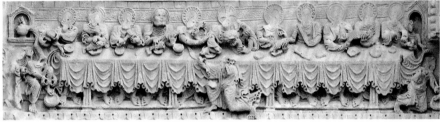

5.49

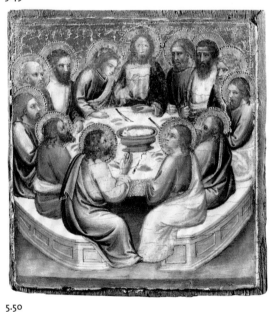

5.50

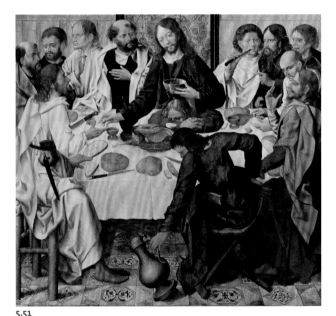

5.51

(1508) (fig. 5.51), now in Lisbon, has been carved into separate segments, such as one might find nowadays in a good supermarket. On the other hand, the lamb in Jacopo Bassano's *Last Supper* (1546) (fig. 5.52), now in the Galleria Borghese, is nothing but a stripped head on a plate, because the dinner has concluded and all that is edible on the head has been eaten. The banquet table in Daniele Crespi's *Last Supper* (1630) (figs. 5.53 and 5.54), now in the Pinacoteca di Brera in Milan, confines itself to the

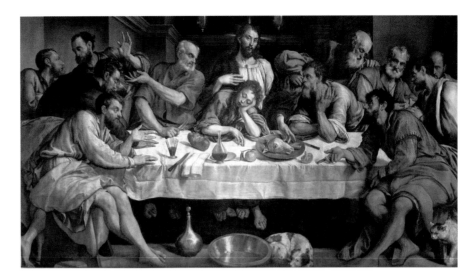

5.52. Jacopo Bassano da Ponte, *The Last Supper*, 1546. Galleria Borghese, Rome

5.53. Daniele Crespi, *The Last Supper*, 1630. Pinacoteca di Brera, Milan

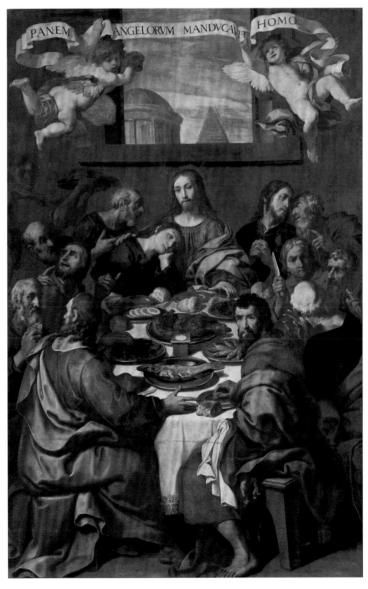

canonical lamb and fish (plus a few other nonessentials, including salt, greens, bread rolls, and something like pomelo), but the representation, angled forward in mouthwatering display, renders them utterly culinary, worthy of five-star dining.

Display is the key word. For generations of artists well before Crespi, the Last Supper table, whatever else it may be, is a canvas upon which they may exhibit their consummate skills of representation. Ghirlandaio, in his *Last Supper* (1480) in the Ognissanti (see fig. 5.25), fulfills the canonical requirement of bread and wine, with the accompanying dining table necessities of knife, decanters, and glasses, but he strews his table with an assortment of fantastically eye-catching cherries. They would, of course, be among the final touches of a (real) Tuscan dinner, and, besides showing off artistic skill, they communicate that these are the final moments of the meal, when, of course, the actual institution of the (undepicted) sacrament would take place. A century later, Alessandro Allori's tabletop canvas in Santa Maria del Carmine (1582) (see fig. 5.29) is fantastically elaborated. No special prominence for the bread and wine, but, once again, the linen is glistening, the moment appears to be dessert time, and the table is covered with exquisitely true-to-life renditions of a cornucopia of fruits.

Thanks to recent restorations, we are able to see the earliest extant *Last Supper* that is signed by a female artist, Plautilla Nelli, another Florentine refectory painting, in Santa Maria Novella (c. 1570) (fig. 5.55).[99] She has chosen an earlier moment in the meal, at which point bread, wine, and lamb are presented, as is (uniquely, as far as I'm aware) salad, apparently one of those Tuscan bitter lettuces that have become known around the world. Yet again, the artist's engagement consists in rendering God's edible plenty as realistically and mouthwateringly as possible. And one final instance, from another country, is Luis Tristán's *Last Supper* (Prado, c. 1620) (fig. 5.56), where the broad array of foods on the table—besides lamb and bread, there are melons, pears, and even a cardoon—reveals unmistakably what all these arrays of edibles have been aiming toward: what is for Jesus and his disciples the Last Supper is for artists the

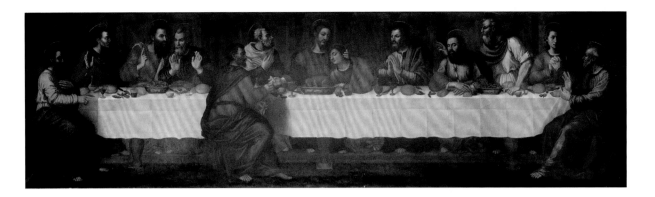

5.55. Plautilla Nelli, *The Last Supper*, 1570. Refectory of Santa Maria Novella, Florence

5.56. Luis Tristán, *The Last Supper*, c. 1620. Museo Nacional del Prado, Madrid

exercise of still life, thus drawing us back to the subject of mimesis, with which we began this chapter.

The unnamed figure behind most of this matter of the table setting is, of course, author of the greatest *Last Supper* of all, who was also the greatest artist of all to record with minute accuracy the productions of nature, whether culinary or otherwise.[100] Between Ghirlandaio's cherries and the grand arrays of edibles that appear on Last Supper tables in the subsequent century, the crucial missing link is Leonardo, who produced his masterpiece, widely celebrated from the moment of its completion, at the convent of Santa Maria delle Grazie in Milan in 1498 (fig. 5.57). Our subject within this massive field is, of course, limited to the food on the table. Unfortunately, given the notorious history that begins with the artist's own poorly chosen medium

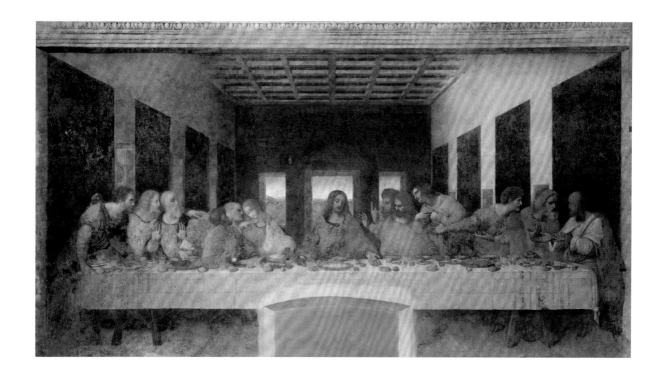

5.57. Leonardo da Vinci, *The Last Supper,* 1498. Santa Maria delle Grazie, Milan

5.58. Leonardo da Vinci, *The Last Supper,* detail of fig. 5.57

and proceeds through decay, destruction, and incompetent restoration, the food on the table suffered greatly—perhaps disproportionately, since it would never have been considered worthy of conservational treatment as scrupulous as the more significant elements in the story. What we see now is, to be sure, a heavily laden table (fig. 5.58), but whether we are looking at eggs or bread rolls, fish or lamb—indeed, whether we are looking at Leonardo's work such as would be visible in 1500 or the work of some well-meaning restorers who wished to fulfill their guesses about the identity of the food: none of this is clear.

Nor do the contemporary copies of Leonardo's work, with their various disputed claims of authority, provide certainty. Some, like the early sixteenth-century engraving attributed to Giovanni Pietro da Birago (fig. 5.59), add major food items (Jesus's plate, empty in all other versions, here houses a big fish), whereas others, like the copy by Leonardo's younger associate Marco d'Oggiono, now in the chapel of the Château d'Ecouen (fig. 5.60), maintain the sense of an elegantly ordered table.[101] In Leonardo's original, there was clearly once an overturned saltcellar, meaningfully placed in the orbit of Judas and frequently noted by earlier viewers, including Goethe; it's not so clear, as claimed by a more recent viewer, that a plate of grilled eels with orange slices is patently present on the bill of fare.[102]

What the present viewer can contribute to questions concerning what's for dinner in Leonardo's *Last Supper* depends not on scrutinizing the table itself but rather the central figure sitting at the table. No Jesus in any earlier *Last Supper* (nor any later one, except for those that explicitly copy Leonardo, as, for instance, Hans Holbein's version in Basel; fig. 5.61),[103] is presented with this kind of relation to the materials on the table—or, indeed in relation to the disciples or to the viewer. Uniquely, Leonardo's Jesus is not attending to the disciples in any way, nor gazing outward at the viewer.

5.58

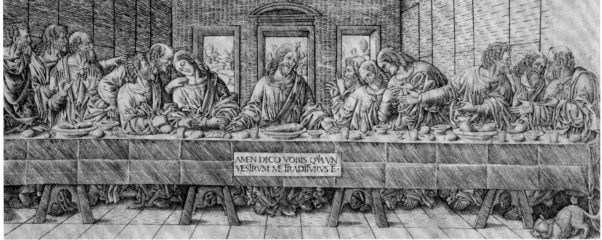

5.59

5.60

5.61

5.59. Giovanni Pietro da Birago, attrib., *The Last Supper, with a Spaniel (after Leonardo)*, c. 1500. The Metropolitan Museum of Art, New York

5.60. Marco d'Oggiono, copy after Leonardo da Vinci's *Last Supper*, 1509. National Museum of the Renaissance, Château d'Ecouen, France

5.61. Hans Holbein the Younger, *The Last Supper*, c. 1527. Kunstmuseum, Basel, Switzerland

His gesture embraces, and blesses, the food, which is to say the products of nature, and which is also to say the exercise of the artist in replicating the products of nature. As with earlier and later painters, after all, the linen-covered table is the artist's canvas, even if in this case the work has been obliterated.

Reading the Last Supper for the food on the table, as we have done here, depends on significances that are latent rather than explicit. The only consumables that are officially significant are bread and wine; the rest just come along with the requirements of representing a banquet and with the universal experience of eating and drinking. There is, however, one aspect of the Last Supper story where non-sacramental food is not latent but blatant. It begins with a curious passage in the Gospel of John:

> Jesus . . . was troubled in spirit, and testified, and said, Verily, verily, I say unto you, that one of you shall betray me. Then the disciples looked one on another, doubting of whom he spake. Now there was leaning on Jesus' bosom one of his disciples, whom Jesus loved. Simon Peter therefore beckoned to him, that he should ask who it should be of whom he spake. He then lying on Jesus' breast saith unto him, Lord, who is it? Jesus answered, He it is, to whom I shall give a sop, when I have dipped it. And when he had dipped the sop, he gave it to Judas Iscariot, the son of Simon. (John 13:21–26, King James Version)

It is a climactic moment in the whole story: Jesus reveals that he will be betrayed, and he reveals, with only the thinnest of disguisings, who the betrayer will be. But why the *sop*? The original, τὸ ψωμίον, tends nowadays to be translated as *morsel*, but I deliberately cite the King James Version, so as to use the old-fashioned term, thus honoring our English expression "giving someone a *sop*," meaning to offer a sort of consolation prize when much grander generosities are being withheld.[104] Jesus here performs the traditional ritual of dipping a piece of bread into the communal dish and, as a gesture of special intimacy, handing it to a favored guest. In the present instance, however, the offer that Jesus makes to Judas is a morsel that merely pretends to be a sign of exceptional favor, when in fact the much greater gifts of love and salvation are being denied. Jesus is giving a sop to Judas.

Yet again an article of food, here occupying the pivotal position in announcing the imminent death of the Savior. Jesus himself offers part of an explanation for his culinary act by referencing Psalm 41, "Even my own familiar friend, in whom I trusted, who ate my bread, has lifted up his heel against me." The present occasion of commensality among the disciples is one that explicitly equates trust with the sharing of bread, and Jesus seizes the moment to provide a kind of parody. Whatever Jesus's motive may have been for such a culinary kiss-off, the gesture of offering the sop becomes in the visual tradition an essential image in the representation of Judas at the Last Supper. It may even be argued that the identification of the betrayal was becoming a more important visual subject in the Western church than the representation of the sacrament itself—hence the Last Supper outpacing the Communion of the Apostles. And the identification takes place via some bread dipped in gravy.

Whether for theological reasons or other reasons, image-making throughout the Western Middle Ages turns obsessively to Judas, and Judas is nearly always receiving that fatal sop.[105] In the ninth-century Stuttgart Psalter (fig. 5.62), the text of Psalm 41 about the friend who ate my bread and betrayed me, is actually illustrated with an image of Jesus, detached from the Last Supper, holding an elaborate chalice as he

5.62. Jesus offering a sop to Judas, Stuttgarter Psalter, fol. 53r, 9th century. Württembergische Landesbibliothek, Stuttgart, Germany, cod.bibl. fol.23, 109 53r

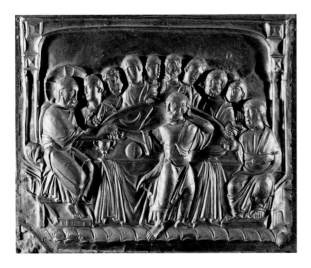

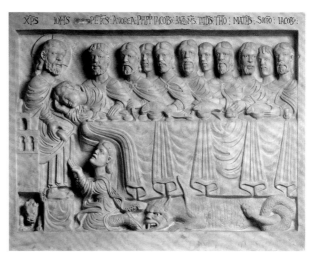

5.63. *The Last Supper*, detail of the golden antependium of Emperor Otto II, c. 1020. Palatine Chapel, cathedral of Aachen, Germany

5.64. *The Last Supper*, marble tile decorated in relief, from pulpit, 13th century. Cathedral of Santa Maria Assunta, Volterra, Italy

feeds Judas the sop (while, in another motif that will appear elsewhere, a blackbird of damnation is also hovering around Judas's mouth). In an eleventh-century altar screen in the cathedral at Aachen (fig. 5.63), Judas is receiving the sop and already has one foot out the door, on his way, presumably, to the betrayal (in fact, Jesus says to him that what he is going to do he should do quickly). The thirteenth-century marble decoration on the pulpit at the cathedral of Volterra (fig. 5.64) isolates a somewhat hatchet-faced Judas (perhaps with the suggestion of a different racial or ethnic type) under the dining table with a hellish serpent behind him; the folds of the tablecloth are drawn back to reveal what is clearly a Communion-like gesture, as Jesus hands him the sop.

Others depicting this scene quite uncanonically eliminate any engagement by Jesus in the process and have Judas feed himself from the sacred table; he is apparently not contented with a mere sop. In the late eleventh-century fresco at Sant'Angelo in Formis (see fig. 5.48), while the other disciples sit demurely around the semicircular table familiar from the early Last Suppers, Judas stretches out his long arm to seize some choice cut of lamb. We see a similar gesture from a hook-nosed Judas, with his hand in the lamb tureen, in a fourteenth-century altarpiece predella by Jaume Serra in

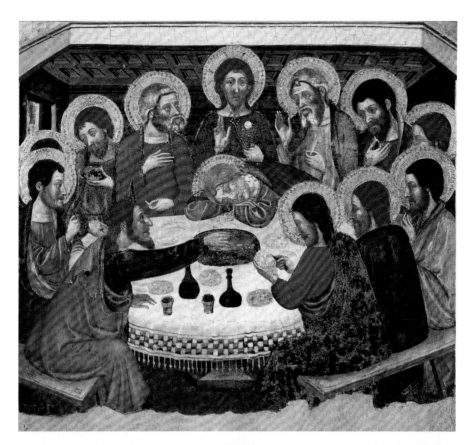

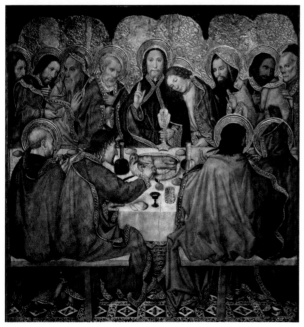

5.66. Jaume Huguet, *The Last Supper* (*Sant Sopar*), detail from the Saint Augustine altarpiece, c. 1462–75. Museu Nacional d'Art de Catalunya, Barcelona

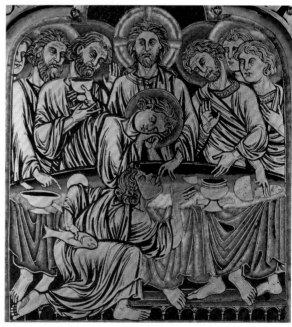

5.67. Nicholas of Verdun, *The Last Supper*, from the Verdun Altar, begun 1181. Sammlungen des Stiftes, Klosterneuburg, Austria

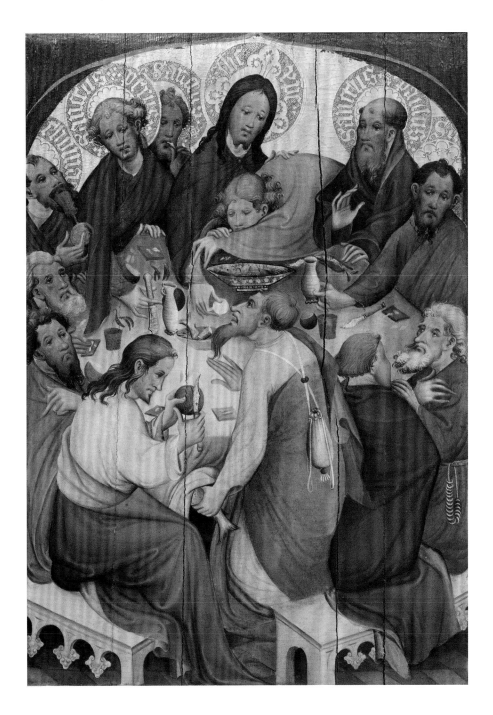

Palermo (fig. 5.65). And in Jaume Huguet's *Last Supper* in Barcelona (fig. 5.66), while all the haloed disciples are exhibiting reverent attitudes, a prominently placed Judas is nonchalantly picking away at the paschal lamb. There is even a further culinary degradation of Judas: an invented fable, according to which he had in previous life stolen a fish; in the twelfth-century enamel and gold decoration on the altar at Klosterneuburg (fig. 5.67) and in Conrad von Soest's early fifteenth-century altarpiece at Bad Wildungen (fig. 5.68), Judas, in the very act of receiving the sop, is concealing his ill-gotten fish, whose shape is not very different from that of his ill-gotten money bag.

There is a good deal of theological significance here, which can be traced back to the idea (for instance, in Augustine on Saint Luke) that Judas did receive the Holy Communion but violated it in some way or that he consumed damnation in the way the others consumed salvation.[106] (After all, dipped bread is, in many versions of the experience, Holy Communion, the practice referred to as intinction.) The visual effect, however, of seeing Judas with the sop, or with his hand in the dish of lamb, or with a stolen fish behind his back, is to suggest—given that, after all, these are scenes of dining—he is only there for the food, hence his presence is as the anti-type of the miracle of the Eucharist, which at its most fundamental (or fundamental*ist*) denies the foodness of food. When the faithful ponder these images, they can choose between the food of heaven and the food whose ties to the Christian life are a mere sop, or worse—a theft. Alternatively, they can make Leonardo's choice. His Judas has done nothing more obviously sinister, gastronomically speaking, than to knock over a salt-cellar. While that act may have a great deal of moral allegory behind it, the food on the table in his *Last Supper* is not the anti-type of salvation; rather, it is receiving the blessing of Jesus.

5

As it happens, one of the most dramatic episodes in the public life of Renaissance art hinges precisely on the food-related questions we have been considering here. To suggest what is at stake when Suppers become dinners, let us consider the famous interrogation to which the Inquisition submitted the artist Veronese after he had produced a gigantic painting of a feast for the refectory at the church of Santi Giovanni e Paolo in Venice, now in the Gallerie dell'Accademia (fig. 5.69).[107] Ever since the nineteenth-century discovery of the document recording this interrogation, there has been an industry of analysis in regard to, among other things, the reasons behind the Inquisition's interest in the matter (this being virtually a unique case of a painter being brought in for such questioning, so far as we know); the reading of the artist's responses, as between playing dumb or really dumb; and the all-important matters of what weight was being given, either by the artist or by the Inquisition, to identifying the specific subject of this painting, and what kind of special decorum was assumed necessary if this work was to be understood as a Last Supper rather than as one of the many other possible feasts in which Jesus took part.

It is beyond dispute that Veronese was commissioned to paint a Last Supper, and, to go to the other end of the story, it is generally agreed that he escaped the wrath of the Inquisition by renaming the picture so that it came to be understood as the Feast in the House of Levi, thus rendering it unnecessary for him to do actual alterations. It follows that if the name change was sufficient to release the artist from the Inquisition, then the Last Supper was understood as special. As will become apparent from the interrogation, its uniqueness, when represented in painting, consisted precisely in the banishment of trappings that resembled an ordinary meal.

Veronese, in fact, was the perfect test case for this problem. By the time he produced this work (1573), he had attained star status as the supreme master of the

gigantically grandiose religious feast picture, as is evident from the following list of his previous efforts along these lines:

> *Christ in the House of Simon the Pharisee*, 1555–56, painted for the
> refectory of the Benedictines in Santi Nazaro e Celso, Verona, now
> in Turin (fig. 5.70)
> *The Pilgrims of Emmaus*, 1560, patron unknown, now in the Louvre
> (fig. 5.71)
> *The Wedding at Cana*, 1562–63, executed for the refectory of the
> convent of San Giorgio Maggiore, Venice, now in the Louvre
> (fig. 5.72)
> *Feast in the House of Simon*, 1570, for the monastery of Saint Sebastian,
> Venice, now in the Brera (fig. 5.73)
> *The Meal at the House of Simon the Pharisee*, 1570, for the refectory of
> the Servites, Venice, now in Versailles (fig. 5.74)
> *The Wedding at Cana*, c. 1571, for the Cuccina family, now in Dresden
> (fig. 5.75)
> *Supper of Saint Gregory*, 1572, for the sanctuary at Monte Berico,
> Vicenza, where it remains (fig. 5.76)[108]

Plus one later work, a Last Supper—the name in this case went unchallenged—executed for the Venetian church of Santa Sofia and now in the Brera (fig. 5.77). (Actually, it is quite eccentric, even mysterious, in its iconography and considerably sparer than any of the other feast paintings; perhaps the Inquisition had indeed put the fear of God in the artist.) One cannot grasp the extent of this oeuvre merely by the frequency with which the painter received and satisfied these commissions; one must also imagine the sheer surface area of this volume of work. Almost single-handedly (though with help from Tintoretto), Veronese had radicalized the notion of the refectory painting as it was practiced by the Tuscans and by Leonardo, altering the iconographic representation from the lean structure of a sparsely populated long table and rendering it quite impossible for any real-life scene of clerical diners in the room to bear much resemblance to the banquet depicted on the wall.

Though the *Feast in the House of Levi* is the largest of all these works, every one of the previous paintings is massive, adorned with grandiose architecture, and peopled with dozens of figures who are extraneous to the story. Even *The Pilgrims of Emmaus*, whose narrative requires only three diners and a loaf of bread, gets rendered with some twenty or so onlookers, plus a spaniel. The moral of the story is that those who commissioned the problematic *Last Supper* in Santi Giovanni e Paolo knew what they were getting, and Veronese knew what he was doing—though it's no surprise that in the course of the interrogation his memory proves vague about some of the figures he had painted.[109]

The inquisitors, for their part, summon up all that history, questioning Veronese in regard to his past work and receiving answers that are vague or evasive. Though the inquisitor asks about "*altre cene*" with the implication that he is referring only to *Last Suppers*, since in his mind that would be the relevant comparandum for the Giovanni e Paolo painting, Veronese in fact already demonstrates his own labile sense of the

5.69. Paolo Veronese (Paolo Caliari), *Feast in the House of Levi*, 1573. Gallerie dell'Accademia, Venice

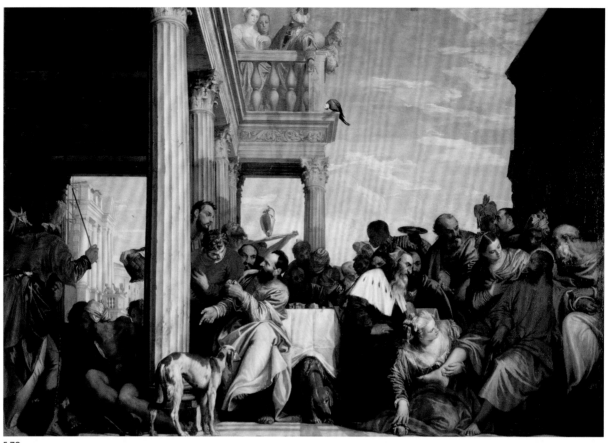

5.70

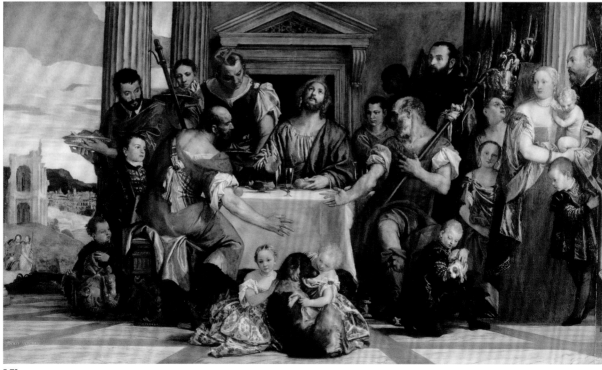

5.71

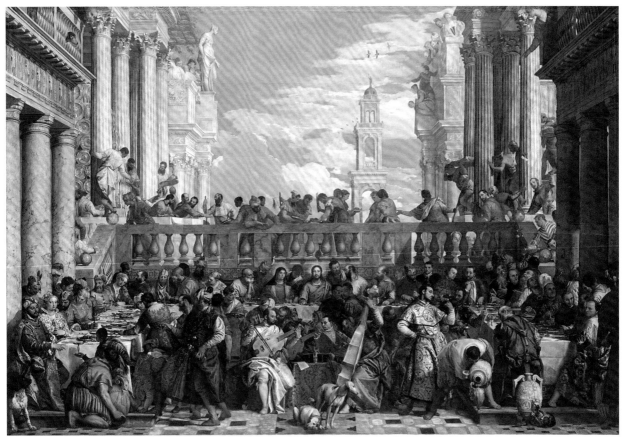

5.72

5.73

5.70. Paolo Veronese (Paolo Caliari), *Christ in the House of Simon the Pharisee*, 1555–56. Galleria Sabauda, Turin

5.71. Paolo Veronese (Paolo Caliari), *The Pilgrims of Emmaus*, 1560. Musée du Louvre, Paris

5.72. Paolo Veronese (Paolo Caliari), *The Wedding at Cana*, 1562–63. Musée du Louvre, Paris

5.73. Paolo Veronese (Paolo Caliari), *Feast in the House of Simon*, 1570. Pinacoteca di Brera, Milan

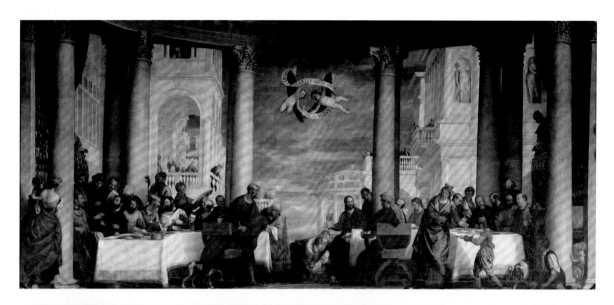

subject by including the San Giorgio Maggiore *Wedding at Cana* (fig. 5.72, now in the Louvre), at which point the inquisitor quickly corrects him as to the painting's subject. In fact, the artist's own proffered list includes no works that could be legitimately titled Last Suppers (possibly a tactic on Veronese's part?), and the interrogator soon makes it clear that he is dedicated to preserving the value of the special theological property that inheres in this particular subject and not in just any old picture of Jesus at a dinner table.

Clearly, all these signs of feasting, coupled with the fact that the actual sacramental business occupies so little space in the picture, represent a threat to the sacred business that is meant to be at the center of the story, especially when it gets buried in the surroundings of a very different sort of conspicuous consumption. And Veronese, with whatever mix of befuddlement and ingenuousness, provokes his questioner by

5.74. Paolo Veronese (Paolo Caliari), *The Meal at the House of Simon the Pharisee*, 1570. Châteaux de Versailles et de Trianon, Versailles, France

5.75. Paolo Veronese (Paolo Caliari), *The Wedding at Cana*, c. 1571. Gemäldegalerie Alte Meister, Staatliche Kunstsammlungen, Dresden

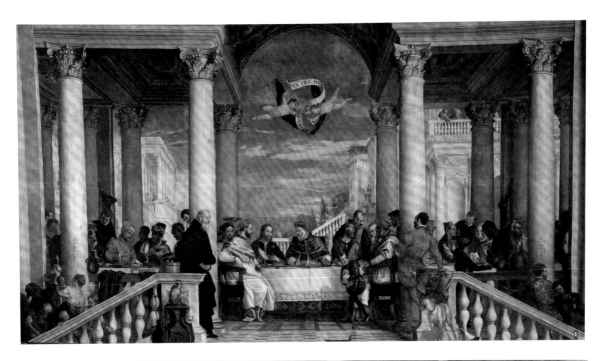

5.76. Paolo Veronese (Paolo Caliari), *Supper of Saint Gregory*, 1572. Basilica of Monte Berico, Vicenza, Italy

5.77. Paolo Veronese (Paolo Caliari), *The Last Supper*, 1585. Pinacoteca di Brera, Milan

insisting on a radically gastronomic account of the scene that he has created, blissfully indifferent to the sacrament; for instance:

INQUISITOR. What is the picture to which you have been referring?

VERONESE. It is the picture which represents the Last Supper of Jesus Christ with His disciples in the house of Simon.

INQUISITOR. Where is this picture?

VERONESE. In the refectory of the monks of San Giovanni e Paolo . . .

INQUISITOR. How many [figures] have you represented? And what is each one doing?

VERONESE. First there is the innkeeper, Simon; then, under him, a carving squire whom I supposed to have come there for his pleasure, to see how the service of the table is managed. (fig. 5.78)[110]

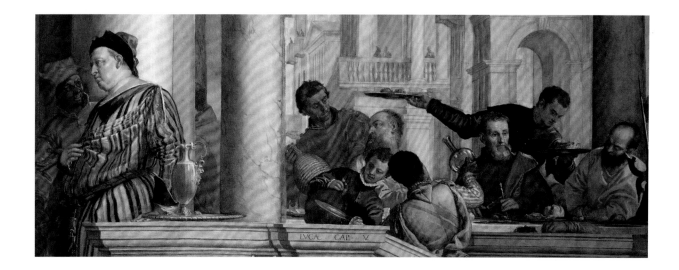

5.78. Paolo Veronese (Paolo Caliari), *Feast in the House of Levi*, detail of fig. 5.69, right side ("innkeeper," "carving squire")

From the start, when the artist declares to the inquisitor that the event takes place in the house of Simon the Pharisee, he is guilty of a double error, since the Bible specifies no location for the Last Supper, and since on the occasion when Jesus did dine in Simon's house he was notably mistreated.[111] None of which really matters, because Veronese's Simon, according to the answers that he offers, isn't a rich Pharisee but the *patron dell'albergo*, the owner of the inn, and he is accompanied by a *scalco*, a uniquely Italian Renaissance gastronomic figure, a sort of gourmet master of ceremonies in the style of Bartolomeo Scappi and Cristoforo di Messisbugo, that is, an individual who is there to make sure that everything goes perfectly at the dinner table (he is the theatrically gesturing headwaiter-type figure dressed in an elegant green cloak). The *scalco* can't solve all problems, however:

> INQUISITOR. In this Supper which you painted for San Giovanni e Paolo, what
> signifies the figure of him whose nose is bleeding (fig. 5.79)?
> VERONESE. He is a servant who has a nose-bleed from some accident.[112]

Such a condition may have been a common enough occurrence in grand Venetian banquets, but it is not mentioned in any of the Gospels. Extraneous blood is the last thing one wants to see at the Last Supper.

It gets worse. The inquisitor continues to ask about a few of the extra figures, including a pair of soldiers whom he characterizes as dressed in German style (fig. 5.80), which, apart from everything else, would be a flashpoint in the aftermath of Luther. Veronese responds that a rich man like the host of this party would have certainly hired security. All of which is a prelude to the more serious questions about the sacred figures themselves:

> INQUISITOR. Who are the persons at the table of Our Lord?
> VERONESE. The twelve apostles.
> INQUISITOR. What is Saint Peter doing, who is the first (fig. 5.81)?
> VERONESE. He is carving the lamb in order to pass it to the other part of
> the table.

5.79. Paolo Veronese (Paolo Caliari), *Feast in the House of Levi*, detail of fig. 5.69, left side (servant with nosebleed)

5.80. Paolo Veronese (Paolo Caliari), *Feast in the House of Levi*, detail of fig. 5.69 (soldiers dressed in German style)

INQUISITOR. What is he doing who comes next?

VERONESE. He holds a plate to receive what Saint Peter will give him.

INQUISITOR. Tell us what the third is doing.

VERONESE. He is picking his teeth with a fork (fig. 5.82).[113]

This is the heart of the matter, the moment when a chasm opens up between Christian orthodoxy and High Renaissance painting in the grand style. Where the inquisitor expects to see the sacramental, Veronese—again, either *naïf* or *faux-naïf*—replies with an account of the most banal, even slightly distasteful, details of the dining table. It functions, like any great moment of comic misunderstanding (and it *is*, inadvertently or not, high comedy),[114] because both the opposing consciousnesses are completely justified in their incompatible understandings. The inquisitor wants to see the sacrament, and he is disappointed; and if Veronese sees only dinner, it is because the whole history of the Last Supper, especially in its visual representation, doesn't actually include the sacrament, at least in the literal sense. If the bites of dinner are metaphorical or metonymical, either for the Eucharistic bread and wine or for the body and blood of Christ to which they are supposedly transformed, Veronese is in effect saying, "I don't see it." And, in the logic of the visual artist, "if I don't see it, I don't paint it."

Veronese's defense, which takes us all the way back to xenia, still life, and mimesis, is to assert the authority of the painter, as the supreme master of the *visible* (as opposed to the *invisible*) world. Though Veronese was certainly not a humanist-artist in the manner of Leonardo or Michelangelo, he had absorbed the great Horatian justification for imaginative fiction that appears in the opening of the *Ars poetica* and that had from the beginning given license to visual artists as well as poets: "Poets and painters have ever had equal authority for attempting any thing."[115] Or in Veronese's version, "We painters use the same license as poets and madmen"[116] (thus adding another group to those with this freedom, as one also sees in the famous lines from

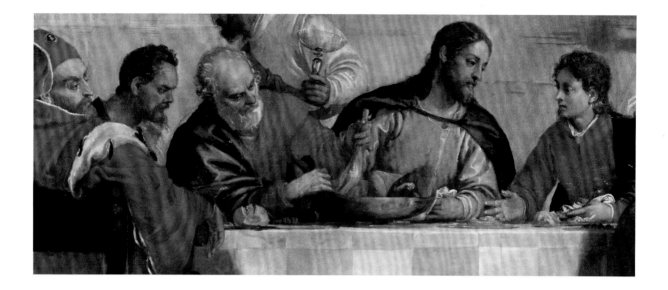

5.81. Paolo Veronese (Paolo Caliari), *Feast in the House of Levi*, detail of fig. 5.69, center (Saint Peter "carving")

Shakespeare's *Midsummer Night's Dream*). He asserts the authority of the real visible world, of his obligation to provide *ornament* to that world, and of his own *intelletto*: "I make pictures with that reflection that is appropriate, that which my *intelletto* can grasp."[117]

That lofty term *intelletto* signals Veronese's wish to insert himself into the heritage of Michelangelo, who in a poem of extraordinary diffusion throughout the late sixteenth century had anchored his own artistic genius (sculptural, in this instance) in precisely that inward space:

> *Non ha l'ottimo artista alcun concetto*
> *c'un marmo solo in sé non circonscriva*
> *col suo superchio, e solo a quello arriva*
> *la man che ubbidisce all'intelletto.*

> The greatest artist does not have any concept which a single piece of marble does not itself contain within its excess, though only a hand that obeys the intellect can discover it.[118]

No surprise, then, that Veronese should try to defend himself by reference to what he took to be a similar act of artistic license by Michelangelo in peopling the Sistine Chapel *Last Judgment* with so many nudes. That argument, however, cuts no ice with the inquisitor, who replies quite sensibly that nudity would be the natural condition of figures experiencing the Last Judgment (which didn't stop Vatican authorities from painting them over exactly at this moment),[119] whereas the biblical Last Supper would not have contained Veronese's wild circus of details. But the underlying Michelangelo defense is that genius declares its inalienable rights, and this claim proves hard to squelch. With regard to the Last Supper, then, one artist in this late Renaissance moment is exercising his *intelletto* by exposing the problematic of the sacramental versus the alimental that has haunted Christianity from the time of its inception.

5.82. Paolo Veronese (Paolo Caliari), *Feast in the House of Levi*, detail of fig. 5.69 (man "picking his teeth with a fork")

Reviewing these teeming banquet scenes ablaze with festivity and featuring tables heavily laden with everything that artists can imagine as the summit of food and drink, it seems one more time inescapable to cite the *Unswept Floor*. Though no premodern artist, theologian, or observer was in a position to draw the lines of connection, it is difficult to resist noting the contrast between the value systems of late antiquity, in which the feast has reached a stage where nothing is left but the dross, versus those of High Renaissance Christianity, in which the feast is present in all its abundance while at the same time prefiguring a heavenly feast that has no end. What the two scenes have in common, however, is the fact that no account of this life or the next can be complete without the unmistakable signs of eating and drinking, whether in anticipation or as a *feast accompli*.

Notes

Introduction

1. Citation is to *The Norton Shakespeare*, ed. S. Greenblatt et al. (New York, 1997).
2. Yi-Fu Tuan, "Pleasures of the Proximate Senses: Eating, Taste, and Culture," in *The Taste Culture Reader*, ed. C. Korsmeyer (London, 2016).

Chapter One. Reading for the Food

1. The scholarship on dining in the ancient world is of extraordinary quality. I cite it *à propos* of the present subject, but its influence informs much of this book. (I emphasize the Greek side here; for the marvelous scholarship on Rome, see note 6 in chap. 2.) See, for instance, the work of Andrew Dalby, *Siren Feasts: A History of Food and Gastronomy in Greece* (London and New York, 1996), and *Food in the Ancient World from A to Z* (London and New York, 2003). Also impressive is the work of John M. Wilkins and his various collaborators, e.g., John M. Wilkins and Shaun Hill, *Food in the Ancient World* (Malden, MA, 2006), and John Wilkins, David Harvey, and Mike Dobson, *Food in Antiquity* (Exeter, UK, 1995). Two particularly important more theoretical works are François Lissarague, *The Aesthetics of the Greek Banquet: Images of Wine and Ritual* (Princeton, NJ, 1990) and Marcel Detienne and Jean-Pierre Vernant, *The Cuisine of Sacrifice among the Greeks* (Chicago, 1989). Specifically regarding the symposium, see O. Murray, ed., *Sympotika: A Symposium on the Symposion* (Oxford, 1990), and the same author's *The Symposion: Drinking Greek Style* (Oxford, 2018); also Massimo Vetta, "The Culture of the Symposium," in *Food: A Culinary History*, ed. A. Sonnenfeld (New York, 1999), 96–105.
2. Plato, *Symposium* 176A, trans. A. Nehamas and P. Woodruff (Indianapolis, 1989).
3. Plutarch, *Moralia*, "Table Talk" 6.686c, trans. P. A. Clement and H. B. Hoffleit, Loeb Classical Library (Cambridge, MA, 1969): "Remembering past delights in food and drink is an ignoble kind of pleasure and one that is, besides, as unsubstantial as yesterday's perfume or the lingering smell of cooking. On the other hand, the topics of philosophical inquiry and discussion not only give pleasure by remaining ever present and fresh to those who actually recall them, but they also provide just as good a feast on the same food to those who, having been left out, partake of them through oral report."
4. For the full text in English, see Immanuel Kant, *Anthropology from a Pragmatic Point of View*, trans. Robert B. Louden (Cambridge, UK, 2006).
5. Kant, *Anthropology*, 136. In this connection, see Miles Rind, "What Is Claimed in a Kantian Judgment of Taste?" *Journal of the History of Philosophy* 38 (2000): 63–85, particularly his concluding argument that, "for Kant, the reason why judgments of taste merit a 'transcendental examination' . . . is their combination of a claim

to and universal agreement with a subjective, non-conceptual, non-cognitive, or in his term 'aesthetic' character." Rind refers to this as a "peculiar" use of *aesthetic*, and he goes on to adduce the (presumably) surprising fact that, "for Kant, 'Canary wine is agreeable' is just as good an example of an 'aesthetic' judgment as is 'The rose is beautiful.'" See also Paul Guyer, *Kant and the Claims of Taste*, 2nd ed. (Cambridge, UK, 1997), and Kevin Sweeney, "Hunger Is the Best Science: The Aesthetics of Food," in *The Philosophy of Food*, ed. D. M. Kaplan (Berkeley and Los Angeles, 2012), 52–68. On Kant and wine, see Rachel Cristy, "Does Wine Have a Place in Kant's Theory of Taste?" *Journal of the American Philosophical Association* 2 (2016): 36–54. Kant's discussion of *Kanariensekt* (English translations always fail to indicate that it is a sparkling wine) is to be found in chap. 15 of the *Critique of Judgment*, where he is distinguishing between the beautiful (*das Schöne*) and the pleasing (*das Angenehme*). For a relatively lucid account of the philosophical issues stemming from Kant's apparent fondness for sparkling wine from the Canary Islands and its place in his reasoning, see *Stanford Encyclopedia of Philosophy*, s.v. "Aesthetic Judgment."
6. There has been much interesting work, both historical and philosophical, on the subject of taste. See especially Carolyn Korsmeyer, *Making Sense of Taste* (Ithaca, 1999), and Denise Gigante, *Taste: A Literary History* (New Haven, 2005). See also Nicola Perullo, *Taste as Experience: The Philosophy and Aesthetics of Food* (New York, 2016), and the very interesting range of essays in Carolyn Korsmeyer, ed., *The Taste Culture Reader* (Oxford, 2005).
7. Citation is to Leon Battista Alberti, *On Painting* 2.40, trans. C. Grayson (London, 1991).
8. See Francesca Schironi, "The Reception of Ancient Drama in Renaissance Italy," in *A Handbook to the Reception of Greek Drama*, ed. B. van Zyl Smit (Wiley online, 2016), 133–53.
9. See the broadly based account of the way in which the term *historia* stretches into the realms of rhetoric, literature, and history, in Anthony Grafton, "Historia and Istoria: Alberti's Terminology in Context," *I Tatti Studies in the Italian Renaissance* 8 (1999): 37–68. On the question of Albertian composition, see Jack M. Greenstein, "On Alberti's 'Sign': Vision and Composition in Quattrocento Painting," *Art Bulletin* 79 (1997): 669–98.
10. For the history and extent of Varro's vast—and vastly lost—oeuvre, see G. L. Hendrickson, "The Provenance of Jerome's Catalogue of Varro's Works," *Classical Philology* 3 (1911): 334–43.
11. Citation is to Aulus Gellius, *Attic Nights*, vol. 2, trans. J. C. Rolfe, Loeb Classical Library (Cambridge, MA, 1927). On the reception of Aulus Gellius in the Renaissance, see Hans Baron, "Aulus Gellius in the Renaissance and a Manuscript from the School of Guarino," *Studies in Philology* (48): 107–25.
12. For more on the triclinium, see chap. 2 of this volume.
13. See the work of Jack Greenstein, including "On Alberti's 'Sign': Vision and Composition in Quattrocento Painting," *Art Bulletin* 79 (1997): 669–98.
14. Citations are to Giorgio Vasari, *Lives of the Painters, Sculptors, and Architects*, trans. Gaston duC. deVere (New York, 1996). Where the Italian is referenced, it is from *Le opere di Giorgio Vasari con nuove annotazioni e commenti di Gaetano Milanesi* (Florence, 1878–85).
15. A 2010 exhibition entitled *I Grandi bronzi del battistero Rustici e Leonardo* (see "The Great Rustici Emerges from the Shadows,"

New York Times, 13 Dec. 2010) produced a brief flurry of rediscovery regarding Rustici's work.

16. On the Boucher painting, see Colin Bailey et al., *The Age of Watteau, Chardin, and Fragonard* (New Haven, 2003), and John David Farmer, "A New Painting by François Boucher," *Bulletin of the Art Institute of Chicago* 68 (1974): 16–20. The composition exists in two versions. The oval, represented here, is in the Art Institute of Chicago; a rectangular version (now generally thought to be subsequent to the Chicago picture), with some other changes in the ancillary figures, was commissioned by the royal Swedish architect in 1747 and now hangs in the Stockholm National Museum. On the relations with Favart and the *fêtes galantes*, see Melissa Hyde, "Confounding Conventions: Gender Ambiguity and François Boucher's Painted Pastorals," *Eighteenth Century Studies* 30 (1996): 25–57.

17. The title, correctly rendered *Pensent-ils au raisin?*, but often cited in some form of singular (*Pense-t-il*, is *he* thinking . . .), or with *pensent* misspelled as *pensant*, or with an otiose plural for *raisin*, necessary in English but not in French, first appears in a contemporary engraving of the painting made by Jacques Philippe Le Bas; the format there is rectangular (see previous note) and left-right reversed in relation to the painting. Though it is not absolutely possible to attach the titular question to Boucher's original conception, it is nonetheless the case that this painting, along with its pendant, *Le joueur de flageolet*, were inspired by Favart's pastoral entertainment, *Les vendanges de Tempé*, where such activities were figured.

18. See my *Unearthing the Past: Archaeology and Aesthetics in the Making of Renaissance Culture* (New Haven, 1999).

19. The letter was first published in Carlo Fea, *Miscellanea filologica, critica e antiquaria* (Rome, 1790), 1.329. Translation mine.

20. I first learned of this alternative translation from the kind review of *Unearthing the Past* by the late F. W. Kent (*Renaissance Quarterly* 55 [2002]: 689–90), which corrected me on this point. It should be noted that citations of this letter in English tend to translate *desinare*, in Sangallo's phrase "ci tornammo a desinare," as "draw." It seems, however, that we have been mistaken on this point. Now that I make a comprehensive search, in fact, I can find no historical lexicon of Italian where *desinare* is said to be a form of *disegnare*. Rather it is always about consuming food, which suggests to me that Sangallo was definitely referring to lunch rather than draftsmanship. An interesting, even uncanny detail in that *RQ* review is that, directly after correcting me on *desinare*, the author graciously says the book "left this reader hungry for more." He seems to have had in mind that I should write a similar book on architecture (in his words, "there is another grand theme worthy of Leonard Barkan"). I have not taken up architecture, but I hope that the present volume would have nevertheless satisfied some of Prof. Kent's hunger.

21. It is irresistible to point out that the other great narrative of discovery in respect to ancient art in Renaissance Rome, that of Nero's Golden House, also comes with a set of mealtime references—and again with some textual ambiguity. In the lively poetic account of Roman ruins offered by a certain Prospettivo Milanese around 1500, we are told that painters swarm all over the "grottoes" (the house was erroneously thought to have been built underground, hence the paintings were "grotteschi" and hence our term *grotesque*), "Andian per terra con nostre ventresche / con pane con presutto poma e vino / per esser piu bizzarri alle grottesche" ("We crawl on the ground with our sausages, with bread, with prosciutto, fruit, and wine, so as to be more bizarre among the *grotteschi*"). Curiously, here too there has been some uncertainty of translation—that is, as to whether they are crawling on their belly (*ventre*) or eating a sausage known as *ventresca*. About the prosciutto, fruit, and wine, however, there is no doubt. The tantalizing claim that picnicking in the midst of the ruins made them "more bizarre among the *grotteschi*" is not easy to decode; perhaps it refers to the incongruity of having such a plebeian nosh among the remains of sublime ancient painting. For the text of Prospettivo Milanese, see Gilberto Govi, *Antiquarie prospettiche romane composte per Prospettivo Milanese dipintore*, http://www.franuvolo.it/sito/doc/Leonardo-in/154.pdf.

22. See I. A. Richards, *The Philosophy of Rhetoric* (New York, 1936), 95–112. See also I. A. Richards and C. K. Ogden, *The Meaning of Meaning* (New York, 1947), 212–42.

23. Pliny, *Natural History* 35.65. I discuss this well known story in *Unearthing the Past*, 87–88, and again in *Mute Poetry, Speaking Pictures* (Princeton, NJ, 2012), 158–59. Yet once more, it will be considered in chap. 5 of this vol.

24. For Plato, *Republic*, see especially book 10. On this complex and much discussed topic, see the masterful work of Stephen Halliwell, *The Aesthetics of Mimesis: Ancient Texts and Modern Problems* (Princeton, NJ, 2002).

25. The brilliant essay, to which I am much indebted, is Stephen Nichols, "Seeing Food: An Anthropology of Ekphrasis, and Still Life in Classical and Medieval Examples," *Modern Language Notes* 106 (1991): 818–51.

26. On *historia* and history, see note 9, this chap. But see also the strenuous argument for the disambiguation of the two terms in Charles Dempsey, "*Historia* and Anachronism in Renaissance Art," *Art Bulletin* 87 (2005): 416–21. On the subject of loneliness, I cite (as always, with love and respect) the work of my *Doktorvater*, Thomas M. Greene, *The Light in Troy: Imitation and Discovery in Renaissance Literature* (New Haven, CT, 1982), especially chap. 1, "Historical Solitude."

27. Varro, *On the Latin Language*, vol. 2, trans. Roland G. Kent, Loeb Classical Library (Cambridge, MA, 1938), 9.4: "For we see that nouns and verbs which we inflect in similar ways are in general usage, and we compare others with this usage, and if there is any error we make the correction with the help of usage. For if those who have arranged the dining-room have among the three couches set one that is of a different size, or among couches that match have brought one too far forward, or not far enough, we join in making the correction according to common usage and to the analogies of other dining-rooms; in the same way, if in speech any one in his utterance should so inflect the words as to speak irregular forms, we ought to revise his mistake according to the model of other similar words."

28. See chap. 2 of this volume for more on the triclinium, and chap. 5 of this volume for more on Last Suppers.

29. For basic overviews of both Taddeo's and Agnolo's careers, see Andrew Ladis, *Taddeo Gaddi: Critical Review and Catalogue Raisonné* (Columbia, MO, 1982), and Bruce Cole, *Agnolo Gaddi* (Oxford, 1977).

30. The phrase itself is not found verbatim in any classical text. The sentiment is, however, often said to be derived from an anecdote in Plutarch's *Life of Caesar* (17.5). It seems that when, at a banquet in Milan, Caesar was served asparagus dressed with myrrh rather than with olive oil, he ate this (apparently repellent) concoction without grumbling, making the point to his underlings that it was more ill-mannered to complain about badly made food than to produce it in the first place. If this is the origin of *de gustibus non est disputandum*, as has been claimed, then it's clear that the *gustus* involved was always at base culinary.

31. The subject is treated with all due solemnity in Steven Lowenstam, "Aristophanes' Hiccups," *Greek, Roman and Byzantine Studies* 27 (1986): 43–56. Lowenstam, it should be pointed out, believes that the hiccups are a sign of overeating rather than overdrinking.

32. Unlike *de gustibus . . .* , this phrase has a notable classical pedigree. It forms part of Pliny the Elder's diatribe against excessive tippling. On the occasion of extreme drinking bouts among men, Pliny declares, "Then it is that greedy eyes bid a price for a married woman, and their heavy glances betray it to her husband; then it is that the secrets of the heart are published abroad: some men specify the provisions of their wills, others let out facts of fatal import, and do not keep to themselves words that will come back to them through a slit in their throat—how many men having lost their lives in that way! and truth has come to be proverbially credited to wine [*volgoque veritas iam attributa vino est*]." Pliny, *Natural History* 14.142, trans. H. Rackham, Loeb Classical Library (Cambridge, MA, 1942). In notable contradiction to our use of the phrase, Pliny seems to be talking about truths that should be hidden and are accidentally revealed by those who are inebriated. It turns up as Erasmus's *Adagia* 354, where the implication is that wine brings out the drinker's true character; Alcibiades is quoted as saying, "'Wine and children tell the truth'—and wine does so on its own!" (Plato, *Symposium* 271E).

33. Someone *has* written such a book, and a very good one: Mark Kurlansky, *Salt: A World History* (Penguin, 2003).

34. Brief bibliographical references on these vastly researched topics: On high and low culture, classic accounts include Raymond Williams, *The Sociology of Culture* (New York, 1982), and Herbert J. Gans, *Popular Culture and High Culture*, rev. ed. (New York, 1999). The notion of center and periphery begins with the study of world economy, especially that of Immanuel Wallerstein, *The Modern World System: Capitalist Agriculture and the Origins of the European World-Economy in the Sixteenth Century* (New York, 1974). See also Edward Shils, *Center and Periphery: Essays in Macrosociology* (Chicago, 1975). Within the realm of humanistic pursuits, see Gian-Paolo Biasin, "The Periphery of Literature," *Modern Language Notes* 111 (1996): 976–89. On the Return of the Repressed, one of the classic formulations is Freud's 1915 paper "Repression," *Standard Edition* 14: 141–58. See also Ken Gemes, "Freud and Nietzsche on Sublimation," *Journal of Nietzsche Studies* 38 (2009): 38–59. The truth is that all these discourses may tend to be found in a less methodically rigorous form in the present text. As far as High and Low Culture is concerned, with nearly everything in these pages resolutely in the realm of "High," the notion is rather that eating and drinking may represent a "lower" aspect within High Culture. As for Centers and Peripheries, I think of that structure as a useful analogue to the place of eating and drinking

amidst what are considered loftier human enterprises. And the Return of the Repressed has less to do with the specifics of repression than the ways in which a particular set of bodily activities insists on being paid attention to despite its marginalization. In regard to anthropology and sociology directly concerned with eating and drinking, the masterpieces in the field include Jack Goody, *Cuisine and Class: A Study in Comparative Sociology* (Cambridge, UK, 1982); Sidney Mintz, *Tasting Food, Tasting Freedom: Excursions into Eating, Culture and the Past* (Boston, 1996); and Mary Douglas, *Purity and Danger* (London, 1966).

35. Among the classic treatments are Stephen Orgel, *The Illusion of Power: Political Theater in the English Renaissance* (Berkeley and Los Angeles, 1975), and Roy Strong, *Art and Power: Renaissance Festivals 1450–1650* (Berkeley and Los Angeles, 1973), though neither of these works places the emphasis on eating and drinking. On Catherine de Médicis, in addition to Strong, see R. J. Knecht, *Catherine de Medici* (London and New York, 1998).

36. For the practice of *Alltagsgeschichte*, as it came to be called, see the work of Fernand Braudel, especially *Civilization and Capitalism, 15th–18th Centuries*. The first volume, *The Structures of Everyday Life* (Berkeley and Los Angeles, 1992), helped launch a revolution in the historicization of eating and drinking, not only by presenting the material data in ways that previous historians had not undertaken but even more by the methodological sense that real substantial history could be written from a study of wheat, rice, and maize, from the development of tastes for particular foods, and from class behaviors with respect to consumption at table. It is owing to this kind of history writing that Carlo Ginzburg could choose a humble miller as the subject of his famous work *The Cheese and the Worms* (London, 1980). For the more recent scholarship theorizing this activity as part of a social structure that includes the historians themselves, see the work of Alfred Ludtke, e.g., *The History of Everyday Life: Reconstructing Historical Experiences* (Princeton, NJ, 1995).

37. See the very useful listings in Carolyn Stevens, "History of Women and Work: A Bibliography," *Feminist Teacher* 7 (1993): 49–61. The field has of course grown vastly in the past twenty-five years. The classic work that joins women with food in the premodern period is, of course, Caroline Bynum, *Holy Feast and Holy Fast: The Religious Significance of Food to Medieval Women* (Berkeley and Los Angeles, 1988). For an approach more geared to the contemporary world, see Carole M. Counihan, *The Anthropology of Food and Body: Gender, Meaning, and Power* (New York and London, 1999); the same author in collaboration with Steven L. Kaplan edited a collection entitled *Food and Gender: Identity and Power* (London and New York, 1998). Another collection, Stephanie Lynn Budin and Jean MacIntosh Turfa, eds., *Women in Antiquity: Real Women across the Ancient World* (London and New York, 2016), while not focusing on food, offers important glimpses into early gender roles.

38. See chap. 3 of this volume.

39. See chap. 4 of this volume.

40. This brief sketch—not to be confused with the more famous "Dead Parrot" sketch—can be found at: Another Bleedin' Monty Python Website, Monty Python Scripts, "The News for Parrots / The News for Gibbons," http://montypython.50webs.com/scripts/Series_2/51.htm.

41. See Edward Skidelsky, *Ernst Cassirer: The Last Philosopher of Culture* (Princeton, NJ, 2011), esp. chap. 5, "The Philosophy of Symbolic Forms."

42. See the marvelous joint project between the Warburg Institute and the Cornell University Library, which have helped bring the *Mnemosyne* project to new life. Note esp. their joint website, "Mnemosyne: Meanderings through Aby Warburg's Atlas," https://warburg.library.cornell.edu/. As the present volume goes to press, there has been announced an exhibition and a publication that recreates Warburg's project: *Aby Warburg: Bilderatlas Mnemosyne*, ed. R. Ohrt and A. Heil (Berlin, 2020).

43. The pathbreaking work on this subject is Rensselaer Lee, *Ut Pictura Poesis: The Humanistic Theory of Painting* (New York, 1967). The topic threads its way into nearly everything that I have written. I take it up directly in *Mute Poetry, Speaking Pictures* (Princeton, NJ, 2013), which includes an extensive bibliography of the subject.

44. On this relation see, for instance, Katherine Golsan, "The Beholder as Flâneur: Structures of Perception in Baudelaire and Manet," *French Forum* 21 (1996): 165–86. My thinking on this material owes a great deal to Alexander Nehamas (*Only a Promise of Happiness: The Place of Beauty in a World of Art* [Princeton, NJ, 2007]) and to Michael Fried (*Manet's Modernism: The Face of Painting in the 1860s* [Chicago, 1998]).

45. The diagram, along with a more discursive explanation, can be found in Erwin Panofsky, *Studies in Iconology: Humanistic Themes in the Art of the Renaissance* (New York, 1972), 3–17; and in Panofsky, *Meaning in the Visual Arts* (Garden City, NY, 1955), 26–54.

46. See Paul Ricoeur, *Hermeneutics and the Human Sciences* (Cambridge, UK, 1981), especially "What Is a Text: Explanation and Understanding," 145–60.

47. Pliny, *Natural History* 36.60, trans. D. E. Eichholtz, Loeb Classical Library (Cambridge, MA, 1962), 10:145.

48. On this magnificent work, the great scholarly/interpretive study has yet to be written. Meanwhile, see such useful works as: Bartolomeo Nogara, *I Mosaici antichi conservati nei palazzi pontifici del Vaticano e del Laterano* (Milan, 1910) 3–5; K. E. Werner, *Die Sammlung antiker Mosaiken in den Vatikanischen Museen* (Vatican City, 1998), 260–75; E. Moormann, "La Bellezza dell'immondezza," in *Sordes urbis*, ed. X. Dupré Raventós and J.-A. Remolà (Rome, 2000), 83–91; and Paolo Liverani and Giandomenico Spinola, *Vaticano: I Mosaici antichi* (Vatican City, 2002), 30–35, 104–6.

49. Pliny, *Natural History* 35.25. For some of these retellings of mine in print, see *Unearthing the Past*, 81–82; see also *Mute Poetry*, 35–36, 90–91.

50. See, for example, the chapter "Rococo, Realism, and the Exotic," in J. J. Pollitt, *Art in the Hellenistic Age* (Cambridge, UK, 1986), 127–49; see also John Onians, *Art and Thought in the Hellenistic Age* (London, 1979), 17–52.

51. See the discussions of xenia and still life in chap. 5 of this volume.

52. The punchline, after listing what Santra demands for himself at table ("three helpings of boar's sweetbreads, four of loin, both haunches of hare and two shoulders"), as well as what he steals in his napkin, is that he rushes home, locks himself in his room, and then, just when the reader expects he will gorge himself on it, we're told that Santra "sells it next day." Martial, *Epigrams*, trans.

D. R. Shackleton Bailey, Loeb Classical Library (Cambridge, MA, 1993), 2:89.

53. *Institutio oratoriae* 8.3, trans. D. A. Russell, Loeb Classical Library (Cambridge, MA, 2002), 126:379. The passage comes from Cicero's fragmentary *Pro quinto gallio* oration.

54. The reference is, of course, to Johan Huizinga, *Homo Ludens* (London, 1949). See especially chap. 10, "Play-Forms in Art."

55. See the works of Martial *passim*, for instance *Epigrams* 11.77: "Vacerra spends all the hours in the privies, sitting all day long. He doesn't want a shit, he wants a dinner," on which the helpful Loeb note is, "He hopes to meet some acquaintance and get an invitation," 480:65. On these matters, see Matthew Britten, "Don't Get the Wrong End of the Stick: Lifting the Lid on Roman Toilet Behavior," *Reinvention* 7, no. 1 (2014), https://warwick.ac.uk/fac/cross_fac/iatl/reinvention/issues/volume7issue1/britten/#Note1.

56. See also the discussion in chap. 2 of this volume, concerning the question of orderliness at Roman banquets.

Chapter Two. Rome Eats

1. In book 35 of the *Natural History* (concerned with painting), Rome figures prominently as a place where art has developed and been patronized by emperors, but when Pliny declares at 35.34 that he "will now run through as briefly as possible the artists eminent in painting," the names are all Greek. Along similar lines with sculpture in book 36: objects are located in Rome and woven into Roman imperial history, but they are made by Greeks. See Francesco de Angelis, "Pliny the Elder and the Identity of Roman Art," *Res: Anthropology and Aesthetics* 53/54 (2008): 79–92; and Valérie Naas, "L'art grec dans l'*Histoire Naturelle* de Pline l'Ancien," *Histoire de l'Art* 35/36 (1996): 15–26.

2. "Others, I doubt not, shall with softer mould beat out the breathing bronze, coax from the marble features to the life, plead cases with greater eloquence and with a pointer trace heaven's motions and predict the risings of the stars: you, Roman, be sure to rule the world (be these your arts), to crown peace with justice, to spare the vanquished and to crush the proud." Virgil, *Aeneid* 6.847–53, trans. H. R. Fairclough, Loeb Classical Library (Cambridge, MA, 1967).

3. Two pronouncements on Cicero from scholarship recent and not so recent: "To speak about Cicero and Greek philosophy is to speak about Cicero and philosophy, period. Philosophy, for the Romans of Cicero's age, was a Greek thing, and there was no other philosophy around," Gisela Striker, "Cicero and Greek Philosophy," *Harvard Studies in Classical Philology* 97 (1995): 53–61; and "If the historian of ancient art were absolutely dependent upon Cicero for information, his history of ancient painting would present the following names: Apelles, Aglaophon, Polygnotus, Zeuxis, Timanthes . . . ," Grant Showerman, "Cicero's Appreciation of Greek Art," *American Journal of Philology* 25 (1904): 306–14.

4. On farming, see Alan Bowman and Andrew Wilson, *The Roman Agricultural Economy: Organization and Production* (Oxford, 2013). On grapes and wine, see Stuart J. Fleming, *Vinum: The Story of Roman Wine* (Glen Mills, PA, 2001), and André Tchernia, *Le vin de l'Italie romaine* (Rome, 1986). See also note 6, below.

5. The oft-quoted (*too* oft-quoted?) line is to be found in Walter Benjamin, *Über den Begriff der Geschichte* 7: "Es ist niemals ein

Dokument der Kultur, ohne zugleich ein solches der Barbarei zu sein."

6. Excellent introductions to the subject are to be found in Jean-Louis Flandrin and Massimo Montanari, eds., *Food: A Culinary History from Antiquity to the Present* (New York, 1999); Paul Freedman, ed., *Food: The History of Taste*, (Berkeley and Los Angeles, 2007); and John Wilkins and Robin Nadeau, eds., *A Companion to Food in the Ancient World* (Malden, MA, 2015). For studies of the particular foodstuffs that Romans produced and ate, see Patrick Faas, *Around the Roman Table* (Chicago, 2005), and I. G. Giacosa, *A Taste of Ancient Rome* (Chicago, 1994). In a class by themselves are two books that set the highest standards for work of the kind the present volume aspires to: Katherine M. D. Dunbabin, *The Roman Banquet: Images of Conviviality* (Cambridge, UK, 2003), and Emily Gowers, *The Loaded Table: Representations of Food in Roman Literature* (Oxford, 1993). Equally inspiring are the essays of John H. D'Arms, unfortunately not yet collected in a single volume; see note 45, this chap. Valuable essays, some of them cited below, are to be found in "Roman Dining," special issue, *American Journal of Philology* 124, no. 3 (Autumn 2003).

7. Hence this chapter title. Think of it as something like, "Athens Philosophizes, Florence Paints, Rome Eats."

8. Martial, *Epigrams* 4.44, trans. D. R. Shackleton Bailey, Loeb Classical Library (Cambridge, MA, 1993). For other poetic responses to the catastrophe, see Martial, *Book 4: A Commentary*, ed. R. M. Soldevila (Leiden, 2017), 327. On Martial's adaptation of the lost cities trope, see L. and P. Watson, *Martial: Selected Epigrams* (Cambridge, UK, 2003), 332–334.

9. "As for the wines of Pompei, their topmost improvement is a matter of ten years, and they gain nothing from age" (Pliny the Elder, *Natural History* 14.70, trans. H. R. Rackham, Loeb Classical Library [Cambridge MA, 1945]), from which Pliny deduces a remarkable principle that would challenge and intrigue a modern wine connoisseur: "These instances, if I am not mistaken, go to show that it is the country and the soil that matter, not the grape, and that it is superfluous to go on with a long enumeration of kinds, since the same vine has a different value in different places." This comes at the conclusion of a very long enumeration of varietals on Pliny's part. Further evidence of this contradiction comes in his challenging of Virgil's (in his view) scanty enumeration of wines.

10. See "Trade Routes and Commercial Products of Roman Pompeii," Campus Pompei, 29 Sept. 2015, http://www.campuspompei.it/2015/09/29/trade-routes-and-commercial-products-of-roman-pompeii/. Amphorae with Pompeiian inscriptions have been found much farther afield as well, for instance in Spain, though they may be the result of forgery, suggesting that the reputation of Pompeiian vintages was sufficient to produce wine fraud.

11. See Miko Flohr and Andrew Wilson, *The Economy of Pompeii* (Oxford, 2017), esp. 23–52.

12. On garum, see the discussion later in the present chapter.

13. See Paul Roberts, *Life and Death in Pompeii and Herculaneum* (Oxford, 2013), which accompanied the great Pompeii exhibit at the British Museum, 224–45; see also Steven J. R. Ellis, "The Pompeian Bar: Archaeology and the Role of Food and Drink Outlets in an Ancient Community," *Food and History* 2 (2004): 41–58.

14. References are to *Corpus Inscriptionum Latinarum*, for which see "CIL Open Access," iDAIimages/Arachne, German Archaeological Institute (DAI) and Archaeological Institute of Univ. of Cologne, https://arachne.uni-koeln.de/drupal/?q=en/node/291.

15. On the inscriptions, see Alison E. Cooley and M.G.L. Cooley, *Pompeii and Herculaneum: A Sourcebook* (London and New York), 2004.

16. For an excellent summary of the historiography on thermopolia, see Ellis, "The Pompeiian Bar."

17. On the triclinium and other aspects of domestic architecture, see Andrew Wallace-Hadrill, *Houses and Society in Pompeii and Herculaneum* (Princeton, 1994). For other perspectives, see Bettina Bergmann, "The Roman House as Memory Theater: The House of the Tragic Poet in Pompeii," *Art Bulletin* 76 (1994): 225–56; John Stephenson, "Dining as Spectacle in Late Roman Houses," *Bulletin of the Institute of Classical Studies* 59 (2016): 54–71; and David Frederick, "Grasping the Pangolin: Sensuous Ambiguity in Roman Dining, *Arethusa* 36 (2003), 309–43. Katherine Dunbabin, *Roman Banquet*, is indispensable here. See also her "Triclinium and Stibadium," in *Dining in a Classical Context*, ed. W. J. Slater (Ann Arbor, 1991), 121–48. For a list of rooms in Pompeii that can be readily identified as triclinia, see Dunbabin, *Roman Banquet*, 219n39.

18. Roberts, *Life and Death in Pompeii and Herculaneum*, the catalogue for the British Museum exhibition; and the general account of the city in Cooley and Cooley, *Pompeii and Herculaneum: A Sourcebook*, provide the best overall account of the city, the former with strong emphasis on questions of dining.

19. For background, see Joan Burton, "Women's Commensality in the Ancient Greek World," *Greece and Rome* 45 (1998): 143–65. See also Matthew B. Roller, *Dining Posture in Ancient Rome* (Princeton, NJ, 2006), esp. chap. 2, "Dining Women: Posture, Sex, and Status."

20. Fritz Saxl, "Continuity and Variation in the Meaning of Images," in *The Heritage of Images* (Harmondsworth, 1970), 13–26.

21. For a fuller understanding of this genre, see Caitlin E. Barrett, "Recontextualizing Nilotic Scenes: Interactive Landscapes in the Garden of the Casa dell'Efebo, Pompeii," *American Journal of Archaeology* 121 (2017): 293–332.

22. Cicero, *De Senectute* 45, trans. W. A. Falconer, Loeb Classical Library (Cambridge, MA, 1923).

23. See chap. 1, note 3.

24. On the *mensa delphica*, see Roger B. Ulrich, *Roman Woodworking* (New Haven, CT, 2008), 225–27.

25. See Werner Hilgers, *Lateinische Gefässnamen* (Düsseldorf, 1969), 15.

26. For the fullest account of this remarkable monument, see Stephan T.A.M. Mols and Eric M. Moorman, "Ex parvo crevit: Per una lettura iconografica della Tomba di Vestorius Priscus," *Rivista di Studi Pompeiani* 6 (1993–94): 15–52.

27. See Laura Casalis and Antonio Scarfoglio, *Gli argenti di Boscoreale* (Milan, 1988); see also the splendid work of Ann L. Kuttner, *Dynasty and Empire in the Age of Augustus: The Case of the Boscoreale Cups* (Berkeley and Los Angeles, 1995).

28. An admittedly not very scientific survey on my part involved a count of all objects catalogued in Roberts, *Life and Death in Pompeii and Herculaneum*: out of 325 objects, 119 (or 37 percent) were food and drink related.

29. On the supposition that this object (see fig. 2.19) served only to keep food warm as it was transported from kitchen to dining space, one would conclude that its artistic decoration had little exposure time, at least among those who counted for something.

30. Columella, *On Agriculture*, trans. H. B. Ash, Loeb Classical Library (Cambridge MA, 1941), book 1, preface, where he recounts the alternative professions that have been (unfortunately) undertaken in preference to that of farming.

31. Pliny, *Natural History* 18.6–24.

32. For a general understanding of the (nonculinary) philosophical issues between these schools of thought, see A. A. Long, *Hellenistic Philosophy: Stoics, Epicureans, Sceptics* (London, 1986), and R. W. Sharples, *Stoics, Epicureans, Sceptics: An Introduction to Hellenistic Philosophy* (London, 1996).

33. As early as the sixteenth century, the term *epicure*, while generally associated with Epicurus and the notion of pleasure, was already focusing upon specifically gastronomic pleasure; e.g., the *OED*'s earliest citation, from Thomas Becon, *A Fruitfull Treatise of Fasting* (!): "He sate so swelling & sweting at the table thorow yᵉ tomuch deuouringe of pleasaunte meats & whot wines, yᵗ if Apelles had bene present with his pensil he might haue had a ioly paturn to paint a right Epicure."

34. Athenaeus, *The Learned Banqueters*, Loeb Classical Library, trans. D. Olson (Cambridge, MA, 2007), 280a. Athenaeus is discussed extensively in chap. 4 of this volume.

35. *Enchiridion* 15, in O. A. Johnson and A. Reath, *Ethics: Selections from Classical and Contemporary Writers* (Boston, 2004).

36. The fullest account of these, to which I am much indebted, is Katherine M. D. Dunbabin, "*Sic erimus cuncti* . . . The Skeleton in Graeco-Roman Art," *Jahrbuch des deutschen archäologischen Instituts* 101 (1986): 185–255, esp. 224–30. See also Bernard Frischer, *The Sculpted Word: Epicureanism and Philosophical Recruitment in Ancient Greece* (Berkeley and Los Angeles, 1982), esp. chap. 2 ("From Theory to Practice: Quantitative and Qualitative Problems of Epicurean Images").

37. William Michael Short, "'Transmission' Accomplished: Latin's Alimentary Metaphors of Communication," *American Journal of Philology* 134 (2013): 247–75.

38. References are to Quintilian, *The Orator's Education*, trans. Donald A. Russell, Loeb Classical Library (Cambridge, MA, 1922).

39. For a transfer of these animal activities to that of reading, see a discussion of Sir Francis Bacon's account of different kinds of books in chap. 5 of this volume.

40. Virgil, *Georgics*, 2.89–108, trans. H. R. Fairclough, Loeb Classical Library (Cambridge, MA, 1916).

41. On quantity, see Ovid, *Ars amatoria* 1.57 (trans. G. P. Goold, J. H. Mozley, Loeb Classical Library [Cambridge, MA, 1979]), enumerating the multitude of beautiful women in Rome, "as numerous as . . . the grape bunches of Methymna." On quality, Galen, *Method of Medicine* 833K, singles out the wines of Methymna (and its neighbors on the island of Lesbos) as of such quality that they should not be mixed with seawater, a notable accolade, given the habits of wine-drinking in antiquity.

42. Pliny, *Natural History* 14.1. The catalogue of grapes and wines occupies almost the entirety of book 14. Citations of specific quoted passages will be found in the text.

43. On these technical and theoretical issues concerning the differentiations within the taste and contents of wine, see my "Time, Space, and Burgundy," *Yale Review* 92 (2004): 109–21.

44. I refer to the so-called Whorfian Hypothesis (or the Sapir-Whorf Hypothesis) arguing that language determines thought rather than the reverse. A good introduction is to be found in Chris Soyer, "The Linguistic Relativity Hypothesis," in *Stanford Encyclopedia of Philosophy Archive*, Summer 2015 ed., https://plato.stanford.edu/archives/sum2015/entries/relativism /supplement2.html.

45. The work of John H. D'Arms is indispensable in this field. See "Control, Companionship and Clientela: Some Social Functions of the Roman Communal Meal," *Echos du Monde Classique* 28 (1984): 327–48; "The Roman *Convivium* and the Idea of Equality," in *Sympotika: A Symposium on the Symposion*, ed., O. Murray (Oxford, 1990), 308–20; and "Performing Culture: Roman Spectacle and the Banquets of the Powerful," in B. Bergmann and C. Kondoleon, eds., *The Art of Ancient Spectacle* (New Haven, 1999). See also John F. Donahue, "Toward a Typology of Roman Public Feasting," in "Roman Dining," special issue, *American Journal of Philology* 124 (2003): 423–41; and Florence Dupont, "The Grammar of Roman Dining," in *Food: A Culinary History*, ed. Flandrin and Montanari: 113–27. For larger sociological theorizations, see Jack Goody, *Cooking, Cuisine and Class* (Cambridge, UK, 1996), and Claude Grignon, "Commensality and Social Morphology: An Essay of Typology," in *Food, Drink, and Identity: Cooking, Eating, and Drinking in Europe since the Middle Ages*, ed. P. Scholliers (Oxford, 2001).

46. Plutarch, *Life of Julius Caesar* 55.

47. Statius, *Silvae* 4.2.45–65, trans. D. R. Shackleton Bailey, Loeb Classical Library (Cambridge, MA, 2015). It is worth reading every gushing line of Statius's thanksgiving to the emperor, particularly in Shackleton Bailey's grandiloquent translation: "But I, now that for the first time Caesar has granted me novel joy of his sacred banquet, granted me to attain to his imperial board, with what lyre am I to celebrate my answered prayers, what thanks shall I avail to render? Not though Smyrna and Mantua both were to bind holy laurel on my happy head should I find fitting utterance. Meseems I recline with Jupiter among the stars and take immortal liquor proffered by Ilian hand. Barren are the years behind me. This is the first day of my span, here is the threshold of my life." See the sensitive close analysis of the scene in Jean-Michel Hulls, "Lowering One's Standards—On Statius," *Classical Quarterly* 57 (2007): 198–206.

48. The source on this fascinating individual is Suetonius, *Lives of the Caesars*. A sampling of Vitellius's culinary activity: "He divided his feasts into three, sometimes into four a day, breakfast, luncheon, dinner, and a drinking bout; and he was readily able to do justice to all of them through his habit of vomiting. Moreover, he had himself invited to each of these meals by different men on the same day, and the materials for any one of them never cost less than four hundred thousand sesterces. Most notorious of all was the dinner given by his brother to celebrate the emperor's arrival in Rome, at which two thousand of the choicest fishes and seven thousand birds are said to have been served. He himself eclipsed even this at the dedication of a platter, which on account of its enormous size he called the 'Shield of Minerva, Defender of the City.'" Suetonius,

Lives of the Caesars, Vitellius 7.13, trans, J. C. Rolfe, Loeb Classical Library (Cambridge, MA, 1914).

49. Plutarch, *Lives*, Lucullus 40, trans. B. Perrin, Loeb Classical Library (Cambridge, MA, 1914). After narrating a sequence of episodes regarding grandiose feasting, Plutarch offers the famous anecdote: "Once, when he was dining alone, and a modest repast of one course had been prepared for him, he was angry, and summoned the servant who had the matter in charge. The servant said that he did not suppose, since there were no guests, that he wanted anything very costly. 'What sayest thou?' said the master, 'dost thou not know that to-day Lucullus dines with Lucullus?'" (40.2). On this question of the single diner, see the excellent treatment by Susanna Morton Braund, "The Solitary Feast: A Contradiction in Terms?" *Bulletin of the Institute of Classical Studies* 41 (1996): 37–52.

50. Pliny, *Natural History* 8.78. On the whole question of Pliny's anxiety about excess, see the marvelous article by Andrew Wallace-Hadrill, "Pliny the Elder and Man's Unnatural History," *Greece and Rome* 37 (1990): 80–96.

51. The source is Livy, *History of Rome* 24.16, trans. F. G. Moore, Loeb Classical Library (Cambridge, MA, 1943). See the fine analysis in Andrew Feldherr, *Spectacle and Society in Livy's History* (Berkeley and Los Angeles, 1998), 32–34.

52. Pliny the Younger, *Panegyricus* 49, trans. B. Radice, Loeb Classical Library (Cambridge, MA, 1969).

53. Plutarch, *Moralia*, "Table Talk" 1.616, trans. P. A. Clement and H. B. Hoffleit, Loeb Classical Library (Cambridge, MA, 1969).

54. The principal sources in this case are Macrobius, *Saturnalia* 3.13, and Sallust, *Histories* 2.59.

55. Macrobius, *Saturnalia* 3.13.9, trans. R. A. Kaster, Loeb Classical Library (Cambridge, MA, 2011).

56. See Suetonius, *Lives of the Caesars*, Augustus 70.

57. On *silphium*, see Yvonne Gönster, "The Silphion Plant in Cyrenaica: An Indicator for Intercultural Relationships?" in E. Kistler et al., eds., *Sanctuaries and the Power of Consumption* (Wiesbaden, 2015); Henry Koerper and A. L. Kolls, "The Silphium Motif Adorning Ancient Libyan Coins: Marketing a Medicinal Plant," *Economic Botany* 53 (1999): 133–43 (more broadly revealing than its title, or the journal title, may suggest); and Andrew Dalby, *Dangerous Tastes: The Story of Spices* (Berkeley and Los Angeles, 1999), 17–19. Regarding fig. 2.25, there is considerable question about whether the commodity being gathered here is, in fact, silphium. For a discussion of the problem, see Chalmers M. Gemmill, "Silphium," *Bulletin of the History of Medicine* 40 (1966): 295–313.

58. Theophrastus, *Enquiry into Plants* 6.3.

59. Plautus, *Rudens* 6.30–33.

60. See Apicius, 1.10: "Ut unciam laseris toto tempore utaris" (Apicius knew silphium under its alternative name *laser*).

61. Two useful volumes on the subject of garum—both rather more technical than broadly cultural—are Michel Ponsich and Miguel Tarradell, *Garum et industries antiques de salaison dans la Méditerranée occidentale* (Paris, 1965), and Robert I. Curtis, *Garum and Salsamenta: Production and Commerce in Materia Medica* (Leiden, 1991). For a more humanistically oriented discussion, see Robert I. Curtis, "In Defense of Garum," *Classical Journal* 78 (1983): 232–40. The best source remains Pliny. His fullest account is to be found in *Natural History* 31.43–44; see also 9.67 and 30.25

for material on its medical uses and 9.31 for the record of its use by the gastronome Apicius as a sauce for mullet.

62. For the debate on this point, see "The Garum Debate: Was There a Kosher Roman Delicacy at Pompeii?" *Bible History Daily*, 25 Jan. 2012, Biblical Archaeology Society, https://www.biblicalarchaeology.org/daily/archaeology-today/biblical-archaeology-topics/the-garum-debate. Pliny does specifically mention the Jews in relation to garum (31.44), but it's clear that he does not have his facts straight, since he suggests that Jews consume only the kind made from fish *without* scales; the opposite, of course, would be the case. (To make the matter even more intriguing, he lumps the Jewish use of garum with that of consumers who abstain from sex. See the reference in this chap. to Martial's epigram 11.27, in which a different connection is drawn between garum and sexual abstinence.)

63. See Robert I. Curtis, "Umami and the Foods of Classical Antiquity," *American Journal of Clinical Nutrition* 90 (2009): 712S–718S, which quite rightly classes garum among the world of fish sauces. The traditional balsamic vinegar of Modena has nothing to do with fish, but it is credited with definite umami properties. It appears that highly concentrated food substances of very different kinds (for example, tomato paste) share this "fifth taste" property.

64. See the excellent edition and commentary by T. J. Leary, *Martial Book 13: The Xenia* (London, 2016).

65. Pliny, *Natural History* 12.13. On the history of pepper, see Dalby, *Dangerous Tastes*, 88–94, and J. Innes Miller, *The Spice Trade of the Roman Empire* (Oxford, 1969), 80–83.

66. In the reference material to Jacques André, ed., *Apicius: L'art culinaire* (Paris, 2002), the superb French and Latin edition of Apicius, the index of plants gives up on listing page numbers for pepper and merely says *passim*.

67. On Roman satire in the broadest sense, see Michael Coffey, *Roman Satire* (London, 1976); Niall Rudd, *Themes in Roman Satire* (London, 1986); and Susanna Morton Braund, *The Roman Satirists and Their Masks* (Bristol, 1996). Some superb essays, notably those by Emily Gowers, Victoria Rimell, and John Henderson, are included in *The Cambridge Companion to Roman Satire*, ed. K. Freudenburg (Cambridge, UK, 2006).

68. Textual references are to Lucilius, *Remains of Old Latin*, trans. E. H. Warmington, Loeb Classical Library (Cambridge, MA, 2014).

69. On the *Satyricon*, see especially Patrick Walsh, *The Roman Novel* (Cambridge, UK, 1970), and Edward Courtney, *A Companion to Petronius* (Oxford, 2002).

70. On Horace's satires, see Niall Rudd, *The Satires of Horace: A Study* (Cambridge, UK, 1966) and Edward Courtney, "The Two Books of Satires," in *Brill's Companion to Horace*, ed., Hans-Christian Günther (Leiden, 2013). On Juvenal, see the work of Susanna Morton Braund, including *Roman Verse Satire* (Oxford, 1992) and the commentaries in her edition, *Satires: Book 1* (Cambridge, UK, 1996). On all these subjects, once again, Gowers, *Loaded Table* (see note 6, this chap.), is an indispensable guide.

71. See note 45, this chap., for texts on the normative shape of a Roman meal.

72. There is a long debate about the possible connection between satire and *satura*, a kind of sausage. See J. W. Jolliffe,

"Satyre:Satura:ΣΑΤΥΡΟΣ: A Study in Confusion," *Bibliothèque d'Humanisme et Renaissance* 18 (1956): 84–95, and Gowers, *Loaded Table*, 110–115. The best answer to the vexed question of this relationship is that quite possibly there was no etymological connection, but from early times the writers of satire *thought* there was. Which may be even better.

73. Pliny the Younger, *Epistles* 2.6. The letter records how the host of the dinner where this conversation is taking place has three different kinds of wine on the table, not so that guests may take their choice but so that the classes of guests can be differentiated. By contrast, Pliny explains his own mealtime egalitarianism, including even the freedmen, and boasts that he saves money "because my freedmen do not drink the sort of wine I do, but I drink theirs."

74. On this particular poem, along with Braund, *Roman Satirists*, see Mark Morford, "Juvenal's Fifth Satire," *American Journal of Philology* 98 (1977): 219–45; and J. Adamietz, "Untersuchungen zu Juvenal," *Hermes Einzelschrift* 26 (1972), 78–116. See also Juvenal's Satire 11 for a different account of culinary simplicity and pretension. Shakespeare seems to have gotten wind of this multi-menu practice: when Timon stages his seemingly conciliatory but ultimately vengeful banquet, he begins by reassuring the soon-to-be-humiliated guests, "Your diet shall be in all places alike," *Timon of Athens* 3.5.67.

75. Persius, prologue, *Juvenal and Persius*, trans. S. M. Braund (Cambridge, UK, 2004).

76. See the excellent job of sorting this matter out, particularly in regard to Ofellus in *Satires* 2.2, in Deena Berg, "The Mystery Gourmet of Horace *Satires* 2," *Classical Journal* 91 (1995): 141–51. The Loeb Classical Library introduction to 2.4. speaks with the traditional voice of disdain for cuisine: "In the Rome of the Augustan Age cookery seems to have held the place it had occupied in Greece in the degenerate days of the Middle and New Attic Comedy, when, as Mahaffy says, 'it was no mere trade, but a natural gift, a special art, a school of higher philosophy.' This false importance given to the subject is gently satirized by Horace . . . ," H. R. Fairclough, *Horace, Satires, Epistles and Ars Poetica*, Loeb Classical Library (Cambridge, MA, 1929), 183. "Degenerate"? "False importance"? Not in my book.

77. See Lowell Edmunds, "The Latin Invitation-Poem: What Is It? Where Did It Come From?" *American Journal of Philology* 103 (1982): 184–88.

78. Catullus, *Carmina* 13, trans. F. W. Cornish, Loeb Classical Library (Cambridge, MA, 1913).

79. Among the accounts of simple cuisine in Roman literature, mention should be made of the haunting Virgilian (or pseudo-Virgilian) "Moretum," in which a humble solitary peasant prepares his own breakfast. He grinds and sifts the grains, "then straightway on a smooth table he lays it out, pours warm water on it and packs together the now mingled moisture and meal into lumps which he turns over and over till they are hardened and cohere through the action of hand and liquid, from time to time sprinkling salt thereon. And now he lifts the kneaded mixture and with open palms spreads it out into its rounded shape which he marks into quadrants, stamped out at equal intervals. Then he puts it in the hearth . . . and covers it with tiles, heaping up the fire above." Virgil, *Minor Poems*, trans. H. R. Fairclough, Loeb Classical Library (Cambridge, MA, 1969).

80. Horace, *Odes and Epodes*, trans. C. E. Bennett, Loeb Classical Library (London, 1934).

81. For readers who haven't yet reached retirement age: in the late 1970s, the great actor Orson Welles appeared in commercials for Paul Masson wines (hardly *grands crus* in the opinion of experts), intoning, "We will sell no wine before its time."

82. See *Dio's Roman History*, trans. Earnest Cary, Loeb Classical Library (Cambridge, MA, 1914), Epitome of Book 67, 9.

83. On this work and others like it, see Dunbabin, "*Sic erimus cuncti* . . . The Skeleton in Graeco-Roman Art" (see note 36, this chap.).

84. See Petronius, *Satyricon* 71–72.

85. The indispensable treatment of the subject is Lauren Hackworth Petersen, "The Baker, His Tomb, His Wife, and Her Breadbasket: The Monument of Eurysaces in Rome," *Art Bulletin* 85 (2003): 230–57. For more extensive documentation (though less by way of historical analysis), see Paola Ciancio Rossetto, *Il Sepolcro del fornaio Marco Virgilio Eurisace a Porta Maggiore* (Rome, 1973). More recent work on a broader cultural level can be found in Nathaniel B. Jones, "Exemplarity and Encyclopedism at the Tomb of Eurysaces," *Classical Antiquity* 37 (2018): 63–107.

86. See Nicholas Purcell, "Tomb and Suburb," in H. von Hesberg and P. Zanker, eds., *Römische Grabstrassen* (Munich, 1957): 155–82.

87. *De officiis* 1.62. Cicero identifies his source as Terence (*Eunuch*, line 256), though the original is not nearly so disparaging of these professions as Cicero wishes to suggest.

88. See the very revealing essays in Jaś Elsner, ed., *Art and Rhetoric in Roman Culture* (Cambridge, UK, 2014), especially Part 3, "The Funerary."

89. It turns out that Eurysaces is not the only Roman baker memorialized in this way. See Andrew Wilson and Katia Schörle, "A Baker's Funerary Relief from Rome," *Papers of the British School at Rome* 77 (2009): 101–23, for more miniature representations of the baking process in travertine, now located (appropriately!) at Ristorante Romolo in the Via Porta Settiminiano.

90. On the relation between the display of Augustus's deeds and the Ara Pacis monument, see Suna Güven, "Displaying the Res Gestae of Augustus: A Monument of Imperial Image for All Author(s)," *Journal of the Society of Architectural Historians* 57 (1998), 30–45.

91. On the kneading machines, see Ciancio Rossetto, *Il Sepolcro del fornaio*, 33–34, and Nicholas Monteix, "Contextualizing the Operational Sequence: Pompeian Bakeries as a Case Study," in A. Wilson and M. Flohr, eds., *Urban Craftsmen and Traders in the Roman World* (Oxford, 2016), 153–80.

92. See Dunbabin, *Roman Banquet* (note 6, this chap.), chap. 4, "Drinking in the Tomb," and J. P. Alcock, "The Funerary Meal in the Cult of the Dead in Classical Roman Religion," in *The Meal: Proceedings of the Oxford Symposium on Food and Cookery 2001* (Totnes, UK, 2002), 31–41.

93. On the wider diffusion of the topos, see the essays in C. M. Draycott and M. Stamatopoulou, eds., *Dining and Death: Interdisciplinary Perspectives on the "Funerary Banquet" in Ancient Art, Burial and Belief* (Leuven, Belgium, 2016), and Poul Pedersen, "The Totenmahl Tradition in Classical Asia Minor and the Maussolleion at Halikarnassos," in E. Mortensen, B. Poulsen, eds., *Cityscapes and Monuments of Western Asia Minor* (London, 2017).

94. Saxl, "Continuity and Variation" (see note 20, this chap.).

95. On Flavius Agricola, in addition to Dunbabin, *Roman Banquet*, 103–4, see H. Wrede, "Klinenprobleme," *Archäologische Anzeige* 96 (1981): 86–131, and Michael Koortbojian, "Mimesis or Phantasia? Two Representational Modes in Roman Commemorative Art," *Classical Antiquity* 24 (2005): 285–306.

96. *Tibur mihi patria, Agricola sum vocitatus,*
 Flavius idem, ego sum discumbens ut me videtis,
 sic et aput superos annis quibus fata dedere
 animulam colui, nec defuit umqua(m) Lyaeus. . . .
 Amici, qui legitis, moneo, miscete Lyaeum
 et potate procul redimiti tempora flore
 et venereos coitus formosis ne denegate puellis:
 cetera post obitum terra consumit et ignis.

97. See Roller, *Dining Posture*, 42–45 (note 19, this chap.), on this subject; see also Dunbabin, *Roman Banquet*, chap. 4.

98. "Gravest penalties, most absolute excommunication, and terrifying threats by the pontiff."

Chapter Three. Fooding the Bible

1. The standard work on this episode in the life of Mary from a historical and theological perspective is Sister Mary Jerome Kishpaugh, O.P., *The Feast of the Presentation of the Virgin Mary in the Temple: An Historical and Literary Study* (Washington, DC, 1941). See as well D. R. Cartlidge and J. K. Elliott, *Art and the Christian Apocrypha* (London and New York, 2001), 21–46.

2. See the Protoevangelium of James, chaps. 7 and 8, and the Infancy Gospel of Matthew, chap. 4. It's the latter account that seems to have set the stage for the traditional visual representation of the subject: "When [Mary] was put down before the doors of the temple, she went up the fifteen steps so swiftly, that she did not look back at all; nor did she, as children are wont to do, seek for her parents. Whereupon her parents, each of them anxiously seeking for the child, were both alike astonished, until they found her in the temple, and the priests of the temple themselves wondered." The Gospel of Pseudo-Matthew, Gnostic Society Library, http://gnosis.org/library/psudomat.htm.

3. See Kathryn Ann Smith, *Art, Identity, and Devotion in Fourteenth-Century England* (London, 2003), 256–60. From Jacobus de Voragine, *Golden Legend*: "Around the Temple there were fifteen steps, corresponding to the fifteen Gradual Psalms."

4. Among the examples of the subject by Venetian artists, besides that of Titian (see fig. 3.1), are a Cima da Conegliano now in Dresden (see fig. 3.3), a Tintoretto at Madonna dell'Orto in Venice, a Carpaccio now in the Pinacoteca di Brera in Milan, and a Leandro Bassano at the Pia Casa delle Zitelle in Venice.

5. David Rosand's definitive work on this subject is "Titian's Presentation of the Virgin in the Temple and the Scuola della Carità," *Art Bulletin* 58 (1976): 55–84. See also Harold Wethey, *The Paintings of Titian*, vol. 1: *The Religious Paintings* (London, 1969), cat. 87, and William Hood, "The Narrative Mode in Titian's 'Presentation of the Virgin,'" *Memoirs of the American Academy in Rome* 35 (1980): 125–62.

6. See chap. 5, for more on the Last Supper and anachronistic superfluity of details, especially in the work of Paolo Veronese. The definitive recent scholarly work on the general subject of anachronism is Alexander Nagel and Christopher Wood, *The Anachronic Renaissance* (New York, 2010).

7. See Erwin Panofsky, *Problems in Titian* (New York, 1969), 37–40. It is noteworthy that in the pre-iconography days of art history, the egg-selling woman occasioned rapturous viewer responses generally on the grounds that she represented a triumph of naturalistic representation, e.g., "non si può esprimere, quanto sia naturale" (Ridolfi) and "più naturale, che si fosse viva" (Zanetti, both cited in Rosand, "Titian's Presentation of the Virgin," who reports that the old woman "has inspired more comment than any other single figure in the composition"). Rosand also cites John Ruskin's dissent, "The 'celebrated' old woman with her basket of eggs is as dismally ugly and vulgar a filling of spare corner as was ever daubed on a side-screen in a hurry at Drury Lane." A marvelous reflection on the whole range of responses to Titian, both in the nineteenth century and later, is to be found in Francis Haskell's "Explaining Titian's Egg Seller," *New York Review of Books*, 2 July 1970, where the old woman is invoked as a sign of the limits of intricate iconographic reading. Haskell suggests that Titian's source for the egg seller is Carpaccio's *Arrival of the English Ambassadors* (located, as it happens, in the Gallerie dell'Accademia), which does indeed include a seated elderly figure in exactly the same position as the one in the Titian; this lady is not selling anything, however. The dispute between these instances of source hunting encapsulates two different generations of art historiography.

8. On the original functioning of the Scuola Grande, prior to its dissolution and refoundation as the Accademia delle Belle Arti, see Brian Pullan, *Rich and Poor in Renaissance Venice* (Cambridge, MA, 1971), 33–193.

9. *Queering* has become a term of art used to suggest almost any kind of destabilization of what might have been thought a static entity, and not necessarily having to do with sexuality. The original reference, of course, is *queer* as a term of abuse applied to (generally male) homosexuals; it was then annexed as a term of opposition to what has been called "heternormativity." The many current titles using this term (filling nineteen pages on Amazon, seventeen pages on JStor) testify to its utility as a way of suggesting difference.

10. As with many Bible-related subjects, the scholarship on food is not always disentangled from the scholar's own faith. Among the useful texts are Nathan MacDonald, *What Did the Israelites Eat? Diet in Biblical Times* (Grand Rapids, MI, 2008), valuable in itself and including a superb bibliography, and Oded Borowski, *Daily Life in Biblical Times* (Atlanta, 2003). See the essays in N. MacDonald, L. S. Rehmann, and K. Ehrensperger, eds., *Decisive Meals: Table Politics in Biblical Literature* (London, 2012.). Very useful as well are two essays in Flandrin and Montanari, eds., *Food: A Culinary History* (see chap. 2, note 6): Edda Brasciani, "Food and Culture in Ancient Egypt," and Jean Soler, "Biblical Reasons: The Diet of the Ancient Hebrews"; along with another essay by Jean Soler, "The Semiotics of Food in the Bible" in C. Counihan and P. Van Esterik, *Food and Culture: A Reader* (New York and London, 1997), 55–66. Unless otherwise credited, all translations from the Bible are taken from New King James Version, online at https://www.biblestudytools.com/nkjv/.

11. On this general subject, see Dean R. Ulrich, *From Famine to Fullness: The Gospel According to Ruth* (Phillipsburg, NJ, 2007).

12. The principal texts are to be found in Exodus 16 and Numbers 11.

13. On manna, see the very detailed account in Paweł Rytel-Andrianik, *Manna: Bread from Heaven* (New York, 2017).

14. *Webster's Revised Unabridged Dictionary*, s. v. *bdellium*: "An unidentified substance mentioned in the Bible . . . variously taken to be a gum, a precious stone, or perhaps a kind of amber found in Arabia."

15. For an excellent introduction to the study of the parables, see Klyne R. Snodgrass, *Stories with Intent: A Comprehensive Guide to the Parables* (Grand Rapids, MI, 2008).

16. The terminology about signs and its wide applicability can be traced ultimately to Fernand de Saussure, *Course in General Linguistics* (Chicago, 1986). For a good introduction see Daniel Chandler, *Semiotics: The Basics* (New York, 2002).

17. A complex and vexed topic upon which even the most seemingly nonpartisan scholars appear to have some ax to grind. Useful, both in itself and for its references, is the chapter "Jesus and Torah," in André LaCocque, *Jesus the Central Jew* (Atlanta, 2015), 71–130. On the Pauline New Testament side of this, see David Rudolph, *Paul the Jew* (Minneapolis, 2016), 151–81.

18. See chap. 5 of this volume, where this issue is connected with the Eucharist.

19. The words of Jesus regarding this matter are quoted in very parallel ways between Mark 7:15–21 and Matthew 15:11–20. Only in Mark does the categorical phrase about declaring all foods clean appear (more literally: "he cleansed all foods"). See the lucid and learned discussion of the matter in Lawrence M. Wills, "Negotiating the Jewish Heritage of Early Christianity," in M. Aymer et al., *The Gospels and Acts: Fortress Commentary on the Bible Study Edition* (Minneapolis, 2016), 41–44.

20. See Andrew S. Jacobs, *Christ Circumcised: A Study in Early Christian History and Difference* (Philadelphia, 2012), 41–71.

21. See the essays in D. W. H. Arnold and P. Bright, *De doctrina Christiana: A Classic of Western Culture* (Notre Dame, 1995), especially those by David Dawson, R. A. Markus, and Roland J. Teske.

22. The Greek ἐκρατοῦντο or *held fast*, seems to be a unique usage in this phrase; the debate surrounding the passage has to do with the extent of divine intervention in the disciples' failure to recognize Jesus.

23. The classic treatment of this subject is Stephen J. Greenblatt, *Hamlet in Purgatory* (Princeton, NJ, 2013).

24. There are at least three extant versions of this subject by Wtewael, in Berlin, Los Angeles, and St. Petersburg, all very similar, all including considerable quantities of comestibles, mostly fruit but not limited to grapes and therefore beyond simply illustrating inebriation. See A. Lowenthal, "Lot and His Daughters as Moral Dilemma," in *The Age of Rembrandt: Studies in Seventeenth-Century Dutch Painting*, ed. R. Fleischer and S. S. Munshower (State College, PA, 1988), 12–28. Wtewael's composition is by far the most culinary. Few treatments of this subject include anything beyond wine goblets and grapes, but see Hendrik Goltzius in the Rijksmuseum and Jan Massys in Brussels, which add a bit of fruit and bread.

25. Regarding feasts of the gods, the most famous work is that of (as it is now classified) Giovanni Bellini and Titian in the National Gallery of Art in Washington, DC, which was made for the Camerino d'Alabastro of Alfonso d'Este in 1514, where it would be joined by other Bacchanalian scenes by Titian and Dosso Dossi.

The space was not designated for dining, and it is probably no coincidence that this "feast" of the gods is less a feast than a family portrait with a few pieces of fruit and wine accoutrements. For feasts that involve Olympians seated at a banquet table, see chap. 4 of this volume. As for Cleopatra, the passage in Pliny (*Natural History* 9.119–121) is, not surprisingly, part of one of his attacks on excess. His interest is not in the banquet per se but in the whimsical destruction of an extremely valuable jewel. The story has wide currency in the pictorial work of the seventeenth and eighteenth centuries, both north and south of the Alps. There is a lively discussion of whether a pearl could actually dissolve in vinegar. See B. L. Ullman, "Cleopatra's Pearls," *The Classical Journal* 52 (1957): 193–201, and Prudence J. Jones, "Cleopatra's Cocktail," *The Classical World* 103 (2010): 207–20. See Jones, esp. her note 26, for a list of examples in art. We'll return to another pagan banquet—the wedding feast of Cupid and Psyche—in chap. 4 of this volume.

26. The biblical text is to be found at Matthew 14:6–12 and Mark 6:14–29; the brief mention is at Luke 9:9. Even more extensive by way of narration is the version in the *Golden Legend*. See Jacobus de Voragine, *The Golden Legend: Readings on the Saints*, trans. William Granger Ryan (Princeton, NJ, 2012), 518–26. For an excellent account of the pictorial tradition, see Jane C. Long, "Dangerous Women: Observations on the Feast of Herod in Florentine Art of the Early Renaissance," *Renaissance Quarterly* 66 (2013): 1153–1205.

27. The rash promise is classified in the Aarne-Thompson index of folktale motifs as M223; it is a favorite of Chaucer's, turning up in both "The Franklin's Tale" and "The Wife of Bath's Tale."

28. Cited in Evelyn Welch, "Public Magnificence and Private Display: Giovanni Pontano's *De Splendore* (1498) and the Domestic Arts," *Design History* 15 (2002): 211–21.

29. For a very interesting reading, quite distinct from mine, see Barbara Baert, *Revising Salome's Dance in Medieval and Modern Iconology* (Leuven, Belgium, 2016).

30. On the whole question of narrative simultaneity, continuous narration, and the transfer of textual storytelling to pictorial space in the visual arts of the Renaissance, see Lew Andrews, *Story and Space in Renaissance Art: The Rebirth of Continuous Narrative* (Cambridge, UK, 1998). The story of Herod's feast is one of Andrews's most interesting examples (82–83).

31. It's not always possible to determine the emotional meaning of facial expressions among the guests being served at the feast of Herod. In the case of Donatello's relief in the Siena baptistery (see fig. 3.14), the horror is manifest. But see, for instance, the Peter Paul Rubens in the National Gallery of Scotland, where the head on the platter seems to be greeted by a forest of smiles.

32. There are several versions of this composition. The Frankfurt Städelsches Kunstinstitut version is illustrated (see fig. 3.18). The version in the Wadsworth Atheneum in Hartford, CT, does not exhibit quite the same eye contact between the server of dessert and the viewer, nor does that in the Dresden Gemäldegalerie, credited to Lucas Cranach the Younger.

33. The passage is quoted here in the Revised Standard Version, where the specifics of the terminology are clearer than in the New King James. On Mary and Martha, see the useful collection of exegeses in Giles Constable, *Three Studies in Medieval Religious*

and *Social Thought: The Interpretation of Mary and Martha; the Ideal of the Imitation of Christ; the Orders of Society* (Cambridge, UK, 1995). The varieties of theological argument are elucidated in David Grumett, "Action and/or Contemplation? Allegory and Liturgy in the Reception of Luke 10:38–42," *Scottish Journal of Theology* 59 (2006): 125–39.

34. Augustine, Sermon 54, in *Nicene and Post-Nicene Fathers, First Series*, vol. 6, trans. R. G. MacMullen (Buffalo, 1888). Augustine's Sermon 53 also delves into the mysteries of the "one thing" and the "many things."

35. Petrarch, *De vita solitaria* 2.9.

36. A selection of versions of the text, with the relevant adjective italicized:

> Greek NT: Μαριὰμ γὰρ τὴν ἀγαθὴν μερίδα ἐξελέξατο
> Latin Vulgate: Maria *optimam* partem elegit
> Wycliffe NT: Mary hath chosen the *best* part
> King James: Mary hath chosen that *good* part
> New International Version: Mary has chosen what is *better*
> New American Standard Bible: Mary has chosen the *good* part
> English Standard Version: Mary has chosen the *good* portion
> Today's New International Version: Mary has chosen what is *better*
> Luther: Maria hat das *gute* Teil erwählt
> Diodati: Maria ha scelta la *buona* parte
> La Nuova Diodati: Maria ha scelto la parte *migliore*
> Louis Segond: Marie a choisi la *bonne* part
> La Bible du semeur: Marie a choisi la *meilleure* part

37. See Christopher Heuer, *The City Rehearsed: Object, Architecture, and Print in the Worlds of Hans Vredeman de Vries* (New York, 2009), 30.

38. See A. Pigler, *Barockthemen* (Budapest, 1956), 318–21.

39. Augustine, Sermon 179. See *Sermons on the Liturgical Seasons, The Fathers of the Church*, vol. 38, trans. Sister Mary Francis Muldowney (Washington, 1959), 350.

40. Saint Teresa of Avila, *The Interior Castle*, cited in Grumett, "Action and/or Contemplation?" 133.

41. An invaluable guide to this moment in art historical representation is Larry Silver, *Peasant Scenes and Landscapes: The Rise of Pictorial Genres in the Antwerp Art Market* (Philadelphia, 2006). See also Elizabeth Honig, *Painting and the Market in Early Modern Antwerp* (New Haven, 1999); Claudia Goldstein, *Pieter Bruegel and the Culture of the Modern Dinner Party* (London, 2016); Reindert Falkenburg, "Matters of Taste: Pieter Aertsen's Market Scenes, Eating Habits, and Pictorial Rhetoric in the Sixteenth Century," in *The Object as Subject*, ed. A. W. Lowenthal, (Princeton, NJ, 1996), 13–28; and I. Baatsen, B. Blondé, and J. DeGroot, "The Kitchen between Representation and Everyday Experience: The Case of Sixteenth-Century Antwerp," *Netherlands Yearbook for the History of Art* 64 (2014), 162–85. For a parallel case of food market art in Italy, see Sheila McTighe, "Foods and the Body in Italian Genre Paintings, about 1580: Campi, Passarotti, Carracci," *Art Bulletin* 86 (2004): 301–23.

42. On the subject of still life, closely connected in both concept and chronology to these works, see chap. 5 of this volume.

43. Painters "portray Mary and Martha receiving Our Lord to supper, the Lord speaking with Mary and John as a youth talking secretly in a corner with Martha, while Peter drains a tankard.

Or again, at the feast, Martha standing behind by John, with one arm over his shoulders, while with the other she seems to mock at Christ, [who is] unaware of all this." Erasmus, *Christiani Matrimonii Institutio*, quoted in Keith Moxey, "Erasmus and the Iconography of Pieter Aertsen's 'Christ in the House of Martha and Mary' in the Boymans-van Beunigen Museum," *Journal of the Warburg and Courtauld Institutes* 34 (1971): 336. See also Erwin Panofsky, "Erasmus and the Visual Arts," *Journal of the Warburg and Courtauld Institutes* 32 (1969): 200–227, and Daniela Hammer-Tugendhat, "Disturbances in the Art of the Early Modern Netherlands and the Formation of the Subject in Pieter Aertsen's "Christ at the House of Martha and Mary," *American Imago* 57 (2000): 387–402.

44. See Panofsky, "Erasmus and the Visual Arts": "Erasmus's insistence on a clear-cut distinction between the sacred and the profane compelled him to agree with both Luther and the Council of Trent in answering one of the basic artistic questions of his day: was it permissible or even desirable to represent the sacred personages of the Bible and the Acta Sanctorum in the guise of mythological characters? Luther as well as the Council of Trent sternly disapproved of such a fusion. Luther called it a kind of prostitution; and the Council of Trent placed on the Index 'all the allegorical or tropological [i.e., Christianizing] commentaries on or paraphrases of Ovid's *Metamorphoses*,' while raising no objection to the unadulterated paganism of the original" (212). For our purposes, the most interesting aspect of this argument is the sense that early modern theological perspectives, whether of Erasmus or of the Council of Trent, understood the domestication of the gospel narrative—its placement, in this instance, in the kitchen—as equivalent to the domestication of mythological narratives, which was the norm in northern painting of a classical bent.

45. See the definitive work of Charlotte Houghton, "This Was Tomorrow: Pieter Aertsen's *Meat Stall* as Contemporary Art," *Art Bulletin* 86 (2004): 277–300. See also Kenneth M. Craig, "Pieter Aertsen and 'The Meat Stall,'" *Oud Holland* 96 (1982), 1–15.

46. See, for instance, the very valuable methodological and historiographical work of Keith Moxey, "The 'Humanist' Market Scenes of Joachim Beuckelaer: Moralizing Exempla or 'Slices of Life,'" *Koninklijk Museum voor Schone Kunsten Antwerpen Jaarboek* (1976): 109–87; and the same author's "Interpreting Pieter Aertsen: The Problem of 'Hidden Symbolism,'" *Netherlands Yearbook for History of Art* 40 (1989): 29–39.

47. On Velázquez in these respects, see Tanya J. Tiffany, "Visualizing Devotion in Early Modern Seville: Velázquez' 'Christ in the House of Martha and Mary,'" *Sixteenth Century Journal* 36 (2005): 433–53; Emily Umberger, "Velázquez and Naturalism I; Interpreting 'Los Borrachos,'" *RES Anthropology and Aesthetics* 24 (1993), 21–43; and Antonio Domínguez Ortiz, Alfonso E. Pérez Sánchez, and Julián Gállego, *Velázquez* (New York, 1989).

48. See Vicente Carducho, *Un diálogo de la pintura* (Alicante, 2012), pt. 7, fol. 112; see Gállego, "Velázquez," in Ortiz et al., *Velázquez*, 58.

49. See Gállego, "Velázquez," 60: "With her right hand she removes oil from the glazed earthenware bowl, using a wooden spoon so that the white will not stick; with the left, she prepares to break another egg on the edge of the vessel, which rests on a brazier."

50. On these spatial matters, see, for instance, John R. Searle, "'Las

Meninas' and the Paradoxes of Pictorial Representation," *Critical Inquiry* 6 (1980): 477–488.

51. For the yeast, see Matthew 13:33 and Luke 13:20–21; for the mustard seed, see Mark 4:30–32, Matthew 13:31–32, and Luke 13:18–19; for the fig tree, see Mark 13:28–32, Matthew 24:32–36, and Luke 21:29–33.

52. For anyone wishing to follow along, see the complete catalogue of the holdings in all the state musems of Berlin, including the Gemäldegalerie, on the Staatliche Museen zu Berlin website, https://www.smb.museum/forschung/online-kataloge-datenbanken.html.

53. For a general background on this genre, see Karl Schade, *Andachtsbild: Die Geschichte eines kunsthistorischen Begriffs* (Weimar, 1996), and Erwin Panofsky, *Imago Pietatis: Ein Beitrag zur Typengeschichte des Schmerzensmannes und der Maria Mediatrix* (Leipzig, 1927).

54. On these figural equivalences, in addition to the Moxey works mentioned above (note 46), see the operations of symbolic reading and the debate surrounding that process in such work as Peter Hecht, "The Debate on Symbol and Meaning in Dutch Seventeenth-Century Art: An Appeal to Common Sense," *Simiolus* 16 (1986): 173–87; Reindert L. Falkenburg, *The Fruit of Devotion: Mysticism and the Imagery of Love in Flemish Paintings of the Virgin and Child (1450–1550)* (Amsterdam and Philadelphia, 1994); and Mirella Levi-d'Ancona, *The Garden of the Renaissance: Botanical Symbolism in Italian Painting* (Florence, 1977). These issues will arise once again in chap. 5 of this volume, which is explicitly concerned with questions of the symbolic vs. the actual.

55. See *Hall's Dictionary of Signs and Symbols in Art* (New York, 1974), 249, and Patricia Langley, "Why a Pomegranate?" *British Medical Journal* 321 (2000): 1153–54. Note as well the review of F. Muthmann's *Der Granatapfel: Symbol des Lebens in der Alten Welt* in *Journal of Hellenic Studies* 104 (1984): 268–69. The reviewer, Lucilla Burn, points out that the pomegranate may have been a symbol of life, as Muthmann's title suggests, but it was also a symbol of death. It is this sort of either-or signification that turns my thinking to the idea that sometimes a pomegranate is just a pomegranate.

Chapter Four. The Debate over Dinner

1. The Bertrand Russell essay is "Logical Positivism," *Revue Internationale de Philosophie* 4 (1950): 3–19. Roman Jakobson's text can be found in *Translation Studies Reader*, ed. Lawrence Venuti (New York, 2000). It appears that cheese has had quite a career as the philosophical *it* object for what is or isn't real. For instance: Everett W. Hall, "The Extra-Linguistic Reference of Language," *Mind* 52 (1943): 230–246: "If upon looking into the ice-box you say, 'There is no cheese here,' you must have *judged* in the case of each thing observed, 'This is not cheese'"; and Morris Lazerowitz, "The Existence of Universals," *Mind* 55 (1946): 1–24: "A person who behaved appropriately on hearing the request, 'Please pass the cheese to me,' who knew how to make his own wants known in similar words, and could even talk at length on the differences between cheeses, might not know the abstract idea of cheese, although we should say he knew the correct use of 'cheese' in the language."

2. Citation is to *The Rhetoric of Morality and Philosophy: Plato's*

Gorgias *and* Phaedrus," trans. Seth Benardete (Chicago, 1991). See the very helpful introduction and notes in James H. Nichols Jr., *Plato Gorgias* (Ithaca, 1998). A particularly suggestive account of the rhetoric issue can be found in Gabriela Roxana Carone, "Rhetoric in the 'Gorgias,'" *Canadian Journal of Philosophy* 35 (2005): 221–41.

3. See the lucid and valuable introduction to the subject of *techne* in Richard Parry, "Episteme and Techne," *Stanford Encyclopedia of Philosophy* (online, 2014); see also an article with the same title by F.I.G. Rawlins in *Philosophy and Phenomenological Research* 10 (1950): 389–97.

4. I have discussed elsewhere this Socratic procedure in regard to the parallel between poetry and painting as Plato presents it in the *Republic*. See my *Mute Poetry* (chap. 1, note 23), 30–44.

5. See Priscilla Parkhurst Ferguson, "Writing out of the Kitchen: Carême and the Invention of French Cuisine," *Gastronomica* 3 (2003): 40–51, and, on the larger question of systematization, see the same author's "A Cultural Field in the Making," *American Journal of Sociology* 104 (1998): 597–641.

6. The first edition by Julia Child, Simone Beck, and Louisette Bertholle (which I still possess and use in all its sauce-stained glory) was published by Knopf in 1961. A good account of the whole Julia Child publication phenomenon can be found in Megan J. Elias, *Food on the Page: Cookbooks and American Culture* (Philadelphia, 2017), 107–44.

7. See, for instance, Alison K. Ventura and John Worobey, "Early Influences on the Development of Food Preferences," *Current Biology* 23 (2013): 401–8, and Nicola Perullo, *Taste as Experience: The Philosophy and Aesthetics of Food* (New York, 2016), 27–52.

8. For Freud, see "Three Essays on Sexuality," *Standard Edition* 7: 173–206. On Lacan and breast-feeding, see John O'Neill, "Merleau-Ponty and Lacan on Infant Self and Other," *Synthese* 66 (1986): 201–17.

9. See the argument that begins at *Gorgias* 464c.

10. As far as that "one man" is concerned, consider the case of Michelangelo as reported in Donato Giannotti's dialogue *Concerning the Days That Dante Spent in Hell and Purgatory*, in which the artist receives an invitation to lunch among the genial friends with whom he has been engaged in learned conversation. He refuses the invitation, with the explanation, "Every time I see someone who has a certain talent, who demonstrates some liveliness of genius, who knows how to say or do something more dextrously than other people, I am constrained to fall in love with that person, and I give myself up to him, so that I am no longer mine, but entirely his. If, therefore, I were to come to lunch with all of you—being all so blessed with talent and grace—besides what you three have already taken from me, each person who was at lunch would steal away a part of me. So, in the attempt to cheer myself up, I would completely lose my way and myself, so that for many days I would not know in what world I was living." See my "Dante, Michelangelo, and What We Talk about When We Talk about Poetry," in R. Hentschell and K. Lavezzo, eds., *Laureations: Essays in Memory of Richard Helgerson* (Newark, DE, 2012).

11. Citations are from Athenaeus, *The Learned Banqueters*, trans. S. Douglas Olson, Loeb Classical Library (Cambridge, MA, 2006); specific quotations are cited by book and section number in that edition. It is an excellent and lively translation; necessarily, being

in the Loeb series, it does not include the kind of vast annotation that the text warrants. This lack has been addressed (at least for speakers of Italian) by Luciano Canfora and Christian Jacob, *I Deipnosofisti* (Rome, 2001); I am much indebted to this edition's extensive notes. As for scholarship on the book, one can learn much from the essays in D. Braund and J. Wilkins, eds., *Athenaeus and His World* (Exeter, UK, 2000) and from Christian Jacob's excellent brief introductory work, *The Web of Athenaeus* (Washington, DC, 2013), though it is worth noting that in the case of both these texts (especially Jacob's), the fact that the *Learned Banqueters* is all about food does not play quite as central a role as would seem appropriate. Two interesting readings of the work are John Paulas, "How to Read Athenaeus' *Deipnosophists*," *American Journal of Philology* 133 (2012): 403–39, and Robert J. Gorman and Vanessa B. Gorman, *Corrupting Luxury in Ancient Greek Literature* (Ann Arbor, 2014), 146–239.

12. On this narratological feature, see William A. Johnson, "Frame and Philosophical Idea in Plato," *American Journal of Philology* 119 (1998): 577–98, and Stephen Halliwell, "The Theory and Practice of Narrative in Plato," in *Narratology and Interpretation*, ed. J. Grethlein and A. Rengakos (Berlin, 2009), 15–42, https://core .ac.uk/download/pdf/9821978.pdf.

13. Plato, *Symposium* 175B.

14. See chap. 1, note 3.

15. See Geoffrey Arnott, "Athenaeus and the Epitome: Texts, Manuscripts and Early Editions," in Braund and Wilkins, *Athenaeus and His World*, 41–52.

16. On *différance* as deferral and difference, see Jacques Derrida, *Margins of Philosophy* (Chicago, 1982).

17. Athenaeus, *The Learned Banqueters* 14.658e–662e. We'll hear about this range of skills again in this chapter, when we consider two of Athenaeus's Renaissance readers, Michel de Montaigne and Ben Jonson.

18. As far as I can tell, Olson's interesting word choice has gone uncommented upon. But see Stephen E. Kidd, *Nonsense and Meaning in Ancient Greek Comedy* (Cambridge, UK, 2014), 20, where an association is made between ἀλαζονεία and the concept immortalized by Harry Frankfurt in *On Bullshit* (Princeton, NJ, 2005).

19. Athenaeus, 14.658e. There is no other surviving reference to this dish; it is a culinary *hapax legomenon*. See Andrew Dalby, *Food in the Ancient World from A to Z* (London and New York, 2003), 226.

20. The postclassical history of the *Deipnosophistae* is not quite a blank, but it appears to be rather sparse. Natalis Comes translated the work into Latin in 1556. Sir Thomas Browne in the seventeenth century wrote a brief essay entitled "From a Reading of Athenaeus"; Ben Jonson possessed a copy of the *Deipnosophistae* with his signature and annotations, which sold at auction in 2006 for $5,775; and there are clear presences of his work in Erasmus and Montaigne (discussed in this chap.).

21. On the survival of text via Athenaeus, see Heinz-Günther Nesselrath, "Later Greek Comedy in Later Antiquity" in M. Fontaine and A. C. Scafuro, eds., *The Oxford Handbook of Greek and Roman Comedy* (Oxford, 2014), 667–79.

22. See Ruth Scodel, "Tragic Sacrifice and Menandrian Cooking," in *Theater and Society in the Classical World* (Ann Arbor, 1993), 161–76; quote on p. 161. See also the comprehensive work of John

Willkins, *The Boastful Chef: The Discourse of Food in Ancient Greek Comedy* (Oxford, 2000).

23. On the cook as ritual slaughterer/sacrificer or *mageiros*, see Scodel, "Tragic Sacrifice," 162, and A. A. Benton, "The Classical Cook," *Sewanee Review* 2 (1894): 413–24.

24. Citation is to "Of the Vanity of Words," in *The Complete Essays of Montaigne*, trans. Donald Frame (Stanford, CA, 1958): 221–23.

25. The speech appears in Ben Jonson, *The Staple of News*, ed. Anthony Parr (Manchester, UK, 1988), 4.2.18–37, and also in Jonson, *Neptune's Triumph* 61–79, in *Selected Masques*, ed. Stephen Orgel (New Haven, CT, 1970). On the relationship between Jonson and Jones, which is being shadowed here, see D. J. Gordon, "Poet and Architect: The Intellectual Setting of the Quarrel between Ben Jonson and Inigo Jones," *Journal of the Warburg and Courtauld Institutes* 12 (1949): 152–78. Also, see later in this chap. for a similar, but less ironic, encomium by Sperone Speroni.

26. Citations are to Erasmus, *On Copia of Words and Ideas*, trans. Donald B. King and H. David Rix (Milwaukee, 1999).

27. See Anthony Grafton, "Petronius and Neo-Latin Satire: The Reception of the Cena Trimalchionis," *Journal of the Warburg and Courtauld Institutes* 53 (1990): 237–49.

28. Citations in English are to François Rabelais, *Gargantua and Pantagruel*, trans. M. A. Screech (London, 2006). Citations in French are taken from Rabelais, *Oeuvres complètes*, ed. M. Huchon (Paris, 1994). Subsequent citations in the present text are indicated with the particular book—*P*, *G*, *3P*, *4P*—followed by chapter and page in the Screech edition. The indispensable work on food in Rabelais is Michel Jeanneret, *A Feast of Words: Banquets and Table Talk in the Renaissance*, trans. J. Whiteley and E. Hughes (Cambridge, MA, 1991), along with the same author's "Quand la Fable se met à Table: Nourriture et structure narrative dans *Le Quart Livre*," *Poetique* 13 (1983): 163–80. See also Elise-Noël McMahon, "Gargantua, Pantagruel and Renaissance Cooking Tracts: Texts for Consumption," *Neophilologus* 76 (1992): 186–97; Thomas Parker, *Tasting French Terroir* (Berkeley and Los Angeles, 2015), 13–36; and Timothy Tomasik, "Fishes, Fowl, and *La Fleur de toute cuysine*: Gaster and Gastronomy in Rabelais's *Quart Livre*," in *Renaissance Food from Rabelais to Shakespeare*, ed. J. Fitzpatrick (London and New York, 2010), 25–54.

29. The *Fifth Book* was published eleven years after Rabelais's death, and it has not always been viewed as authentic. See the summary of the question, from the perspective of a century ago, in A. Tilley, "The Fifth Book of Rabelais," *Modern Language Review* 22 (1927): 409–20. More recently, the general opinion has swung in the direction of its authenticity but with much debate as to what constitutes an accurate text. But see the following footnote in which Bakhtin seems to assume that the *Fourth Book* was the last part of Rabelais's own composition.

30. See Mikhail Bakhtin, *Rabelais and His World* (Bloomington, IN, 1984). After quoting from *4P*, chap. 67, he writes "These are the last words of the Fourth Book, and actually the last sentence of the entire book that was written by Rabelais' own hand. Here we find twelve synonyms for excrement, from the most vulgar to the most scientific. At the end it is described as a tree, something rare and pleasant. And the tirade concludes with an invitation to drink, which in Rabelaisian imagery means to be in communion with the truth" (175).

31. In this regard, see Bakhtin, *Rabelais and His World*, on the post-Rabelaisian culture: "In the new official culture there prevails a tendency toward the stability and completion of being, toward one single meaning, one single tone of seriousness. The ambivalence of the grotesque can no longer be admitted. The exalted genres of classicism are freed from the influence of the grotesque tradition of laughter" (101).

32. See Screech trans., 831. See also Max Gauna, *The Rabelaisian Mythologies* (Madison, NJ, 1996), 245–52.

33. Philippians 3:19.

34. The narrative, which goes back to Aesop and Saint Paul, then onward to Shakespeare's *Coriolanus* and beyond, has been discussed in A. D. Harvey, *Body Politic: Political Metaphor and Political Violence* (Cambridge, UK, 2007).

35. For a very useful listing of early cookery books, with links to online texts, see Martha Carlin, "Medieval Culinary Texts (500–1500)," Univ. of Wisconsin–Milwaukee website, https://sites.uwm.edu/carlin/medieval-culinary-texts-500-1500/. See also Henry Notaker, *A History of Cookbooks* (Berkeley and Los Angeles, 2017), 7–46, and, a little farther afield but immensely suggestive, Wendy Wall, *Recipes for Thought: Knowledge and Taste in the Early Modern Kitchen* (Philadelphia, 2015). Given the present volume's tendency to elide the period between the ancients and the early moderns, it is worth paying special attention to the work of Christina Normore, *A Feast for the Eyes: Art, Performance and the Late Medieval Banquet* (Chicago, 2015).

36. On Platina, see the magisterial work of Bruno Laurioux, *Gastronomie, humanisme et société à Rome au milieu du XVe siècle: Autour du De honesta voluptate de Platina* (Florence, 2006), and the extensively commentated dual-language edition of Mary Ella Milham, *Platina On Right Pleasure and Good Health* (Tempe, AZ, 1998); citations to Platina's work are to the Milham edition. See also Laurioux, "Athénée, Apicius et Platina: Gourmands et gourmets de l'Antiquité sous le regard des humanistes romains du XVe siècle," in *Pratiques et discours alimentaires en Méditerranée de l'Antiquité à la Renaissance* (Paris, 2008).

37. See Mary Ella Milham, "The Latin Editions of Platina's 'De honesta voluptate,'" *Gutenberg-Jahrbuch* 52 (1977): 57–63; also, by the same author, "The Vernacular Translations of Platina's 'De honesta voluptate,'" *Gutenberg Jahrbuch* 54 (1979): 87–91, as well as "Five French Platinas," *Library* 1.2 (1979): 164–66.

38. The definitive edition of Apicius, in Latin and French, is Jacques André, ed., *Apicius: L'art culinaire* (Paris, 2002). Also useful is Christopher Grocock and Sally Granger, *Apicius: A Critical Edition* (Totnes, UK, 2006). See the work, once again, of Bruno Laurioux, "Cuisiner à l'antique: Apicius au moyen âge," *Médiévales* 24 (1994): 17–38, and of Mary Ella Milham, "Apicius in the Northern Renaissance," *Bibliothèque d'Humanisme et Renaissance* 32 (1970): 433–43.

39. On disambiguating the various individuals named Apicius (or who were given the name Apicius in retrospect), see Dalby, *Food in the Ancient World*, 16–18. In the same vein, see Sally Grainger, "The Myth of Apicius," *Gastronomica* 7 (2007): 71–77.

40. For Apicius's textual history, see the introduction to the Jacques André edition cited above (note 38).

41. See the useful discussion of this recipe in Anne Willan and Mark Cherniavsky, *The Cookbook Library: Four Centuries of the Cooks, Writers, and Recipes That Made the Modern Cook* (Berkeley and Los Angeles, 2012), 6–7.

42. There is a vast literature on the subject of the Renaissance rediscovery *of* and rivalry *with* antiquity, beginning with Jacob Burckhardt's "Revival of Antiquity," in *The Civilization of the Renaissance in Italy* (London, 1995; first published in German in 1860), and proceeding to Robert Weiss, *The Renaissance Discovery of Classical Antiquity* (New York, 1969). Among more recent entries, my own *Unearthing the Past* (see chap. 1, note 18).

43. See the *Oxford Latin Dictionary*, where the definition for *gula* begins with "throat," then proceeds to "regarded as the seat of appetite" and to "regarded as the seat of taste."

44. See Michael Symons, "Epicurus, the Foodies' Philosopher," in *Food and Philosophy: Eat, Think, and Be Merry*, ed. F. Allhoff and D. Monroe (Malden, MA, 2007), 20.

45. Platina is clearly proud of these kinds of borrowings and offers them with some ostentation; as he says in his dedicatory introduction, "I have written about food in imitation of that excellent man, Cato, of Varro, the most learned of all, of Columella, of C. Matius, and of Caelius Apicius." Milham (103) sees in this Platina's wish to associate himself with the humanistic interests of Pomponio Leto.

46. On Maestro Martino's career and recipe work, see Nancy Harmon Jenkins, "Two Ways of Looking at Maestro Martino," *Gastronomica* 7 (2007): 97–103.

47. See *Ars poetica*, 48–69. Horace's lines in which he compares words to leaves, which are born, grow old, and die, became a highly significant trope in the reception of antiquity. On which see Basil Dufallo, "Words Born and Made: Horace's Defense of Neologisms and the Cultural Poetics of Latin," *Arethusa* 38 (2005): 89–101.

48. The story of Tereus, Procne, and Philomela, with its narrative of rape, murder, and cannibalism, appears in Ovid, *Metamorphoses* 6.401–674.

49. For the decoding and describing of Platina's circle of friends, see the enormously valuable material in Milham, 81–91. See also the vast collection of information in Mario Cosenza, *Biographical and Bibliographical Dictionary of the Italian Humanists and of the World of Classical Scholarship in Italy, 1300–1800*, 6 vols. (Boston, 1962–67).

50. On this episode, see Milham, 9–31. See also the very exhaustive account in Richard J. Palermino, "The Roman Academy, the Catacombs and the Conspiracy of 1468," *Archivum Historiae Pontificiae* 18 (1980): 117–55.

51. Cited from Milham, 15–16. The dating of the letter as between Platina's two episodes of imprisonment is subject to debate.

52. On this moment of historical change, see Anthony F. D'Elia, *A Sudden Terror: The Plot to Murder the Pope in Renaissance Rome* (Cambridge, MA, 2009).

53. An angry exchange between Pomponio Leto and Callimachus (*né* Filippo Buonaccorsi) involves mutual accusations in regard to generating the conspiracy and/or betraying it. See the materials in Michael Tworek, "Filippo Buonaccorsi," *Repertorium Pomponianum*, http://www.repertoriumpomponianum.it/pomponiani/buonaccorsi_filippo.htm.

54. I am thinking here not so much of the dialogues (like the *Phaedo* and the *Apology*) that actually treat the last days of Socrates as of works, such as the *Phaedrus* and the *Symposium*, written

well after his death but in which he is brought onstage almost as though he is still alive—though there is a lot of play on that question of *almost*.

55. On these historical developments, see the fine work of Ken Albala, *Eating Right in the Renaissance* (Berkeley and Los Angeles, 2002) and *The Banquet: Dining in the Great Courts of Renaissance Europe* (Urbana, 2007). See as well Alberto Cappati and Massimo Montanari, *Italian Cuisine: A Cultural History* (New York, 2003). See also the very helpful reference materials in Scappi (see following note).

56. The superb English edition with annotations is Terence Scully, *The* Opera *of Bartolomeo Scappi* (Toronto, 2008). See as well Deborah L. Krohn, *Food and Knowledge in Renaissance Italy: Bartolomeo Scappi's Paper Kitchens* (London and New York, 2015).

57. See *La vita e le opere di Sperone Speroni* (Empoli, Italy, 1920). The translation of the phrases is mine.

58. Leading in this conversation is Stephen Greenblatt's award-winning *The Swerve: How the World Became Modern* (New York, 2012), which combines a page-turning account of coming upon a Lucretius manuscript with a historical argument about the relation between the rediscovery of formerly anathematized Epicurean doctrines, on the one hand, and the eponymous "swerve" from the medieval to the modern on the other. For other significant accounts of the phenomenon, see Alison Brown, "Lucretius and the Epicureans in the Social and Political Context of Renaissance Florence," *I Tatti Studies in the Renaissance* 9 (2001): 11–62; Gerard Passannante, *The Lucretian Renaissance: Philology and the Afterlife of Tradition* (Chicago, 2011); and Ada Palmer, *Reading Lucretius in the Renaissance* (Cambridge, MA, 2014).

59. For the text in both Latin and English, see Lorenzo Valla, *On Pleasure: De Voluptate*, trans. A. K. Hieatt and Maristella Lorch (New York, 1979).

60. On the developments of the text, see Maristella de Panizza Lorch, "*Voluptas, Molle Quoddam et Non Invidiosum Nomen*: Lorenzo Valla's Defense of *Voluptas* in the Preface to His *De Voluptate*," in *Philosophy and Humanism: Essays in Honor of Paul Oskar Kristeller*, ed. E. P. Mahoney (Leiden, 1976), 214–28.

61. See, for instance, Charles Trinkaus's very interesting review in *Annali d'Italianistica* 5 (1987): 278–80, of Lorch's "*Voluptas . . .*" (cited in previous note), in which he notes that over the years Lorch had moved away from a wholehearted embrace of the radical early parts of the work to a more serious consideration of the less unorthodox later books.

62. See chap. 2 of this volume for a discussion of this matter with respect to Epicureanism in ancient Rome.

63. On this general subject, see Notaker, *A History of Cookbooks*, 201–12.

64. See the magisterial treatment by Wolfgang Liebenwein, "Honesta Voluptas: Zur Archäologie des Genießens" in *Hülle und Fülle*: Festschrift für Tilmann Buddensieg (Alfter, Germany, 1993), 337–56. In a more specifically culinary vein, see the fundamental work of Ken Albala, *Eating Right in the Renaissance* (Berkeley and Los Angeles, 2002).

65. All citations to the *Colloquies* are to *The Colloquies of Erasmus*, trans. Craig R. Thompson (Toronto, 1997).

66. Pomponius, in Cicero's *De finibus* (5.1), locates the favored classroom space of Epicurus in a garden; even in that passage, there seems to be some embarrassment when Pomponius admits to having been a disciple of Epicurus.

67. Both the "Table Talk" and the *Attic Nights* are cited on dozens of occasions in the *Apophthegmata* and the *Adages*. On Erasmus's relation to Aulus Gellius and to Plutarch, see Egbertus van Gulik, *Erasmus and His Books*, trans. J. G. Grayson (Toronto, 2019), 339, 380.

68. See Deno J. Geanakoplos, "Erasmus and the Aldine Academy of Venice," *Greek, Roman, and Byzantine Studies* 3 (1960): 107–34.

69. The Aldine edition of the *Deipnosophistae* was published in 1514. Erasmus's annotated copy is located in the Bodleian Library, Oxford. In the Toronto edition of the *Adages*, there are over 500 citations of Athenaeus.

70. See "The Profane Feast," note 16 (Toronto ed.), for an extensive account of Erasmus's references to the wines of Beaune: "He could not get along without it; most foods he could not eat, other wines he could not drink; if in his old age he was deprived of Beaune he felt his health was immediately imperilled."

71. See, for instance, the essays in J. C. Olin, J. D. Smart, and R. E. McNally, *Luther, Erasmus, and the Reformation: A Catholic-Protestant Reappraisal* (New York, 1969).

72. See discussion in chap. 3 of this volume.

73. See the introduction to the "Usefulness of the Colloquies," *Colloquies* (Toronto ed.), 1095–97.

74. It should be noted that "Erasmius" here is not a misprint but rather an authorial alteration made between the 1518 edition and those of 1522. This voice was thereby not only detached from the author but also assigned to his godson, Erasmius Froben.

75. On the history and theology of the relation between fasting and the nonconsumption of animal flesh, see *Catholic Encyclopedia*, s.v. *fast, abstinence*.

76. See *Colloquies*, 713, and note on Erasmus's identity as Eros.

77. This longest of all the *Colloquies* is entitled "A Fish Diet." *Colloquies*, 675–762.

78. "A Fish Diet," *Colloquies*, 715–17.

79. For Alberti, the *historia*, and the triclinium, see chap. 1 of this volume.

80. See note 55, this chap., for bibliography on princely dining.

81. On Charles V's visit, see William Eisler, "The Impact of the Emperor Charles V upon the Italian Visual Culture 1529–1533," *Arte Lombarda* N.S. 65 (1983): 93–110.

82. See Giacinto Romano, ed., *Cronaca del soggiorno di Carlo V in Italia* (Milan, 1892).

83. There has been a considerable literature on both the architecture and the painting in the Palazzo del Te. On the aspects that most concern us, in the Sala di Amore e Psiche, see especially Frederick Hartt, "Gonzaga Symbols in the Palazzo del Te," *Journal of the Warburg and Courtauld Institutes* 13 (1950): 151–88; Egon Verheyen, *The Palazzo del Te in Mantua: Images of Love and Politics* (Baltimore, MD, 1977); and Maria F. Maurer, "A Love that Burns: Eroticism, Torment, and Identity at the Palazzo Te," *Renaissance Studies* 30 (2015): 370–88. On broader questions about visual style in the Palazzo del Te, see Sally Hickson, "More than Meets the Eye: Giulio Romano, Federico II Gonzaga and the Triumph of Trompe-l'oeil at the Palazzo del Te in Mantua," in *Disguise, Deception, Trompe-l'oeil: Interdisciplinary Perspectives*, ed. L. Boldt-Irons, C. Federici, and E. Virgulti (New York, 2009), 41–60. On

the subject of the Gonzaga banqueting service, see Valerie Taylor, "Banquet Plate and Renaissance Culture: A Day in the Life," *Renaissance Studies* 19 (2005): 621–33.

84. On the early Latin origins of the contrast, see R. J. Baker, "'Well Begun, Half Done': 'Otium' at Catullus 51 and Ennius 'Iphigenia,'" *Mnemosyne* 42 (1989): 492–97. See the comprehensive account of the subject in a two-part article by Brian Vickers, "Leisure and Idleness in the Renaissance: The Ambivalence of Otium," *Renaissance Studies* 4 (1990), no. 1: 1–37 and no. 2: 107–54.

85. For the citations in several of Cicero's works, see Arina Bragova, "The Concept *cum dignitate otium* in Cicero's Writings," *Studia Antiqua et Archaeologica* 22 (2016): 45–49.

86. Citation is to Ariosto, *Orlando Furioso* 7.40, ed. E. Sanguineti (Milan, 1974); translation from William Stuart Rose (Washington, 1907).

87. Machiavelli, *Istorie fiorentine* 5.1., ed. P. Carli (Florence, 1927); translation from *History of Florence and the Affairs of Italy*, trans. H. Rennert (Washington, 1901), 204.

88. See, for instance, M. C. O'Brien, *Apuleius' Debt to Plato in the* Metamorphoses (New York, 2002); Carl Schlam, "Platonica in the *Metamorphoses* of Apuleius," *TAPA* 101 (1970): 477–87; and Walter Englert, "Only Halfway to Happiness: A Platonic Reading of Apuleius' *Golden Ass*," in *Philosophy and the Roman Novel*, ed. M. P. Futre Pinheiro and S. Montiglio (Groningen, 2015), 81–92. Regarding the visual tradition, in addition to the works mentioned above, in note 83, useful background on the Apuleian original and its Renaissance depiction can be found in Luisa Vertova, "Cupid and Psyche in Renaissance Painting before Raphael," *Journal of the Warburg and Courtauld Institutes* 42 (1979): 104–21.

89. The original, as described here, is to be found in Apuleius, *The Golden Ass*, books 4–6.

90. See Eisler, "Impact of the Emperor Charles V," on Charles's visit.

91. On the Farnesina decoration, see John Shearman, "Die Loggia der Psyche in der Villa Farnesina und die Probleme der letzten Phase von Raffaels graphischem Stil," *Jahrbuch der Kunsthistorischen Sammlungen zu Wien* 24 (1964): 59–100, and Hubertus Günther, "Amor und Psyche. Raffaels Freskenzyklus in der Gartenloggia der Villa des Agostino Chigi und die Fabel von Amor und Psyche in der Malerei der italienischen Renaissance," *Artibus et Historiae* 22 (2001): 149–66. It's worth noting that Giulio Romano is not the only common term between the two Cupid and Psyche banqueting spaces. Isabella d'Este, the great benefactress and lover of the antique, was not only the mother of the Palazzo del Te's Federico Gonzaga but connected via both financial and artistic relations to Agostino Chigi, on which see Roberto Bartallini, "Due episodi del mecenatismo di Agostino Chigi e le antichità della Farnesina," *Prospettiva* 67 (1992): 17–38.

92. On this remarkable figure, see the magisterial work of Ingrid Rowland, "Render unto Caesar the Things Which are Caesar's: Humanism and the Arts in the Patronage of Agostino Chigi," *Renaissance Quarterly* 39 (1986): 673–730.

93. This anecdote, whose ultimate source is elusive, can be found in Ludwig Pastor, *The History of the Popes from the Close of the Middle Ages* (London, 1908), 8:117.

94. Hartt, "Gonzaga Symbols."

95. Compare the banquet episode in the *Hypnerotomachia Poliphili*, where as much attention is paid to the removal of each course in the meal as to its arrival. See Francesco Colonna, *The Strife of Love in a Dream*, trans. Joscelyn Godwin (London, 1999), 106–10.

96. Cited in James R. Lindow, *The Renaissance Palace in Florence: Magnificence and Splendour in Fifteenth-Century Florence* (London, 2007), 140. For the original text, see Giovanni Pontano, *I Libri delle virtù sociali*, ed. F. Tateo (Rome, 1999), 232. See the excellent treatment of Pontano in Evelyn Welch, "Public Magnificence and Private Display: Giovanni Pontano's *De splendore* (1498) and the Domestic Arts," *Journal of Design History* 15 (2002): 211–21.

97. See chap. 1 of this volume.

98. The indispensable informant on these botanical matters is Giulia Caneva, *Il Mondo di Cerere nella Loggia di Psiche* (Rome, 1992). See as well Jules Janick, "Fruits and Nuts of the Villa Farnesina," *Arnoldia* 70 (2012): 20–27.

99. Giorgio Vasari, *Lives of the Painters, Sculptors, and Architects*, trans. Gaston duC. deVere (New York, 1996), 2:493.

100. See J. Janick and G. Caneva, "The First Images of Maize in Europe," *Maydica* 50 (2005): 71–80.

101. Too vast an issue for treatment in these pages. For an early but eloquent and prescient view of this matter, see the seminal work of E. H. Carr, *What Is History?* (Cambridge, UK, 1961), 144: "It is only today that it has become possible for the first time even to imagine a whole world consisting of peoples who have in the fullest sense entered into history and become the concern, no longer of the colonial administrator or of the anthropologist, but of the historian." Clearly, the Annales school, microhistory, Marxist history, and indeed the kind of cultural history attempted by the present volume have all responded. The closest to inclusivity that could be said to be taking place in these pages is the fact that eating is universal.

102. The unsurpassed account of the bubonic plague and its relation to the arts remains Millard Meiss, *Painting in Florence and Siena after the Black Death* (Princeton, NJ, 1951). For the data on sixteenth-century England, see W. G. Hoskins, "Harvest Fluctuations and English Economic History, 1480–1619," *Agricultural History Review* 12 (1964): 28–46. See also Guido Alani, *Calamities and the Economy in Renaissance Italy* (Basingstoke, UK, 2013). The great innovative piece of historiography on this kind of suffering is Piero Camporesi, *Bread of Dreams: Food and Fantasy in Early Modern Europe* (Chicago, 1996).

103. See the introduction to the First Day of the *Decameron*, with its graphic account of the plague in Florence. Once the ten characters have removed themselves from the city and begun their project of elegant living and tale-telling, there are regular references to the laying of tables for their evening feasts but scarcely any menu information.

104. See the definitive work of Herman Pleij, *Dreaming of Cockaigne: Medieval Fantasies of the Perfect Life* (New York, 1997).

105. Quoted from Pleij's translation of Dutch rhyming texts. See his *Dreaming of Cockaigne*, 34.

106. See Ross H. Frank, "An Interpretation of *Land of Cockaigne* (1567) by Pieter Breugel the Elder," *Sixteenth Century Journal* 22 (1991), 299–329.

107. Reading Columbus (as well as the literature around him) for the food is a lively and varied experience. Citations are to *The Four*

Voyages of Christopher Columbus, trans. J. M. Cohen (New York, 1969).

108. On spices, see the work of Andrew Dalby, *Dangerous Tastes: The Story of Spices* (Berkeley and Los Angeles, 1999), and "Christopher Columbus, Gonzalo Pizarro, and the Search for Cinnamon," *Gastronomica* 1 (2001): 40–49.

109. On this process, see Aaron M. Shatzman, *The Old World, the New World, and the Creation of the Modern World* (London and New York, 2013), esp. chap. 3, "Spain Ascendant: Conquest and Colonization."

110. See Robert Applebaum and John Wood Sweet, eds., *Envisioning an English Empire: Jamestown and the Making of the North Atlantic World* (Philadelphia, 2005), esp. Applebaum, "Hunger in Early Virginia: Indians and English Facing Off over Excess, Want, and Need." See also Michael A. Lacombe, "'A continuall and dayly Table for Gentlemen of fashion': Humanism, Food and Authority at Jamestown, 1607–1609," *American Historical Review* 115 (2010): 669–87, and Mary C. Fuller, *Voyages in Print: English Travel to America 1576–1624* (Cambridge, UK, 1995), 85–140. On a closely related subject, see as well Rachel B. Herrman, "The 'tragicall history': Cannibalism and Abundance in Colonial Jamestown," *William and Mary Quarterly* 68 (2011): 47–74.

111. See Louis B. Wright, ed., *A Voyage to Virginia in 1609* (Charlottesville, 1964), and William Strachey, Gent., *The Historie of Travaile into Virginia Britannia* (London, 1899; repr., Cambridge, UK, 2015). See also Alden T. Vaughan, "William Strachey's 'True Repertory' and Shakespeare: A Closer Look at the Evidence," *Shakespeare Quarterly* 59 (2008): 245–73.

112. Quoted in Philip L. Barbour, ed., *The Jamestown Voyages under the First Charter, 1606–1609* (London, 1969), 2:225.

113. There are two rather different biographical accounts of this intriguing individual. S. G. Culliford, *William Strachey 1572–1621* (Charlottesville, VA, 1965), covers the whole range of his life, whereas Hobson Woodward, *A Brave Vessel: The True Tale of the Castaways Who Rescued Jamestown and Inspired Shakespeare's* The Tempest (New York, 2009) concentrates on the theater and the Jamestown adventures.

114. Citations are from L. B. Wright, ed., *A Voyage to Virginia in 1609* (Charlottesville, 2013).

115. The dating of the Strachey document and of the composition of Shakespeare's play remain somewhat uncertain. For which see Tom Reedy, "Dating William Strachey's 'A True Repertory of the Wracke and Redemption of Sir Thomas Gates': A Comparative Textual Study," *Review of English Studies* 61 (2010): 529–52.

116. Citations are to *The Tempest*, ed. Stephen Orgel, Oxford Shakespeare (Oxford, 1987).

117. See notes in *The Tempest*, ed. Orgel.

118. See Peter C. Mancall, *Deadly Medicine: Indians and Alcohol in Early America* (Ithaca, 1995).

119. *Macbeth* 2.3.27–30: "Lechery, sir, it provokes, and unprovokes; it provokes the desire, but it takes away the performance: therefore, much drink may be said to be an equivocator with lechery: it makes him, and it mars him; it sets him on, and it takes him off."

120. See Kenji Go, "Montaigne's 'Cannibals' and 'The Tempest' Revisited," *Studies in Philology* 109 (2012): 455–73. On the broader question of the relations among Montaigne, Shakespeare, and the translator John Florio, see Stephen Greenblatt's introduction to his

and Peter Platt's *Shakespeare's Montaigne: The Florio Translation of the Essays* (New York, 2014).

121. See Virgil, *Aeneid*, 3.219–257. There is a distinguished critical literature on the relation between the *Aeneid* and *The Tempest*. See Donna B. Hamilton, *Virgil and* The Tempest*: The Politics of Imitation* (Columbus, OH, 1990); Heather James, *Shakespeare's Troy* (Cambridge, UK, 1997), 189–220; and David Scott Wilson-Nakamura, "Virgilian Models of Colonization in Shakespeare's *Tempest*," *ELH* 70 (2003): 709–37.

122. The classic statement on Shakespeare's jagged relation to the rules of ancient drama is Herder's. See Johann Gottfried Herder, "Shakespeare," in *Selected Writings on Aesthetics* (Princeton, 2006), 291–307. *The Comedy of Errors*, Shakespeare's most faithful attempt to imitate classical drama, also observes something like a unity of time, which is essential to the workings of its plot as farce.

Chapter Five. Mimesis, Metaphor, Embodiment

1. See, for instance, Salima Ikram, "A Re-Analysis of Part of Prince Amenemhat Q's Eternal Menu," *Journal of the American Research Center in Egypt* 48 (2012): 119–35.

2. See Melinda Hartwig et al., *The Tomb Chapel of Menna (TT69): The Art, Culture, and Science of Painting in an Egyptian Tomb* (Cairo and New York, 2013).

3. Vitruvius, *Ten Books on Architecture*, trans. Ingrid D. Rowland (Cambridge, UK, 1999), 82–83.

4. On *xenia*, see Jean-Michel Croisille, *Natures mortes dans la Rome antique* (Paris, 2015); Bernadette Cabouret, "*Xenia* ou cadeaux alimentaires dans l'Antiquité tardive," in *Dieu(x) et hommes* (Rouen, 2005), 369–388; and the collection entitled *Xenia: Recherches franco-tunisienne sur la mosaïque de l'Afrique antique* (Rome, 1990). My thoughts on the subject are especially influenced by Norman Bryson, *Looking at the Overlooked: Four Essays on Still-Life Painting* (London, 1990), 17–58.

5. In a volume such as the present one, it is worth pointing out that the *Odyssey* may well be the most food-and-wine-obsessed literary work of all time and that the occasion of travel to remote places and reception there by friends or strangers, which is the central activity in the poem (as it is of xenia), locates the business of dining as perhaps the most central human activity. Telemachus reaching the court of Nestor, Alcinous receiving Odysseus, Odysseus being received back home by his faithful swineherd Eumaeus, Telemachus returning home to Ithaca: every one of these is celebrated with a detailed account of what was consumed and sometimes includes quite specific information on how it was prepared (see, for instance, the roast lamb recipe at 14.79–90). But it's not only on the occasion of voyages. The hated suitors are hated most of all for the food and wine they consume in Odysseus's palace. And, perhaps most interesting of all, the whole episode of the Cyclops is framed around cheese and wine: the Cyclops, though culinarily primitive to the point of cannibalism, nevertheless proves to be an expert *fromager* and *affineur*, whose choice products Odysseus and his men steal; and as far as wine is concerned, the Cyclops is, in the great tradition ascribed to savages, unaccustomed to drinking alcohol and therefore catastrophically subject to its effects.

6. See the superbly annotated edition of *The Xenia Book 13*, ed., T. J. Leary (London, 2001). See also Sarah Blake, "Martial's Natural History: The 'Xenia' and 'Apophoreta' and Pliny's Encyclopedia," *Arethusa* 44 (2011): 353–77, and Sarah Culpepper Stroup, "Invaluable Collections: The Illusion of Poetic Presence in Martial's *Xenia* and *Apophoreta*" in R. R. Nauta, H-J. van Dam, and J.J.L. Smolenaars, eds., *Flavian Poetry* (Leiden, 2006), 315–28.

7. Book 14 of Martial's *Epigrams*, the *Apophoreta*, is also closely connected to the business of feasting; it recounts gifts (not necessarily culinary) that are brought to feasts.

8. For many well-reproduced examples, beyond those shown here, see Croisille, *Natures mortes*; see also Katherine Dunbabin, *Mosaics of the Greek and Roman World* (Cambridge, UK, 1999).

9. On these matters of style, see Bryson, *Looking at the Overlooked*; see also Stephen Bann, *The True Vine: Visual Representation and the Western Tradition* (Cambridge, UK, 1989). See as well the very illuminating review of Bann and Bryson by Lesley Stevenson, "Fruits of Illusion," *Oxford Art Journal* 16 (1993): 81–85.

10. On the *Imagines*, in addition to Bann, *The True Vine*, and Bryson, *Looking at the Overlooked*, see the work of Michael Squire, including "Ecphrasis: Visual and Verbal Interactions in Ancient Greek and Latin Literature," *Oxford Handbooks Online* http://www.oxfordhandbooks.com/view/10.1093/oxfordhb /9780199935390.001.0001/oxfordhb-9780199935390-e-58. See also Simon Goldhill, "The Naive and the Knowing Eye: Ecphrasis and the Culture of Viewing in the Hellenistic World," in *Art and Text in Ancient Greek Culture*, ed. S. Goldhill and R. Osborne (Cambridge, UK, 1994), 197–222, and Norman Bryson, "Philostratus and the Imaginary Museum," in the same volume, 255–82.

11. Citations are to Philostratus the Elder et al., *Imagines*, trans. Arthur Fairbanks, Loeb Classical Library (Cambridge, MA, 1931).

12. The anecdote is narrated in Pliny, *Natural History*, 35.65.

13. See my "Praxiteles' *Aphrodite* and the Love of Art," in *The Forms of Renaissance Thought*, ed. L. Barkan, S. Keilen, and B. Cormack (London, 2008).

14. Two excellent overviews of the genre are Norbert Schneider, *Still Life Painting in the Early Modern Period* (Cologne, 2003), and Sybille Ebert-Schifferer, *Still Life: A History* (New York, 1999).

15. The case was the 1964 decision in *Jacobellis v. Ohio* concerning pornography, the object in question was Louis Malle's film *Les Amants*, and Justice Stewart, invoking "I know it when I see it," was declaring that Malle's film wasn't it.

16. Charles Sterling, *Still Life Painting from Antiquity to the Twentieth Century* (New York, 1981), 25.

17. For the Rijksmuseum, see "Search in Rijksstudio," s.v. "Still Life," https://www.rijksmuseum.nl/en/search?q=%22still%20life %22&v=&s=relevance&ii=0&p=1; for the Louvre, see "Visitor Trails, Still Life Painting, Northern Europe," https://www.louvre .fr/en/routes/still-life-painting.

18. This simple yet decisive fact had eluded me until my colleague Carolina Mangone pointed it out.

19. Considering the extraordinary quality of Peeters's work in general, it is surprising that there is still relatively little literature devoted to her. A notable exception, though it is only partly about Peeters, is Celeste Brusati, "Stilled Lives: Self-Portraiture and Self-Reflection in Seventeenth-Century Netherlandish Still-Life Painting," *Simiolus* 20 (1990–91): 168–82. The lone monograph devoted to the artist is Pamela Decoteau, *Clara Peeters 1594–ca. 1640* (Lingen, 1992). There has recently been a show of her work at the Prado; see the catalogue, Alejandro Vergara, *The Art of Clara Peeters* (Antwerp and Madrid, 2016). Of particular interest for the present argument and going far beyond the single case of Peeters, is Quentin Buvelot, ed., *Slow Food: Dutch and Flemish Meal Still Lifes 1600–1640*, exhibition catalogue (The Hague, 2017), perhaps the only work on still life that recognizes the centrality of food.

20. On this particular foodstuff—and harking back to the discussion between the two twentieth-century philosophers in chap. 4 of this volume—see Josua Bruyn, "Dutch Cheese: A Problem of Interpretation," *Simiolus* 24 (1996): 201–8.

21. See, for example Aarts Conserven, which produces many types of preserved cherries for domestic and export markets. In his letters from 1654, written in New Netherland, Nicasius de Sille praises the "sweet and sour cherries in abundance," which are almost like those at home. See A. J. F. van Laer, "Letters of Nicasius de Sille, 1654," *Quarterly Journal of the New York State Historical Association* 1 (1920): 98–108.

22. For the early history, see Clifford A. Wright, "Did the Ancients Know the Artichoke?" *Gastronomica* 9 (2009): 21–28. For later appearances in the kitchen and in art, see Paul Freedman, ed., *Food: The History of Taste* (Berkeley and Los Angeles, 2007), 197–99, including the reproduction of a painting (c. 1635) by Abraham Bosse depicting "taste," in which the defining object on the dining table is a globe artichoke. See also Gillian Riley, *Food in Art* (London, 2015), 83, 207–8. Clearly, it was a luxury item for Isabella d'Este at the beginning of the sixteenth century. It then comes to be associated with Catherine de Médicis and the story that she brought Italian cooking to France a few decades later. That origin story is widely discredited, but the idea that the artichoke entered France via this route may have some validity.

23. See Inês Amorim, "Salt Trade in Europe and the Development of Salt Fleets," in *The Sea in History—The Early Modern World*, ed. C. Buchet and G. Le Bouëdec (London, 2017), 244–53. The issue with the value of salt in the Low Countries is not so much its rarity as a natural resource as the fact that the cuisine of preservation (especially of fish) is so central a part of the diet.

24. See Quentin Buvelot, "Slow Food: On the Rise and Early Development of Dutch and Flemish Meal Still Lifes," in *Slow Food*, ed. Buvelot, 13–32.

25. In addition to several paintings of Claesz, see a couple of works by Willem Claesz Heda, including *Still Life with Oysters, a Silver Tazza, and Glassware* at the Metropolitan Museum of Art in New York and *Still Life with Oysters, a Rummer, a Lemon, and a Silver Bowl* at the Museum Boijmans van Beuningen in Rotterdam.

26. On these valuables and others, such as appear in these paintings, see the fine work of Julie Berger Hochstrasser, *Still Life and Trade in the Dutch Golden Age* (New Haven, CT, 2007).

27. Note that Ben Jonson, in his poetic equation of Inigo Jones with a cook, declares that he "raiseth ramparts of immortal crust" (see chap. 4 of this volume on this bit of verse); clearly this particular food item inspired military thoughts.

28. See Buvelot, "Slow Food," 83.

29. I have also offered this kind of reading because I was inspired

by an intellectually life-changing conference organized at New York University's Institute of Fine Arts by Jaś Elsner, entitled "Art History and the Art of Description," where I had the honor of sharing the stage with Svetlana Alpers, Thomas Crow, and Michael Fried.

30. The term goes back to Roland Barthes and "l'effet de Réel," in *The Rustle of Language* (New York, 1986), 141–48, and it gets picked up as the "effect of the real" by Joel Fineman in "The History of the Anecdote: Fiction and Fiction," in *The New Historicism*, ed. H. A. Veeser (New York, 1989), 61–62. In all its various uses, it is a way of talking about gestures to indicate absolute reality that are in truth an *effect* rather than a *fact* or an effect masquerading as a fact.

31. Of course, it behooves us as scholars to recall that constricting the ocular experience to the real is, particularly in our materialistic age, the universal impulse of picture-viewing, as is evident if one eavesdrops on conversations at any museum, among those who appreciate art but are not professionally engaged in analyzing it. Whether the art on the walls is secular or sacred, portraiture or history painting, representational or abstract, the urge to locate mimetic reality inside the frame appears fundamental, a circumstance that is unwise to discount.

32. Arthur K. Wheelock Jr. et al., *Dutch Paintings of the Seventeenth Century*, NGA Online Editions, http://purl.org/nga/collection/catalogue/17th-century-dutch-paintings. Though I am disputing his conclusion in this case, it is important to note that Wheelock throughout his work displays a wide and deep understanding of the issues, from the most material to the most abstract, that still life raises. See his "Still Life: Its Visual Appeal and Theoretical Status in the Seventeenth Century," in *Still Lifes of the Golden Age*, ed. Wheelock, exhibition catalogue, National Gallery of Art (Washington, DC, 1989). See also, in this National Gallery catalogue, Wheelock's account of a Willem Kalf still life from 1660: "To judge from paintings such as this, Kalf's primary intent must have been to create an arrangement of elegant and luxurious objects that could be enjoyed for their aesthetic appeal. As opposed to earlier Haarlem still-life painters, he seems to have had little interest in instilling moralizing messages into his works." The present work is likely to spread the notion of aesthetic—and gustatory—reception a little wider than the particular case of Kalf.

33. A good introduction to the *vanitas* theme in the traditional mode is to be found in Ingvar Bergström, *Dutch Still-Life Painting in the Seventeenth Century* (London, 1956), 154–90.

34. Two interesting essays on this theme are Robert Hahn, "Caught in the Act: Looking at Tintoretto's Susanna," *Massachusetts Review* 45 (2004–5): 633–47, and Jennie Grillo, "Showing Seeing in Susanna: The Virtue of the Text," *Prooftexts* 35 (2015): 250–70. It's an issue of viewerly reception that goes far beyond the case of Susanna.

35. Cited in Wheelock, *Dutch Paintings*, 562–63. Some of my skepticism about the universal presence of the *vanitas* theme derives from a very appreciative reading of Harry Berger Jr., *Caterpillage: Reflections on Seventeenth-Century Dutch Still Life Painting* (New York, 2011).

36. Francis Bacon, "Of Studies," in *Essays* (London, 1906), 150.

37. See chap. 2 of this volume for the discussion of verbs and therefore metaphors based on eating.

38. *Troilus and Cressida* 1.1.14–24. Shakespeare citations in this chapter are to *The Norton Shakespeare*, ed. S. Greenblatt et al. (New York, 1997).

39. See Beryl Rowland, "A Cake-Making Image in *Troilus and Cressida*," *Shakespeare Quarterly* 21 (1970): 191–94.

40. Shakespeare, *Henry IV, Part 1*, 5.4.85.

41. Marcel Proust, *In Search of Lost Time*, trans. C. K. Scott Moncrieff and Terence Kilmartin (New York, 2003), 60. See the elegant treatment of this episode in Serge Doubrovsky, "The Place of the Madeleine: Writing and Phantasy in Proust," *Boundary 2* 4 (1975): 107–34.

42. On the subject of tenor and vehicle, see chap. 1, note 22.

43. The French original is cited from *A la recherche du temps perdu*, ed. J.-Y. Tadié (Paris, 1987), 44.

44. Citations to the Hebrew Bible are to the New King James Version, online at https://www.biblestudytools.com/nkjv/.

45. On the question of taste as having its origins in knowing what it is safe to consume, see the discussion of Kant in chap. 1 of this volume; see also texts referred to in chap. 1, note 5.

46. For a full and enlightening discussion, see Robert Appelbaum, "Eve's and Adam's 'Apple': Horticulture, Taste, and the Flesh of the Forbidden Fruit in 'Paradise Lost,'" *Milton Quarterly* 36 (2002): 221–39. See also James Patrick McHenry, "A Milton Herbal," *Milton Quarterly* 30 (1996): 45–119, s.v. "apple."

47. Sigmund Freud, "Negation," *Standard Edition* 19: 235–39.

48. See chap. 1 of this volume on Kant and note 45, this chap.

49. See Appelbaum, "Eve's and Adam's 'Apple'"; see also Karen Edwards, *Milton and the Natural World: Science and Poetry in Paradise Lost* (Cambridge, UK, 1999), esp. chap. 8, "Naming and Not Naming."

50. On the painters, see Appelbaum, "Eve's and Adam's 'Apple,'" 228; see also James Snyder, "Jan van Eyck and Adam's Apple," *Art Bulletin* 58 (1976): 511–15.

51. Citations are to *The Poems of John Milton*, ed. J. Carey and A. Fowler (London, 1968). A particularly illuminating reading of *Paradise Lost* in this respect is to be found in Michael C. Schoenfeldt, *Bodies and Selves in Early Modern England: Physiology and Inwardness in Spenser, Shakespeare, Herbert, and Milton* (Cambridge, UK, 1999), 131–68.

52. The famous line appears on page 6 of William Blake, *The Marriage of Heaven and Hell*: "The reason Milton wrote in fetters when he wrote of Angels & God, and at liberty when of Devils & Hell is because he was a true Poet and of the Devils party without knowing it."

53. See Augustine, *On Christian Doctrine*, books 1 and 2, which are concerned with signs and things.

54. On this luncheon scene, see Amy L. Tigner, "Eating with Eve," *Milton Quarterly* 44 (2010): 239–53; Jack Goldman, "Perspectives of Raphael's Meal in 'Paradise Lost,' Book V," *Milton Quarterly* 11 (1977): 31–37; and especially the superb work of David B. Goldstein, *Eating and Ethics in Shakespeare's England* (Cambridge, UK, 2013), 171–204.

55. The chuckling—in this case something more severe—begins with Richard Bentley, Milton's very censorious eighteenth-century academic reader, who rejected the whole idea of anything alimentary in the lives of angels. In regard to the notion of all created things requiring feeding, he snorts, "This doctrine may pass in

Heaven, where nectar and ambrosia are always in plenty; but how will it do in Hell? If the Devils want feeding, our author made poor provision for them in his Second Book, where they have nothing to eat but 'hell-fire,' and no danger 'of their dinner cooling.'" J. H. Monk, *The Life of Richard Bentley* (London, 1833), 2:315.

56. Nor has fire been invented yet: see note to *Paradise Lost* 5.396 in *Poems of John Milton*, ed. Carey and Fowler.

57. See note on 5.339–41 in ibid. for the geographical range and precision of the menu. For a splendid account of Milton and eating, see Denise Gigante, "Milton's Aesthetics of Eating," *Diacritics* 30 (2000): 88–112, in which she declares that "the poet in our own country who has written with the greatest gusto on the subject of eating is Milton."

58. On these relations with other angelic encounters, see Jason Rosenblatt, "Celestial Entertainment in Eden: Book V of 'Paradise Lost,'" *Harvard Theological Review* 62 (1969): 411–27, and two articles by Beverley Sherry, "Not by Bread Alone: The Communication of Adam and Raphael," *Milton Quarterly* 13 (1979): 111–14, and "Milton's Raphael and the Legend of Tobias," *JEGP* 79 (1979): 227–41.

59. On Milton's relations with the Book of Tobit, see Raymond B. Waddington, *Designs and Trials in* Paradise Lost (Toronto, 2012), 128–50. On the general status of the Book of Tobit, see the *Oxford Annotated Apocrypha* (Oxford, 2018), 11–33.

60. In another version of the Vulgate, the angel declares that he was eating food that is invisible to human beings: "videbar quidem vobiscum manducare et bibere sed ego cibo invisibili et potu qui ab hominibus videri non potest utor."

61. See Gerald O'Collins, SJ, *Saint Augustine on the Resurrection of Christ* (Oxford, 2017), 12–16.

62. On this somewhat surprising word choice, see Marshall Grossman, "'Transubstantiate': Interpreting the Sacrament in 'Paradise Lost,'" *Milton Quarterly* 16 (1982): 42–47. In regard to the later stages of the digestive process, see Kent Lehnhof, "Scatology and the Sacred in Milton's 'Paradise Lost,'" *English Literary Renaissance* 37 (2007): 429–49.

63. Within the vast literature on the Eucharist, I have found particularly helpful—and diverse in their approaches—Paul E. Bradshaw and Maxwell E. Johnston, *The Eucharistic Liturgies* (Collegeville, MN, 2012); Gillian Feeley-Harnik, *The Lord's Table: The Meaning of Food in Early Judaism and Christianity* (Washington, 1981); Maggie Kilgour, *From Communion to Cannibalism* (Princeton, 1990); and Gary Macy, *The Theologies of the Eucharist in the Early Scholastic Period* (Oxford, 1984). Also useful is William R. Crockett, *Eucharist: Symbol of Transformation* (Collegeville, MN, 1989).

64. See the definitive treatment of this subject, Andrew McGowan, "Eating People: Accusations of Cannibalism against Christians in the Second Century," *Journal of Early Christian Studies* 2 (1994): 413–42.

65. On this provocative response, see Augustine, Tractate 27, in *Tractates on the Gospel of John 11–27* (Washington, 1988), 277–88.

66. See the very interesting argument in Feeley-Harnik, *The Lord's Table*, 19, in which she suggests that every critical element of the Passover celebration is reversed in this ritual.

67. See Bradshaw and Johnson, *Eucharistic Liturgies*, 48–50.

68. Ibid, 103.

69. Augustine, Sermon 272, Early Church Texts, https://earlychurchtexts.com/public/augustine_sermon_272_eucharist.htm.

70. On this debate, see Bradshaw and Johnson, *Eucharistic Liturgies*, 222–25, and Crockett, *Eucharist*, 106–109.

71. *Book of Ratramn on the Body and Blood of the Lord* (Oxford, 1838), 40.

72. See the relatively lucid account of this relation in John F. X. Knasas, "Aquinas' Ascription of Creation to Aristotle," *Angelicum* 73 (1996): 487–505.

73. On this development, see James F. McCue, "The Doctrine of Transubstantiation from Berengar through Trent: The Point at Issue," *Harvard Theological Review* 61 (1968): 385–430, and Joseph Goering, "The Invention of Transubstantiation," *Traditio* 46 (1991): 147–70.

74. On this phase of the history, see Bradshaw and Johnson, *Eucharistic Liturgies*, 233–271.

75. John Calvin, *Institutes* 4.17.26, cited in ibid., 267.

76. On the early mealtime practices of the faithful, see Valeriy A. Alikin, *The Earliest History of Christian Gathering* (Leiden, 2010), 17–78, and Christopher P. Jones, *Between Pagan and Christian* (Cambridge, MA, 2014), 61–77.

77. See *The Alliance of Divine Offices Exhibiting All the Liturgies of the Church of England* (London, 1699).

78. This is a shadowy doctrine whose origins are sometimes ascribed to the ninth-century theologian Amalarius, but it appears to have operated almost entirely as a weapon against extremists of the real presence. See A. Gaudel, "Stercorianisme," *Dictionnaire de Théologie Catholique* 14 (1941): 2590–2612. It turns up still in anti-Catholic lore that focuses its attack on a literalist notion of the Eucharist, e.g., "If the elements were really Christ, hide, hair, blood, guts and gore, then this would transform our Lord Christ, our sacrifice without spot or wrinkle into filth. According to transubstantiation, Jesus becomes dung! This is abhorrent, repugnant, retching, and a lie. It is just another proof of the Roman Church's paganism." Larry Ball, *Escape from Paganism* (Victoria, BC, 2008), 189.

79. See chap. 3 of this volume.

80. Thus Guitmund of Aversa: "We believe without a doubt that the body of the Lord in no way goes into the sewer. Furthermore, we do not concede that everything that enters into the mouth is expelled into the latrine. For that statement of the Lord cannot be competently understood, except as it pertains to foods that are ingested to sustain the life of this mortal body. For no one would even dare to speculate about what the Savior ate after his own Resurrection, or about the angels who ate in the presence of Abraham. Therefore, just as when corruptible food is consumed by immortals, that food is not fittingly believed to be bound by the law of the sewer; so it is a sacrilege to think that incorruptible food, which is the body of the Lord, when it is eaten by mortals, must endure the necessity of the latrine." *The Fathers of the Church, Medieval Continuation*, trans. Mark G. Vaillancourt (Washington, 2009), 137–38.

81. See the exhaustive treatment of the subject in Gary Macy, "Of Mice and Manna: Quid Mus Sumit as a Pastoral Question," *Recherches de Théologie Ancienne et Médiévale* 58 (1991): 157–66.

82. See Bradshaw and Johnson, *Eucharistic Liturgies*, 227; and Enrico Mazza, *The Celebration of the Eucharist* (Collegeville, MN, 1999), 220–22.

83. See the essays in René Dirven and Ralf Pörings, *Metaphor and Metonymy in Comparison and Contrast* (Berlin and New York, 2003). See also the enchanting cultural treatment of these issues in Harry Berger Jr., *Figures of a Changing World: Metaphor and the Emergence of Modern Culture* (New York, 2015).

84. Of the several dozen sites answering this question that I currently find online, see, for instance, "Chewing the Eucharist," Catholic Answers: Forums, https://forums.catholic.com/t/chewing-the-eucharist/16131.

85. See Christine Schenk, *Crispina and Her Sisters: Women and Authority in Early Christianity* (Minneapolis, 2017), 121–58. On the various representations of the Eucharist, see Gertrud Schiller, *Iconography of Christian Art* (Greenwich, CT, 1972), 24–41; and Valerie Pennanen, "Communion," in *Encyclopedia of Comparative Iconography*, ed. H. E. Roberts (Chicago and London, 1998), 179–88.

86. On the identification of the Saint Callixtus subject, see E. R. Barker, "The Topography of the Catacombs of S. Callixtus in the Light of Recent Excavations," *Journal of Roman Studies* 1 (1911): 107–27. For the identification of the Priscilla subject, see Schenk, *Crispina and Her Sisters*, 121–58.

87. On this subject, see Barry M. Craig, *Fractio Panis: A History of the Breaking of Bread in the Roman Rite*, Studia Anselmiana 151 (Rome, 2011).

88. Fundamental work on this conjunction of setting and subject was done by Creighton Gilbert, "Last Suppers and Their Refectories," in *The Pursuit of Holiness*, ed. C. Trinkaus and H. A. Oberman (Leiden, 1974), 371–402. A useful, more recent introduction to this phenomenon is the first chapter of Diana Hiller, *Gendered Perceptions of Florentine Last Supper Frescoes, c. 1350–1490* (Abingdon, UK, 2014), 7–35.

89. See, earlier in this volume, chap. 2 on Pompeiian dining and chap. 4 on Italian Renaissance princely banquet halls.

90. On Reformation altarpieces, and images in general, see the definitive work of Joseph Leo Koerner, *The Reformation of the Image* (Chicago, 2004). See also Schiller, *Iconography*, 40–41.

91. See William Hood, *Fra Angelico at San Marco* (New Haven, CT, 1993), 244–45.

92. For the specific passages that appear on the adjacent scrolls, see Schiller, *Iconography*, 29.

93. On this altarpiece, see William S. A. Dale, "'Latens Deitas': The Holy Sacrament Altarpiece of Dieric Bouts," *Canadian Art Review* 11 (1984); 110–16.

94. On this and related works, see H. D. Gronau, "The Earliest Works of Lorenzo Monaco, I," *Burlington Magazine* 92 (1950): 183–88.

95. For the context of this work, see Hayden B. J. Maginnis, "Pietro Lorenzetti: A Chronology," *Art Bulletin* 66 (1984): 183–211.

96. British Library Add MS17280, f. 96v. On this manuscript, see Janet Backhouse, "The So-Called Hours of Philip the Fair: An Introductory Note on British Library Additional MS 17280," *Wiener Jahrbuch für Kunstgeschichte* 46–47 (1994): 45–54.

97. There is an interesting variant on these perplexities on what's for dinner at the Last Supper, a sort of "none of the above." When the scene is depicted by Ghiberti on the north doors of the Florentine baptistery at the beginning of the fifteenth century, or by Andrea del Castagno (see fig. 5.24) at the convent of Sant'Apollonia in the middle of the century, or by Fabrizio Boschi in the Florentine Ospedale Bonifacio in the later seventeenth century, the composition is designed expressly so that our point of view does not enable us to see what is on the table. In other words, since painters and sculptors do not paint or sculpt what viewers cannot see, *nothing* is on the table. Whatever the other consequences of this compositional choice may be, these works relieve the artist of confronting a theological/gastronomic dilemma.

98. On this equivalence, see Gedaliahu G. Stroumsa, "The Early Christian Fish Symbol Reconsidered" in *Messiah and Christos*, ed. I. Gruenwald, S. Shaked, and G. G. Stroumsa (Tübingen, Germany, 1992), 200–205; and Todd Edmondson, "The Jesus Fish: Evolution of a Cultural Icon," *Studies in Popular Culture* 32 (2010): 57–66.

99. On Nelli's *Last Supper*, see "Edible Abstinence: Plautilla Nelli's *Last Supper* and the Florentine Refectory Tradition," https://www.academia.edu/35401648, one of the rare studies of a Last Supper that places the question of the food in a central position, focussing rather specifically on the idea that it is a Lenten meal. On the restoration, see C. Acidini et al., *Orate pro pictura/Pray for the Paintress* (Florence, 2009).

100. The painting has, of course, generated a gigantic bibliography, notably including two studies, several decades apart, by Leo Steinberg: "Leonardo's *Last Supper*," *Art Quarterly* 36 (1973): 297–410, and *Leonardo's Incessant Last Supper* (New York, 2000). The latter in particular has done some of the most incisive work in the whole canon on the question of the moment that Leonardo was depicting, including the issue of the betrayal by Judas vs. the institution of the sacrament. In addition, I have found particularly helpful the essays of Jack Wasserman, especially "Rethinking Leonardo da Vinci's 'Last Supper,'" *Artibus et Historiae* 28 (2007): 23–35, and "Leonardo da Vinci's Last Supper: The Case of the Overturned Salt Cellar," *Artibus et Historiae* 24 (2003): 65–72.

101. On the tradition of copies, see Georg Eichholz, *Das Abendmahl Leonardo da Vincis: Eine Systematische Bildmonographie* (Munich, 1998); and Ludwig H. Heydenreich, *Leonardo: The Last Supper* (New York, 1974): 99–105.

102. On Goethe and the saltcellar, see Heydenreich, *Leonardo: The Last Supper*, 85–90. For the eels, see John Varriano, "At Supper with Leonardo," *Gastronomica* 8 (2008): 75–79.

103. On the Holbein-Leonardo connection, see Oskar Bätschmann, "Holbein and Italian Art," *Studies in the History of Art* 60 (2001): 36–53.

104. On this scene, see Bincy Matthew, *The Johannine Footwashing as the Sign of Perfect Love* (Tübingen, Germany, 2018), 307.

105. On Judas and his various representations, see Helene E. Roberts, ed., *Encyclopedia of Comparative Iconography* (Chicago, 1998), s.v. "Betrayal" and "Communion." See also the interesting revisionist ideas in Almut-Barbara Renger, "The Ambiguity of Judas: On the Mythicity of a New Testament Figure," *Literature and Theology* 27 (2013): 1–17.

106. See Augustine, Tractate 62, *Tractates on the Gospel of John*, vol. 4, trans. J. W. Rettig (Washington, 1994).

107. The earliest appearance in English of the document of the interrogation is in *Watson's Art Journal*, 15 Feb. 1868, 233–34. I follow the translation by Charles Yriarte that appeared in Francis Marion Crawford, *Salve Venetia* (New York, 1905), 2:29–34, though I have made some alterations based on the transcription of the original Italian by Philipp Fehl. The most suggestive account of the story, and of the painting itself, is also one of the earliest: Philipp Fehl, "Veronese and the Inquisition: A Study of the Subject Matter of the So-Called 'Feast in the House of Levi,'" *Gazette des Beaux-Arts* 58 (1961): 325–54; it also contains the most reliable transcription of the record, along with an invaluable textual commentary. (It is that transcription, with some modernizations, that appears in these notes.) For useful analyses of the events, see also Edward Grasman, "On Closer Inspection—The Interrogation of Paolo Veronese," *Artibus et Historiae* 30 (2009): 125–34, which offers a valuable account of the historiography surrounding the discovery of the text and its history of interpretation. See also Brian T. D'Argaville, "Inquisition and Metamorphosis: Paolo Veronese and the 'Ultima Cena' of 1573," *RACAR* 16 (1989): 43–48.

108. For some relevant information on these works as a group, see Gianni Moriani, *Le fastose cene di Paolo Veronese* (Crocetta del Montello, Italy, 2014).

109. Until prompted by the interrogators, Veronese can remember only Simon: "There are many other figures but I cannot remember, it's been a long time since I finished the painting."

110. *Ei dictum; Che quadro è questo che avete nominato?*
 R. Questo è un quadro della Cena ultima, che fece Gesù Cristo cum li suoi Apostoli in ca de Simeon.
 Ei dictum: dov'è questo quadro?
 R. In refettorio delli frati de S. Zuane Polo. . . .
 Ei dictum: Dite quanti Ministri, et li effetti che ciascun di loro fanno.
 R. El patron dell'albergo Simon: oltra questo ho fatto sotto questa figura un scalco, il qual ho finto chel sia venuto per suo diporto a vedere come vanno le cose della tola.

111. Luke 7:36–50. This is the scene where the sinful woman treats Jesus with respectful awe, whereas Simon, the rich Pharisee, not only disdains the woman but also fails to perform the loving gestures toward Jesus for which she is exemplary.

112. *Ei dictum: In questa Cena, che avete fatto in S. Giovanni Paolo che significa la pittura di colui che li esce il sangue dal naso?*
 R. L'ho fatto per un servo, che per qualche accidente, li possa esser venuto il sangue dal naso.

The question itself suggests that Veronese's interrogators had examined the painting *very* closely, as is clear when one stands in front of the work at the Accademia and searches out the nosebleed.

113. *Ei dictum: Alla tavola del Signor chi vi sono?*
 R. Li dodici apostoli.
 Ei dictum: Che effetto fa S. Piero, che è il primo?
 R. El squarta [or possibly *guarda*] *l'agnello per darlo all'altro Capo della tola.*
 Ei dictum: Dite l'effetto che fa l'altro che è appresso questo.
 L'ha un piatto per ricever qualche li dara S. Pietro
 Dite l'effetto che fa l'altro che è appresso.
 R. L'è uno, che ha un piron, che si cura i denti.

114. The comic bathos starts early, at the very beginning of the interrogation, when Veronese is asked whether he knows why he was sent for and he replies, in effect, "is it about the dog?" It seems that someone whose name he doesn't know wants him to replace the dog in the painting with Mary Magdalene. He doesn't want to make that change because he doesn't think Mary Magdalene would look good there, "for a variety of reasons, which I can speak to if I am given the chance."

115. "Pictoribus atque poetis / quidlibet audendi semper fuit aequa potestas." Horace, *Ars poetica*, lines 9–10. This was seized upon not only by poets (which were the individuals whom Horace really had in mind), but equally by painters and those who were theorizing painting, as, for instance in Francisco de Hollanda's *Four Dialogues on Painting* (trans. A.F.G. Bell [London, 1928]), in which a version of this dictum is placed in the mouth of Michelangelo. See Judith Dundas, "The Paragone and the Art of Michelangelo," *Sixteenth-Century Journal* 21 (1990): 87–92.

116. "Noi pittori ci pigliamo la licenza che si pigliano i poeti e i matti."

117. "Io fazzo le pitture con quella consideratione che è conveniente, che'l mio intelletto può capire."

118. *Rime* 151. Translation from Christopher Ryan, *Michelangelo: The Poems* (London, 1996). Easily the most widely quoted of all of Michelangelo's poems, both in his own time and later. It formed the basis of the first lecture given by Benedetto Varchi at the newly founded Florentine Academy. See Leatrice Mendelsohn, *Paragoni: Benedetto Varchi's* Due Lezzioni *and Cinquecento Art Theory* (Ann Arbor, 1982).

119. For a brief account of this act of censorship, see Giovanni Garcia-Fenech, "Michelangelo's Last Judgment—uncensored," Artstor, 13 Nov. 2013, https://artstor.blog/2013/11/13/michelangelos -last-judgment-uncensored/.

Index

House of the Physician, Pompeii, *49*, 50, 51
House of the Triclinium, Pompeii, *42*, 43–44, *43*
Huguet, Jaume, *The Last Supper (Sant Sopar)*, *270*, 271
Huizinga, Johan, 35
humanism: culinary texts in tradition of, 158–71; effect of discovery of Lucretius on, 170; persecution of, 165; pleasure as topic for, 170–73
hunger. *See* scarcity/hunger, in the Renaissance

indigenous peoples, 195–200
Infancy Gospel of Matthew, 91
Inquisition, 272, 278–82
Institution of the Sacrament. *See* Communion of the Apostles
intelletto, of the artist, 282
interdisciplinarity, 27–28
in vino veritas (in wine, there is truth), 24, 287n32
invitations to dinner, 78
Irenaeus, 242

Jakobson, Roman, 141–42, 148
James I, King of England, 24
Jamestown colony, 196–97
Jesus: in Leonardo's *Last Supper*, 266–67; in Madonna and Child paintings, 130–39; in Martha and Mary's house, 113, 116–30; stories involving food associated with, 98–102, 130, 174; and supper at Emmaus, 103, 127; symbols of, 260–61; transubstantiation/Last Supper and, 241–72
Jones, Inigo, 151
Jonson, Ben, 151, 170, 198
Jordaens, Jacob, *Cleopatra's Feast*, *ii* (detail), 103, *105*
Julius III, Pope, 167
Juvenal, *Satire 5*, 75–76

Kalf, Willem, 228–29; *Still Life with Silver Bowl, Glasses, and Fruit*, 222, *224*
Kant, Immanuel, 16, 22, 205, 234; *Anthropology from a Pragmatic Point of View*, 8–9
kosher laws, 100–101

Lacan, Jacques, 143
Lairesse, Gérard de, 228
language, eating and drinking in relation to, 58–59, 74, 141–42, 146–49, 229–31
Laocoön, 15
Last Supper, 19–20, *20–21*, 242, 246–72; Communion of the Apostles compared to, 252–55, 257, 268; contemporary life incorporated into scenes of, 250–52; dining contexts for, 249–51; dinner scenes imitated by, 247–48; display of food in scenes of, 261–64; food references in scenes of, 255–61, 266; Judas at, 268–72; Leonardo's version of, 265–68, 272; Veronese's *Feast in the House of Levi* and, 272–75, 278–83

The Last Supper, golden antependium of Emperor Otto II, Palatine Chapel, Cathedral of Aachen, Germany, 269, *269*
The Last Supper, tile decorated in relief, from pulpit, Cathedral of Santa Maria Assunta, Volterra, Italy, 269, *269*
Le Bas, Jacques Philippe, after François Boucher, *Pensent-ils au raisin? (Are They Thinking about the Grapes?)*, 13, *14*
Lentulus Niger, 65
Leo X, Pope, 178
Leonardo da Vinci, 281; *The Last Supper*, 254, 265–68, *266*, *267* (detail), 272
Leto, Pomponio, 159, 165
Liber de coquina, 158
Libro per cuoco, 158
linear perspective, 19, 20
Lippi, Filippo, *Herod's Banquet (Dance of Salome)*, 106, *107*, 109, 111
literature: art in relation to, 27, 281; limitations of discursive nature of, 28
Livy, 63–65
Lord's Supper, 98
Lorenzetti, Pietro, *The Last Supper*, 259, *259*
L'Orme, Philibert de, 155
love (eros): in Boucher's *Pensent-ils au raisin?*, *12*, 13–14, 16; food substituted for, 13–14, 16; in Plato's *Symposium*, 7, 23–24, 145, 156; in Raphael's *Loggia di Psiche*, 183, 185, 192; in Romano's Palazzo del Te murals, 182–83
Lucilius, 72
Lucretius, *De rerum natura*, 170
Lucullus, 62
Luini, Bernardino, *Madonna with Child and Apple*, *131*, 133
Lusius Vetutius Placidus, thermopolium of, *41*
Luther, Martin, 244, 251, 280, 295n44
luxury, 58, 65, 69, 71

Machiavelli, Niccolò, 179, 182
Macrobius, 65–66
madeleines, 232–34, 236
Madonna and Child theme, 130–39
Manet, Edouard, *Olympia*, 28, *28*
manna, 97–98
Mariotto di Nardo, *Scenes from the Life of Christ: The Last Supper*, 261, *262*
Mark Antony, 146
Martial, 34, 39, 69–70, 73, 78; *Epigrams*, 69, 75, 208
Martino of Como, 162–64
Mary, mother of Jesus: in Madonna and Child paintings, 130–39; presentation at the temple, as a youth, 91–94
Massys, Quentin, *Enthroned Madonna*, 136, *138*
Master of the Dresden Prayer Book, *The Last Supper*, from *Hours of Philip the Fair*, 259–60, *260*
Master of the Female Half-Lengths, *The Virgin and Child*, 136, *136*
Mazzolino, Ludovico, central panel of *Triptych with Virgin and Child, Saints Anthony Abbot and Mary Magdalene*, 134, *135*
Medici, Cosimo de', 168

4.10, 4.12, 4.16, 4.18, 4.20, 4.21, 4.22, 4.23, 4.24, 4.25,
5.4, 5.9, 5.24, 5.25, 5.26, 5.27, 5.29, 5.34, 5.37, 5.38,
5.40, 5.47, 5.48, 5.53, 5.54, 5.55, 5.70, 5.76, 5.77, 5.78

Scala / Ministero per i Beni e le Attività Culturali / Art
Resource, New York: figs. 2.26, 3.1, 3.2, 3.4, 4.19, 5.28,
5.52, 5.57, 5.58

Sonia Halliday Picture Library: fig. 5.31

Sotheby's: fig. 3.41

© Staatliche Kunstsammlungen, Dresden / Bridgeman
Images: fig. 5.75

Städelsches Kunstinstitut, Frankfurt: fig. 3.18

© The State Hermitage Museum, St. Petersburg, Russia /
HIP / Art Resource, New York: fig. 3.7, 3.8, 3.47

Szathmary Collection, Special Collections, The University of
Iowa Libraries: fig. 4.2

Szépművészeti Múzeum / Museum of Fine Arts, Budapest,
2020: fig. 3.5

© Vanni Archive / Art Resource, New York: figs. 2.12, 5.6,
5.7, 5.8

Württembergische Landesbibliothek, Stuttgart: fig. 5.62

About the Author

Leonard Barkan is the Class of 1943 University Professor of Comparative Literature at Princeton University. His books include *Mute Poetry, Speaking Pictures* (Princeton), *Unearthing the Past: Archaeology and Aesthetics in the Making of Renaissance Culture*, and *Satyr Square: A Year, a Life in Rome*.